Microanalysis of Parchment

Microanalysis of Parchment

Edited by René Larsen

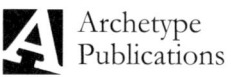
Archetype Publications

First published 2002 by Archetype Publications Ltd.

Archetype Publications Ltd.
6 Fitzroy Square
London W1T 5HJ

www.archetype.co.uk

Tel: 44(207) 380 0800
Fax: 44(207) 380 0500

© 2002: Copyright is held jointly among the authors and Archetype Publications

The authors and publisher can take no responsibility for any harm or damage that may be caused by the use or misuse of any information contained herein.

ISBN 1-873132-68-9

British Library Cataloguing in Publication Data
A catalogue record for this book is available from the British Library

All rights reserved. No part of this publication may be reproduced, stored in a retrieval system, or transmitted, in any form or by any means, electronic, mechanical, photocopying, recording or otherwise, without the prior permission of the publishers.

Typeset by Kate Williams, Abergavenny
Printed and bound in Great Britain by Bell & Bain Limited, Glasgow

Contents

Contributors	ix
Acknowledgements	xi
Preface *René Larsen*	xiii
Introduction *René Larsen*	xv
Parchment	xvii
Materials	xix

I Microsampling and Microscopical Assessment of Parchment including Microchemical Analysis of Binding Media, Dyes and Ink

1 A New Microsampling Technique for Parchment — 3
Leopold Puchinger and Herbert Stachelberger

Introduction	3
Description of the microdrilling instrument	3
Drill sizes and technique of needle sharpening	5
Evaluation of drill bits and holes left in the parchment – applications	6
Summary	7
References	8

2 Evaluation of Old Parchment Collagen with the help of Transmission Electron Microscopy (TEM) — 9
Leopold Puchinger, Dietmar Leichtfried and Herbert Stachelberger

Introduction	9
Materials and methods	9
Discussion of the results obtained with TEM	10
Discussion of the results from TEM by comparison with other methods	12
Conclusions	12
References	12

3 Evaluation of Methods for the Microanalysis of Materials Added to Parchment — 13
Jan Wouters, Johan Claeys, Karijn Lamens and Marina Van Bos

Introduction	13
Historical sources for the composition of miniatures	13
Materials and methods	13
Results and discussion	17
Conclusion	26
Acknowledgements	29
References	29

4 Characterization of Vegetable Gums used as Binding Media in Inks by Gas Chromatography and Multivariable Analysis — 31
Pascale Richardin, Sylvette Bonnassies-Termes and Jean-Christophe Doré

- Introduction — 31
- Experimental — 31
- Characterization by gas chromatography of neutral sugars and uronic acids — 32
- Analysis of vegetable gums — 35
- Application to metallogallic inks — 39
- Conclusion — 41
- Acknowledgements — 41
- References — 41
- Appendices — 42

5 Sulphur Inclusions within Parchment and Leather Exposed to Sulphur Dioxide — 45
Derek J. Bowden and Peter Brimblecombe

- Introduction — 45
- Experimental — 45
- Results — 47
- Discussion — 50
- Conclusions — 50
- Acknowledgement — 51
- Endnotes — 51
- References — 51

II Thermophysical and Thermochemical Analysis of Microsamples

6 The Hydrothermal Stability (Shrinkage Activity) of Parchment Measured by the Micro Hot Table Method (MHT) — 55
René Larsen, Dorte V. Poulsen and Marie Vest

- Introduction — 55
- Experimental — 55
- Samples — 56
- Results — 57
- Discussion — 58
- Conclusions — 61
- References — 62

7 The Thermal Response of Parchment and Leather to Relative Humidity Changes — 63
Derek Bowden and Peter Brimblecombe

- Introduction — 63
- Background — 63
- Experimental — 64
- Examples and results — 67
- Conclusions — 71
- Endnotes — 72
- References — 72

8 Characterization of Historic and Unaged Parchments using Thermomechanical and Thermogravimetric Techniques — 73
Marianne Odlyha, Neil Cohen, Gary Foster and Roberto Campana

- Introduction to thermomechanical and thermogravimetric techniques — 73
- Dynamic mechanical thermal analysis (DMTA): stress–strain measurements — 74
- DMTA: Measurement of viscoelastic properties — 75
- DMTA: Underwater heating creep measurements — 79
- Thermogravimetry analysis (TGA) — 83
- Overall conclusions from thermomechanical and thermogravimetric measurements — 87
- Principal component analysis (PCA) — 88
- References — 89

III Chemical and Structural Characterization of Collagen and Palaeogenetics of Parchment

9 Amino Acid Analysis of New and Historical Parchments — 93
René Larsen, Dorte V. Poulsen, Marie Vest and Arne L. Jensen

- Introduction — 93
- Experimental — 93
- Results — 94
- Discussion — 95
- Conclusion — 98
- References — 98

10 ^{13}C and ^{15}N Solid State Nuclear Magnetic Resonance (NMR) Spectroscopy of Modern and Historic Parchments — 101
Marianne Odlyha, Neil Cohen, Gary Foster, Roberto Campana and Abil Aliev

- Introduction — 101
- Experimental — 101
- Results (^{13}C NMR spectra) — 102
- Results: ^{15}N solid state NMR spectra — 105
- Conclusions — 107
- References — 108

11 Study of the Chemical Breakdown of Collagen and Parchment by Raman Spectroscopy — 109
Thomas Garp, Kurt Nielsen and Soghomon Boghosian

- The principles and methods of Raman spectroscopy — 109
- FT-Raman spectroscopic studies of parchment — 110
- Conclusions — 115
- References — 116

12 Detection of Radicals in Collagen and Parchment Produced by Natural and Artificial Deterioration, Electron Spin Resonance Spectroscopy (ESR) and its Implications for Artificial Ageing and Test of Conservation Treatments — 117
Daniella Bechmann Hansen, Kurt Nielsen and Søren Birk Rasmussen

- The principles and methods of electron spin resonance spectroscopy (ESR) — 117
- Results and discussion: ESR spectroscopic study of parchment — 119
- Conclusion — 120
- References — 121

13 Determination of the Molecular Weight Distribution in Parchment Collagen by Steric Exclusion Chromatography — 123
Frédérique Juchauld and Claire Chahine

- Introduction — 123
- Materials and methods — 123
- Experiment — 124
- Correlation between the two chromatographic methods — 129
- Correlation with differential scanning calorimetry (DSC) results — 129
- Conclusions — 131
- References — 131

14 SDS-PAGE and 2D-Electrophoresis — 133
René Larsen, Dorte V. Poulsen and Marie Vest

- Introduction — 133
- Experimental — 134
- Results and discussion — 137
- Conclusions — 145
- Acknowledgements — 146
- Endnotes — 146
- References — 146

15	**Analysis of Collagen Structure in Parchment by Small Angle X-ray Diffraction**	149
	Timothy J. Wess and Kurt Nielsen	
	Background to collagen structure	149
	X-ray diffraction	149
	Synchrotron radiation	150
	Data analysis and parameters	151
	Model building	152
	Principal component analysis	153
	Conclusion	153
16	**Pyrolysis Capillary Gas Chromatography (PY-CGC) of Historical Parchment Samples**	155
	Leopold Puchinger, Dietmar Leichtfried and Herbert Stachelberger	
	Introduction	155
	Materials and methods	155
	Pyrolysis capillary gas chromatography (PY-CGC)	155
	Discussion of the results obtained with PY-CGC	156
	Discussion of the results from TEM and PY-CGC by comparison with other methods	156
	Conclusions	158
	References	158
17	**Palaeogenetics of Parchment**	159
	Joachim Burger	
	Introduction	159
	Genetic background	159
	Methods (from Burger et al. 2000b)	159
	Results and discussion	160
	From which individual animal did this come? DNA profiling	161
	Conclusion	161
	References	161
		161

IV Complementary and Comparative Analysis

18	**The Use of Complementary and Comparative Analysis in Damage Assessment of Parchments**	165
	René Larsen, Dorte V. Poulsen, Marianne Odlyha, Kurt Nielsen, Jan Wouters, Leopold Puchinger, Peter Brimblecombe and Derek Bowden	
	Introduction	165
	Experimental	165
	Deterioration characterized by shrinkage phenomena	166
	The impact of chemical deterioration on the hydrothermal stability	168
	Chemical damage modelling by the prediction of T_s from chemical data	172
	PCA of thermomechanical, thermogravimetric and solid state NMR data	175
	Macroscopic and microscopic properties vs. measurement data	175
	Conclusions	176
	Epilogue: The problem of model building and correlation analysis	178
	References	179

Contributors

Dr Abil Aliev, Solid State NMR Spectroscopy Service, Department of Chemistry, UCL, 20 Gordon Street, London WC1H 0AJ, UK.

Dr Soghomon Boghosian, Institute of Chemical Engineering and High Temperature Processes, University of Patras, GR 26 500 Patras, Greece.

Sylvette Bonnaissies-Termes, Centre de Recherches sur la Conservation des Documents Graphiques, 36, rue Geoffroy Saint Hilaire, 75005 Paris, France.

Derek Bowden, School of Environmental Sciences, University of East Anglia, Norwich NR4 7TJ, UK.

Peter Brimblecombe, School of Environmental Sciences, University of East Anglia, Norwich NR4 7TJ, UK.

Dr Joachim Burger, Institute of Anthropology, Johannes Gutenberg-Universität Mainz, Saarstrasse 21, D-55099, Mainz, Germany.

Johan Claeys, Royal Institute of Cultural Heritage, Jubelpark 1, B-1000 Brussels.

Claire Chahine, Centre de Recherches sur la Conservation des Documents Graphiques, 36, rue Geoffroy Saint Hilaire, 75005 Paris, France.

Dr Roberto Campana, School of Biological and Chemical Sciences, Birkbeck College, Gordon House, 29 Gordon Square, London WC1H OPP, UK.

Dr Neil Cohen, School of Biological and Chemical Sciences, Birkbeck College, Gordon House, 29 Gordon Square, London WC1H OPP, UK.

Jean-Christophe Doré, Laboratoire de Chimie Appliquée, Museum National d'Histoire Naturelle, Paris, France.

Dr Gary Foster, School of Biological and Chemical Sciences, Birkbeck College, Gordon House, 29 Gordon Square, London WC1H OPP, UK.

Thomas Garp, Department of Chemistry, Technical University of Denmark Building No. 207, 2800 Lyngby, Denmark.

Daniella B. Hansen, Department of Chemistry, Technical University of Denmark, Building No. 207, 2800 Lyngby, Denmark

Arne L. Jensen, Department of Protein Chemistry, University of Copenhagen, Øster Farimagsgade, 1353 Copenhagen K, Denmark. Now at: Zealand Pharmaceuticals a/s, Smedeland 26b, 2600 Glostrup, Denmark.

Fréderique Juchauld, Centre de Recherches sur la Conservation des Documents Graphiques, 36, rue Geoffroy Saint Hilaire, 75005 Paris, France.

Karijn Lamens, Royal Institute for Artistic Heritage, Jubelpark 1, 1000 Brussels, Belgium.

René Larsen, Royal Academy of Fine Arts, School of Conservation, Esplanaden 34, 1263 Copenhagen K, Denmark.

Kurt Nielsen, Department of Chemistry, Technical University of Denmark, Building No.207, 2800 Lyngby, Denmark.

Dr Marianne Odlyha, School of Biological and Chemical Sciences, Birkbeck College, Gordon House, 29 Gordon Square, London WC1H OPP, UK.

Dorte V. Poulsen, Royal Academy of Fine Arts, School of Conservation, Esplanaden 34, 1263 Copenhagen K, Denmark.

Leopold Puchinger, Vienna University of Technology, Institute for Applied Botany Technical Microscopy and Organic Raw Material Studies, Getreidemarkt 9, A-1060 Vienna, Austria.

Søren Birk Rasmussen, Department of Chemistry, Technical University of Denmark, Building No.207, 2800 Lyngby, Denmark.

Pascale Richardin, C2RMF, 6 rue des Pyramides, 75041, Paris Cedex 01, France.

Herbert Stachelberger, Vienna University of Technology, Institute for Applied Botany, Technical Microscopy and Organic Raw Material Studies, Getreidemarkt 9, A-1060 Vienna, Austria.

Marina Van Bos, Royal Institute for Artistic Heritage, Jubelpark 1, 1000 Brussels, Belgium.

Marie Vest, Royal Academy of Fine Arts, School of Conservation, Esplanaden 34, 1263 Copenhagen K, Denmark.

Dr Timothy J. Wess, Department of Biological and Molecular Sciences, University of Stirling, Stirling FK9 4LA, UK.

Jan Wouters, Royal Institute for Artistic Heritage, Jubelpark 1, 1000 Brussels, Belgium.

Acknowledgements

As partners in the European joint research project *Microanalysis of Parchment*, we would like to express our appreciation and gratitude to Dr Marianne Odlyha, Dr Neil Cohen, Dr Gary Foster, Dr Roberto Campana (School of Biological and Chemical Sciences, Birkbeck College) and Dr Abil Aliev (Solid State NMR Spectroscopy Service, London University); Dr Timothy J. Wess (Department of Biological and Molecular Sciences, University of Stirling); Dr Joachim Burger (Institute of Anthropology, University of Mainz, former Georg-August University, Goettingen); Dr Soghomon Boghosian (Institute of Chemical Engineering and High Temperature Processes, University of Patras). Without their generous contribution and that of their institutions to the project, large parts of this book would not have been realized.

The contributors are also very to grateful to Dr Charles Greenblatt and Dr Gila Kahila Bar-Gal (Hadassah Medical School, The Hebrew University, Jerusalem) for their scientific contributions to their work; Mrs J. Sanyová for her help with the study of historical sources and the preparation of laboratory reference parchments; Dr N. K. Tovey (Reader in Environmental Sciences, University of East Anglia; Norwich) for his help with development of image processing algorithms; Dr Peter M. Larsen and Dr Steven Fey (The Centre for Proteome Analysis, Odense University) for their advice and help in the development of the 2D-PAGE analysis. We would also like to thank Dr Jana Odvárková, Dr Magda Souckova and Jiri Vnoucèk (The National Library of the Czech Republic); Werner Schmitzer and Jutta Göpfrich (Deutsches Ledermuseum – Deutsches Schuhmuseum, Offenbach) for their active contribution and sharing of experience within practical conservation, and for the hospitality shown by their institutions in hosting our research meetings.

We are very grateful to Dr Christopher Calnan (The National Trust, London); Library of Trinity College, Dublin; The Arnamagnian Institute, University of Copenhagen; The Royal Library, Copenhagen; The National Archive of Denmark and the Regional Archive, Copenhagen for supplying historical parchment samples for the experimental development and analysis. Pr. Bernard Bodo (Director, Laboratoire de Chimie Applique, MNHN) for the samples of prestigious natural products and Mr Vitold Nowik (Laboratoire de Recherhe sur les Monuments Historiques) for the samples of old gums. Many thanks to the students and teachers in the European Advanced Study Course 1999 *Methods in the Analysis of the Deterioration of Collagen-Based Historical Materials in Relation to Conservation and Storage* for their engaged contribution to the critical discussion of our work.

Thanks are also due to Dorte V. Poulsen, Sidse Stammerjohan, Marie Vest and not least Karen Borchersen for their editorial work, to Christina Lund Olsen for her proofreading of some of the manuscripts and Mogens Koch for his editorial support (all at the School of Conservation, The Royal Danish Academy of Fine Arts).

Finally, we would like to thank Dr Eddie A. Maier (Scientific Officer, Commission of the European Union, the Directorate General for Research Technology and Development) for financial support and helpful advice in matters of administration and management of the project; the Danish Ministry of Culture for financial support and the School of Conservation, The Royal Danish Academy of Fine Arts, for the financial and administrative support without which the development and research work as well as the production of this book would not have been possible.

Preface

René Larsen

The content of this book builds mainly on the techniques, methods and work produced during the European joint research project *Methods in the Micro Analysis of Parchment* (MAP project) contract no. SMT4-96-2101. The project involved research partners from Austria, Belgium, Denmark, England, France, Germany, Israel and the Czech Republic. It was performed and supported financially within the Environment and Climate subprogram, Standard, Measurement and Testing under the Fourth Framework Program of the European Union, General-Directorate XII for Science, Research and Development (now the Research Directorate-General).

Many of the analytical methods and techniques presented are new (developed during the project) or have been modified and used on historical cultural heritage parchments for the first time. Although the primary goal of the European project was to develop and improve the methods and techniques of microsampling, non-destructive analysis and microanalysis, the work has produced many useful results and new knowledge has been gained. These are presented as examples of the use of methods and techniques, and may hopefully form the basis for further, more intensive studies in the analysis and conservation of historical cultural heritage parchment objects. Additionally, the techniques may prove useful in the studies of other collagen-based cultural heritage objects.

Introduction

René Larsen

Parchments, especially in the form of written and illuminated manuscripts, are objects of a highly complex chemical and physical nature. This has to be taken into consideration when studying their deterioration and conservation. Moreover, compared to new materials, historical parchments may be very different in nature; they are often precious and of great cultural value which may limit the possibilities of sampling. Analysis therefore needs to be based on very accurate microanalytical or non-destructive methods producing valid results. This handbook presents sampling techniques and non-destructive, microanalytical and semi-microanalytical methods for the analysis and testing of historical parchments based on visual, microscopical as well as chemical and physical techniques. Some of the analytical methods and techniques are relatively simple and may be used in practical applied conservation in the treatment of individual objects or for the assessment of a collection of objects. Other methods and techniques are rather more advanced and require specialized expertise and equipment. These may be used in the fundamental study of the deterioration and conservation of parchment objects. However, some of the advanced non-destructive and microanalytical methods may also be used for applied purposes in the assessment and identification of historical parchments. In these cases, cooperation between conservation workshops and specialized laboratories is necessary. This, of course, already takes place, but the contributors to this book hope that their work will contribute to the creation of more cooperative networks.

The first part of the book is devoted to a short description of the samples of historical and new parchments that have been used to develop the techniques and produce the analytical results. This is followed by three main sections. The first section covers the techniques of microsampling, microscopical assessment of the parchment as well as microchemical analysis binding media, dyes and inks. The second covers the thermophysical and thermochemical analysis of parchment and the third section presents the methods of analysis of chemical and structural characteristics of the collagen as well as palaeogenetics of parchment. In each paper of the three main sections, the individual techniques and methods are described and discussed in detail in relation to their use in the assessment and conservation of historical parchments, including the application of the methods and the analytical data to theoretical prediction of breakdown mechanisms and deterioration, as well as to practical diagnosis and conservation. The final chapter (18) is a joint paper written by several of the contributing authors. This paper discusses the analytical results of a selection of historical parchment samples that have been analyzed by most of the analytical programs. The idea is to show how complementary studies may be used to give a detailed picture of the deterioration and nature of complex materials such as parchment objects. In addition, the analytical data and results presented are so informative that we are convinced that these provide a very fine basis for further advanced studies as well as for practical conservation – not only in connection with historical parchments, but also in connection with the study and conservation of other collagen-based historical materials.

Parchment

Parchment, probably produced originally as a writing material, is made from the dermis of animal skin. The Dead Sea Scrolls found in Qumran date from around 250 BC to AD 68, and to date are the oldest known parchments. However, paintings on papyrus and tomb walls indicate that parchment was being manufactured in Egypt and the Middle East as early as 2500 BC. The earliest description of European parchment production dates to the 8th century. Today parchment is still produced according to old recipes, e.g. for production of Thora Scrolls.

Several terms are currently used – parchment, vellum, rawhide, skin – to describe the product 'parchment' more accurately with respect to its animal provenance, its method of production and its qualities. The extent to which these terms do cover specific parchment production types and their inherent qualities is not, however, clear.

The most historical European parchment documents were made from smaller animals such as calf, goat and sheep. Parchment differs from leather in its fibre structure which normally is not treated with tannin materials. However, remains of parchment and historical documents indicate that sometimes parchment has been treated with vegetable tannins to colour or tan it. The most common method of manufacture was to treat the flayed skin in a bath or several baths of lime. When the hair had loosened it was scraped off the limed skin, which was then stretched on a wooden frame and scraped with a knife on both sides until the desired thickness was obtained. In between the scraping, the skin was left to dry, wetted and stretched until the fibre network had obtained an almost horizontal structure. Parchment produced for writing purposes was probably treated with chalk and the surface ground with pulverized pumice stone. The stretched structure makes the parchment rather inflexible in its dry state. Moreover, the fibre structure possesses a lot of tension, which makes it very sensitive to changes in relative humidity (RH) and temperature, which may lead to drastic dimensional changes of the parchment. The untanned skin structure is also very vulnerable to microbiological attack.

The fibrous hide protein, collagen, constitutes the main part of the parchment structure. Apart from the collagen, the parchment contains water (10–15%) and a small percentage of the so-called hide ground substance. The latter is a mixture of mucopolysaccharides, mucoproteins, other non-fibrous proteins, lipids, in organic salts and smaller organic compounds. More details on the history, manufactory and technology of parchment can be found in the references (see below).

References

La Lande, F. (1993) *Die Kunzt Pergament zu machen, übersetzt und kommentiert von Johann Heinrich Gottlob von Justi 1763*, Landschaftsverband Westfalen-Lippe, Westfälische Archivamt Texte und Untersuchungen zur Archivpflege 4, Münster.

Reed, R. (1972) *Ancient Skins, Parchments and Leathers*, Seminar Press, London (ISBN 0-12-903550).

Reed, R. and J. B. Poole (1964) 'A study of some Dead Sea Scroll and leather fragments from Cave 4 at Qumran Part II – chemical examination', *Proceedings of the Leeds Philosophical and Literary Society*, Leeds, p. 171.

Rück, P. (1991) *Pergament – Geschicte, Struktur, Restaurieung, Herstellung*, Jan Thorbecke Verlag, Sigmaringen (ISBN 3-7995-4202-7).

Parry, D. V. and S. D. Ricks (eds) (1996) *Current Research and Technological Developments on the Dead Sea Scrolls*, E. J. Brill, Leiden.

Materials

Samples of new and historical parchments have been used in the development of the methods and techniques described in this book. The parchment samples were collected and stored in the 'sample bank' at the School of Conservation in Copenhagen for use in future research and studies. Table 1 shows the origin of the 7 new parchments and Table 2 provides data on the 48 historical parchments and includes a short description of their visual appearance. The 12 samples highlighted (grey tint) were selected for a final analysis using most of the techniques described in the book in order to obtain more detailed information on the deterioration and its evolution. The selection criteria was that they should represent a range from severe deterioration with a low hydrothermal stability (gelatinization) to minimal deterioration with a hydrothermal stability close to new parchment. The sampling was carried out on locations on the parchments which visually, on a larger area, appeared to represent a uniform degree of deterioration.

Table 1 New parchments.

No.	Produced by	Origin
NP 1	Cowleys of Newport Pagnell, England	calf
NP 2	Cowleys of Newport Pagnell, England	calf
NP 3	Z. H. de Groot, Rotterdam, The Netherlands	calf
NP 4	Z. H. de Groot, Rotterdam, The Netherlands	calf
NP 5	Bodin Joyeux, Levroux, France	
NP 6	Z. H. de Groot, Rotterdam, The Netherlands	calf
NP 7	Z. H. de Groot, Rotterdam, The Netherlands	calf

Table 2 Historical parchments.

No.	Dating	Used for	Visual appearance	Origin
HP 1 a + b	17th C. Paris	bookbinding	Samples from spine and board side of binding. Spine facing south window, very degraded. Side joint sound. The Long Room, Library of Trinity College, Dublin.	calf
HP 2 a + b	17th C. Venice	bookbinding	Calf vellum. Samples from spine and board side of binding. Spine facing south window, very degraded. Side joint sound. The Long Room, Library of Trinity College, Dublin.	calf
HP 3 a + b	1704 Venice	bookbinding	Samples from spine and board side of binding. The Long Room, Library of Trinity College, Dublin.	calf
HP 4 a	17th C.	bookbinding	Samples from spine and board side of binding. Spine facing south window, side joint sound. The Long Room, Library of Trinity College, Dublin.	calf
HP 5 a	1678	bookbinding	Samples from spine and board side of binding. Spine facing south window, side joint sound. The Long Room, Library of Trinity College, Dublin.	calf
HP 6 a + b	1609 Hanover	bookbinding	Samples from spine and board side of binding. The Long Room, Library of Trinity College, Dublin.	calf
HP 7	17th C.	bookbinding	Regional Archive, Denmark.	?
HP 8	1797–99	bookbinding	National Archive, Denmark.	?
HP 9	1641	bookbinding	Royal Library, Denmark.	calf ?
HP 10	unknown	manuscript	Red decoration, black ink, very dirty. Royal Library, Denmark.	?
HP 11	unknown	bookbinding	Back and board. Dark green. Hair follicles. Royal Library, Denmark.	calf
HP 12	unknown	unknown	Fragment, light green. Royal Library, Denmark.	calf
HP 13	unknown	bookbinding	Former manuscript, colours, holes for … Royal Library, Denmark.	?
HP 14	Middle Ages	manuscript	Royal Library, Denmark.	calf ?
HP 15	unknown	bookbinding	Back with gold print. Royal Library, Denmark.	sheep
HP 16	unknown	bookbinding	Back with remnants of gold print, thick. Royal Library, Denmark.	?
HP 17	unknown	bookbinding	Hole bookbinding. Glossy surface, hair follicles, yellow. Royal Library, Denmark.	sheep/ goat ?

(contd overleaf)

MICROANALYSIS OF PARCHMENT

No.	Dating	Used for	Visual appearance	Origin
HP 18	unknown	bookbinding	Thick, back and board. Royal Library, Denmark.	sheep
HP 19	unknown	unknown	Probably bookbinding. Thick. Royal Library, Denmark.	sheep
HP 20	unknown	bookbinding	Whole bookbinding. Royal Library, Denmark.	calf / sheep
HP 21	unknown	bookbinding	Gold print. Back and board. Royal Library, Denmark.	?
HP 22	unknown	unknown	Probably bookbinding. Royal Library, Denmark.	calf
HP 23	unknown	unknown	Probably bookbinding, leftovers of glue on the flesh side. Royal Library, Denmark.	sheep ?
HP 24	unknown	bookbinding	Board, thin. Royal Library, Denmark.	sheep
HP 25	unknown	bookbinding	Board, thin. Royal Library, Denmark.	sheep
HP 26	unknown	bookbinding	Board, thin. Royal Library, Denmark.	sheep
HP 27	unknown	bookbinding	Board, very stiff, incipient horning. Royal Library, Denmark.	?
HP 28	unknown	bookbinding	Back, ink. Royal Library, Denmark.	calf
HP 29	unknown	bookbinding	Back, hair follicles, very thin. Royal Library, Denmark.	sheep
HP 30	unknown	bookbinding	Whole bookbinding, very stiff, incipient horning. Royal Library, Denmark.	?
HP 31	unknown	bookbinding	Board, partly horned, ink letters. Royal Library, Denmark.	calf
HP 32	unknown	bookbinding	Back, partly horned (shrunk?) holes in the middle. Royal Library, Denmark.	?
HP 33	unknown	bookbinding	Back, thin. Royal Library, Denmark.	sheep
HP 34	unknown	unknown	Probably bookbinding, smooth surface. Royal Library, Denmark.	?
HP 35	unknown	bookbinding	Board, horned, dark colour. Royal Library, Denmark.	calf
HP 36	unknown	bookbinding	Board, very light, mounted on board, newspaper. Royal Library, Denmark.	?
HP 37	1841	document	Ink and red colour. Arnamagnian Institute, University of Copenhagen.	?
HP 38	unknown	musical notation	Ink and red, blue and purple colours Arnamagnian Institute, University of Copenhagen.	calf
HP 39	unknown	manuscript	Letters faded/grind off. Arnamagnian Institute, University of Copenhagen.	calf ?
HP 40	Middle Ages	manuscript	Arnamagnæansk Institut, University of Copenhagen.	?
HP 41	unknown	bookbinding	Board, horned. Arnamagnian Institute, University of Copenhagen.	calf
HP 42	unknown	bookbinding	Board, spine, ink letters. Arnamagnian Institute, University of Copenhagen.	calf ?
HP 43	unknown		Arnamagnian Institute, University of Copenhagen.	calf
HP 44	unknown	bookbinding	Board, spine, 'striked'. Arnamagnian Institute, University of Copenhagen.	calf
HP 45	unknown	bookbinding	Whole binding, partly horned. Arnamagnian Institute, University of Copenhagen.	calf
HP 46	unknown	bookbinding	Green parchment, spine. Arnamagnian Institute, University of Copenhagen.	calf ?
HP 47	1763	bookbinding	Board, spine, inscription: 'Kongelige forordninger i årene 1757—1763'. Arnamagnian Institute, University of Copenhagen.	calf ?
HP 48	unknown	manuscript	Arnamagnian Institute, University of Copenhagen.	calf

I Microsampling and Microscopical Assessment of Parchment including Microchemical Analysis of Binding Media, Dyes and Ink

1 A New Microsampling Technique for Parchment

Leopold Puchinger and Herbert Stachelberger

Introduction

The majority of extant historical manuscripts were written on parchment. Compared to paper, the most distinctive characteristic feature of this material is its durability. The degradation mechanisms of paper are now, to a large extent, well known and form an important basis for restoration. However, due to the differences in chemical composition and manufacturing process of the two materials, scientific results cannot be transferred from paper to parchment. Furthermore, the relevant literature seldom highlights the importance of only taking small parchment samples – one of the main reasons why curators as well as restorers are reluctant to supply valuable museum objects for investigative purposes – nor does it provide suggestions for reducing the sample size. A representative selection of some sophisticated methods and the sample areas required for parchment testing are illustrated in Table 1.1.

Table 1.1 Methods for analysis of parchment and their sample requirement.

Method	Sample size	References
^{14}C-Radiocarbon dating	4	Fuchs 1991
DNA analysis	>13	Watzman 1995
Gel electrophoresis (UDIEF)	8	Oltrogge & Fuchs 1990
TEM, REM, PLM, XRD, EMA, IMA	0.03	McCrone 1976, 1988

Most researchers use parchment pieces greater than 1mm² for their studies (Rebrikova and Muldiyarov 1982, 1983); some do not even mention the sample size (Polacheck 1989). Scientists working on the role of microorganisms in the decay of parchment need fragments up to a few square centimetres (Strzelcyzk 1994; Karbowska and Strzelczyk 1996). For studies on the Vinland Map, McCrone (1976) elaborates on a virtually non-destructive microsampling method using a tungsten needle with 1μm diameter at the point. By this means, fibre fragments are pulled from the parchment, 120μm in breadth and 240μm in length. This technique is used for small particle analysis including polarized light microscopy (PLM), X-ray diffraction (XRD), scanning electron microscopy (SEM), electron microprobe analysis (EMA), transmission electron microscopy (TEM) and ion microprobe analysis (IMA) (McCrone 1988). This sampling method is also particularly well suited for the identification of ink on parchment manuscripts and is restricted only to the surface of a document. Szonntagh's machine, with drill bit diameters down to 0.4mm, is used for representative analysis of bronze coins (Szonntagh 1981). He understands the dependence of the length of the sample piece on the drill diameter: the less the cylinder diameter, the less the possible cylinder length.

There was a need to develop a 'micro apparatus' to make possible sampling that would leave no visible traces on the parchment and allow the samples to be analysed by micromethods such as optical microscopy, electron microscopy, Fourier transform infrared spectroscopy (FTIR) as well as high-performance liquid chromatography (HPLC) in order to reveal the painting technique of miniatures (Puchinger *et al.* 2002a; Wouters *et al.* 2002).

Description of the microdrilling instrument

The fourth version of the hollow drill machine is a completely finished apparatus ready for parchment sampling (Fig. 1.1). The centrepiece of the instrument is a Hamilton syringe, similar to those used in thin-layer chromatography (TLC) (Fig. 1.1b, 1). In the needle itself is a thread that can be moved in order to remove the sample from the needle (Fig. 1.4b). Two adaptors are available to compensate for the differences in needle lengths (Fig. 1.1b, 2) equipped with connections for screwing in both directions, one to the syringe body and the other to the thread insertion unit (Fig. 1.1b, 4). During the sampling process all parts together form a strong unit. Further accessories include a tube to prevent the drills from bending (Fig. 1.1b, 3) as well as two hexagon keys (Fig. 1.1b, 5) to adjust the bolt (Fig. 1.1a, 3) and regulate the strength of thread insertion (Fig. 1.1a, 4). Surrounding the vertical parts of the thread insertion unit, lines are engraved to allow the measurement of the penetration depth of the drill with an accuracy of 0.05mm (one turn

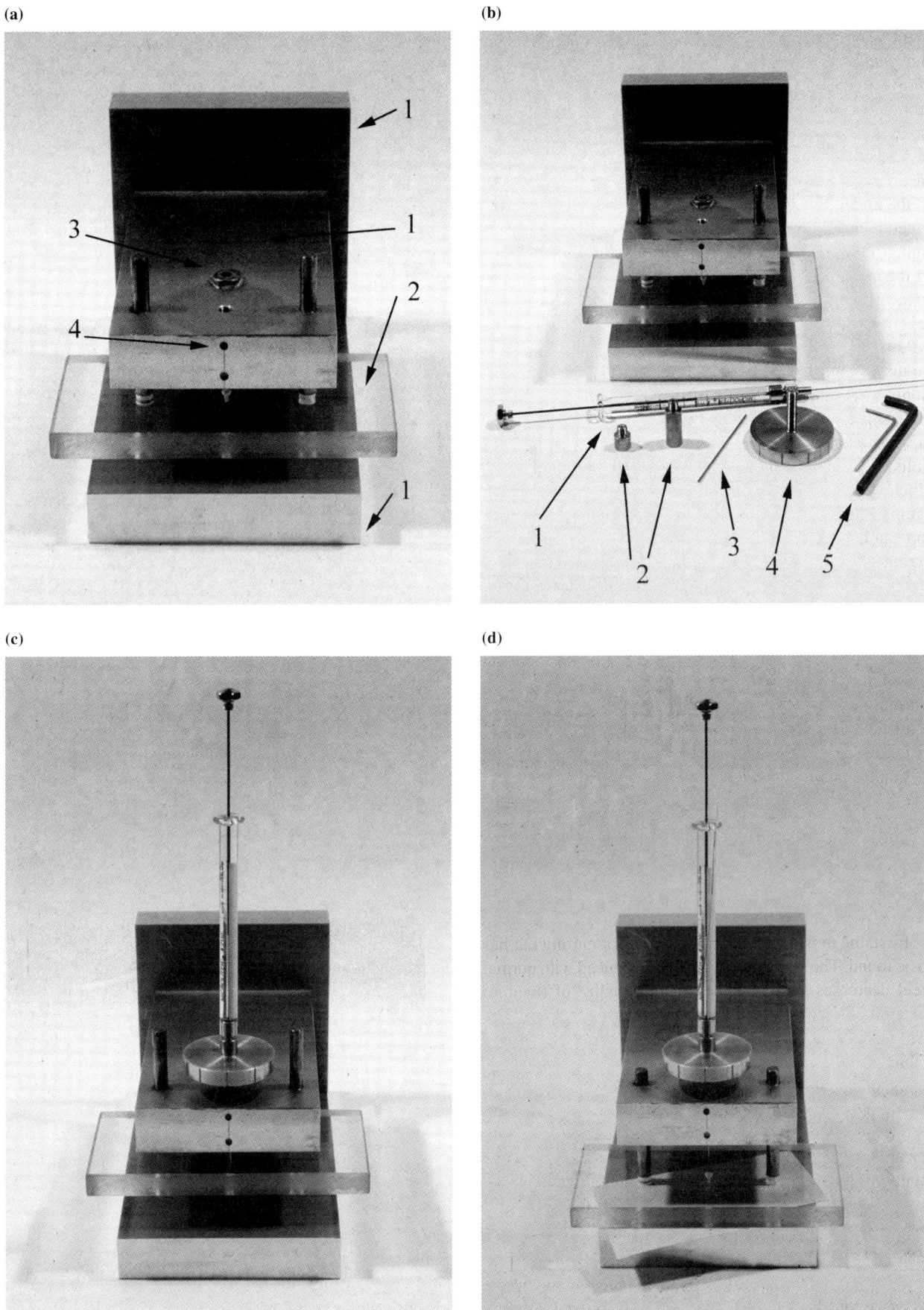

Figure 1.1 The microdrilling instrument ready for operation. (a) the starting point; 1: metal body; 2: Plexiglas plate; 3: bolt for adjusting the syringe; 4: regulator strength (b) the accessories; 1: syringe; 2: adapters for needle length; 3: stabilization tube for needles; 4: thread insertion; 5: Allen keys for regulation (c) adjustment of the syringe-adaptor-thread insertion unit; (d) parchment sampling with the drill unit.

of thread insertion unit corresponds to 0.5mm vertical movement). During sampling, the specimen is held between a movable upper Plexiglas plate and a fixed lower metal block (Fig. 1.1d). The microdrilling unit permits the investigation from most common formats. From A4 sheets, samples can be taken from each point of the hide material.

The starting point for the actual sampling process is the instrument minus its accessories, the Plexiglas plate being in the upper position (Fig. 1.1a). The syringe is then combined with an appropriate adaptor and the thread insertion unit. The whole unit is screwed into the upper metal block of the machine so it just touches the surface of a PVC pad in the lower block to avoid damaging the needle (Fig. 1.1c). It is important to fix this position with the bolt (Fig. 1.1a, 3). Afterwards the 'syringe-adaptor-thread' insertion unit has to be turned anticlockwise to allow sufficient space for positioning the sample between the two blocks (Fig. 1.1d). Having pressed the plate to the parchment, the instrument is now operational under controlled conditions. With the fixed bolts providing resistance, the hollow drill may be moved clockwise to provide the necessary space for gathering the sample. Now the piece of parchment captured in the needle top can be ejected with the aid of the metal thread of the syringe.

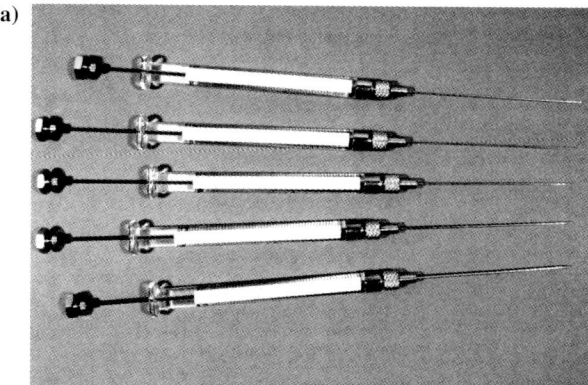

Figure 1.2 Modified Hamilton syringes with internal diameters between 0.11mm and 0.74mm. Metal thread (a) inside and (b) outside the needle.

Drill sizes and technique of needle sharpening

Currently the microdrilling equipment is provided with five sharpened Hamilton syringes for cutting out parchment pieces in the sizes 0.11mm, 0.15mm, 0.21mm, 0.47mm and 0.74mm diameter (Table 1.2, Fig. 1.2). Initially, this demanded a lot of time but the quality of drills was greatly improved compared to the results obtained at the beginning. However, now even the Hamilton 7000.5 is of the best quality (Fig. 1.3). An inner needle diameter of 0.11mm can be assumed to be the limit of the procedure – a further reduction seems too expensive as well as unnecessary (see below).

First, the most suitable drill material for cutting out has to be found. The sharpness of needles produced with normal steel decreases very quickly and the quality of titanium material is simply not good enough for this purpose. The best results are obtained with hardened steel needles (see Table 1.2 for the drill dimensions).

In order to determine the correct angle of the sharpening edge upwards from the needle top, as well as the optimal wall thickness on the needle end, precise studies had to be carried out to obtain satisfactory results in relation to the quality of drill bits punched out and to ensure intactness of

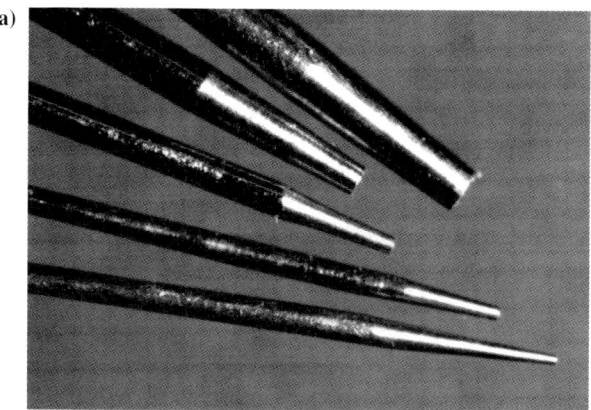

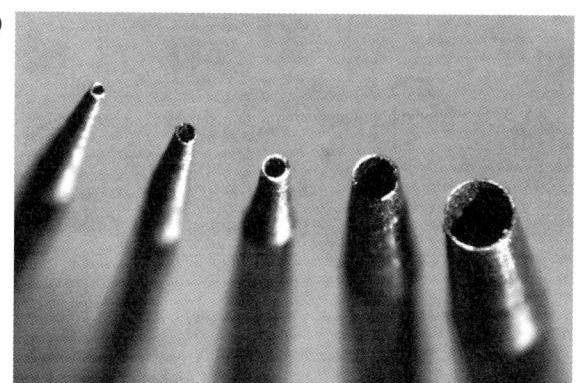

Table 1.2 Physical specifications of the hollow drills.

Syringe needle name	Needle diameter (mm) inner	outer	Wall thickness (mm)
Hamilton 7125	0.74	1.10	0.18
Hamilton 7110	0.47	0.89	0.21
Hamilton 7102	0.21	0.69	0.24
Hamilton 7101	0.15	0.71	0.28
Hamilton 7000.5	0.11	0.51	0.20

Figure 1.3 Hamilton syringes after the sharpening process (internal diameter 0.11mm, 0.15mm, 0.21mm, 0.47mm and 0.74mm). (a) viewed from the side and (b) from above.

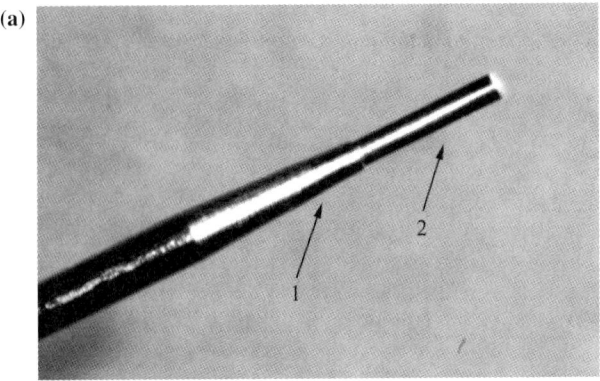

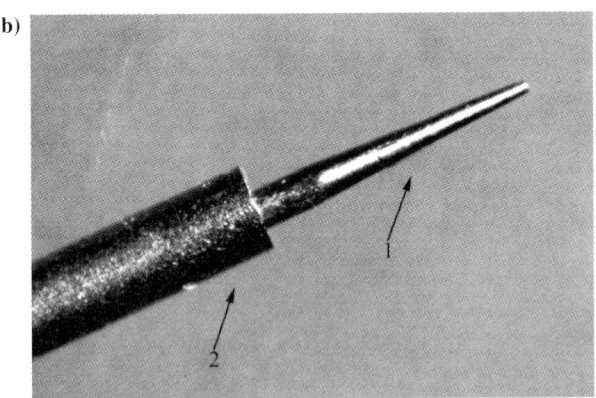

Figure 1.4 *The appearance of the Hamilton 7102 in the top area (a) needle (1) and thread (2); (b) needle (1) and tube (2).*

the remaining parchment sheet. Judging the drill by appearances, the needles in Figure 1.3a would seem to be the most appropriate, which in this case is quite right. But even tubes that look as good as these may not work if the needle is flat-topped. Such needles leave visible impressions around the holes of the parchment and they may be damaged by bending. The quality of a drill should not be determined from looking at the side view but must be inspected from above (Fig. 1.3b). A needle that has been sharpened too much will become damaged on first use. It will not survive the mechanical stress caused by turning around on the parchment, and tears in the hardened steel will become apparent. Syringe needles with an inner diameter less than 0.21mm have to be supported with a steel tube (Fig. 1.4b) to prevent bending, which would cause their destruction. Regarding wall thickness, all drills are very similar, varying between 0.18mm and 0.28mm (Table 1.2). The stability of the cutting edge is improved when the perimeter of the needle is greater.

The sharpening of all drills can now be carried out in the Vienna University of Technology (Department of Mineralogy, Crystallography and Structural Chemistry, Prof. Dr. F. Kubel and H. Tobolka). All that is required is a work bench (Fig. 1.5) with a rotary part (Fig. 1.5b, 1), in which the needle is clamped either with brass or plastic adaptors. The grinding disk (Fig. 1.5b, 2) was manufactured by the Rappold Company with grain size 500 and is an independent rotary component. The position of the grinding disk to the fixed needle as a component of the work bench can be regulated. It is essential to ensure that the needle is held securely in the work bench in order to achieve the required quality of the syringe cutting edge – it may be advantageous to apply a glue such as Loctite (cyanoacrylate adhesive) into the needle before handling. In its solid state it will protect the needle from losing its shape as a consequence of the outside pressure produced by grinding disk. The glue can be removed from the hollow space of the needle using acetone in an ultrasound bath.

Evaluation of drill bits and holes left in the parchment – applications

Figure 1.6 demonstrates the quality of parchment pieces obtained by the different drill diameters. Within a group, the size and shape of sample pieces look relatively homogenous. From the pieces with internal diameters of 0.11mm and 0.21mm only a profile view is observable (because they are longer than their diameter they therefore turn to the side).

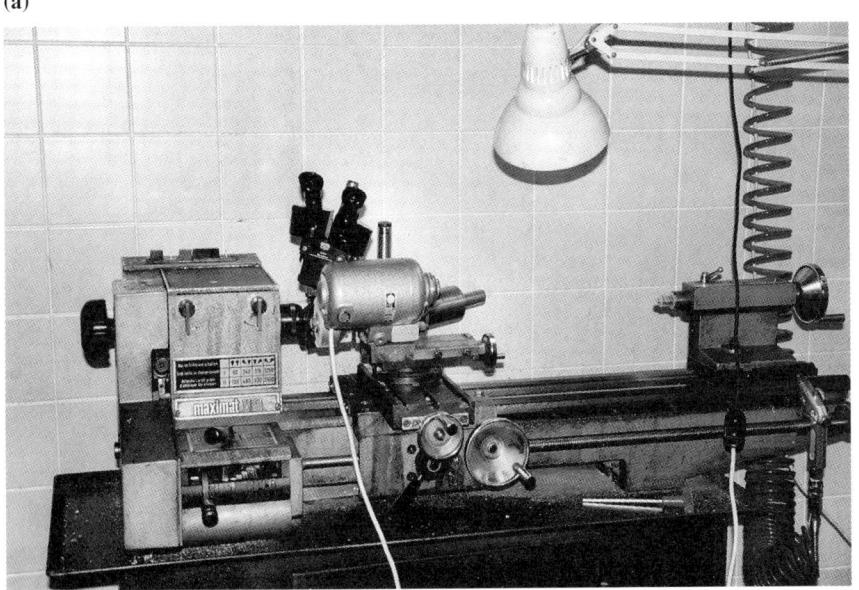
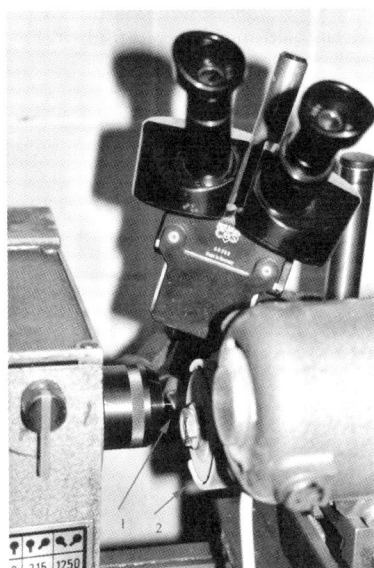

Figure 1.5 *Equipment for sharpening syringe needles. (a) work bench; (b) rotary part with needle (1) and rotary grinding disk (2).*

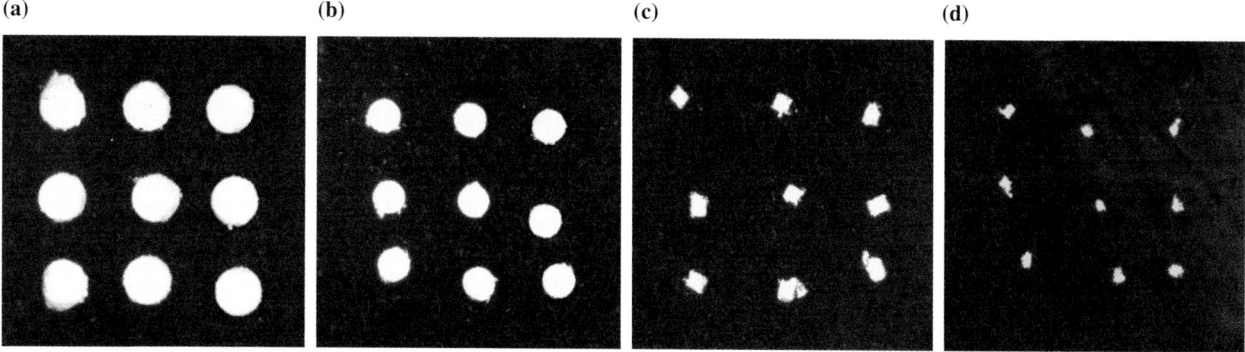

Figure 1.6 Drill bits obtained with different internal diameters (a) 0.74mm; (b) 0.47mm; (c) 0.21mm; (d) 0.11mm.

From the curator's point of view, the most important factor is that by using a drill with an internal diameter of 0.11mm, there are no visible marks left by sampling for scientific investigation – the object can be returned undamaged to the museum or library. The front side of the parchment sometimes attracts attention owing to the imprecise edge detected all around the holes in the proved diameters, but this probably depends on the geometry of the syringe needle top. A large angle out from the sharpening edge will result in holes that have diameters greater than those of the internal diameters of the needles. This is not quite so noticeable on the back side of the parchment.

Table 1.3 gives statistics based on 15 measured values for each hollow drill. Differences in diameter of sample pieces of all needles are within 0.06mm. In all cases, the holes on the front side of the parchment are a little larger.

Samples obtained with the microdrilling instrument have been used very successfully at Koninklijk Instituut voor Het Kunstpatrimonium (since 1988) for further analytical techniques such as optical microscopy, electron microscopy, FTIR and HPLC (Wouters *et al.* 2002).

One of the first uses to which the hollow drill in the Vienna University of Technology was put was to examine the dependence of sample size on the thickness of ultramicrotomical sections embedded in Spurr (low viscosity embedding media). The optimum of 60nm for TEM could only be reached using the drill with the smallest internal diameter. Microdrilling of samples for pyrolysis gas chromatography as well as electron microscopy followed (Puchinger *et al.* 2002a).

Summary

As part of the MAP project, it was possible to develop a simple microdrilling instrument for sampling of parchment and similar materials, especially useful for curators and restorers as well as natural scientists working in the analytical area. This technique takes drill bits of good quality from hide materials down to 0.11mm in diameter. A further reduction in sample size with hardened steel needles seems unlikely and is, in any case, unnecessary, as an 0.11mm drill leaves no holes or visible traces left on the parchment. This new method is currently being applied successfully to many analytical techniques in connection with parchment evaluation.

Table 1.3 The microdrilling method statistics.

Statistics	Hamilton 7000.5			Hamilton 7101			Hamilton 7102			Hamilton 7110			Hamilton 7125		
	SC	HFS	HBS	SC	HFS	HBS	SC	HFS	HBS	SC	HFS	HBS	SC	HFS	HBS
Mean value (mm)	0.13	0.17	0.14	0.21	0.32	0.28	0.24	0.34	0.31	0.50	0.57	0.53	0.75	0.86	0.80
Max. value (mm)	0.17	0.19	0.16	0.23	0.35	0.29	0.27	0.35	0.33	0.52	0.59	0.55	0.76	0.90	0.83
Min. value (mm)	0.11	0.13	0.11	0.20	0.29	0.26	0.22	0.31	0.29	0.47	0.55	0.52	0.72	0.82	0.77
Standard deviation	0.02	0.02	0.01	0.01	0.01	0.01	0.01	0.02	0.01	0.01	0.01	0.01	0.01	0.02	0.02

SC: sample cylinders; HFS: holes in parchment front side; HBS: holes in parchment back side

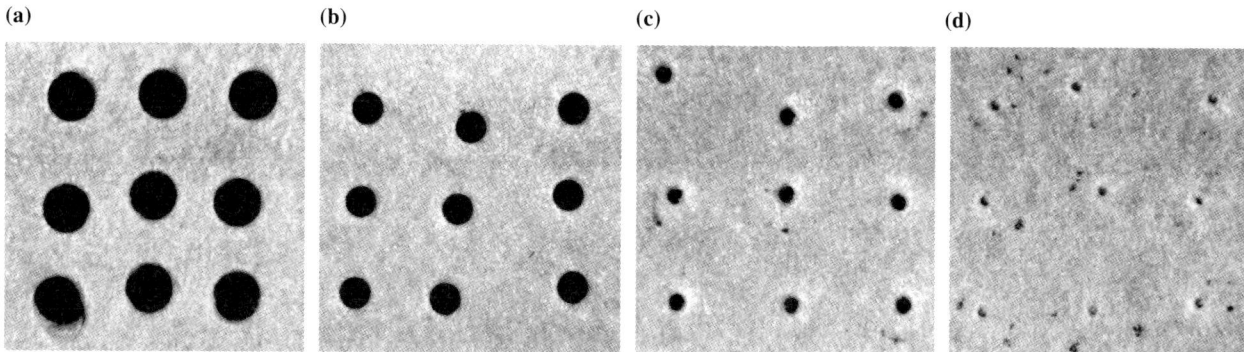

Figure 1.7 The state of the front side of the parchment after microsampling with different hollow drills (enlarged stereomicroscopically).

References

Fuchs, R. (1991) 'Des Widerspenstigen Zähming. Pergament in Geschichte und Struktur', in P. Rück (ed.)) *Pergament – Gescichte, Struktur, Restaurieung, Herstellung*, Jan Thorbecke Verlag, Sigmaringen (ISBN 3-7995-4202-7), p. 1.

Karbowska, J. and A. B. Strzelczyk (1996) 'Scanning electron microscope and biochemical studies of parchment deteriorated by *Streptomyces* spp.', *Dechema Monographs* 133, p. 387.

McCrone, W. (1976) 'Authenticity of a medieval document tested by small particle analysis', *Analytical Chemistry* 48, p. 676A.

McCrone, W. (1988) 'The Vinland Map', *Analytical Chemistry* 60, p. 1009.

Oltrogge, D. and R. Fuchs (1990) 'Naturwissenschaftliche Untersuchungen an historischem Pergament', in *ICOM-Leder- und Pergamenttagung*, Offenbach, p.104.

Polacheck, I. (1989) 'Damage to an ancient parchment document by *Aspergillus*', *Mycopathologia* 106, p. 89.

Puchinger, L., D. Leichtfried and H. Stachelberger (2002a) 'Evaluation of old parchment collagen with the help of transmission electron microscopy (TEM)'. This volume, pp. 9–12.

Rebrikova, N. I. and P. YA. Muldiyarov (1982) 'Electron microscopic study of parchment', *Byuletten Eksperimental'noi Biologii i Meditsiny* 94, pp. 104–7.

Rebrikova, N. I. and P. YA. Muldiyarov (1983) 'Electron microscopy of parchment', *Restaurator* 5, pp. 183–90.

Strzelczyk, A. B. (1994) 'The role of microorganisms in the decay of parchment', *Acta Microbiologica Polonica* 43, p. 165.

Szonntagh, E. L. (1981) 'Sampling method for representative elemental analysis of non-homogeneous coins', *Mikrochimica Acta* 1, p. 191.

Watzman, H. (1995) 'DANN to unravel secrets of the Dead Sea Scrolls', *New Scientist* 14 January, p. 5.

Wouters, J., J. Claeys, K. Lamens and M. Van Bos (2002) 'Evaluation of methods for the microanalysis of materials added to parchment'. This volume, pp. 13–30.

2 Evaluation of Old Parchment Collagen with the help of Transmission Electron Microscopy (TEM)

Leopold Puchinger, Dietmar Leichtfried and Herbert Stachelberger

Introduction

In principle, before starting the characterization of historical parchments, the natural scientist should make a critical study of physical and chemical analytical methods. This is particularly important because although restorers usually require cost-effective, fast and precise results, the sample amounts made available may be extremely limited. Transmission electron microscopy (TEM) fulfils these demands and has emerged as an ideal tool for the study and diagnosis of various problems involving collagen, since the information obtained by this technique is at the ultrastructural level (Tzaphlidou and Kounadi 1998). The use of TEM or scanning electron microscopy (SEM) is dependent upon the subject. Karbowska uses SEM to show micro-organisms on the surface of parchment fibrils (Karbowska and Strzlczyk 1996), whereas the characteristic cross-banded pattern that results from the D-periodicity of the collagen fibrils (the regular dark banding at 67μm spacing seen with negatively stained collagen fibrils) could well be shown by TEM (Tzaphlidou and Kounadi 1998; Reed 1972). If collagen fibres roughly cylindrical in form and bearing the characteristic pattern of cross-banding are observed, this immediately confirms that one is dealing with material of animal origin. Sheet materials such as paper and papyrus are based on thin cellulosic fibres which are not cross-banded and are usually packed together more regularly than dermal collagen fibres. Owing to the age and conditions of storage of the material, not all the collagen fibres will have remained intact and in most cases signs of damage and weakness will be apparent. Thus, in some instances – especially with very old materials found in unfavourable sites – the cross-banding of the fibres may have disappeared almost completely and be difficult to recognize. The state of the collagen fibres as observed in the electron microscope provides some assurance as to the antiquity of a sample.

Although in respect of their overall characteristics, skin materials are remarkably durable given reasonable conditions of storage, their collagen fibres nevertheless degenerate slowly especially when exposed to water vapour, light and heat. The literature discusses different preparation methods of parchment, but generally most procedures seem quite destructive and may give misleading results. It cannot be ruled out that a few reagents used for preparation are responsible for changes of the collagen fibril structure, especially of pre-damaged fibrils. Reed (1972) recommends the maceration of softened samples (30% v/v aqueous isopropanol) in double distilled water with needles or a hand-operated tissue grinder. For microtome sectioning, a water-soluble wax or paraffin wax is used. Rebrikova and Muldiyarov (1983) studied parchment fragments of around 1mm^2 of samples from the 11th to the 19th centuries in comparison with modern parchment. Fixed samples were embedded (2% OsO_4) in Araldite (epoxy resin) and the ultra-thin sections were stained with 30% (w/v) aqueous phosphotungsten acid and lead citrate. Two *in situ* changes could have been demonstrated: on the one side the forming of cracks between fibril fascicles and on the other side the decay of fibrils as a result of lytic activity (i.e. breakdown of cells) of micro-organisms (bacteria and fungi).

It should be worth investigating the condition of the main material collagen as well as the state of preservation of collagen fibres with TEM. The main aim of this study will be to judge the suitability of this technique for parchment assessment, therefore the link to the results of the established methods in this area also has to be taken into consideration.

Materials and methods

Samples

TEM studies on parchment were made with some new and a series of historical samples. For this analysis sample pieces in the size of 0.74mm in diameter (ca. 87μg) were considered sufficient and were taken using the microdrilling instrument described in Chapter 1. The following samples were investigated with TEM: Liophilyzed (freeze-dried) collagen, NP3, HP7*, HP8*, HP16*, HP18*, HP20*, HP22*, HP26*, HP28*, HP31*, HP36*, HP37*, HP38* (* indicates that these samples are described in detail, see also Table 2, p. xix).

Transmission electron microscopy (TEM)

Sample preparation by maceration

Three cylindrical pieces of parchment were punched out using the technique described in Chapter 1 and the fragments softened for 30 minutes in a 2ml cone-shaped glass vial in a solvent mixture (30ml isopropanol + 5ml citrate buffer pH5 + 65ml distilled water). The collagen fibres can be separated successfully using two preparation needles (normally used in microscopy) in the same vial. The suspension is then transferred into a glass sinter pot (G2), the liquid is removed using a vacuum pump and the collagen fibres are treated with 800ml washing water (30ml citrate buffer pH5 in 1l distilled water). The maceration obtained in this way is now stained twice in the same vessel: first with a 2% (w/v) aqueous solution of phosphotungstic acid, and secondly with a 2% (w/v) aqueous solution of sodium uranyl acetate. The parchment collagen is kept in contact with both heavy metal solutions for 1 hour at room temperature. The specimen is bathed with 300ml washing water to remove unreacted stain. Finally, the maceration is stirred in 5–10ml distilled water and a syringe is loaded with the collagen suspension for mounting on copper grids (300 mesh) covered with a thin layer of formvar/carbon for optimal distribution of the fibres on the grid. Immediately after covering the grid, the maceration must be frozen very quickly over liquid nitrogen; the water sublimates at a temperature of –20°C.

TEM examination of parchment samples prepared by maceration

Investigations with the aid of TEM were carried out at the Vienna University of Technology, Institute of Applied and Technical Physics by Professor Dr. P. Schattschneider and Dr Cécile Hébert-Souche. All measurements were performed on a JEOL 200 CX in transmission mode. Voltage in this study is always adjusted to 200kV and all magnifications of TEM pictures lie between 15 and 37kx.

Discussion of the results obtained with TEM

These studies do not confirm Reed's assertion that missing cross-banding in collagen fibre structure and the widening of certain fibril sections are signs of historical as well as polluted parchment (Reed 1972). It is however possible to place each of 14 analysed parchment samples in one of 6 classes (Table 2.1, Fig. 2.1). The criterion for classification is the amount of gelatin surrounding the fibres – the thicker the envelope of this degradation product of collagen, the less visible the cross bands. Because Class I contains all new parchment samples (and therefore perfect cross-banding) this can be regarded as the best achievable state of parchment. This standard was not quite met by any of the old parchments in the sample series investigated, but Class II (HP18, HP28) is very close. From Class III onwards the fibrils become more wrapped in gelatin (HP22) and the intensity of cross bands is reduced. Finally, in Class V, the appearance of samples (HP16, HP36) is very poor and more bundled-up collagen units are observed. In Classes IV and V, breakdown of collagen assumes great dimensions, so that the space between cross-linked fibres is almost completely filled with clusters of gelatin. HP26 (Classes IV and VI) does not represent a 'worsening' of Class V, but in this parchment crystalline and amorphous carbon occurs (Fig. 2.1l). These particles are threaded on fibril-like pearls and are probably made of graphite or coal, which were used as pigments in earlier times. It seems that increased gelatin is a reliable indication of damaged parchment, but this phenomenon could also be a consequence of the manufacturing process.

With regard to sample preparation, maceration was considered to be preferable to embedding following ultramicrotomy. Although both procedures have a low sample demand, maceration is less time-consuming. It provides a perfect example of the care that is needed concerning the changing of object structures for a successful TEM of parchment. In connection with this study some interesting scientific findings resulted.

First, although there are various ways of homogenizing parchment and covering the grid with maceration, most are not appropriate for this purpose. The best results were achieved by handling the softened sample piece with two preparation needles in a vial (using an ultrasound bath for chopping up or treatment of drill bits in liquid nitrogen (3–4 min.) does not fulfil the requirements). In the case of nitrogen (–100°C) for instance, only a fine powder without any visible structure elements is obtained with TEM. It is most important that the suspension is frozen by sublimation – it should not be dried, put on the grid with a syringe and then shock frozen with liquid nitrogen under ambient conditions. Otherwise the strong pressure generated in the water suspension during drying affects the cylindrical fibril structures and as a consequence of hydrostatic deformation they become flat. The lack of visible cross bands in collagen fibres may be caused by (1) covering with gelatin and (2) hydrostatic deformation. Before starting the drying process, the grids are positioned on an object-slide, which may damage them. Even if the grid is kept with the specimen between

Table 2.1 Evaluation of parchment samples with the aid of TEM.

Classes	Name of parchment	Characteristics of TEM specimens
I	Lyophil. Collagen, NP3	Completely intact. Collagen fibres with clearly visible cross bands
II	HP18, HP28	Collagen fibres a little wrapped in gelatine, visible cross bands
III	HP8, HP31	Collagen fibres give the impression of sticking to Formvar, bundled-up collagen units, visible cross bands
IV	HP7, HP20, HP22, HP26, HP37, HP38	Bundled-up collagen units, greatly reduced contrast on one side of the collagen fibre
V	HP16, HP36	Poor appearance, more bundled-up collagen units
VI	HP26	Only a few collagen fibres, drum-shaped crystalline objects, amorphous particles

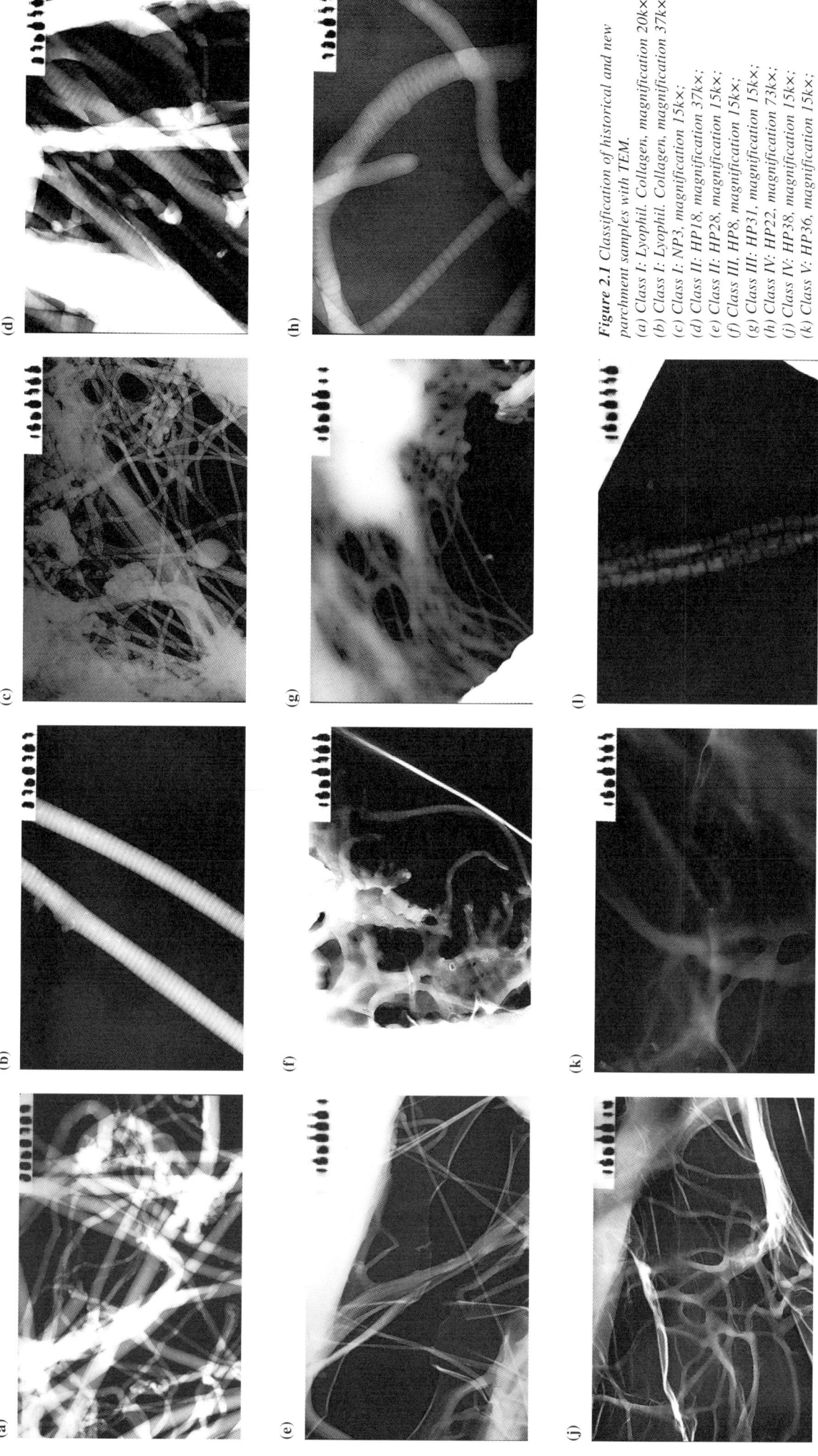

Figure 2.1 Classification of historical and new parchment samples with TEM.
(a) Class I: Lyophil. Collagen, magnification 20k×;
(b) Class I: Lyophil. Collagen, magnification 37k×;
(c) Class I: NP3, magnification 15k×;
(d) Class II: HP18, magnification 37k×;
(e) Class II: HP28, magnification 15k×;
(f) Class III: HP8, magnification 15k×;
(g) Class III: HP31, magnification 15k×;
(h) Class IV: HP22, magnification 73k×;
(j) Class IV: HP38, magnification 15k×;
(k) Class V: HP36, magnification 15k×;
(l) Class VI: HP26, magnification 15k×.

a pair of tweezers (to prevent the grid sticking to the object-slide) the Formvar can crack.

In this investigation, double staining with phosphotungstic acid and sodium uranyl acetate was preferred as only 200kV TEM was available – without contrast, medium cross bands of collagen would be hardly visible as a consequence of too much energy. It is however well known that chemical contrast materials may effect and change the state of parchment collagen.

Discussion of the results from TEM by comparison with other methods

At first glance it may appear strange that HP18 and HP28 – on the basis of their low shrinkage temperature and B/A ratio (Larsen et al. 2002a) considered to be badly damaged samples by TEM investigation – have been classified as Class II immediately following new parchment. However, looking more closely and taking into account both the maceration process as well as the possibility of different gelatin phases, this phenomenon can be cleared up.

In new parchment (NP3, NP7) very little degradation of collagen into gelatin took place, so almost completely intact fibres with clearly visible cross bands are observed. However, in historical samples more or less gelatin was produced depending on environmental factors. In the case of HP18 and HP28 it is not visible because it was removed by washing with water during sample preparation for TEM. Although the same maceration technique was used for HP16, HP26 and HP36, in these samples there were bundled-up collagen units with a thick gelatin envelope, therefore cross-banding was scarcely visible, probably because of differences in gelatin structure compared to HP18 and HP28. The high peak ratio 174/171 in HP16, HP26 and HP36 obtained with solid state nuclear magnetic resonance spectroscopy (NMR) (Odlyha et al. 2002a) suggests that acid hydrolysis occurred in collagen and this is confirmed by TEM observation, where gelatin adheres strongly to the fibres. On the contrary, this ratio in HP18 and especially in HP28 is much lower, a sure sign of oxidation (Odlyha et al. 2002a). The chemical affinity of this kind of gelatin to collagen is smaller than to water and therefore is nearly completely removed by the preparation washing process. HP18 and HP28 have the strongest diffraction from lipids (Wess and Nielsen 2002) and in certain respects this group can be supposed to be something crucial in this event. The double bonds of fatty acids associated with lipids could cross link with gelatin thus preventing collagen from excessive wrapping in this material. Similarly, a precise separation of samples affected either by oxidation or acid hydrolysis is found with pyrolysis capillary gas chromatography (PY-CGC) (Puchinger et al. 2002b). The PY-categories II and III contain HP16, HP26 and HP36, while HP18 and HP28 are found in the PY-categories V and VI. Contrary to the TEM technique, by which no gelatin blocks could be observed, they have a part in the peak pattern by pyrolysis. This is evident particularly in the pyrogram of HP28 which contains more components compared to other categories. Furthermore, these peaks are not only pyrolysis products of collagen, but are also almost certainly some of gelatin as well as of lipids. HP28 is a warning that a correct evaluation of parchment is only possible in connection with other suitable methods of characterization, for example with PY-CGC.

Conclusions

Contrary to chemical determination of parchment collagen as well as its hydrolysis, oxidation and degradation products with the aid of high-performance liquid chromatography (HPLC), electrophoresis and NMR, TEM allows direct observation of the state of the fibres. TEM studies on a series of historical parchment samples confirmed the suitability of this method for evaluation of parchment condition. Many positive properties, which have high priority in parchment analysis, highlight the advantages of TEM such as sample demand in the µg range, a simple sample preparation, less time-consuming and more cost-effective. In the case of TEM investigation, maceration as well as the method had to be adapted carefully to the problem. A classification schema based on six classes was developed dependent on the amount of the collagen degradation product gelatin, which envelopes the fibrils. As the gelatin layer increases in thickness, less cross-banding is visible. With regard to evaluation, different chemical structures of gelatin are obviously responsible for the similarity between badly damaged historical parchment fibres and those of new parchment, and this needs to be borne in mind. Furthermore, the TEM results accord well with the other sophisticated methods of parchment assessment used in this study.

References

Karbowska, J. and A. B. Strzelczyk (1996) 'Scanning electron microscope and biochemical studies of parchment deteriorated by *Streptomyces* spp.', *Dechema Monographs* 133, p. 387.

Larsen, R., D. V. Poulsen, M. Vest and A. L. Jensen (2002a) 'Amino acid analysis of new and historical parchments'. This volume, pp. 93–9.

Odlyha, M., N. Cohen, G. Foster, R. Campana and Abil Aliev (2002a) '^{13}C and ^{15}N solid state nuclear magnetic resonance (NMR) spectroscopy of modern and historical parchments'. This volume, pp. 101–8.

Puchinger, L. and H. Stachelberger (2002) 'A new microsampling technique for parchment'. This volume, pp. 3–8.

Puchinger, L., D. Leichtfried and H. Stachelberger (2002b) 'Pyrolysis capillary gas chromatography (PY-CGC) of historical parchment samples'. This volume, pp. 155–8.

Rebrikova, N. I. and P.YA. Muldiyarov (1983) 'Electron microscopy of parchment', *Restaurator* 5, p. 183.

Reed, R. (1972) *Ancient Skins, Parchments and Leathers*, Seminar Press, London and New York.

Tzaphlidou, M. and E. Kounadi (1998) 'The effect of lithium treatment on collagenous tissues: an electron microscope study', *Micron* 29, p. 235.

Wess, T. J. and K. Nielsen (2002) 'Analysis of collagen structure in parchment by small angle X-ray diffraction'. This volume, pp. 149–53.

3 Evaluation of Methods for the Microanalysis of Materials Added to Parchment

Jan Wouters, Johan Claeys, Karijn Lamens and Marina Van Bos

Introduction

The analysis of materials such as paint is performed routinely in several laboratories all over Europe on objects such as canvas paintings, mural paintings and polychromed sculptures. However, when it comes to the analysis of decorations. which must be considered to be small (e.g. an ink line in a manuscript) or to contain fine details (e.g. in a miniature painting), the taking of samples is avoided and, hence, no analyses are performed. Eventually applications of non-invasive techniques may be found, such as X-ray radiography, infrared reflectography (IR), ultraviolet (UV) illumination and X-ray fluorescence (XRF) under atmospheric conditions, or destructive analytical methods applied on particles obtained by non-invasive sampling (Devos *et al.* 1995). None of these non-invasive techniques is likely to deliver the details sufficient to describe a painting technique – indeed, no information can be gathered on the stratigraphic construction or on the composition of binding media.

The technological features of painting technique and writing are important elements in the study of manuscripts, complementary to stylistic, historical and technological observations. Moreover, one or more elements of painting or ink may be responsible for an observed alteration phenomenon. The right estimation of the correlation between specific product(s) and degradation may only be obtained by analysis at a level of detail beyond the low compositional resolution obtained by non-invasive techniques.

Hence, a methodology had to be developed which involved the withdrawal of microsamples from documents and the application of currently used analytical techniques, eventually adapted to cope with the limited size and the inherent complexity of the samples. A new technique for the preparation of samples by microdrilling was developed in close collaboration with the Technical University of Vienna (see Chapter 1). This paper describes in further detail the process of microdrilling and analysis of the sub-samples obtained, including the possibilities and limitations of the procedures.

Historical sources for the composition of miniatures

There are many sources dealing with the preparation of paint, ink and metal leaves for miniatures. A limited number of publications, covering several historical treatises, was surveyed (Dimier 1927; Merrifield 1967; Braekman 1986; Driessen 1934; Rosen-Runge 1967; Thompson 1936) and a selection of representative recipes was applied for the preparation of materials to be used for the creation of appropriate references of painted parchment. These references were prepared in the laboratory under carefully controlled conditions and were used to evaluate treatments involving drilling and analysis.

Once a procedure had been established, it could be applied to historical documents.

Materials and methods

Preparation of reference samples

Parchment
Two new calf parchment skins were encoded as NP1 and NP2. Before cutting and carrying out any further treatment, the skins were preconditioned for one week at 55% relative humidity (RH), 20°C. The skins were then cut into individual sheets of 90 × 150mm.

Pigments
- Minium, inorganic red, Pb_3O_4 (code: Mi), is a commercial product (origin unknown, composition checked).
- Cochineal, *Dactylopius coccus* COSTA, is an organic red, containing mainly carminic acid. Treatment in ammonia solution produced ammoniacal cochineal (code: ACo): 2g of crushed cochineal insects was treated in 8N ammonia solution for two days at room temperature; after filtration 6g of alum was added, and the lake was precipitated with 10% (w/v) KOH (stepwise); the dry deposit was recovered after nine days (Samohylová 1997).

- Verdigris, inorganic green, $Cu(CH_3COO)_2 \cdot 2Cu(OH)_2$, was represented by commercial copper acetate, $Cu(CH_3COO)_2 \cdot H_2O$ (code: Vdg) (Merck, Darmstadt, Germany).
- Mussiv gold, inorganic yellow, $Sn(IV)S_2$ (code: MG), was prepared in the laboratory: an amount of tin was put in a porcelain melting cup and melted over a flame; the same amount of mercury was added to the melted tin and stirred; the amalgam was cooled and crushed, then rinsed with distilled water and left to dry; equal amounts of sulphur and ammonium chloride were crushed; in a melting cup equal amounts of the Sn–Hg amalgam and the S–NH_4Cl mixture were mixed together; the cup was completely wrapped in aluminium foil and heated slowly to 250°C (kept at this temperature until smoking stopped), then heated to 600°C and held at that temperature for 90 minutes (per 4 g) (Lagutt 1897).

Binding media
- Gum arabic (code: AG): the gum was fragmented and made up to 15% (w/v) in tap water; the gum was soaked overnight; it was heated to 100°C for 30 minutes then stirred and filtered through linen (Dimier 1927: 91).
- Gelatin (code: GE): 5% (w/v) of gelatin was made up (250 Bloom, Fluka Chemie, Sigma-Aldrich, Bornem, Belgium) in distilled water, containing 0.2% (w/v) of Nipagine (Merck, Darmstadt, Germany); stirred overnight (at room temperature).
- Egg white (code: EW): the egg white was separated from the yolk and whipped to a foam; the foam was kept at 5°C overnight; the liquid phase was decanted and Nipagine up to 0.2 % (w/v) added (Dimier 1927: 88–9).
- Egg white with sugar (code: EWS): the procedure was carried out as for EW; sugar up to 5% (w/w) was added and stirred (Dimier 1927: 88–9).
- Parchment glue (binding medium or sizing) (code: P): remnants of parchment skins were cut; tap water was added to reach 5% (w/v) of parchment clippings in water; the solution was soaked overnight at room temperature; it was heated slowly to 80°C and stirred; the liquid was decanted and 0.2 % (w/v) of Nipagine added (Dimier 1927: 84–5); its composition and concentration were evaluated by amino acid analysis.

XAG	XGE	XEW	XEWS	
XAG, P	XGE, P	XEW, P	XEWS, P	P
XAG, P, Pb	XGE, P, Pb	XEW, P, Pb	XEWS, P, Pb	P, Pb

Figure 3.1 Composition of reference paintings on parchment: NP1 (Parchment 1)/NP2 (Parchment 2). X = any pigment of Mi (minium), Aco (ammoniacal cochineal), Vdg (verdigris) or MG (Mussiv gold). The binding media are AG (gum arabic), GE (gelatin), EW (egg white) or EWS (egg white with sugar). P = parchment glue (size or binding medium). Pb = lead white, used in the ground layer. Grey areas represent respective blanks.

Ground layer
Lead white $(2(PbCO_3) \cdot Pb(OH)_2)$ (Merck, Darmstadt, Germany) was ground together with parchment glue on a polished glass plate.

Painted parchment
All possible combinations of parchment, pre-treatment, pigment and binding medium were made for the preparation of the model samples. Equivalent sets of samples were prepared for our laboratory and for other interested parties.

The general procedure used for painting the parchment was as follows: parchment sheets were pinned onto cardboard and parchment size and/or a ground layer of lead white in parchment glue applied; the ground layer (if applied) was dried; the pigment was ground together with water on a polished glass plate (with the exception of Mussiv gold which was ground not too finely in a mortar with a pestle); the wet, ground pigment was partially dried and the binding medium added with a brush to make a paste for painting the parchment.

The composition of the models is shown in Figure 3.1 using the codes described above.

Microdrilling

Simple microsampling technique: Turner biopsy needle
Three different needle types were available: DTB 18: GAGE = 18, needle diameter 1.29mm and length 15cm; DTB 20: GAGE = 20, needle diameter 0.92mm and length 15 cm; DTB 22: GAGE = 22, needle diameter 0.73mm and length 15cm (Cook Belgium, Strombeek-Bever, Belgium). All types had bevel needle tips.

Sampling took place by holding the needle perpendicular to the surface and, by the action of pushing and turning it around, cutting out a cylinder. The cylinder was recovered by pushing it out of the needle with a stainless steel rod.

Microdrilling needles and instrument
A series of sampling needles was manufactured from Hamilton microliter syringes having different internal diameters and straight edges (liquid chromatography injection-type needle tip). Therefore, the tips of the commercial needles had to be shaped and sharpened to a cone needle tip. The smallest possible internal diameter produced so far is 0.11mm (see Chapter 1). Microdrilling was performed with the 0.21mm needle unless otherwise stated.

The sample of parchment, paper or leather was carefully positioned to perform an area-specific sampling. It was then immobilized in the machine by clamping. A cylinder was drilled out by gently turning around the needle and the sample recovered as previously described.

Immediately following sampling and before any further action, the complete parchment cylinder was documented by digital imaging with the optical microscope.

Embedding

Selection of products for embedding

The following products were tested: polyester resin New Systems GTS (Vosschemie, Brussels, Belgium); Serifix (Radiometer SA, Neuilly Plaissance, France); polyester resin type 3630 ECO (prepolymerized) (Vulga, Kraainem, Belgium); polyester resin type TRA (prepolymerized) (Vulga, Kraainem, Belgium).

Transfer

After cutting, the cylindrical parchment sample needed to be transferred from the glass plate on which it was recovered to a casting mould. Because of the very small size of the parchment sample, this transfer was a delicate operation, implying possible damage and even loss of the sample. Several transfer methods were tested: a fine-tipped metal pincer; several combinations of vacuum-generating devices and capillary tubing, eventually provided with glass fibre filters; a droplet of tacky embedding medium, taken up and transported at the tip of a syringe needle.

All transfers needed to be executed under the binoculars.

Standard embedding procedure

A thin layer of medium with hardener was pipetted into a silicone casting mould and filled to about half its depth. Air bubbles were eliminated in vacuum. After 30 minutes of hardening, a microdrilled cylinder was carefully deposited onto the tacky first layer. When appropriately positioned and immobilized, a second medium layer was applied. Hardening was completed by keeping the cast overnight at room temperature and by additionally heating it at 100°C for 15 minutes.

As a function of further analyses, two different embedding methods were developed: one for the production of cross sections and one for parallel sections. The embedding for the production of cross sections was performed as shown in Figure 3.2 (positions A and B). The microcylinder had to be placed as closely as possible to one of the tapered ends of the mould to facilitate later clamping of the cast in the microtome and to reduce the surface to be cut.

Eventually, the residue of a partially cross-sectioned embedded cylinder may be used for further parallel sectioning. In this case, the remaining cast was reduced in size by polishing until it fitted in a larger casting mould. It was then deposited onto a first medium layer in the larger mould, in such a way that the cylindrical parchment sample could be cut in a parallel direction, and treated further as described for embedding a microcylinder. This procedure is also depicted in Figure 3.2 (positions C and D).

If only parallel sections had to be made, the cylindrical sample was fixed onto the first medium layer in such a way that it could be cut in a parallel direction (Fig. 3.3).

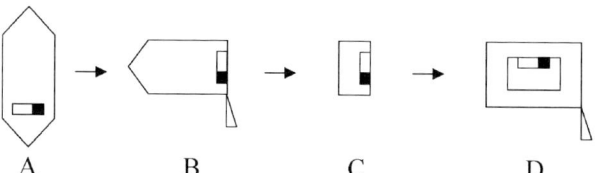

Figure 3.2 Embedding and cutting procedure for the production of cross-sections from microcylinders, eventually followed by the production of parallel sections. A: positioning of microcylinder in the tapered end of the mould. B: microtoming crosswise. C: reduction of the remaining cast. D: new embedding of reduced cast in larger mould, ready for parallel sectioning. The black areas represent the multi-layered paint.

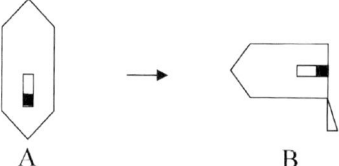

Figure 3.3 Embedding for parallel sections. A: positioning of microcylinder in the tapered end of the mould. B: microtoming in a parallel direction.

Microtomy

Microtomy was performed with a Microm microtome, provided with a Zeiss stereo microscope (Prosan, Merelbeke, Belgium). The cutting angle was 5° and the cutting knife was tungsten carbide. All sections studied were 10μm unless otherwise stated.

Optical microscopy of thin sections

Thin sections had to be reduced in size beforehand to prevent curling, by cutting away as much as possible of the surrounding embedding medium with a scalpel. Size-reduced sections were fixed onto a glass microslide carrier using three possible procedures: dry, covered with a second microslide, taped together with the first one; in a droplet of glycerine or in a droplet of Canada balsam (and covered with a thin cover slide in the latter cases).

Optical microscopy was performed with a Zeiss Axioplan HD/DIC universal research microscope with the following main features: halogen light in transmission/reflection at any ratio, polarizer, dark field filter and magnification up to 400 times (Lux Optic, Antwerp, Belgium). Images were treated and saved with an image processing programme (Ulead Video Studio 2.0, Ulead Systems Inc., USA). Printing was by common computer printers or with a colour video printer (Sony Color Video Printer, Sony Belgium, Brussels, Belgium).

Infrared spectroscopy

After microtoming, the major part of the embedding resin was cut away to allow the sample to fit onto a diamond window of a diamond compression cell (Thermo Optek, Breda, The Netherlands). After gently pressing between the two diamond windows, an infrared transparent sample was obtained. The top diamond window was then removed and the sample, immobilized on the bottom diamond window, was transferred to the motorized stage of the Fourier transform infrared (FTIR) microscope.

With the aid of a video capture system, a mapping line could be drawn and positioned over the layers of the cross section. The distance between the different measuring points was set to 5μm, but the total area analysed measured at least 10 by 10μm at each measuring point.

The apparatus used was a Nicolet 5DXC FTIR with Omnic ESP software in combination with a Spectra-Tech IR Plan microscope, provided with μView Video Microscopy and Atlμs FTIR Microscopy software packages (Thermo Optek, Breda, The Netherlands).

Scanning electron microscopy with energy dispersive X-ray fluorescence (SEM-EDX) detection

After microtoming, the major part of the embedding resin was cut away and the trimmed sample was transferred to a sample holder covered with a carbon tape. The sample was coated with a thin gold layer to prevent charging.

The apparatus used was a JSM6300 scanning electron microscope (Jeol, Japan), at a primary electron energy of 20 KeV and a Link-ISIS 300 EDX-system (Oxford Instruments, Great Britain).

Energy dispersive X-ray fluorescence (EDXRF) at atmospheric conditions

Due to its mobile configuration, the analysis could be executed in a non-destructive manner by placing the object close to an X-ray molybdenum tube. The EDXRF analysis was carried out using a Dubois Object-Analyser 404 (Tracor X-ray, California, USA) with a primary X-ray accelerating voltage of 40 kV and 1 mA. The corresponding X-ray spectra were collected during 60 or 120 seconds.

High-performance liquid chromatography (HPLC)

Natural organic dyes

All analyses were executed by HPLC and photodiode array detection, described earlier (Wouters and Verhecken 1989; Wouters 1999).

To 50μl of a solution or to one or more microtome sections was added 250μl of 37% HCl/methanol/water (2/1/1, v/v/v). The mixture was heated for 10 minutes at 105°C in open Pyrex tubes in a heating block. After cooling down, any particulate matter was removed by filtering through a porous polyethylene frit. The filtrate was dried over NaOH in an evacuated exsiccator. The residues were taken up in 35μl of methanol/water (1/1, v/v) and 20μl of the latter solution was injected into the chromatograph. The HPLC equipment consisted of a high-pressure pump programmable for flow rate, time periods and composition of the eluting solvents (Model M615 pump, Waters, USA); a column with renewable cartridges of 4.6 × 125mm of Spherisorb ODS2, 3μm (Alltech, Laarne, Belgium); a photodiode array detector (Model 996, Waters, USA); a system for data storage, manipulation, and retrieval (Millennium, Waters, USA). Three solvents were used: (A) water, (B) methanol, and (C) 5% (w/v) phosphoric acid in water. The elution program was: 60A/30B/10C: 3 minutes; linear gradient to 10A/80B/10C: 26 minutes; flow rate: 1,2 ml/minute, creating a system back-pressure of 18 to 24 MPa; the temperature in the chromatography laboratory was stabilized between 20°C and 22°C. Any dye component was identified according to two criteria: the retention time and the ultraviolet-visible (UV-VIS) spectrum.

Amino acids

Acid hydrolysis of proteins was performed in the gas phase (Knecht and Chang 1986), created in a custom-made vessel (Egilabo, Machelen, Belgium), which could contain a maximum of 8 reaction tubes of 75 × 10mm; the total volume of the vessel was approximately 465ml; thin sections or an appropriate amount of an amino acid standard were put into and eventually dried in the tubes (in a Teflon rack in the vessel); 1500μl of 6 N HCl (constant boiling, Sigma-Aldrich, Bornem, Belgium) and 1% (v/v) of phenol (Acros Chimica, Geel, Belgium) were put on the bottom of the recipient. The vessel was closed airtight and the hydrolysis medium was frozen in liquid air (–190°C). Vacuum was applied with an oil pump and flushing was carried out with the help of nitrogen (N55 grade, Air Liquide, Machelen, Belgium). The evacuating/flushing sequence was repeated five times. Finally a vacuum was applied. The vessel was put in the oven for hydrolysis (20 hrs at 110°C); the test tubes were dried in an exsiccator and the residues dissolved in 100μl 0,1 N HCl. Amino acid analyses were performed with the Waters AccQ.Tag amino acid analysis method (Waters ACCQ.Tag Chemistry Package 1993); HPLC separation and detection of the fluorescent amino acid derivatives were performed with a HPLC pump (Series 1050, Hewlett Packard, Waldbronn, Germany) and a fluorescence detector (Model 470 Scanning Fluorescence Detector, Waters, Milford, USA), respectively. The temperature of the column (AccQ.Tag column, 3.9 × 150 mm, Waters, Milford, USA) was set to 35°C and the elution programme was as follows: eluent A (aqueous buffer, Waters AccQ.Tag Eluent A), eluent B (acetonitrile/water: 60/40; acetonitrile for HPLC far UV, Acros Chimica, Geel, Belgium); 0 min: 100A; 0.5 min: 100A; 0.51 min: 99A/1B; 16 min: 97A/3B; 23 min: 92A/8B; 32 min: 74A/26B; 40 min: 64A/36B; 42 min: 64A/36B; 42.01 min: 100B; 45 min: 100B; 45.01 min: 100A; 55 min: 100A (all gradients were linear). The flow rate was 1.0ml/min; the injection volume was 5μl (sample loop). The wavelengths were set at 250nm (excitation) and 395nm (emission).

Calibration of amino acid analyses was performed with the help of an amino acid standard solution for collagen hydrolysates (Sigma-Aldrich, Geel, Belgium). The linearity of fluorescence was investigated over a concentration range of 0 to 50 pmol (250 pmol for glycine) in 5μl of injection volume. All responses were found to be linear in this concentration interval. A blank involved all possible contamination from labware, reagents and manipulations. To reduce contamination, all glassware was pyrolyzed at 550°C for at least 3 hours and all manipulations involved wearing gloves.

Amino acid compositions are represented as mole% of individual amino acids. Amounts of proteins were calculated by summing up the amounts of individual amino acids, obtained after calibration.

Ion chromatography

Ion chromatography was performed on a low capacity ion exchange stationary phase, 3.0 × 150mm (Alltech Allsep Anion, Alltech, Laarne, Belgium). The eluent was 4.0mM phthalic acid mono potassium salt ($KC_8H_5O_4$) and 0.2mM ammonium nitrate (NH_4NO_3) in water, adjusted to pH 4.20 with potassium hydroxide and degassed by filtering through a 0.22mm filter (Millipore, Evere, Belgium). Pumping occurred at 1.0 ml/min with a HPLC pump (Waters Model 510, Waters Evere, Belgium) and the column effluent was monitored with a conductivity detector (Waters 430 Conductivity Detector, Waters, Belgium). The treatment of chromatigraphic data was done with Waters Millennium software (Waters, Belgium). Detected amounts of chlorine, nitrate and sulphate were quantified with the help of standards and expressed as amounts relative to the unit weight of parchment.

Samples were prepared by cutting into about 1mm² fragments. After acclimatization for 48 hours at 20°C and an RH of 65%, they were weighed and extracted in water (MilliQ, Millipore, Evere, Belgium) for 24 hours at room temperature. After extraction the pH was measured (Hamilton Minitrode, Hamilton, Bonaduz, Switzerland; Radiometer standard pH-meter, Van der Heyden, Brussels, Belgium) and a sample of the extract was injected into the ion chromatograph after appropriate dilution.

Historical samples

Microdrilling was performed on fragments of objects (mainly parchment) belonging to different collections. The applicability of the technique was occasionally tested out on other sheet-like materials such as paper and leather (for detailed data see Table 3.4, pp. 20–22).

Most of the samples analysed belonged to the sample bank of the School of Conservation, Copenhagen, Denmark. Most of them were of unknown date and area of production, and showed several aspects of interest such as coloured decorations and inks. All these samples bear the code 'HP', followed by a consecutive number indicating its place in the sample bank and a second number representing the specific microsample.

A few samples were withdrawn from Islamic manuscripts, dated to the 9th to 11th centuries and belonging to the collection of the Islamic Museum of Kairouen, Tunisia. They were encoded by 'MX' or 'MPK', followed by a microsample number.

A series of samples was withdrawn from manuscripts belonging to the library of the University of Jerusalem as a function of specific questions posed by the restorers referring to degradation and relationships of individual volumes. All these bear the code 'JER' in Table 3.4.

Some samples were taken from gilt leather wall hangings, in the course of a conservation treatment, as a function of specific questions about alterations and technology. The wall hangings belonged to the collection of the Museum Hof van Busleyden in Mechelen, Belgium, and were dated from the 16th to the 18th centuries. These are coded 'HvB', followed by a microsample number.

A meso-American document with Aztec pictography was analysed for added materials in the first place. More research was performed as to the nature of the carrier material following results obtained on the added materials. It was encoded 'PAB', followed by a microsample number.

Only one sample of paper was subjected to microdrilling. A paper conservation workshop was dealing with a relined paper and wanted to know the complete composition of the document, both original and added paper, before proceeding to any action. This sample was characterized by the code 'DD'.

Results and discussion

Microdrilling

A series of tests was executed on samples of reference painted parchments and painted leather with Turner biopsy needles. Below a diameter of 0.7mm, no suitable samples could be prepared by cutting with these needles because of the force needed and the risk of breaking the needle. Moreover, even a diameter of 0.7mm was considered to be too large to be applied on precious historical samples.

With the help of the microdrilling instrument (see Chapter 1), routine microdrilling could be performed down to a cylinder diameter of 0.21mm on parchment, paper and leather.

To date, 180 drillings have been performed with one and the same needle.

Preparation and use of thin sections

A microdrilled cylinder was transformed into a series of thin sections by microtomy to dispose of a number of nearly equivalent samples with improved transparency to electromagnetic radiation (UV, visible and infrared). A cylinder diameter of 210μm makes available about 100μm for the preparation of sections bearing more than 85% of total thickness. The cylinder can create about 10 sections of 10μm thickness each, or 20 sections of 5μm each. It appeared from experimental work that 10μm sections represented a suitable compromise between sample consumption, facility of handling and sensitivity of detection. A series of sections is represented in Plate 3.1 (see colour plate section), each of 10μm thickness, prepared from a 0.21mm microcylinder, withdrawn from a painted parchment of a Javanese shadow puppet, analysed with the optical microscope at 100× magnification and illuminated with a combination of transmitted and reflected light.

In order to make the most of the microsample, it was decided to proceed stepwise with different kinds of instrumental analysis, selected as a function of a previous observation. The first observation was always performed with the optical microscope on the entire cylinder, after microdrilling but before embedding. The embedded cylinder was microtomed until a first good section was obtained. This section was prepared for optical microscopy by trimming as

described and embedding in Canada balsam. Optical microscopy was used to determine the stratigraphy of the sample and to eventually observe specific features. The second good quality section was always used for FTIR analysis. This section was trimmed before putting it onto the window of the diamond cell. In theory, it would be possible to recover this sample from the window for subsequent analysis. In practice however, it turned out that it stuck too tightly to the window to mechanically remove it without damage in most cases. So, a third good section was required for SEM-EDX analysis.

At this point a decision has to be made as to whether a layer of added material should be specifically removed by microtomy in the parallel direction of the microcylinder for confirmation or more detailed analysis of the binding medium or the presence of an organic dye. In this case, liquid or gas chromatographic analyses would have to be performed.

Any output of any analytical device was archived in its original format.

HPLC analysis of proteinaceous binding media in microsamples

Downscaling of the existing method

Taking a microcylinder with a diameter of 0.21mm as a starting point and supposing that a paint layer may be obtained in a reasonably pure condition as a 5µm thick parallel section, it may be calculated that the volume of the section removed will represent about 160000µm³. If the density of this material is taken as 1.0, then this volume represents about 160ng. If it is supposed that 50% of this mass is binding medium, then this would show up in the analysis as 80ng of protein. This low figure is problematic since the mean amino acid background signal represents 75ng of protein. An overall amino acid signal of 2.5 times the background is routinely considered a minimum amount to determine the presence of protein in an unknown sample (Wouters *et al* 2000a), so at least 200ng of amino acids should be found. To achieve this meant downscaling the amino acid analysis method so a fivefold concentration step was introduced just before the derivatization. A similar concentration step executed on a blank did not substantially influence its response, meaning that the signals of the blank must be predominantly due to the separation system (e.g. contamination of injector and tubing).

Protein analysis of parallel sections from reference painted parchments

Parallel sections (10µm) of verdigris paint in gelatin on parchment sized with parchment glue were analysed. Each section was visually evaluated for contamination of the paint. The results are summarized in Table 3.1.

The overall amino acid response of samples was lower than 2.5 times the blank in the uncontaminated paint sections. However, the relatively high signals of hydroxyproline and glycine were more significant and could be used for evaluation. The first three sections were not visually contaminated by parchment and together represented a layer thickness of 30µm. In all sections with the exception of the first was found a suggestive collagen composition. The response increased from the fourth section on because of the presence of parchment in the sample. A statistical method for the evaluation of amino acid compositions against known reference products (Schilling and Khanjian 1996) was applied to samples 3 and 6 – both were found to be a best match with a mean aged collagen composition (Wouters *et al.* 2000b), 0.966 and 0.997 respectively. This experiment showed that it was possible to measure a proteinaceous bind-

Table 3.1 Microanalysis of a proteinaceous binding medium of paint on parchment; verdigris in gelatin on glue-sized parchment (thickness of paint layer: 30µm; parallel sections: 10µm).

Sample number	Relative amount of paint layer	Total amino acids Signal/background	Glycine Signal/background	Glycine (pmol)	Hydroxyproline (pmol)
1	100	9.0	43	30	1
2	100	1.3	10	7	1
3	100	1.9	16	11	2
4	60	10.0	39	27	5
5	50	16.0	43	30	8
6	50	15.0	70	49	13
7	10	n.d.	83	58	14
8	0	n.d.	70	49	13

Table 3.2 Microanalysis of a proteinaceous binding medium of paint on parchment; verdigris in glair on parchment prepared with lead white in parchment glue (thickness of paint layer: 30µm; parallel sections: 5µm).

Sample number	Relative amount of paint layer	Total amino acids Signal/background	Glycine Signal/background	Glycine (pmol)	Hydroxyproline (pmol)
1	100	3.1	9	16	0
2	100	0.9	1.6	3	0
3	60	2.0	7.1	12	3
4	60	n.d.	3.8	6	1
5	25	n.d.	28	48	4
6	70	n.d.	1.6	3	0
7	40	7.9	23	39	4

ing medium based on collagen in parallel sections obtained from a paint layer applied onto parchment. It should be borne in mind however that this kind of experiment must be based on detailed stratigraphic and statistical analysis and requires therefore a considerable investment in time (two days of analysis and calculations in this case).

In a second experiment, 5μm parallel sections of verdigris paint in glair on parchment prepared with a ground layer of lead white in parchment glue were analysed. These results are summarized in Table 3.2. Because these samples were even smaller compared to the previous experiment, even lower signal/background ratios were found. More fluctuating quantitative results were possibly due to a larger relative importance of any contamination (e.g. sample 3) as well as to the enhanced risk of partial sample loss during manipulations (e.g. samples 3 and 6). The first two sections were free of hydroxyproline, thus pointing to the non-collagenous composition of any protein present. Because of the low signal/background ratios, not very significant statistical evaluations were obtained, as shown by the following best matches: mean aged collagen (0.859) in B1 and a gum with low hydroxyproline content in B2 (0.964), B5 (0.961) and B7 (0.915).

Gas chromatography-mass spectrometry (GC-MS) analysis of gums in microsamples

Experiments on laboratory reference painted parchments and on thin sections from historical documents were performed at the laboratory of the Centre de Recherches sur la Conservation des Documents Graphiques (CRCDG). The results were significant in the case of the references only (Richardin *et al.* 2002).

HPLC analysis of natural organic dyes in microsamples

All HPLC analyses were executed according to the methodology described above. No significant results were found and a small amount of glaze layer had to be scraped off to obtain an interpretable analytical data.

From historical literature it appeared that in the main, biological sources were used for the preparation of paint other than for dyeing fibres or fabrics: e.g. saffron (*Crocus sativus* L.), brazilwood (*Caesalpinia* L.), gamboge (*Garcinia morella* DESR.), elderberries (*Sambucus nigra* L.). Some of these are fugitive to light (e.g. brazilwood) and others do not run on the HPLC system (e.g. saffron). Problems concerning the more general applicability of analytical equipment for the analysis of natural organic dyes and the sensitivity of detection should be tackled by introducing other techniques. One possible candidate is certainly mass spectrometric analysis (Molart 1998), eventually via electrospray ionization (ESI) and ion trap collection of molecular ions and fragments (MS(n)), possibly still involving preliminary liquid chromatographic separation. The enhanced performance of ESI-MS(n) for the detection of natural organic dyes was tested out on demonstration equipment. The lower limit of detection for components such as purpurin, gallic acid and quercetin was found to be around 100 fmol. This is between 100 and 1000 times more sensitive than current HPLC-PDA equipment. There was no further opportunity however to apply this technique to preparations from historical documents.

Analysis of laboratory-prepared reference samples

A selection of ten samples is given in Table 3.3. These samples were handled in the first half of the project period to evaluate mechanical treatments and chemical analyses.

Analysis of historical samples

The description of all historical samples, as well as the analytical techniques executed on them, are given in Table 3.4. Some samples of this series were selected for full documentation including image documentation. Each of the selected samples will be treated in detail below.

HP15_2
The object was a bookbinding parchment, sheep, area and date of production unknown, with gold-coloured print. A

Table 3.3 Analysis of laboratory-prepared samples.

Sample code	Composition of added materials	Analyses
021 VPbA	Verdigris in gum arabic on lead white in parchment glue	
021 VPbE	Verdigris in egg white on lead white in parchment glue	
021 VPbS	Verdigris in (egg white + sugar) on lead white in parchment glue	
021 Pb	Lead white in parchment glue	
021 MPbA	Mussiv gold in gum arabic on lead white in parchment glue	
021 MPbG	Mussiv gold in gelatin on lead white in parchment glue	
021 MPbE	Mussiv gold in egg white on lead white in parchment glue	
021 MPbS	Mussiv gold in (egg white + sugar) on lead white in parchment glue	
021 VPG	8 successive parallel sections (10μm) of verdigris in gelatin on parchment glue	The presence of gelatin in the paint layer may be distinguished from that of collagen in the parchment (LCaa): see appropriate section
021 VPbE	7 successive parallel sections (5μm) of verdigirs in egg white on lead white in parchment glue	The presence of a non-collagenous protein in the paint layer may be suggested; all samples display low signal/background rations (LCaa): see appropriate section

OM = optical microscopy; FTIR = Fourier transform infrared spectroscopy; SEM = scanning electron microscopy combined with energy dispersive X-ray fluorescence analysis; LCaa = high-performance liquid chromatography of amino acids; LCod = high-performance liquid chromatography of natural organic dyes.

Table 3.4 Provenance, nature and sampling of historical documents.

Sample code	Description	Photo	OM cylinder	OM section	FTIR	SEM-EDX	Chromatography	XRF-Dubois
HP10_1	Parchment, manuscript, area and date of production unknown, Royal Library of Denmark, black ink	✓	✓	5RT^	✓	✓	0	0
HP10_2	Parchment, manuscript, area and date of production unknown, Royal Library of Denmark, black ink	✓	✓	0	0	0	0	0
HP10_3	Parchment, manuscript, area and date of production unknown, Royal Library of Denmark, red ink, capital A	✓	✓	0	0	0	0	✓
HP10_4	Parchment, manuscript, area and date of production unknown, Royal Library of Denmark, red ink, capital S	✓	✓	4RT^	✓	✓	0	✓
HP10_5	Parchment, manuscript, area and date of production unknown, Royal Library of Denmark, blue ink	✓	✓	5RT^	✓	✓	0	✓
HP10_6	Parchment, manuscript, area and date of production unknown, Royal Library of Denmark, blue ink	✓	✓	0	0	0	0	✓
HP10_7	Parchment, manuscript, area and date of production unknown, Royal Library of Denmark, gold coloured, figure representing a hand	✓	✓	4RT^	✓	✓	0	✓
HP10_8	Parchment, manuscript, area and date of production unknown, Royal Library of Denmark, gold coloured, figure representing a hand	✓	✓	0	0	0	0	✓
HP11_1	Parchment, calf, bookbinding, back and board, area and date of production unknown, Royal Library of Denmark, green stain	✓	✓	0	0	0	0	✓
HP11_2	Parchment, calf, bookbinding, back and board, area and date of production unknown, Royal Library of Denmark, green stain	✓	✓	5RT^	✓	✓	0	✓
HP11_3	Parchment, calf, bookbinding, back and board, area and date of production unknown, Royal Library of Denmark, red stain	✓	✓	0	0	0	0	✓
HP11_4	Parchment, calf, bookbinding, back and board, area and date of production unknown, Royal Library of Denmark, red stain	✓	✓	4RT^	✓	✓	0	✓
HP15_1	Parchment, sheep, bookbinding, area and date of production unknown, Royal Library of Denmark, gold print, capital S, third line	✓	✓	0	0	0	0	✓
HP15_2	Parchment, sheep, bookbinding, area and date of production unknown, Royal Library of Denmark, gold print, capital L, second line	✓	✓	6RT^ 1T^ 1R^	✓	✓	0	✓
HP42_1	Parchment, calf?, bookbinding, board, spine, area and date of production unknown, Arnamagnaeansk Institut, University of Copenhagen, brownish ink	✓	✓	0	0	0	0	✓
HP42_2	Parchment, calf?, bookbinding, board, spine, area and date of production unknown, Arnamagnaeansk Institut, University of Copenhagen, brownish ink	✓	✓	5RT^	✓	✓	0	✓
HP38_1	Parchment, musical notation, area and date of production unknown, Arnamagnaeansk Institut, University of Copenhagen, black ink	✓	✓	4RT^	✓	✓	0	✓
HP38_2	Parchment, musical notation, area and date of production unknown, Arnamagnaeansk Institut, University of Copenhagen, black ink	✓	✓	0	0	0	0	✓
HP38_3	Parchment, musical notation, area and date of production unknown, Arnamagnaeansk Institut, University of Copenhagen, blue ink, capital	✓	✓	0	0	0	0	✓
HP38_4	Parchment, musical notation, area and date of production unknown, Arnamagnaeansk Institut, University of Copenhagen, blue ink, capital	✓	✓	3RT^ 1T^ 1R^	✓	✓	0	✓

HP: sample collection from the School of Conservation, Copenhagen, Denmark. JER: samples taken from document fragments at the University Library in Jerusalem. MX3 and MPK19: samples from an Islamic manuscript fragment, Kairouen, Tunisia. HvB: samples taken from gilt leather panels, Museum Hof van Busleyden, Mechelen, Belgium. PAB: small fragment of a meso-American document with Aztec pictography. DD: small fragment of a tracing paper, relined with paper.
(Photo: colour photography of document or fragment; OM: optical microscopy at reflected (R) or transmitted (T) light or a combination (RT); ^: cross-section; //: parallel section; FTIR: Fourier transform infrared spectroscopy; SEM-EDX: scanning electron microscopy and energy dispersive X-ray fluorescence analysis; Lcod: HPLC of organic dyes; Lcaa: HPLC of amino acids; GC-MS: gas chromatography-mass spectroscopy; XRF-Dubois: X-ray fluorescence measured at atmospheric conditions; 0: not executed; ✓: executed)

Table 3.4 (continued)

Sample code	Description	Photo	OM cylinder	OM section	FTIR	SEM-EDX	Chromatography	XRF-Dubois
HP38_5	Parchment, musical notation, area and date of production unknown, Arnamagnaeansk Institut, University of Copenhagen, red ink, capital	✓	✓	0	0	0	0	✓
HP38_6	Parchment, musical notation, area and date of production unknown, Arnamagnaeansk Institut, University of Copenhagen, red ink, capital	✓	✓	5RT^	✓	✓	0	✓
HP38_7	Parchment, musical notation, area and date of production unknown, Arnamagnaeansk Institut, University of Copenhagen, red ink, line	✓	✓	8RT^	✓	✓	LCod	✓
HP38_8	Parchment, musical notation, area and date of production unknown, Arnamagnaeansk Institut, University of Copenhagen, red ink, line	✓	✓	0	0	0	0	✓
HP35_1	Parchment, calf, bookbinding, board, horned, area and date of production unknown, Royal Library of Denmark, parchment without any material added	✓	✓	1RT^	✓	✓	0	✓
HP37_1	Parchment, document, 1841, area of production unknown, Arnamagnaeansk Institut, University of Copenhagen, red paint, line	✓	✓	0	0	0	0	✓
HP37_2	Parchment, document, 1841, area of production unknown, Arnamagnaeansk Institut, University of Copenhagen, red paint, line	✓	✓	2RT^	✓	✓	0	✓
HP37_3	Parchment, document, 1841, area of production unknown, Arnamagnaeansk Institut, University of Copenhagen, black ink	✓	✓	2RT^	✓	✓	0	✓
HP37_4	Parchment, document, 1841, area of production unknown, Arnamagnaeansk Institut, University of Copenhagen, black ink	✓	✓	0	0	0	0	✓
HP37_5	Parchment, document, 1841, area of production unknown, Arnamagnaeansk Institut, University of Copenhagen, brownish ink	✓	✓	2RT^	✓	✓	0	✓
HP37_6	Parchment, document, 1841, area of production unknown, Arnamagnaeansk Institut, University of Copenhagen, brownish ink	✓	✓	0	0	0	0	✓
HP37_7	Parchment, document, 1841, area of production unknown, Arnamagnaeansk Institut, University of Copenhagen, parchment without any material added	✓	✓	0	0	0	0	✓
HP37_8	Parchment, document, 1841, area of production unknown, Arnamagnaeansk Institut, University of Copenhagen, parchment without any material added	✓	✓	1RT^	✓	✓	0	✓
HP46_1	Parchment, calf?, bookbinding, spine, area and date of production unknown, Arnamagnaeansk Institut, University of Copenhagen, green, paper applied on recto and verso	✓	✓	3RT^	✓	✓	0	✓
HP46_2	Parchment, calf?, bookbinding, spine, area and date of production unknown, Arnamagnaeansk Institut, University of Copenhagen, green, paper applied on verso	✓	✓	3RT^	0	✓	0	✓
HP46_3	Parchment, calf?, bookbinding, spine, area and date of production unknown, Arnamagnaeansk Institut, University of Copenhagen, green	✓	✓	2RT^	✓	✓	0	✓
HP46_4	Parchment, calf?, bookbinding, spine, area and date of production unknown, Arnamagnaeansk Institut, University of Copenhagen, darkest green	✓	✓	1RT^	✓	✓	0	✓
JER_11	Parchment, Hebrew manuscript, Spain, 1322, blue paint	0	0	3RT^	0	✓	0	0
JER_18	Parchment, Hebrew manuscript, Passover Haggadah, Catalonia?, ca.1320, red paint	0	0	6RT^	✓	✓	0	0
JER_19	Parchment, Hebrew manuscript, Passover Haggadah, Catalonia?, ca.1320, green paint	0	0	9RT^	✓	✓	0	0
JER_20	Parchment, Hebrew manuscript, Passover Haggadah, Catalonia?, ca.1320, pink paint	0	0	3RT^	✓	✓	0	0
JER_27	Parchment, Hebrew manuscript, Catalonia?, ca.1320?, blue paint	0	0	2RT^	✓	✓	0	0

HP: sample collection from the School of Conservation, Copenhagen, Denmark. JER: samples taken from document fragments at the University Library in Jerusalem. MX3 and MPK19: samples from an Islamic manuscript fragment, Kairouen, Tunisia. HvB: samples taken from gilt leather panels, Museum Hof van Busleyden, Mechelen, Belgium. PAB: small fragment of a meso-American document with Aztec pictography. DD: small fragment of a tracing paper, relined with paper.

(Photo: colour photography of document or fragment; OM: optical microscopy at reflected (R) or transmitted (T) light or a combination (RT); ^: cross-section; //: parallel section; FTIR: Fourier transform infrared spectroscopy; SEM-EDX: scanning electron microscopy and energy dispersive X-ray fluorescence analysis; GC-MS: gas chromatography-mass spectroscopy; XRF-Dubois: X-ray fluorescence measured at atmospheric conditions; 0: not executed; ✓: executed)

Table 3.4 (continued)

Sample code	Description	Photo	OM cylinder	OM section	FTIR	SEM-EDX	Chromatography	XRF-Dubois
JER_28	Parchment, Hebrew manuscript, Catalonia?, ca.1320?, red paint	0	0	4RT^ 1T^ 1R^	✓	✓	0	0
JER_29	Parchment, Hebrew manuscript, Catalonia?, ca.1320?, green paint	0	0	7RT^	✓	✓	0	0
JER_30	Parchment, Hebrew manuscript, Catalonia?, ca.1320?, pink paint	0	0	2RT^	✓	✓	0	0
MX3/4a-4b	Parchment, manuscript, Koran of Moez Ibn Badis (governor), beginning of 11th century, Laboratory of Manuscripts in the Museum of Raqquada, Kairouen, green paint, medallion, front	✓	0	8RT^	✓	✓	0	0
MPK19_2a	Parchment, manuscript, Koran, first quarter of 11th century, Laboratory of Manuscripts in the Museum of Raqquada, Kairouen, green paint, diacritic sign, front	✓	0	6RT//	✓	✓	LCaa	0
MPK19_2b	Parchment, manuscript, Koran, first quarter of 11th century, Laboratory of Manuscripts in the Museum of Raqquada, Kairouen, green paint, diacritic sign, front	✓	0	5RT^	✓	✓	0	0
HvB_3d	Gilt leather, 1625–1630, Southern Netherlands (maybe Spain), a grid of clear yellow stripes	✓	✓	2RT^ 1T^ 1R^	✓	✓	0	0
HvB_3e	Gilt leather, 1625–1630, Southern Netherlands (maybe Spain), a duller yellow background	✓	✓	2RT^ 1T^ 1R^	✓	✓	0	0
PAB_1	Meso-American document with Aztec pictography, red pigment, line	✓	✓	2RT// 6RT^ 1T^ 1R^	0	0	LCaa	0
PAB_2	Meso-American document with Aztec pictography, red pigment, line	✓	✓		✓	✓	0	0
DD_1	Relined tracing paper	0	✓	5RT^	✓	✓	0	0

HP: sample collection from the School of Conservation, Copenhagen, Denmark. JER: samples taken from document fragments at the University Library in Jerusalem. MX3 and MPK19: samples from an Islamic manuscript fragment, Kairouen, Tunisia. HvB: samples taken from gilt leather panels, Museum Hof van Busleyden, Mechelen, Belgium. PAB: small fragment of a meso-American document with Aztec pictography. DD: small fragment of a tracing paper, relined with paper.

(Photo): colour photography of document or fragment; OM: optical microscopy at reflected (R) or transmitted (T) light or a combination (RT); ^: cross-section; //: parallel section; FTIR: Fourier transform infrared spectroscopy; SEM-EDX: scanning electron microscopy and energy dispersive X-ray fluorescence analysis; Lcod: HPLC of organic dyes; Lcaa: HPLC of amino acids; GC-MS: gas chromatography-mass spectroscopy; XRF-Dubois: X-ray fluorescence measured at atmospheric conditions; 0: not executed; ✓: executed)

sample was drilled from the capital L of the second line. The presence of a non-transparent metallic layer was detected by observing a thin section with the optical microscope at transmitted, and a combination of transmitted and reflected, light (Plate 3.2, colour plate section). SEM-EDX analysis revealed the presence of a gold foil, containing small amounts of silver and copper (Fig. 3.4).

Examination of the optical microscope picture suggested the presence of a medium that would have been used to apply the foil to the parchment (weak discoloration of parchment in a narrow zone under the metallic layer). However, no analytical evidence could be obtained to confirm the presence or to analyse the composition of such a medium.

MX3

This sample was taken from a green painted area in a medallion present on an Islamic manuscript of the 11th century. Optical microscopy revealed a green paint layer on metal leaf, probably gold (Plate 3.3, colour plate section). With SEM-EDX, copper and chlorine were found together in the green paint, suggesting a green copper pigment, possibly atacamite. Chlorine was present throughout the parchment section. The metal was gold (Fig. 3.5). An FTIR analysis, referring to a spot from the green paint, was selected from a linear mapping executed through paint and carrier. It indicated the presence of a gum as binding medium. This was confirmed by amino acid analysis of another green paint containing the same pigment, present on the same leaf (MPK19).

MPK19

Because of the very fragmented nature of the paint layer (Plate 3.4, colour plate section), five thin sections of 5μm each had to be used for amino acid analysis. The results are given in Table 3.5 and Figure 3.18. A sample/background ratio of 11 makes the result significant for the presence of protein. The three best matches for the amino acid composition were as follows: gum arabic originating from Egypt (0.948), a mean aged collagen sample (0.941), a mean gum with low hydroxyproline content (0.937). These results did confirm the FTIR detection of a gum in the green paint of sample MX3, originating from the same manuscript.

HP38_6 and HP38_7

Sample HP38_7 was drilled through brown-red lines drawn on a musical notation in such a way that paint was recovered from both sides of the sheet (Plate 3.5, colour plate section). The only elements detected in both paint layers were aluminium and sulphur, pointing to the presence of aluminium sulphate and, hence, a lake containing an organic dye. Calcium was found to be very unevenly distributed over the parchment cross-section (Fig. 3.6). HPLC analysis of the organic dye on an acid extract of parallel sections, prepared from what was left over from cross-sectioning, was

Figure 3.4 SEM-EDX mappings on cross-sections 10μm thick. HP15_2. Left: Au. Middle: Ag. Right: Cu.

Figure 3.5 SEM-EDX mappings on cross-sections 10μm thick. MX3. Left: Au. Middle: Cu. Right: Cl.

Figure 3.6 SEM-EDX mappings on cross-sections 10μm thick. HP38_7. Left: Al. Middle: S. Right: Ca.

Table 3.5 Amino acid analysis of green paint of a diacritic symbol on an Islamic manuscript of the 11th century.

Amino acid	Ng in blank	Ng in green paint
Hydroxyproline	0	9
Aspartic acid	1	13
Serine	1	10
Glutamic acid	1	22
Glycine	1	32
Histidine	1	4
Arginine + threonine	1	15
Alanine	1	12
Proline	1	13
Cysteine	1	3
Tyrosine	1	3
Valine	1	4
Methionine	1	2
Lysine	1	5
Isoleucine	1	4
Leucine	1	19 *
Phenylalanine	1	22
Sample/blank		11

(* not taken into consideration because of the presence of a large contaminating peak)

unsuccessful. The analysis of scrapings of a small area however, indicated the presence of brazilwood (Fig. 3.19), a red dye prepared from a tree of the *Caesalpinia* L. family. In this particular case, the colouring component brazilein was found, as well as one of its major breakdown products of still unknown composition (Quye and Wouters 1992).

Sample 38_6 contained another red paint used for the construction of a capital in the same musical notation (Plate 3.6, colour plate section). In this case, the pigment used was vermilion. The same uneven distribution of calcium as in sample HP38_7 was observed (Fig. 3.7). This would suggest a side-specific application of chalk to improve the writing qualities of one side, probably the flesh side, of the carrier. The binding medium was analysed by FTIR on a small grain isolated from the paint layer and pleated between the windows of a diamond cell. A protein spectrum was found (Fig. 3.15).

HP37_3 and HP37_5

Historical parchment HP37 was produced in 1841 at an unknown location. It showed a written text in gold brown colour and a number of fine black streaks with an ink-like appearance. In both cases very thin layers of ink were

Table 3.6 X-ray fluorescence results of brown and black inks on document HP37.

	Brown ink		Black ink	
Element	XRF (blank)	SEM-EDX	XRF (blank)	SEM-EDX
Iron	30 (8)	+	7 (8)	+
Copper	0 (0)		5 (0)	
Calcium	200 (190)	+	280 (190)	+
Zinc	0 (0)		37 (0)	
Phosphorous	n.d.		n.d.	+

XRF = X-ray fluorescence at atmospheric conditions; SEM-EDX = energy dispersive fluorescence mapping in the SEM. Figures represent peak heights without calibration. Blank analyses were executed as closely as possible near the ink line. n.d. = could not be determined because of experimental conditions.

observed with optical microscopy on thin sections (Plates 3.7 and 3.8, colour plate section). As both inks were well isolated from interfering materials they could be analysed in the first instance with XRF in atmospheric conditions. Taking into consideration the values of the blanks, it was concluded that the main component of the brown ink was iron and that of the black ink, calcium. SEM-EDX analysis revealed the coinciding presence of iron and calcium in the brown ink (Fig. 3.8) and iron, calcium and phosphorous in the black ink (Fig. 3.9). Phosphorous could not be detected by XRF in atmospheric conditions. All results are compiled in Table 3.6. These results were sufficient to characterize the inks as follows. The brown ink (HP37_5) was of the metal-tannate type and a pure kind of iron sulphate must have been used for precipitating the tannin (Wouters and Banik 2000). The black ink (HP37_3) was a carbon black ink, animal bone being the most probable source for carbon because of the simultaneous presence of calcium and phosphorous in the ink line.

PAB

This object was a document of meso-American origin with Aztec pictography believed to be made of hide. It contained a painted red line, the composition of which was requested. A few holes were drilled in the middle of the red line (Plate 3.9, colour plate section). A first thin section was analysed with the optical microscope. Three layers were present: a thin dark layer in direct contact with the carrier, a thick red layer and a thin dark layer at the top (Plate 3.10, colour plate section). The elemental composition was measured with SEM-EDX: iron and silicon, and lead in the first, second and third layer, respectively (Fig. 3.10). Apparently, a first thin paint layer containing a red earth pigment had been applied, followed by a thick red layer containing minium. The third dark layer may have been formed by the deposition of dirt and/or the transformation of minium into lead(IV) oxide.

Table 3.7 Amino acid analysis of red paint and carrier of a meso-American document with Axtec pictography.

Amino acid	Ng in blank of red paint	Ng in red paint sample	Ng in blank of carrier	Ng in carrier sample
Hydroxyproline	0	0	0	0
Aspartic acid	0	53	3	4
Serine	1	64	4	3
Glutamic acid	1 (°)	191 (°)	6	5
Glycine			5	6
Histidine	1	15	1	1
Arginine + threonine	1	65	4	3
Alanine	1	22	2	2
Proline	1	15	1	2
Cysteine	2	41	2	2
Tyrosine	1	*	*	*
Valine	1	17	1	2
Methionine	1	7	1	1
Lysine	1	35	1	1
Isoleucine	1	35	1	1
Leucine	1	46	2	2
Phenylalanine	1	22	1	1
Sample/blank		42		1

(* not taken into consideration because of the presence of a large contaminating peak; (°): glutamic acid and glycine co-eluting).

Figure 3.7 SEM-EDX mappings on cross-sections 10μm thick. HP38_6. Left: Hg. Middle: S. Right: Ca.

Figure 3.8 SEM-EDX mappings on cross-sections 10μm thick. HP37_5. Left: Fe. Right: Ca.

Figure 3.9 SEM-EDX mappings on cross-sections 10μm thick. HP37_3. Left: Fe. Middle: Ca. Right: P.

Figure 3.10 SEM-EDX mappings on cross-sections 10μm thick. PAB. Left: Fe. Middle: Si. Right: Pb.

This kind of transformation is known to occur under the influence of light together with aqueous binding media (Schramm 1988).

The eventual presence of protein in the red paint was checked by amino acid analysis on six consecutive 5μm thick parallel sections (Plate 3.11, colour plate section). As a reference was analysed, a complete microcylinder was drilled from the carrier without any added material present. The results of amino acid analyses are given in Table 3.7. A significant amount of protein was found in the red paint. The absence of hydroxyproline excluded any collagen-based material. Statistical evaluations revealed the following proteins: silk sericin (0.935), gum with a low hydroxyproline content (0.866) and gum arabic (0.854). The first result may be eliminated for logical reasons; it was probably generated by the combination of glutamic acid and glycine in one peak. The other two point to the presence of a gum as binding medium of the red paint. Another sample of this paint was given to CRCDG for direct measurement of gum components by GC-MS, but this analysis failed because of a lack of sensitivity.

The amino acid analysis of the carrier was interesting in that no amino acids were found, suggesting that the carrier was not composed of a skin material. Infrared spectroscopy revealed a cellulose-like spectrum. The material could not be disintegrated for fibre analysis by cooking in water or in dilute sodium carbonate. It must be concluded that the carrier was composed of a native cellulose-containing material, such as bark or bast. Within the geographic context given, this could point to tappa or amate.

HvB_3d and HvB_3e
These two samples were taken from a clear yellow grid and from a duller yellow background, respectively, of a fragment of a gilt leather wall hanging produced around 1625–1630, probably in the Southern Netherlands, or maybe in Spain. The clear yellow grid had no correlation to the polychrome decoration of the gilt leather (Plate 3.12, colour plate section). Before proceeding to any conservation activity, the restorers wanted to know the cause of the observed phenomenon.

Since the effect of gold in gilt leather was obtained by the application of a yellow glaze on silver leaves, a thin layer of silver must be expected between leather and varnish. In the pictures taken with the optical microscope of sections prepared from microcylinders drilled at specific locations in the bright yellow line and in the dull yellow background, no indications were found for the presence of silver. The varnish layer on the background sample (Plate 3.13, colour plate section) was thicker than the layer in the bright yellow sample (Plate 3.14, colour plate section). These observations were completed by SEM-EDX analysis and showed a fine silver foil in the dull yellow sample (Fig. 3.11), but not in the other sample (Fig. 3.12). The same analyses (optical microscopy and SEM-EDX) executed on an independent set of two new samples gave exactly the same result. This information was used to perform X-ray radiography of the whole fragment (Plate 3.15, colour plate section). Obviously, the clear yellow grid was visible as an area of a lower material's density by the lack of silver foil.

According to these results, the following hypothesis could be put forward: the gilt leather was produced by applying silver leaves to leather, but leaving an open distance of a few millimetres around each individual leaf. Alteration reactions involved tarnishing of the silver, producing a.o. silver sulphide, which is black. This reaction has caused the duller yellow colour over the silver leaves as well as swelling of the varnish layer, while the bright yellow paint was preserved in between the tarnished leaves. The presently visible effect was not due to any (re)painting, aiming to produce a grid-like decoration.

DD
A paper conservation workshop wanted to know the composition of original and added paper of a relined tracing paper, as well as of the adhesive used, before proceeding to any conservation activity. A microcylinder was isolated from the composite material and microtomed. Optical microscopy of a thin section is depicted in Plate 3.16 (colour plate section). At lower magnification, all the layers were visible. From top to bottom: an opaque layer representing the original tracing paper; a transparent layer of adhesive used for pasting the relining paper, visible as a thick bottom layer. At higher magnification the gap under the adhesive layer could be seen more clearly, created by microtoming a mechanically heterogenous multi-layered material. FTIR indicated the presence of an alkyd resin in the relining paper (Fig. 3.16) and identified the adhesive as a cellulose derivative (Fig. 3.17). SEM-EDX revealed the presence of lead in the tracing paper and of large amounts of chlorine in the relining paper (Fig. 3.13). GC-MS of a dichloromethane extract of a tracing paper fragment indicated oil, wax and resin (Fig. 3.20).

From these observations and measurements, executed on one single microcylinder (except GC-MS), the following conclusions can be drawn about the composition and construction of the sandwich. The original paper, about 50μm thick, contained lead white and an oil-wax-resin mixture. This might refer to a procedure such as one given for the production of tracing paper applied in the 19th century involving a mixture of linseed oil, lead turnings, zinc oxide, Venice turpentine, copal and gum sandarac (Yates 1984). On a later date the original tracing paper was relined with a relatively thick paper (about 0.5mm). This paper was prepared from wood pulp and chemically treated with chlorine and alkali to eliminate lignins. The period of introduction of this technology (second quarter of the 20th century) (Trobas 1982) corresponds to the one given for the introduction of alkyd resin for sizing paper (after 1927) (Roff and Scott 1971).

Conclusion

A method was developed for the microsampling of sheet-like materials by microdrilling and for the embedding of these microsamples in polyester resin. From one embedded microcylinder with a diameter of 0.21mm, several almost equivalent samples were prepared by microtomy as 5 or 10μm thin sections. Depending upon the direction of sectioning, cross-sections were prepared in order to study the stratigraphic structure of samples and parallel sections, and

Figure 3.11 SEM-EDX mappings on cross-sections 10μm thick. HvB. Ag.

Figure 3.12 SEM-EDX mappings on cross-sections 10μm thick. HvB. Ag.

Figure 3.13 SEM-EDX mappings on cross-sections 10μm thick. DD. Left: Pb. Right: Cl.

Figure 3.14 FTIR spectroscopy on cross-sections, thickness 10μm. MX3 reference (dotted line): gum.

Figure 3.15 FTIR spectroscopy on cross-sections, thickness 10μm. HP38_6 reference (dotted line): protein.

Figure 3.16 FTIR spectroscopy on cross-sections, thickness 10μm. DD: relining paper.

Figure 3.17 FTIR spectroscopy on cross-sections, thickness 10μm. DD: adhesive between original and relining paper.

Figure 3.18 Chromatographic techniques. MPK19: HPLC of amino acids.

Figure 3.19 Chromatographic techniques. HP38_7: HPLC of organic dye. BRA = brazilein; ORH = unknown redwood breakdown product (Quye and Wouters 1992).

Figure 3.20 Chromatographic techniques. DD: GC-MS of tracing paper fillers. Az = azelate; P = palmitate; S = stearate; C20, C24 = wax-specific carboxylic acids; H1, H2 = resin components.

to isolate one or more specific layers from a multi-layered structure. This sample preparation method has been applied to laboratory-prepared painted parchments and to a series of historical documents. In total, some 200 microdrilling operations have been performed on historical documents. A representative selection of them was used to describe the particular qualities of this sample preparation procedure and to indicate remaining problems in terms of sample quality and analytical sensitivity and representation.

This method of sampling offers several advantages over more 'accidental' ways of sample removal, e.g. at the damaged edge of a gap or tear. Microdrilling is highly area-specific and can be executed at a predetermined spot, e.g. on an ink line or in a small painted area. It causes little damage, even in non-damaged areas. By careful positioning of the drilling needle, it is sometimes possible to obtain a micro-cylinder which bears added materials at both its ends. The size, the structure and, hence, the way the microsample has to be manipulated and prepared for subsequent analyses is standardized and known to a large extent. This contributes to ease of interpretation and to sample recovery. It also contributes to a restriction of sample consumption because a microdrilled cylinder represents the complete stratigraphy in one single sample. The generation of a series of sub-samples from one single cylinder and the application of various analytical techniques to each of them offers considerable flexibility.

In general, good results were obtained with optical microscopic and SEM-EDX analyses of thin sections. The materials' density was high enough to see structural differences and to detect minor elements. The thin sections offered the additional benefit of allowing work to proceed at any combination of transmitted and reflected light in the microscope.

However, FTIR analyses were not always successful as the polyester resin frequently disturbed mappings. On some occasions this could be overcome by lifting away a single grain from a thin section and pleating it between the windows of a diamond cell. Improvements in FTIR mapping results might be obtained by using another embedding material or by introducing mathematical treatments of FTIR data. Alternatives to pure polyester embedding media have been proposed (Derrick *et al.* 1994; Pilc and White 1995). Preference was given in this project to the investigation of the applicability of analytical techniques on microsamples, but research on improvements of FTIR analyses as a result of the application of another embedding technique will shortly commence.

Chromatographic analyses of binding media of paint, isolated by parallel sectioning of microcylinders occurred at a level close to the sensitivity threshold of classical chromatographic equipment. With respect to amino acid analysis of proteinaceous binding media by HPLC, results could be obtained that were statistically significant after modification of the sample preparation procedure. Appropriate analyses of representative blanks must be executed together with each batch of unknowns, on a daily basis. The sensitivity of the GC-MS equipment used at CRCDG was not sufficient to analyse gums in parallel sections of historical parchment paints.

HPLC analysis of organic dyes in paint lakes was only successful when a small amount of the paint was scraped away. However, the detection of aluminium and sulphur with SEM-EDX together with the observation of a transparent layer with the optical microscope, provided evidence for the presence of a glaze containing the lake of alum with the organic dye. Improvements must be expected in the near future by the development of a better dye recovery system of an organic dye from its lake and by miniaturizing the chromatographic system, together with the introduction of mass spectrometric analysis using electrospray ionization and ion trap collection and subsequent fragmentation (LC-ESI-MS(n)).

During the project, objects other than parchment were also sampled. Materials such as painted leather and paper – and even combinations of paper and parchment – may be sampled and analysed using the same techniques. Moreover, the same microcylinders and thin sections may be used for studies on the carrier by specific sub-sampling of the microsamples or by specific observations. Indications were found in this study that thin sections may be used to analyse the presence and distribution of calcium in the parchment. Another possible application might be the study of the shrinkage temperature as a function of the depth of observation.

The microdimensions of the cylinders and of the thin sections cut from them by microtomy may raise questions as to how representative the analytical results obtained from them are. Indeed, one 10μm thick section prepared from a cylinder which was drilled out of a 0.2mm thick parchment, represents a sub-microgram mass. To overcome this, an analytical result should always be described together with the way in which the microsample was produced. If possible, more than one microsample should be isolated from the document. Other problems may arise from having to work at the limits of detection in many applications. The examples describing various ways of analysing historical samples of different nature have indicated that relying upon the data of one analytical technique may lead to wrong conclusions being drawn. The results need to be confirmed by another technique and further research should concentrate on miniaturization of instrumentation technology .

Acknowledgements

The authors would like to thank Mrs J. Sanyová for her help with the study of historical sources and the preparation of laboratory reference painted parchments.

References

Braekman, W. L. (1986) *Middelnederlandse verfrecepten voor miniaturen en "allerhande substancien"*. Scripta, Brussels.

Derrick, M., L. Souza, T. Kieslich, H. Florsheim and D. Stulik (1994) 'Embedding paint cross-section samples in polyester resins: problems and solutions', *Journal of the American Institute for Conservation* 33, pp. 227–45.

Devos, W., L. Moens, A. von Bohlen and R. Klockenkämper (1995) 'Ultra-microanalysis of inorganic pigments on painted objects by total reflection X-ray fluorescence analysis', *Studies in Conservation* 40, pp. 153–62.

Dimier, L. (1927) *L'art d'enluminure*. Paris.

Driessen, L. A. (1934) 'Un livre flamand de recettes de teinture de 1513', *Revue général des matières colorantes* 38, pp. 68–71.

Knecht, R. and J.-Y. Chang (1986) 'Liquid chromatographic determination of amino acids after gas-phase hydrolysis and derivatization with (dimethylamino)-azobenzene-sulfonyl chloride', *Analytical Chemistry* 58, pp. 2375–9.

Lagutt, J. (1897) *Zeitschrift für angewandte Chemie*, pp. 557–60.

Lehman-Haupt, H. (1972) *The Göttingen Model Book. A Facsimile Edition of a Fifteenth-Century Illuminator's Manual*. University of Missouri Press, Columbia, pp. 76–7.

Merrifield, M. P. (1967) *Original Treatises on the Arts of Painting*, 2 vols. Dover Publications, New York.

Molart (1998) A multidisciplinary NWO PRIORITEIT project on molecular aspects of ageing in painted works of art. Progress report 1995–1998 (December 1998).

Pilc, J. and R. White (1995) 'The application of FTIR-microscopy to the analysis of paint binders in easel paintings', *National Gallery Bulletin* 16, pp. 73–85.

Quye, A. and J. Wouters (1992) 'An application of HPLC to the identification of natural dyes', *Dyes in History and Archaeology* 10, pp. 48–54.

Richardin, P., S. Bonnassies-Termes and J-C. Doré (2002) 'Characterization of vegetable gums used as binding media in inks by gas chromatography and multivariable analysis'. This volume, pp. 31–44.

Roff, W. J. and J. R. Scott (1971) *Fibres, Films, Plastics and Rubbers*. Butterworth & Co., London, p. 234.

Rosen-Runge, H. (1967) *Farbgebung und Technik frühmittelalterlicher Buchmalerei*. Deutscher Kunstverlag.

Samohylová, A. (1997) 'Study of cochineal extract and ammoniacal cochineal', Internal report KIK/IRPA, unpublished.

Schilling, M. R. and H. P. Khanjian (1996) 'Gas chromatographic analysis of amino acids as ethyl chloroformate derivatives. III. Identification of proteinaceous binding media by interpretation of amino acid composition data', *ICOM Committee for Conservation 11th Triennial Meeting, Edinburgh*, pp. 211–19.

Schramm, H-P. (1988) *Historische Malmaterialien und ihre Identificierung*. Graz.

Thompson, D. V. (1936) *Medieval Painting*. London.

Trobas, K. (1982) *ABC des Papiers, Akademische Druck- u. Verlagsanstalt*. Graz, p. 35.

Waters AccQ.Tag Chemistry Package (1993) Instruction Manual, Millipore Corporation, Milford, USA, Manual number WAT052874, Rev. 0.

Wouters, J. (1999) 'La position et l'application de la CLHP dans l'analyse des colorants et des pigments organiques dans les oeuvres d'art', *Art et chimie: la couleur*, CNRS Editions, Paris, pp. 180–86.

Wouters, J. and G. Banik (2000) 'Inks from the Middle Ages: old recipes, modern analysis and future decay', in C. Van den Bergen-Pantens (ed.) *Les Chroniques de Hainaut, ou les Ambitions d'un Prince Bouguignon*. Brepols Publishers, Turnhout, pp. 141–8.

Wouters, J. and A. Verhecken (1989) 'The Coccid insect dyes. HPLC and computerized diode-array analysis of dyed yarns', *Studies in Conservation* 34, pp. 189–200.

Wouters, J., M. Van Bos and K. Lamens (2000a) 'Baroque stucco marble decorations. I. Preparation of laboratory replicas and establishment of criteria for analytical evaluations of organic materials', *Studies in Conservation* 45, pp. 106–16.

Wouters, J., M. Van Bos and K. Lamens (2000b) 'Baroque stucco marble decorations. II. Composition and degradation of the organic materials in historical samples and implications for their conservation', *Studies in Conservation* 45, pp. 169–79.

Yates, S. A. (1984) 'The conservation of nineteenth-century tracing paper', *The Paper Conservator* 8, pp. 20–39.

4 Characterization of Vegetable Gums used as Binding Media in Inks by Gas Chromatography and Multivariable Analysis

Pascale Richardin, Sylvette Bonnassies-Termes and Jean-Christophe Doré

Abstract The aim of this study is to develop a gas chromatographic procedure to analyse the composition of the binding media, based on vegetable gums of inks applied on parchments.

This paper reports in details our procedure for the analysis of polysaccharides, which consists of an acid methanolysis followed by trimethylsilylation, just before chromatography. We present the results obtained for the standards (classical neutral sugars and uronic acids).

We collected numerous old and modern different samples of vegetable gums from some collections of natural products. The gas chromatographic profiles have been put through multivariable calculations in order to differentiate or classify the different types of gums, according to their monosacharides composition.

Experimental inks were then prepared (using an old recipe for metallogallic inks) with a mixture of gall nut, ferrous sulphate and a vegetable gum. One set of each ink was dried while the other set was applied on a new sheep parchment. All the samples were submitted to artificial dry heat ageing and analysed by chromatography. Chromatographic data were also submitted to a multivariable analysis to check our method. Finally, a study was made of real samples of inks; 23 sampling of inks on old French parchments (18th century) were characterized.

Keywords: vegetable gums; binding media; metallogallic inks; parchments; gas chromatography; mass spectrometry; multivariable analysis; factorial map; minimum spanning tree.

Introduction

The purpose of this study is the application of a gas chromatography (GC) procedure for the analysis of the main components of the binding media of inks applied on parchments. Only the vegetable gums were studied because they were commonly used in old recipes of inks (Bleton *et al.* 1996a, 1997; Arpino *et al.* 1977; Sistach and Espadaler 1993).

Vegetable gums, extracted from various trees, are water-soluble or water-dispersible polysaccharides, of variable composition. Many analytical techniques are used for the characterization of carbohydrate compounds, but of these GC is probably the most used due to its sensitivity, selectivity and the possibility of using hyphenated techniques such as gas chromatography-mass spectrometry (GC-MS). However, it requires a prior derivatization procedure to separate the mixture on the column. Methods involving the formation of methylated methyl acetates, acetals, and alditol acetates have been reported, but the use of trimethylsilyl derivatives (TMS=$Si(CH_3)_3$) of carbohydrates is the most popular because of their high volatility and ease of preparation. However, the disadvantage of this method is the presence of 1 to 6 peaks for each monosaccharide.

Nevertheless, the method, described in detail by Bleton *et al.* (1996c) was chosen, because of its very good reproducibility (even for the uronic acids) and the ability to obtain separated peaks in gas chromatography with an adapted column, which has significant and sufficient separation power.

Apart from the study of standard monosaccharides, a series of 60 modern and old vegetable gums from different origin (geographical, botanical) were analysed. Their chromatographic data were analysed by different multivariable calculation methods. The validity of our method was tested on artificial inks (dried or deposited on new parchment) and on more than 20 samples of inks from ancient parchments.

Experimental

Standards

Standards were purchased as follows: arabinose, rhamnose, xylose, galactose, fucose (from Prolabo); quinic acid, gallic acid (from Sigma); shikimic acid, glucuronic acid (from

Fluka); mannose, galacturonic acid (from Touzart et Matignon); glucose (from Labosi) and D-pinitol (from Sigma).

Vegetable gums

Samples of old vegetable gum were collected from five collections of natural products (Centre de Recherches sur la Conservation des Documents Graphiques (CRCDG), Paris; Muséum National d'Histoire Naturelle, Laboratoire de Chimie Appliquée (MNHN), Paris; Laboratoire de Recherche sur les Monuments Historiques (LRMH), Champs sur Marne; Conservatoire National des Arts et Métiers (CNAM), Paris; M. Martin, Germany). A few modern samples were collected directly from trees or purchased from chemical suppliers (Merck and CNI Colloïdes Naturels International, France). Names, origins and reference of the all studied samples are grouped in Table 4.1.

Preparation of experimental metallogallic inks

The four experimental inks were prepared as follows: 4g of a finely powdered gall nut from Turkey (Compagnie Française des Extraits, Le Havre-Graville, France) was put in 30ml of distilled water. After boiling for 15 minutes, the obtained suspension was filtered on Whatman paper in order to eliminate the insoluble part. 0.4g of the selected vegetable gum (gum arabic, Merck; tragacanth gum, Merck; gum gutta, CNAM, Ref. 49; cherry tree gum, CRCDG, Ref. 2) was then added with 0.4g of ferrous sulphate (pure, from Prolabo), mixed again for 15 minutes and 30ml of water finally added.

Materials

Derivatives were prepared in screwcapped glass reacti-vials (Pierce Chemical) fitted with PTFE-coated cap liners. Methanolysis and derivatization were carried out with the Reacti-Therm heating system from Pierce.

Chemicals and reagents

Hydrochloric acid/methanol mixture (0.4M) was prepared with 0.4ml acetyl chloride (Sigma) in 15ml methanol (Merck, gradient grade). Trimethylsilylation reagent consisted of a mixture of hexamethyldisilazane (HMDS), trimethylchlorosilane (TMCS) and pyridine (3:1:9), purchased from Supelco, Inc. Cyclohexane used for dilution and gas chromatography injection was obtained from Merck (99% spectroscopy grade).

Derivatization procedure

The sample (0.1 to 1mg) was put in 1ml of methanolic HCl solution. Reaction was performed at 80°C for 24 hours. Thereafter, 10µl of pyridine was used for neutralization, and then methanol solution was evaporated to dryness under nitrogen stream (U, L'Air Liquide) at 50°C. The dry sample remaining in the tube was reacted with 300µl of silylation reagent and then heated for 2 hours at 80°C. Excess of reagent was removed under dry nitrogen flow at 40°C, then 500µl of dry cyclohexane was added to the dry samples before injection.

Gas chromatography

The gas chromatograph was a Hewlett Packard model 5890 Series II equipped with an Automatic Liquid Sampler 6890 Series Injector. The column is a 60m × 0.25mm I.D. fused-silica column coated with a 0.25µm film of WCOT-CPSIL 8CB (5% phenyl–95% methylsiloxane) (Chrompack). Oven temperature was programmed from 80°C (initial time 3 min) to 290°C at a rate of 3°C/min. Helium (U, L'Air Liquide) was used as carrier gas with a flow rate of 1ml/min. Split/splitless injector and flame ionization detector (FID) were kept at 260°C and 300°C respectively.

Gas chromatography-mass spectrometry (GC-MS)

Mass spectra were obtained with a Nermag R10-10C quadrupole Gas Chromatograph/Mass Spectrometer coupled with a Hewlett-Packard model 6890 Gas Chromatograph. Capillary column and oven temperature program were the same as those mentioned above. Ion source, split/splitless injector and interface temperatures were kept between 150°C and 180°C, 260°C and 290°C, respectively.

Characterization by gas chromatography of neutral sugars and uronic acids

The classical method for the determination of total sugar composition of a polysaccharide consists of a strong acid hydrolysis, releasing basic monosaccharides (neutral sugars and uronic acids), followed by the analysis with chromatographic techniques. A complete review of chromatographic methods for the analysis of gum binding media in art objects has been reported by Vallance (1997).

The selected method (Bleton et al. 1996c) makes it possible to distinguish the various tautomeric forms from a monosaccharide on the same gas chromatogram. We used this method which involves a relatively complex process.

Derivatization method

In a first step, the mixture undergoes an acid methanolysis with a hydrochloric acid solution in methanol, and then a traditional silylation by a mixture hexamethyldisiloxane (HMDS), trimethylchlorosilane (TMCS) in pyridine (Py) in the proportions (3/9/1).

The methanolysis is a depolymerization procedure by acid hydrolysis, with simultaneous esterification of the

Table 4.1 List of the vegetable gum samples.

Ref.	Collection	Name or appellation	No. in the collection	Dated
4	Martins	tragacanth gum in sheets	9.23	end of 19th c.
5		tragacanth gum from Smyrne	9.21	end of 19th c.
6		tragacanth gum from Persia	9.2	end of 19th c.
7		tragacanth gum from Smyrne	9.04	end of 19th c.
8		tragacanth gum from Morea	9.22	end of 19th c.
22		gum arabic from Suakim	9.16	end of 19th c.
23		gum arabic from Persia	9.05	end of 19th c.
24		gum arabic from The Cap	9.03	end of 19th c.
25		gum arabic from Geddah	9.08	end of 19th c.
26		gum arabic from the Indies	9.02	end of 19th c.
30		gum Bassora	9.06	end of 19th c.
44		gum embavi	9.07	end of 19th c.
46		gum ghatti	9.09	end of 19th c.
56		gum Kutera from Bengal	9.11	end of 19th c.
58		gum orenburgensis	9.12	end of 19th c.
59		gum Salabreda	9.14	end of 19th c.
60		gum Senegal	9.15	end of 19th c.
17	MNHN	tragacanth gum	1	end of 19th c.
18		tragacanth gum (*Opuntia ficus Indica*)	11	end of 19th c.
19		tragacanth gum	35	end of 19th c.
29		gum from Australia	26	1892
31		gum Bassora	84	end of 19th c.
32		gum from Brazil tear shape	80a	end of 19th c.
33		gum from Brazil (plum tree?)	80b	end of 19th c.
34		gum from Brazil (unknown)	80c	end of 19th c.
41		cherry tree gum	40	end of 19th c.
42		cherry tree gum	76	end of 19th c.
43		cherry tree gum	98	end of 19th c.
45		English gum	91	end of 19th c.
50		gum gutta	64	end of 19th c.
51		gum gutta	52	end of 19th c.
52		gum gutta	63	end of 19th c.
53		gum gutta	51	end of 19th c.
57		gum Orcays	81	end of 19th c.
47		unknown gum	78	end of 19th c.
48		unknown gum	94	end of 19th c.
27	LRMH	gum arabic		end of 19th c.
28		gum arabic		end of 19th c.
16		tragacanth gum		end of 19th c.
15	CNAM	tragacanth gum		end of 19th c.
49		gum gutta		end of 19th c.
54		insoluble gum		end of 19th c.
9	CRCDG	tragacanth gum Merck		1975
10		tragacanth gum Merck		1975
11		tragacanth gum Merck		1975
12		tragacanth gum Merck		1975
13		tragacanth gum Merck		1975
14		tragacanth gum		?
3		tragacanth gum		1974
21		gum arabic		1965
55		gum from Kordofan – CNI		1998
1		apricot tree gum – Pakistan		1996
2		apricot tree gum – Turkey		1998
20		almond tree gum – Israel		1973
35		cherry tree gum – France	1	1967
36		cherry tree gum – France	2a	1996
37		cherry tree gum – France	3a	1996
38		cherry tree gum old – France	2b	1996
39		cherry tree gum – Normandy	4	1996
40		cherry tree gum old – France	3b	1997

acidic functions. It reacts on polysaccharides by breaking intermolecular connections to release basic monosaccharides. The effectiveness of this method lies in the fact that it does not degrade isolated monosaccharides. Its action results in the formation of numerous products.

We could distinguish at least five possible by-products for one ose (Fig. 4.1): four products resulting from a reaction of glycosidation (two pyranoside forms 1 and 3, two furanoside forms 2 and 4) and one other from an intramolecular condensation (product 5). In the same way, we observed six possible by-products for a uronic acid (Fig. 4.2): four products resulting from glycosidation reaction and the esterification of the acid function (products 1 to 4) and two products from an intramolecular esterification (products 5 and 6).

However, the relative proportion of these various isomers depends on the selected experimental conditions (T°C and time of hydrolysis). It is possible for example, for definite conditions to observe only two or three hydrolysis products.

The presence of very polar groups (such as alcohols R-OH) raises the boiling point and the polarity of the organic compounds, and could create strong interactions with the stationary phase of the column. The silylation process decreases this polarity and replaces each polar group by a trimethylsilyl function: TMS = $Si(CH_3)_3$.

Figure 4.3 *Basic structure of derivatives with TMS = $Si(CH_3)_3$.*

Gas chromatography analysis

The studied standards were: arabinose 1, rhamnose 2, fucose 3, xylose 4, galactose 5, mannose 6 and glucose 7 and two uronic acids, galacturonic 10 and glucuronic acid 11. The 4-O-methyl glucuronic acid 8 was also analysed because of its presence in various acacia gums (de Pinto et al. 1998; Martinez et al. 1996), like those extracted from *Acacia seyal* (Bleton et al. 1996b), and in gum resins (Wiendl et al. 1995). All these compounds have the same basic structure (Fig. 4.3); only the substituents R1 and R2 make it possible to distinguish them (Table 4.2).

The gas chromatogram for each product was recorded with a flame ionization detector (FID) and the total ionic current (TIC) obtained by mass spectrometry using electronic impact at 70eV, to compare the results with those of the original paper (Bleton et al. 1996c).

Arabinose 1 structure is very simple and the GC chromatogram (Fig. 4.4) displays the four expected derivatives. Referring to the original work, we can attribute the four peaks to isomers resulting from glycosidation. For uronic acids, such as glucuronic acid 10, the extra peaks are the two lactone forms (Fig. 4.5).

All the chromatograms obtained from the 11 standards are grouped in Appendix 1. After the verification of the perfect reproducibility of the GC profiles on all standards, alone and in mixture, we have applied this protocol to vegetable gums.

Figure 4.1 *By-products obtained from the methanolysis of altrose.*

Figure 4.2 *By-products obtained from the methanolysis of glucuronic acid.*

Table 4.2 General structure of derivatives.

No.	Name	MW	R1	R2
1	Arabinose	380	-H	$Si(CH_3)_3$
4	Xylose	380	-H	$Si(CH_3)_3$
2	Rhamnose	394	-CH_3	$Si(CH_3)_3$
3	Fucose	394	-CH_3	$Si(CH_3)_3$
6	Mannose	482	-$CH_2OSi(CH_3)_3$	$Si(CH_3)_3$
5	Galactose	482	-$CH_2OSi(CH_3)_3$	$Si(CH_3)_3$
7	Glucose	482	-$CH_2OSi(CH_3)_3$	$Si(CH_3)_3$
8	4-o-methyl glucuronic acid	380	-$COOCH_3$	CH_3
10	Glucuronic acid	438	-$COOCH_3$	$Si(CH_3)_3$
11	Galacturonic acid	438	-$COOCH_3$	$Si(CH_3)_3$

Figure 4.4 Chromatogram of the four derivatives of arabinose 1.

Figure 4.7 Chromatogram of the 'gum arabic from Persia' (Ref. 23).

Figure 4.5 Chromatogram of the six forms of glucuronic acid 10.

Figure 4.8 Chromatogram of the tragacanth gum (Ref. 9).

Figure 4.6 Chromatogram of the 'gum from Kordofan' (Ref. 55).

Figure 4.9 Chromatogram of the 'MNHN tragacanth gum' (Ref. 17).

Analysis of vegetable gums

Analysis of sugars has been performed on a sampling of 60 vegetable gums (see Table 4.1 for the complete list), collected in five natural products collections. The names of the samples are those written on the flasks, but some mistakes or misappellations are always possible.

Gas chromatography study

The sugar distribution of a classical modern arabic gum, for example as the 'gum from Kordofan' (Ref. 55) (Fig. 4.6), shows the presence of arabinose 1, rhamnose 2, galactose 5, glucuronic acid 10 and traces of its 4-O-methyl analogue 8. But, a few samples of gum arabic from ancient collections differ in their sugar composition. For example, the presence of xylose 4 and mannose 6 in the 'gum arabic from Persia' (Ref. 23) were unusual (Fig. 4.7).

It has been reported that xylose 4 and fucose 3 are found together in significant levels only in tragacanth gum (Valance *et al.* 1998), which is comparable to our results on one modern sample (Fig. 4.8) and one old sample from the MNHN (Fig. 4.9).

In this last sample, recently found in some *Astragalus* sp. (Pistelli *et al.* 1998), a high level of a cyclitol was identified by mass spectrometry (Fig. 4.11): the D-pinitol (1D- 3-O-methyl-*chiro*-inositol) 24 (Fig. 4.10).

Figure 4.10 Structure of D-pinitol.

Figure 4.11 EI (70eV) mass spectrum of silyated D-pinitol.

Similar comments apply to the sugar composition of the present samples of vegetable gums (type of sugar, relative proportion).

It is difficult to obtain a rigorous classification of gums from ancient collections because they were named according to various criteria. Some gums were designated from the name of the export seaport ('gum arabic from Geddah', or 'from Smyrne', actually Istanbul), others were named according to their place of harvesting ('gum arabic from The Cap'). Their botanical origin was not previously used as it is now (gum arabic: *Acacia* sp., tragacanth gum: *Astragalus gummifer*, etc.).

In the present work, attempts have been made to classify or more precisely at least differentiate the samples with their chromatographic data. With a suitable method of data analysis, based on the nature and the relative amount of identified compounds, it is possible to replace a simple discrimination by a mathematical method which allows a kind of pattern recognition of the chemical composition profiles.

Multivariable analysis

Data analysis covers a number of methods which aim to describe, synthesize and explain the information contained in very large tables.

Integration parameters for the calculations
The selection of the peaks to be integrated for our calculations was delicate. Indeed, because of the number of products (11) and of the theoretical obtained peaks (46+1), it was necessary to find for each standard a significant peak, not saturated to avoid its deformation and so its area, quite separated and not superimposed with another. The most abundant peak for each standard was selected. In Table 4.3 the retention time and conformation of the major isomer are grouped for each standard selected for the integration. It was verified that the D-pinitol (24) gives only a single and well-separated peak.

By this method all peak areas in the chromatograms corresponding to the main isomer of each monosacharide were measured. The basic matrix is a table with 60 lines (space i, number of gums) and with 11 columns (space j, number of identified peaks). Each element Kij of this matrix gives the relative percentage of the j monosaccharide found in the j gum (Table 4.4).

Minimum Spanning Tree (MST)
From this rectangular matrix (Table 4.4), and by applying the formula of the distance from Khi2, a length matrix (from 60 × 60) was obtained which gives the relative proximity of gums to each other.

It was then possible to build the MST with the Prim's Algorithm (Plate 4.1, colour plate section). It is a tree which connects all nodes (not always directly) in a connected graph with the shortest length. As an example, telephone cables between rural cities may be laid out to form an MST.

The MST graph is articulated indeed around various noddles which define representative categories of vegetable gums. A lot of information can be deduced and four different categories of gums have been determined.

Gum arabic (or gum acacia) is considered the oldest and best known of the gums, and can be traced back to about 2650 BC. The main source of true gum arabic is *Acacia senegal* L. Willd, (fam. *Leguminosae*) which is also the best

Table 4.3 Retention time of a mixture of standards.

		major isomer		other peaks	
No.	Name	form	t_R	form	t_R
1	Arabinose	βp	33.34	αf - αp - βf	33.18- 33.82 - 35.13
2	Rhamnose	αp	34.55	βp - αf - βf	35.04 - 37.00 - ?
3	Fucose	αp	35.71	αf - βp + βf	34.71 - 36.60
4	Xylose	αp	37.54	βf - αf - βp	33.98 - 34.23 - 38.24
5	Galactose	αp	44.13	αf - βf - βp	42.83 - 44.27 - 45.26
6	Mannose	αp	42.6	βp - αf - βf	43.78 - 45.34 - 46.11
7	Glucose	αp	46.19	αf - βf - βp	43.16 - 43.42 - 46.84
8	4-O-Me glucuronic acid	?	?	?	?
10	Glucuronic acid	p2	47.25	α1 - β1 - f1 - f2 - p1	41.02 - 41.81 - ? - ? - 46.84
11	Galacturonic acid	f1	47.71	f2 - p1 - p2	43.16 - 45.74 - 46.11

Table 4.4 Relative percentages of selected peaks for the 60 vegetable gums.

Ref.	ara 1	rha 2	fuc 3	xyl 4	gal 5	man 6	glu 7	Oaglu 8	agal 10	aglu 11	pin 24
1	25.31	2.2	/	4.71	32.64	19.07	/	6.84	8.88	/	0.36
2	25.32	2.4	/	5.29	41.74	10.7	/	5.44	8.64	/	0.47
3	39.06	5.88	1.95	7.69	11.82	/	20.03	1.95	/	8.92	2.7
4	16.86	7.87	7.53	25.57	13.24	/	3.55	0.24	/	23.28	1.85
5	45.63	8.25	1.03	2.84	28.07	/	5.46	0.63	/	6.9	1.18
6	33.66	6.15	0.64	4.48	11.02	/	33.9	2.33	/	6.25	1.57
7	23.97	5.38	4.87	14.35	14.03	/	16.94	/	/	13.51	6.95
8	26.02	6.08	5.47	16.87	15.15	/	12.38	/	/	16.03	2
9	9.07	5.08	18.99	33.51	5.81	/	4.04	/	/	31.57	0.99
10	8.21	4.46	17.33	30.58	5.38	/	3.92	/	/	29.36	0.76
11	8.14	4.63	17.19	30.62	5.29	/	3.8	/	/	29.62	0.71
12	7.97	4.28	16.39	29.16	5.29	/	8.18	/	/	28.07	0.66
13	8.33	4.54	17.29	30.16	5.45	/	3.94	/	/	29.54	0.75
14	27.78	6.69	4.19	14.62	11.47	/	16.8	1.26	/	15.74	1.45
15	26.57	6.41	6.79	20.25	13.09	/	6.67	/	/	18.23	1.99
16	27.86	6.26	6.82	19.15	12.24	/	9.25	/	/	18.42	
17	16.63	6.62	8.2	24.76	11.02	/	6.78	0.16	/	21.99	3.85
18	19	14.59	/	/	52.06	0.27	4.98	/	2.31	6.22	0.57
19	24.54	6.26	7.54	20.35	14.49	/	6.14	0.22	/	18.94	1.53
20	21.8	19.42	/	/	47.02	/	/	0.99	9.53	/	1.24
21	27.27	22.83	/	/	41.61	/	/	1	7.06	/	0.22
22	39.1	4.72	/	/	46.66	/	/	4.82	3.37	/	1.34
23	32.74	1.87	/	15.83	38.19	3.78	/	5.33	2.27	/	/
24	37.5	6.24	/	1.24	46.53	1.12	/	0.5	6.88	/	/
25	38.37	7.72	/	/	45.97	0.43	/	0.16	6.63	/	0.71
26	33.72	7.9	/	/	47.67	0.25	/	5.11	5.2	/	0.16
27	22.19	16.35	/	/	49.82	0.6	/	1.22	9.44	/	0.39
28	22.77	16.69	/	/	49.3	0.4	/	1.15	9.09	/	0.6
29	17.58	3.29	/	0.81	69.3	0.09	/	1.57	2.07	1.57	3.71
30	54.04	1.77	/	/	37.7	0.45	/	1.81	3.96	/	0.28
31	0.15	42.82	/	/	36.61	/	/	0.14	2.39	17.81	0.08
32	33.97	25.17	/	/	37.81	0.12	/	0.42	2.31	/	0.19
33	34.08	6.64	/	17.36	39.76	0.17	/	1.1	0.89	/	/
34	58.46	3.06	/	2.06	35.81	0.24	/	/	0.37	/	/
35	44.93	3.76	/	7.79	33.05	4.59	0.79	3.19	5.08	/	/
36	52.78	2.69	/	7.87	28.95	/	0.55	/	3.98	/	/
37	50.65	3.67	/	7.53	29.75	3.37	0.43	/	4.61	/	/
38	52.4	2.78	/	7.39	29.19	3.15	0.68	/	4.4	/	/
39	51.24	3.32	/	7.62	29.76	3.33	0.21	/	4.53	/	/
40	41.88	3.27	/	6.61	28.1	11.35	/	/	8.48	/	0.31
41	45.91	3.07	/	5.91	27.98	9.57	/	/	7.34	/	0.21
42	55.75	3.22	/	7.93	31.35	0.34	/	/	1.39	/	/
43	32.81	31.87	/	/	12.75	1.36	/	4.06	17.15	/	/
44	31.05	15.78	/	/	48.19	/	/	/	4.77	/	0.21
45	69.29	0.64	/	/	26.37	0.72	/	/	/	/	2.99
46	28.53	0.32	1.12	1.39	33.23	13.66	/	20.3	0.78	/	0.67
47	23.87	18.86	/	/	47.42		/	0.9	8.54	/	0.42
48	13.04	14.28	/	0.54	56.84	1.79	/	5.39	7.2	0.94	/
49	70.48	7.09	/	/	20.3	/	/	/	2.13	/	/
50	62.11	7.1	/	/	25.38	1.76	/	/	3.66	/	/
51	63.48	7.24	/	/	24.15	1.84	/	/	3.29	/	/
52	63.81	7.46	/	/	23.67	1.76	/	/	3.29	/	/
53	65.91	5.09	/	/	24.54	2.11	/	/	2.35	/	/
54	47.63	1.99	/	8.21	34.17	2.58	/	3.75	1.67	/	/
55	34.41	31.85	/	/	30.19	0.14	/	0.39	2.86	/	0.17
56	61.72	6.79	/	/	23.59	3.78	/	/	4.12	/	/
57	22.06	20.99	/	/	45.34	0.07	/	1.29	8.61	/	1.64
58	14.61	0.19	/	0.62	84.58	/	/	/	/	/	/
59	49.26	1.32	/	0.38	41.94	/	/	4.32	2.03	/	0.76
60	25.46	17.36	/	0.51	49.13	/	/	0.45	7.09	/	/

quality (Coppen 1995). But gums from other *Acacia* are also sometimes, though erroneously, referred to by the same name. The gums from *A. arabica* and over 120 other *Acacia* sp. have been shown to differ greatly from gum arabic in terms of chemical composition and structure.

We observed that these gums form a very homogeneous group.

Tragacanth gum (also called 'gum dragon', 'gum elect' or 'Syrian tragacanth'), is the second most important commercial gum and is produced by several shrubby plants of the genus *Astragalus*, growing from Pakistan to Greece (particularly Iran and Turkey). *A. gummifer* (Labill.) was considered to be the main tragacanth gum, but a field survey has established that *A. microcephalus* (Dogan *et al.* 1985) is the main source of the gum.

Tragacanth gums are all located at the top of the graph, and all are adjacent. Their connection with other gums takes place with an edge with a significant length, showing the cleavage between this category and the others. No apparent differences exist between all samples according to the origin (geographical, types of collection, and age). One of the samples (Ref. 5) is attached to the same family but is at the limit. The five chromatograms resulting from the same sample (Ref. 9 to Ref. 13) are closely grouped demonstrating the good reproducibility of the used analytical protocol.

Only one sample from the MNHN collection is not in the group (Ref. 18), named curiously 'tragacanth gum from *Opuntia ficus indica*', which is classified in the *Cactaceae* family and so is not a true tragacanth gum.

Prunus gum. The gums from several *Prunus* species have been used in Europe for centuries, but gums from cherry tree *Prunus sp.*, apricot *P. armeniaca*, plum tree *P. domestica* or peach *P. persica* are similar and not clearly distinguishable (Mills and White 1994).

Cherry tree gums are also all adjacent, except for an historical sample from MNHN (Ref. 43), which does not have a classical composition. No significant degradation between recent and historical gums was observed. At the top of the branch are located apricot gums (Ref. 1 and Ref. 2) with the gum ghatti (Ref. 46) (*Anogeissus latifolia* (Wall.), a substitute of acacia gum), and in a secondary branch we found a 'plum tree gum of Brazil' (Ref. 33), but oddly, the junction is carried out via a 'gum arabic from Persia' (Ref. 6).

Gutta gum, extracted from *Calophyllum inophyllum*, is long reputed to have medicinal properties.

All gutta gums are also grouped in a very stable and coherent branch, in which is also attached the 'gum Kutera from Bengal' (Ref. 56) and the unique sample of 'English gum' (Ref. 45). The assignment of these two different samples in the gutta family appears reasonable.

Apart from these aggregates, there are some 'outsiders' for which it is difficult to propose an assignment because they have different botanical origin or constitute mixtures.

Factorial analysis of correspondence

The second applied method is the factorial analysis of correspondence (FAC) based on the same logic as the principal component analysis (PCA). The main idea is to represent a

Figure 4.12 Graphic of the FAC for the 60 vegetable gum samples (two first factors).

table of numbers (N lines, p columns) by a cluster of N points in a space of dimension p (noted IRp) and by an other cluster of p points in a space of dimension N (noted IRn). FAC is interesting in that all data are interchangeable and it is possible to study the proximity between the two scatter plots (columns and lines).

In Appendix 2, the values on the five axes Φ1 to Φ5 for the 60 gums have been calculated. The graphic representation on the two first factor is given in Figure 4.12.

This chart confirms the results obtained with the first method (MST). All the tragacanth gums and all arabic gums are grouped, and form two well-defined clusters. Cherry gums and gutta gums are also grouped, but in a second approximation (on the third and fourth factors).

Application to metallogallic inks

In order to check if the classification of the vegetable gums is similar when they come from complex mixtures, such as metallogallic inks, four experimental inks were prepared, with one representative of each category of gums. After the analysis of the most used tannins in old recipes of metallogallic inks, the four experimental inks were analysed before and after artificial ageing. More than 20 samples of inks from old written manuscripts were also collected and analysed.

Gas chromatography study of some classical tannins

Tannins are a group of chemicals able to turn hides into leathers (Richardin et al. 1988). Different types of tannins are used for the manufacture of metallogallic inks, but tree galls, produced by parasites, are known to contain a high level of tannin (aleppo (Turkey), acorn, oak-marble, Chinese and Japanese galls). Gallotannic acid is the type of tannin most used for ink-making and is found in high concentration in Aleppo galls.

Aqueous extraction of gallic and tannic acids reacts with ferrous sulphate to form the coloured ferric tannate complex. Hydrolysis of gallotannic acid can be obtained by using acids or slightly acidic solution (e.g. wine or vinegar).

From the tannins collection of the laboratory, 20 gall nut samples from different origin were studied.

The gas chromatogram of a gall nut from Turkey (Fig. 4.13) shows that gallic acid 25 is the main component, released by hydrolysis. A series of monosaccharides are present at lower concentration (arabinose 1, rhamnose 2, xylose 4, galactose 5,etc). In all gall nuts, glucose 7 is the major peak. Some phenolic acids and cyclitols differentiate tannins from gums, such as quinic acid 23, an unknown peak* or shikimic acid 22. In Chinese gall nut, the major peak, apart from gallic acid 25 and glucose 7, is quinic acid 23.

However there is a problem with these chromatographic profiles: the glucose peak covers that of gallic acid. Only tragacanth gum has a low concentration of glucose, but other sugars are specific in this gum, e.g. an high concentration of fucose 3.

Figure 4.13 Chromatogram obtained for a gall nut from Turkey (1978).

A multivariable analysis of the samples of gall nuts, based on their sugar composition (except glucose 7), showed that there is no significant difference between them.

Analysis of experimental inks

The range of objects that contain metallogallic inks is very large: manuscripts, drawings, music scores, etc. Recipes since the Middle Ages prescribe the same basic ingredients: galls and iron sulphate, named 'vitriol' (together forming the colorant), water (the solvent), and gum (the binder).

For our model, aleppo gall from Turkey was chosen because of its high concentration of gallotannic acid, dried ferrous sulphate, water and gum (one representative of each category). They were called 'arabic ink', 'tragacanth ink', 'cherry ink' and 'gutta ink, according to the gum used. However, in the case of arabic ink, vinegar, wine and urine were also used for more complete extraction of gallotannic acid.

The recipe is classic: 4g of gall nut was boiled in 30ml of water; after filtration 0.4g of gum and 0.4g of ferrous sulphate were added and the mixture was again mixed for 15 minutes; finally 30ml of water was added.

When comparing the GC profiles of gum arabic to the dried 'arabic ink' prepared with water (Fig. 4.14), the only extra peaks in the latter are phenolic acids and cyclitols, glucose, and galacturonic acid, all characteristics of gall nut (noted •). The intensity of the other monosaccharide peaks seems the same as in gum arabic alone.

The chromatograms of the aged arabic inks have not been fundamentally modified. When 'arabic ink' is sampled from a new parchment (Fig. 4.15), the extra peaks are from the support.

For the four experimental inks, the same phenomenon was observed. In consequence, for future data analysis and

easier comparison between inks and gums, it was decided to consider only the peaks present in the studied gum.

Based on the same factorial map (two first factors $\Phi 1$ and $\Phi 2$), and the values obtained from gall nut, dried inks and inks sampled from parchment (before and after artificial ageing), no significant shifts have been observed (Fig. 4.16).

Figure 4.14 FID chromatograms of gum arabic and dried 'arabic ink'.

Figure 4.15 FID chromatogram of 'arabic ink' collected from a new parchment (■ peaks from gall nut'; ○ peaks from parchment).

Figure 4.16 Factorial map for the 'arabic ink' samples (two first factors).

A very light shift only in the ink prepared with vinegar was observed. Gall nut is some distance from the inks showing that the contribution of gall nut monosaccharide is not important.

Appendices 3 to 6 show the results obtained for all the experimental inks. In all cases, gall nut is far from the other materials (inks or gums). A very low shift between gums and all inks was also observed. Unaged and aged inks are in the same cluster.

Analysis of inks sampled on parchments

A set of 23 very small samples of inks (<0.1mg) was collected from old 18th-century French parchments. The GC analysis showed that 3 samples out of the 23 do not contain vegetable gums. It would be interesting to go further and verify if the binding media are not lipidic or proteic materials.

The extra peaks coming from parchment are higher than in experimental inks, perhaps due to the sampling size. As expected, on the other 20 inks only very low level of gallic acid was observed (Fig. 4.17); and sometimes none at all (Fig. 4.18) 25. This explains the fading of the inks which appear very pale.

The factorial map (Fig. 4.19) obtained for the 20 old inks shows that no tragacanth gums were used as binding media. The majority of inks have been manufactured with a vegetable gum, which seems to be gum arabic. No exact attribution could be made for four samples (6, 9, 15 and 1).

Figure 4.17 Chromatogram of sample 2 collected from an old parchment (* peaks from parchment).

Figure 4.18 Chromatogram of sample 3 collected from an old parchment (* peaks from parchment).

Figure 4.19 Factorial map for ink samples from old parchments (two first factors).

Conclusion

The sugar composition of vegetable gums can be obtained by gas chromatography after methanolysis and trimethylsilylation of the samples. With a rigorous protocol, this method is very reproducible and it is possible to integrate chromatogram peaks and to obtain the relative abundance of each component. For this, only peaks of the main isomers of each monosaccharide will be integrated because they are all well separated and not superimposed. The matrixes obtained from an important sampling can be treated by an appropriate statistical analysis.

On 60 modern and new samples, it is shown that the data analysis (Minimum Spanning Tree and factorial analysis) can differentiate and classify vegetable gums in four different categories according to their monosaccharide composition: arabic gums, tragacanth gums, cherry tree gums and gutta gums.

The validity of the method has been tested on experimental inks (dried or applied on new parchment) before and after artificial ageing. In the chromatograms, a high level gallic acid, extracted from gall nuts during the ink preparation, is observed. Gall nut sugars do not interfere with those of gums with the exception of glucose; this is the reason for not considering the glucose peak in spite of its presence in tragacanth gum. Other more important criteria (fucose, ...) allow the differentiation of the latter. On factorial maps, gall nuts and the ink samples are all very distant. It has also been demonstrated that there is no significant shift with ageing, either on dried inks and or on inks deposited on parchment.

Of the 23 samples of inks from old French parchments, only 20 binding media are based on vegetable gum (mainly arabic gum). Four samples have a confused attribution, either cherry tree and gutta gum. In all likelihood, cherry tree gum was probably the medium used because gutta gum has never been mentioned in the ancient recipes.

Acknowledgements

The authors wish to thank Pr. Bernard Bodo, director of the Laboratoire de Chimie Appliquée of the MNHN, for all the samples collected in the prestigious collection of natural products and Mr Vitold Nowik, from the Laboratoire de Recherche sur les Monuments Historiques for very old samples of gums.

References

Arpino, P., J. P. Moreau, C. Oruezabal and F. Flieder (1977) 'Gas chromatographic-mass spectrometric analysis of tannin hydrolysates from the ink of ancient manuscripts (XIth to XVIth century)', *Journal of Chromatography* 134, pp. 433–439.

Bleton, J., C. Coupry and J. Sansoulet (1996a) 'Approche d'étude des encres anciennes', *Studies in Conservation* 41, pp. 95–108.

Bleton, J., P. Mejanelle, P. Gourseaud and A. Tchapla (1996b) 'Intérêt du couplage CPG/SM démontré par la caractérisation de l'acide 4-O-méthyl glucuronique dans certaines gommes végétales', *Analusis* 24, M14–M16.

Bleton, J., P. Mejanelle, J. Sansoulet and A. Tchapla (1996c) 'Characterization of neutral sugars and uronic acids after methanolysis and trimethylsilylation for recognition of plant gums', *Journal of Chromatography* A 720, pp. 27–49.

Bleton, J., J. Rivallain and J. Sansoulet (1997) 'Encres de tablettes coraniques Africaines', *Journal d'Agriculture Traditionnelle et de Botanique Appliquée* 39, pp. 95–107.

Coppen, J. J. W. (1995) 'Exudate gums – gum arabic, gum talha and other acacia gums', *Gums, Resins and Latexes of Plant Origin*. Non-Wood Forest Products 6. Food and Agriculture Organization (FAO) if the United Nations, Rome, pp. 11–43.

Dogan, M., T. Ekim and D. M. W. Anderson (1985) 'The production of gum tragacanth from *Astragalus microcephalus* in Turkey', *Biological Agriculture and Horticulture* 2, pp. 329–34.

Martinez, M., G. L. de Pinto, C. Rivas and E. Ocando (1996) 'Chemical and spectroscopic studies of the gum polysaccharide from *Acacia macracantha*', *Carbohydrate Polymers* 29, pp. 247–52.

Mills, J. S. and R. White (1994) *The Organic Chemistry of Museum Objects*, 2nd edn. Butterworths, London, p. 76.

de Pinto, G. L., M. Martinez, L. M. De Bolano, C. Rivas and E. Ocando (1998) 'The polysaccharide gum from *Acacia tortuosa*', *Phytochemistry* 47, pp. 53–6.

Pistelli L., S. Pardossi, A. Bertoli and D. Potenza (1998) 'Cicloastragenol glycosides from *Astragalus verrucosus*', *Phytochemistry* 49, pp. 2467–71.

Richardin, P., C. Capderou, F. Flieder, S. Bonnassies and D. Raison (1988) 'Analyse de quelques tannins végétaux utilisés pour la fabrication des cuirs [Analysis of a few vegetable tannins used in leather fabrication], *Les documents graphiques et photographiques – Analyse et conservation*. Travaux du Centre de Recherches sur la Conservation des Documents Graphiques 1986–1987. L. D. Française, Ed., Paris, pp. 151–82.

Sistach, M. C. and I. Espadaler (1993) 'Organic and inorganic components of iron gall inks', Committee for Conservation, ICOM, Washington, DC, Vol. 2, pp. 485–90.

Vallance, S. L. (1997) 'Applications of chromatography in art conservation: techniques used for the analysis and identification of proteinaceous and gum binding media', *Analyst* 122, pp. 75R–81R.

Vallance, S. L., B. W. Singer, S. M. Hitchen and J. H. Townsend (1998) 'The development and initial application of a gas chromatographic method for the characterization of gum media', *Journal of the American Institute for Conservation* 37, pp. 294–311.

Wiendl, R. M., B. M. Muller and G. Franz (1995) 'Proteoglycans from the gum exudate of myrrh', *Carbohydrate Polymers* 28, pp. 217–26.

Appendix 1 Gas chromatography (FID) of the standards.

1. arabinose

2. rhamnose

3. fucose

4. xylose

5. galactose

6. mannose

7. glucose

8. 4-O-methyl glucoronic acid (in gum ghatti)

10. glucuronic acid

11. galacturonic acid

24. pinitol (in tragacanth gum – Ref. 5)

Appendix 2 Table of correspondence for the 60 gums.

Ref.	Φ1	Φ2	Φ3	Φ4	Φ5	Ref.	Φ1	Φ2	Φ3	Φ4	Φ5
1	−0.4767	0.5117	0.9376	−0.6979	0.3439	31	0.0836	−1.2450	−0.1267	−0.2695	0.4023
2	−0.4366	0.2362	0.6060	−0.4286	0.0281	32	−0.4255	−0.4595	−0.1917	0.0417	0.1813
3	0.5122	0.4499	−0.7837	−0.4754	0.0290	33	−0.0800	0.0071	0.1008	0.1929	−0.2304
4	1.1193	−0.1379	0.1765	0.1257	−0.0025	34	−0.3984	0.2533	−0.1440	0.3764	−0.1220
5	−0.0135	0.1208	−0.3157	0.0671	−0.0251	35	−0.2951	0.2377	0.1094	0.1358	0.0365
6	0.6002	0.6363	−1.3283	−1.0119	0.0053	36	−0.2778	0.2810	−0.0014	0.2113	−0.0367
7	0.8632	0.2403	−0.5946	−0.4051	−0.1295	37	−0.2949	0.2712	0.0456	0.2322	0.0614
8	0.8486	0.1352	−0.3228	−0.1533	−0.0368	38	−0.2909	0.3078	0.0234	0.2488	0.0501
9	1.6982	−0.1693	0.4223	0.2196	0.0073	39	−0.2972	0.2802	0.0530	0.2477	0.0555
10	1.7062	−0.1662	0.4166	0.2133	0.0054	40	−0.3698	0.3736	0.4024	−0.0583	0.2949
11	1.7068	−0.1729	0.4202	0.2161	0.0106	41	−0.3730	0.3749	0.3102	0.0252	0.2499
12	1.6968	−0.0885	0.2262	0.0550	−0.0059	42	−0.2702	0.2614	−0.0799	0.3842	−0.0707
13	1.7009	−0.1692	0.4115	0.2110	0.0077	43	−0.4622	−0.5346	−0.0375	−0.2101	0.8591
14	0.8390	0.2408	−0.5068	−0.3519	0.0250	44	−0.4648	−0.3637	−0.1030	0.0539	−0.0870
15	0.9093	0.0430	−0.0551	0.0744	0.0066	45	−0.3920	0.4651	−0.2307	0.4263	−0.0430
16	0.9214	0.0901	−0.1410	0.0226	0.0453	46	−0.4944	0.6775	1.0363	−0.0608	0.0366
17	1.1812	−0.0411	0.0260	0.0015	−0.0385	47	−0.4775	−0.5060	−0.0524	−0.0740	0.0370
18	−0.1868	−0.3925	−0.2214	−0.2025	−0.2451	48	−0.4840	−0.4349	0.2293	−0.3748	−0.2119
19	0.9345	0.0074	0.0026	0.0791	−0.0125	49	−0.4174	0.3185	−0.2601	0.4657	0.2105
20	−0.4708	−0.5379	−0.0516	−0.1118	0.0133	50	−0.4410	0.2533	−0.1446	0.3371	0.1838
21	−0.4583	−0.5204	−0.1047	−0.0504	0.1377	51	−0.4373	0.2732	−0.1522	0.3489	0.2026
22	−0.4712	0.0315	0.0418	−0.0411	−0.2814	52	−0.4358	0.2717	−0.1587	0.3535	0.2117
23	−0.1519	0.2380	0.3774	−0.0820	−0.1951	53	−0.4375	0.3529	−0.1426	0.3745	0.1609
24	−0.4664	−0.0754	0.0128	0.0997	−0.1518	54	−0.2941	0.3110	0.1532	0.1037	−0.1056
25	−0.4760	−0.1184	−0.0582	0.1184	−0.1437	55	−0.4066	−0.5659	−0.2463	0.0255	0.4036
26	−0.4942	−0.0971	0.0880	−0.1110	−0.2050	56	−0.4492	0.3127	−0.0665	0.2823	0.2550
27	−0.4931	−0.4666	0.0112	−0.1129	−0.0478	57	−0.4579	−0.5459	−0.0659	−0.1299	0.0433
28	−0.4864	−0.4687	−0.0084	−0.1020	−0.0467	58	−0.5151	−0.3078	0.1041	−0.0355	−0.9417
29	−0.4068	−0.2631	0.0607	−0.1276	−0.7135	59	−0.4585	0.2180	0.0062	0.0996	−0.2576
30	−0.4673	0.2279	−0.0591	0.2314	−0.1262	60	−0.4685	−0.4626	−0.0565	−0.0233	−0.0542

Appendix 3 Table of correspondence for the 'arabic inks'.

Sample	Ref.	Φ1	Φ2	Φ3	Φ4	Φ5
Gall nut	1	−1.9558	0.0177	0.0015	−0.0001	+0.0002
gum arabic	2	0.2201	0.0647	−0.0583	−0.0183	-0.0056
dried ink 1	3	0.1981	0.0068	0.0237	0.0284	-0.0331
dried ink 1 (conc.)	4	0.1991	0.0049	0.0253	0.0399	-0.0230
dried ink 2	5	0.1829	−0.0058	−0.0813	−0.0050	-0.0138
dried ink (after ag.)	6	0.1947	−0.0069	0.0253	0.0363	-0.0296
dried ink (water) 12	7	0.2100	0.0452	−0.0549	0.0059	+0.0264
dried ink (vinegar) 10	8	0.0824	−0.2696	0.0143	−0.0155	+0.0142
dried ink (urine) 11	9	0.1991	0.0135	−0.0536	−0.0252	+0.0201
ink on parchment	10	0.2356	0.0643	0.0707	0.0510	+0.0512
ink on parch. (after ag.)	11	0.2340	0.0651	0.0872	−0.0973	-0.0072

Appendix 4 Table of correspondence for the 'tragacanth inks'.

Sample	Ref.	Φ1	Φ2	Φ3	Φ4	Φ5
gall nut	1	−1.3048	0.0333	0.0043	0.0021	0.0001
tragacanth gum	2	0.0960	−0.4834	0.0090	−0.0116	0.0006
dried ink 1	3	0.1905	0.1047	−0.0517	−0.0172	0.0140
dried ink 1 (conc.)	4	0.1823	0.0795	−0.0631	−0.0121	0.0005
dried ink (after ag.)	5	0.1786	0.0308	−0.1051	0.0160	−0.0108
ink on parchment	6	0.2379	0.0235	0.0574	0.0568	0.0038
ink on parch. (after ag.) 1	7	0.2087	0.1328	0.0883	−0.0386	−0.0057
ink on parch. (after ag.) 2	8	0.2109	0.0789	0.0607	0.0047	−0.0025

Appendix 5 Table of correspondence for the 'cherry inks'.

Sample	Ref.	Φ1	Φ2	Φ3	Φ4	Φ5
gall nut	1	−1.2791	−0.0321	−0.0009	0.0015	0.0002
cherry tree gum	2	0.1917	−0.1312	−0.0446	0.0515	0.0100
dried ink 1	3	0.1641	−0.0590	−0.0178	0.0124	−0.0013
dried ink 1 (conc.)	4	0.1788	−0.1291	0.0194	0.0067	−0.0008
dried ink 2	5	0.1565	−0.0491	−0.0072	0.0105	−0.0025
dried ink (after ag.)	6	0.1698	−0.1687	0.0279	−0.0693	−0.0113
ink on parchment 1	7	0.1421	0.0405	−0.0254	−0.0019	0.0032
ink on parchment 2	8	0.1076	0.1243	0.1205	0.0127	0.0146
ink on parch. (after ag.) 1	9	0.0830	0.2110	−0.0069	0.0212	−0.0297
ink on parch. (after ag.) 2	10	0.0858	0.1933	−0.0650	−0.0452	0.0177

Appendix 6 Table of correspondence for the 'gutta inks'.

Sample	Ref.	Φ1	Φ2	Φ3	Φ4	Φ5
gall nut	1	−1.6169	−0.0144	0.0029	0.0007	0.0000
gum gutta	2	0.2849	−0.2261	−0.0509	−0.0074	−0.0118
dried ink 1	3	0.2522	−0.0251	0.0704	0.0567	−0.0002
dried ink 1(conc.)	4	0.2412	−0.0704	−0.0251	−0.0640	0.0153
dried ink 2	5	0.2259	0.0525	0.0712	−0.0029	−0.0033
dried ink (after ag.)	6	0.2427	0.0040	0.0775	0.0297	0.0078
ink on parchment	7	0.1830	0.1678	0.0141	−0.0582	−0.0106
ink on parch. (after ag.)	8	0.1872	0.1116	−0.1602	0.0453	0.0027

5 Sulphur Inclusions within Parchment and Leather Exposed to Sulphur Dioxide

Derek J. Bowden and Peter Brimblecombe

Introduction

The conservation of historical parchment, documents and charters is important due to their significant constitutional, cultural and social value. Parchment degradation occurs through various mechanisms such as physical wear, stress from relative humidity (RH) cycling, mycological attack and chemical reaction with inks, metal fasteners and gases absorbed from the atmosphere. Collagen-based materials are particularly sensitive to sulphur dioxide. Pollutants deposited from the atmosphere partitions into the interstitial water to form sulphurous acid, which is oxidized to sulphuric acid, perhaps via metal catalysis. Strong acids within the collagen structure will cleave proteins over time.

Our work is concerned primarily with the investigation of parchment sulphur distribution profiles using the scanning electron microscope (SEM), but calcium, iron, and copper will also be included. Calcium is expected to be associated with and aid sulphur uptake due to acid/base affinity. Iron and copper can participate in redox and catalytic reactions and enhance degradation by increasing the rate of oxidation of S(IV) to S(VI). They occur naturally at low concentrations in leather and parchment or may be added, in considerably higher concentrations, from tanning agents, inks and paints.

The sulphur distribution and other elements of interest within the cross-section profiles of new, artificially aged and historical parchment were examined using the SEM with X-ray capture.

This research is published in short form for a broader audience (Bowden and Brimblecombe 2000) and the digital image maps will be available via the internet[1].

Experimental

Introduction to the technique

Sulphur and other selected elements within the parchment cross-sections were determined using a Hitachi S-450[2] scanning electron microscope with a Link Systems[3] X-ray capture facility. This technique allows us to investigate the distribution of elements across very small areas (i.e. the edge of the parchment). The following elements were investigated: sulphur (S), titanium (Ti), calcium (Ca), iron (Fe), copper (Cu). Sulphur is representative of atmospheric sulphur dioxide which forms sulphuric acid so relevant to degradation. Titanium was investigated as a possible reference element for inter-image comparison. Calcium, often used in parchment manufacture, was considered as an alkaline material that may assist the uptake of acidic sulphur dioxide gas. Iron and copper can partake and catalyze oxidation reactions.

Samples investigated in our study are listed in Table 5.1. Parchments within this set include: modern (new), modern artificially aged (French parchment P435 aged 0, 2, 4, 8 and 16 weeks in a pollutant atmosphere of 25 ppm SO_2 and 10 ppm NO_2 at 40°C and 30% RH) and historical materials. Additional samples include: (i) Roman sandal leather (Gopfrich 1998) which contained iron rivets that corroded while it was buried, (ii) Persian saddle cover leather (Gopfrich 1998) which was pigmented green with copper compounds. An archived image of an artificially aged leather (Brimblecombe 1997) exposed to very high sulphur dioxide concentrations, was digitally reprocessed using our new computational algorithms.

Table 5.1 Parchment and leather samples used in the sulphur distribution research.

Code	Date	Use
P1	Modern	New
P2	Modern	New
NP3	Modern	New
NP4	Modern	New
P435	Modern	New & artificially aged
HP6a	1609	Bookbinding
HP6b		
HP7	17th C.	Bookbinding
HP8	1797–1799	Bookbinding
HP9	1641	Bookbinding
ROM1, 3	2–4 BC	Roman sandal (Gopfrich 1998)
PER		Persian saddle cover (Gopfrich 1998)
Leather	artificially aged	New (Brimblecombe 1997)

ROM1 and 3 are Roman leather 2–4 BC from excavations at Mainz.

Fluctuations in the electron beam caused some undesirable horizontal banding in SEM images. Titanium was taken as a reference element to monitor the electron beam because it gives a relatively bright image and there is a uniform presence within individual parchments. Detailed notes of band removal, compensation and beam fluctuation correction can be found below under the subheading *Image processing procedure*.

Materials and methodology

Sample preparation

The samples of parchment (Table 5.1) were cut into strips measuring approximately 15 × 6mm. Air was removed from the parchment sample, to aid fixing, by rapid immersion in acetone. The orientation of the parchment, edges exposed directly to the atmosphere during ageing, were noted. The samples were then bent into a 'V' shape to add stability when placed in a cylindrical resin mould and EPOFIX epoxy resin[4] added. Very small and fragile samples were supported in the mould during the initial stages of embedding by using a glass frame. The resin block was cured overnight at 40°C. Final block preparation involved various stages of grinding and polishing:

i) Diamond wheel surface grinding of the block to 0.8cm thickness.
ii) Silicon carbide powder (14μm), polishing time – 1 minute.
iii) Fine polishing using differing grades of diamond polishing paste (6, 1, 0.25μm).

All the above stages include an ultrasonic bath between grinding media changes. The resin block was finally glued to an aluminium SEM stub and vacuum carbon coated.

Each sample cross-section was scanned (20kV setting) simultaneously by the SEM providing a topological (backscatter electron image (BSE)) image and the various elemental analysis images, as required. Elements of interest were selected before scanning and on completion of the scans the final images were saved as layered computer files. The orientation of the scanned image with reference to the original parchment sample was noted.

Parchment image analysis

An example of a BSE image depicting the topological surface representation is shown in Figure 5.1a. This 256 × 256 pixel image is the result of masking out of the unwanted resin block areas and rotation (Fig. 5.1b) using an image processing algorithm (see *Image processing procedure* below). The corresponding raw X-ray capture image for our example (Fig. 5.1c, P435–16w, see Table 5.4, footnote e) displays the raw sulphur data, where the intensity of the pixels are loosely proportional to elemental concentration (Table 5.2). In all greyscale images (all image capture and mathematical processing is undertaken in greyscale, the addition of colour is for clarification and presentation purposes) an intensity scale of 0 to 255 is used. Pure white pixels have the maximum intensity of 255, indicating high concentrations and black areas with an intensity of zero represent voids, 'holes' in the parchment or the resin. Absolute concentrations of elements in parchment cannot be determined by this method because no elemental calibration standards for parchments were available. However, these

Table 5.2 Raw image maximum pixel intensities[a].

Sample	S	K	Ca	Ti	Fe	Cu
P435 – 0w[b]	16	16	47	9	9	7
P435 – 2w[b]	17	11	74	10	51	21
P435 – 4w[b]	59	17	153	51	27	11
P435 – 8w[b]	20	–	–	13	–	–
P435 – 16w[b]	36	–	–	255	–	–
NP3	9	6	10	6	5	5
NP4	5	4	6	4	3	3
HP6a	20	19	40	14	13	9
HP6b	28	81	87	14	51	11
HP7	63	105	52	75	43	12
HP8	14	48	73	7	6	7
HP9	23	107	188	11	12	10
ROM1	25	30	57	21	38	13
ROM3	57	67	80	27	244	241
PER	35	68	117	27	24	21
Leather	28	–	–	–	–	–

Sample coding as Table 5.1. Parchment P435 – modern, artificially aged; NP(X) – new; HP(X) – historical; ROM(X) – Roman; PER – Persian. (a) The number of elements scanned increased as the work progressed, indicated by the gaps in the data. (b) The 'w' associated with the sample P435 represents the number of weeks the parchment was exposed to a pollutant atmosphere of 25 ppm SO_2 and 10 ppm NO_2 at 40°C and 30% RH (artificial ageing).

Figure 5.1 P435_16w. (a) parchment rotated and vertically orientated SEM topological BSE image with resin block areas masked, processed using the SEMPER routines written for this work; (b) image mask and scale; (c) raw sulphur image only compensated for electron beam fluctuation.

relative concentrations give high resolution information on distribution profiles within a cross section of the parchment and leather. Other parchment BSE, raw elemental and associated colour images can be found in the colour plate section (Plates 5.1 to 5.11).

Parchment is a heterogeneous material and thus comparison of element distributions between different parchment samples is difficult. However, inter-comparison within a base set such as the artificially aged P435 samples should be easier as these were derived from the same skin. One common problem is the fluctuation of electron beam strength between individual image captures. If an element displays an even and consistent distribution within individual and subset images, it can be used as a reference (titanium is frequently used). Other elements under investigation can then be ratioed to the reference element for inter-comparison. Banding is sometimes clearly visible as a response to electron beam fluctuation, but may be subtle and not easily detected. Therefore, all images were processed through several stages using SEMPER5 image processing computer software (user custom recompiled (Tovey 1998)). All the element raw images, corrected for electron beam instability (greyscale) and processed images (colour maps) are displayed in Plates 5.1 to 5.11 (colour plate section).

Image processing procedure
Image processing batch files and algorithms were compiled and placed in the SEMPER programme as named custom library routines. These routines then processed the various SEM captured images, BSE and X-ray, within each sample layer file as explained below:

i) The routine Select initiated the following sequences. It requests the selection of an individual sample layered image file and requests the selection of the required layers (element maps) under investigation. Extracted layers are written to a specified named disk file.

ii) The library routine *paperorientate* uses INTRAD and ISTAT SEMPER commands in combination with a custom 'look-up-table' (a reference colour chart related to pixel orientation, degrees of angle) to determine the orientation of the image features. These orientation data are stored for subsequent use to vertically align the image at a later stage.

iii) The library routine paperrotate takes the titanium image as a reference element map to correct for beam instability and then corrects all the other BSE and X-ray images for the individually selected parchment or leather sample under investigation.

The SEMPER command PROJECT was used to horizontally average the pixel intensities. In the enhanced mode, bright spots (which cause inaccuracies during the averaging calculations) are mathematically removed. A threshold limit (mean pixel intensity + (4 × standard deviation)) was selected to remove any bright spot (high intensity) of more than two pixels. The space created by the removal of the bright spot is then filled with pixels of a mean intensity value calculated from the surrounding horizontal layer. Horizontal averaging of the whole reference image was used to compensate the remaining elemental images. Although titanium was used for this work any element which is not the major constituent of any sample, at the low end of the intensity scale, and which covers the whole image area with little variation in pixel intensity can be used.

iv) A masking function allows the manual masking of the unrequired resin part of the image from that of the sample image and stores the mask image as a separate file. Information stored from the previous *paperorientate* library file was then used to orientate the image (i.e. parchment 'grain' structural feature as seen in the BSE image – Fig. 5.1a) to the vertical for subsequent analysis.

v) The band compensated, rotated and masked raw element images were then smoothed using Gaussian filtering (Equation 1) to produce elemental distribution maps. Gaussian smoothing involves the examination of each pixel, together with its relation to the neighbouring pixels for five iteration steps which results in considerable clarification when compared to noisy raw pixel images. A spectral colour key was used to code the resulting individual islands of intensity (red – high, blue – low).

$$e^{-\left(x^2/2r^2\right)} \quad [1]$$

Where x is the distance from the image origin, r is the rms width and values below $e^{-7.5}$ are set to zero.

Results

A progressive approach is used to examine the data in this section:

i) investigation of the feasibility of comparing the arbitrary concentrations for all the parchment and leather samples.

ii) comparison within a small base set consisting of individual modern parchment samples, cut from the same skin, artificially aged by exposure to sulphur dioxide and nitrogen dioxide for differing times.

iii) the examination of the element distributions within the cross section of each individual image for parchment and leather.

Titanium was used as a reference element to remove banding from all images, so it was hoped that it would also be useful for inter-comparing different images. However, this relies on titanium having a relatively constant concentration in all parchments. There are considerable variations in the mean pixel intensities sample to sample (Tables 5.3 and 5.4). Especially notable is the vast difference between NP4 and HP6a. Part of this might arise from a difference in the electron beam energy, but these seem so large that they must relate to real differences in titanium concentrations within parchments.

This meant that we restricted our quantitative analysis to a narrow set (i.e. the base set of parchments – P435)

Figure 5.2 Sulphur – titanium ratios of artificially aged parchment P435. Symbols: solid original calculated ratios from the mean values (Table 5.5); open new S/T_i ratio values calculated from the stated standard deviation (SD) above the mean. Correlation (r^2) for the 0.5 standard deviation and the 2.5 SD data are 0.6918 and 0.7354 respectively.

Table 5.3 Titanium image data.

Material	Mean	Max[a]	SD	Ratio[b]
P435-0w[c]	0.186	4.0	0.428	13.435
P435-2w[c]	0.389	6.0	0.620	6.424
P435-4w[c]	1.463	9.0	1.138	1.708
P435-8w[c]	0.236	8.0	0.486	10.589
P435-16w[c]	1.093	11.0	1.122	2.286
NP3	0.134	5.0	0.360	18.649
NP4	0.009	2.0	0.074	277.667
HP7	1.629	12.0	1.200	1.534
HP8	0.049	6.0	0.236	51.000
HP9	0.166	9.0	0.424	15.054
HP6a	2.499	10.0	1.824	1.000
HP6b	1.827	12.0	1.531	1.368
ROM1	2.163	34.0	1.952	1.155
ROM3	2.361	19.0	2.928	1.058
PER	6.589	155.0	3.818	0.379

(a) New maximum pixel intensities of the compensated images; minimum pixel intensities are zero for all images. (b) Maximum mean pixel intensity (2.499) of the parchment samples/mean pixel intensity. (c) The 'w' associated with sample P435 represents the number of weeks the parchment was artificially aged.

originating from the same skin. Thus we could assume a relatively constant titanium concentration. Although even here, there is an immediate problem as when the sulphur intensity is ratioed to the titanium, sulphur appears to decrease the longer the parchment is exposed to sulphur dioxide (Fig. 5.2, dotted line). This appears to be because the sulphur is not accumulated evenly through the parchment as a whole.

The areas of sulphur accumulation were chosen statistically by setting threshold values at various standard deviations (0.5–3.0) above the mean sulphur intensity/mean titanium intensity ratio. The average S/Ti was determined for pixels that exceeded these thresholds (Table 5.5). The results are shown in Figure 5.2 where the solid lines show how in areas of sulphur accumulation the S/Ti ratio increases dramatically after 16 weeks. This seems to show that sulphur accumulates in specific areas of the parchment rather than all over – very much the expectation from the image Figure 5.1c. The irregular layers we see in the image make quantitative comparisons between parchments difficult.

Subsequent work used a more qualitative analysis that focused on the layering. The images of individual elements for all the parchment and leather samples were smoothed using a Gaussian filter with a width of eight pixels for five computational iterations. These processed elemental maps were then spectrally colour coded according to pixel intensity (see colour plate section).

Sulphur in the artificially aged parchment set P435 (Plates 5.1b, 5.2b, 5.3b, 5.4b,c, colour plate section) changes from a relatively homogenous low value (pixel intensities 1 to 3) for unexposed parchment to complex distributions often at higher intensity after periods of exposure to SO_2. One gets the impression of increasing accumulations of sulphur over time in various areas of the parchments, although an 8-week exposure (Plate 5.4b) showed a rather low sulphur content, which we could not explain. All the modern parchments examined here show that areas with high sulphur intensity are not coincident with areas of high BSE intensity (Fig. 5.3) and shown alternatively in Figures 5.4 and 5.5, using thresholding and displaying only the higher pixel intensities. Electrons are backscattered more

Table 5.4 Sulphur image pixel intensity data.

Material	Mean	Max[a]	SD	New Mean[b]	New Max[c]	S/Ti Ratio[d]
P435-0w[e]	1.006	8	1.057	13.516	107.484	5.409
P435-2w[e]	1.66	14	1.444	10.664	89.938	4.267
P435-4w[e]	5.181	48	3.146	8.85	81.99	3.541
P435-8w[e]	0.907	10	1.114	9.604	105.89	3.843
P435-16[e]	3.531	40	3.043	8.073	91.455	3.231
NP3	0.684	7	0.807	12.756	130.545	5.104
NP4	0.051	6	0.214	14.161	1666	5.667
HP7	5.251	46	3.044	8.055	70.567	3.223
HP8	0.338	12	0.777	17.238	612	6.898
HP9	1.164	11	1.208	17.523	165.596	7.012
HP6a	1.98	13	1.671	1.98	13	0.792
HP6b	1.87	20	1.447	2.558	27.356	1.024
ROM1	1.526	44	1.727	1.762	50.82	0.706
ROM3	1.557	22	1.896	1.647	23.276	0.66
PER	4.847	138	3.676	1.837	52.302	0.736

Sample codes as for Tables 5.1 and 5.2. (a) New maximum pixel intensities of the compensated images; minimum and new minimum pixel intensities are zero for all images. (b) New mean calculated using the ratio data from Table 5.3. (c) Maximum pixel intensity (sulphur) calculated using the ratio data from Table 5.3. (d) S/Ti ratio are calculated from the individual mean sulphur intensity (this table)/mean titanium intensity (Table 5.3). (e) The 'w' associated with sample P435 represents the number of weeks the parchment was artificially aged.

Figure 5.3 3D surface plot for P435_16w artificially aged parchment depicting the relative histogram output for the analysis (frequency – f) of where pixels of similar intensity trends occur on comparison of the BSE and sulphur (S) raw images.

Figure 5.4 Parchment image maps in negative format depicting threshold intensities. (a) P435_16w, BSE > 200 intensity; (b) P435_16w, S > 10.

Table 5.5 Mean sulphur–titanium ratios for P435 parchment.

No. of weeks	Standard deviation above the mean					
	0.5	1	1.5	2	2.5	3.0
0	3.316	3.317	3.317	4.281	4.281	5.226
2	3.618	4.475	4.479	5.447	6.506	6.512
4	8.024	8.738	10.455	11.440	12.522	13.688
8	3.426	3.430	4.387	4.387	5.382	5.282
16	6.868	7.847	8.831	9.831	11.887	12.909

intensely by materials with high atomic number or, as is more likely, in this denser material. Thus it would seem that modern parchments exposed to sulphur dioxide for a short period tend to accumulate this compound in less dense layers.

Calcium is not found in layers, but seems to be present in small areas distributed almost at random in the parchment cross section (Plates 5.1c, 5.2c and 5.3c). There appears to be no consistent correlation with the layered distributions of either sulphur or BSE intensity (Fig. 5.5a and c).

Historical parchments appear rather different. In historical samples, once again we can find sulphur deposited in layered structures (HP7 is particularly notable (Plate 5.7b,c,d)). The highly degraded (gelatinized) HP6a and HP6b parchments contain far less evidence of layered structures (Plate 5.5b), although they both contain sulphur (Plate 5.5c), HP6a images are not shown as they were small after reduction from badly banded raw images. All the small images for HP6a, raw and processed, displayed similar features and element pixel intensities when compared to HP6b (Plates 5.5b to 5.5f).

The calcium deposits in the historical parchment, HP7 seemed to correlate with sulphur accumulations (Plate 5.7d,e). Parchments HP6a and HP6b contain relatively high concentrations of calcium throughout the samples with small areas of especially high calcium concentrations that correlate well with elevated levels of sulphur, iron and copper (Plates 5.5c to 5.5f, Table 5.6). Other images, i.e. HP8 and HP9, (Plates 5.8b,c and 5.9c,d) did not show this association between sulphur and calcium. The distinguishing feature of HP7 seems to be the relatively high concentrations of sulphur in the parchment, so we get the impression that high sulphur concentrations in historical samples are associated with calcium because sulphur was expected to accumulate at the alkaline sites associated with calcium.

Historical leathers were examined in this project, ROM1, ROM3 and PER. The Roman sandal (ROM) was buried and its leather sole contained metal rivets. The Persian saddle cover (PER) leather was decorated by pressing seeds, copper metal, ammonia and salt onto the leather during manufacture. Basic physical analysis determined that large pieces of the Roman leather ROM1 and ROM3 samples were very hard with a packed fibre structure, most probably calf skin, with very little shrinkage activity (Vest 1999). The Persian leather PER was still flexible, but no shrinkage temperature (Ts) could be measured as the fibres turned to gel on contact with

Figure 5.5 P435_4w, negative format. (a) BSE > 200; (b) S > 10 (c) Ca > 10.

Table 5.6 Compensated image pixel intensity data for other elements of interest.

Material	Mean(Ca)	Max[a](Ca)	Mean(Fe)	Max[a](Fe)	Mean(Cu)	Max[a](Cu)
P435-0w	0.969	39	0.115	7	0.087	4
P435-2w	1.97	69	0.704	40	0.217	15
P435-4w	3.637	130	1.371	19	0.829	8
P435-8w	n.s.	n.s.	n.s.	n.s.	n.s.	n.s.
P435-16w	n.s.	n.s.	n.s.	n.s.	n.s.	n.s.
NP3	0.307	8	0.068	3	0	0
NP4	0.029	4	0.011	4	0	0
HP7	3.041	34	1.552	27	0.664	8
HP8	4.185	62	0.044	8	0.037	6
HP9	3.999	51	0.108	5	0.086	5
HP6[a]	12.946	29	1.982	9	1.32	8
HP6[b]	10.285	71	1.924	45	0.993	10
ROM1	8.614	118	2.206	49	1.795	39
ROM3	8.88	74	2.538	106	2.055	38
PER	27.542	254	5.685	79	4.502	79

(a) New maximum pixel intensities of the compensated images; minimum and new minimum pixel intensities are zero for all images. n.s. – element listed not scanned. (b) These values result from calculations involving very low intensities of the raw pixels for copper within the images of the parchments stated (see Table 5.2).

water at ambient temperature (Vest 1999), indicating a highly degraded collagen state. All four elements sulphur, calcium iron and copper are present in ROM1, ROM3 and PER (Plates 5.10c to f and 5.11c to f; ROM1 images not shown) and show a high degree of correlation. Direct contact with the iron rivet in the sandal (ROM3) leads to the elevated concentrations clearly seen in the bottom right of Plates 5.10c to f. The copper pigmentation on the Persian saddle cover (PER) is obvious from high concentrations at the outer edge (vertical right) in Plate 5.11f. High concentrations of iron are also found along this edge (Plate 5.11e). Given the very different histories of these samples the high degree of correlation between sulphur, calcium and the metals suggest that this can occur in widely different samples.

Discussion

Elemental distribution profiles have been determined for a series of modern parchment, modern artificially aged (sulphur dioxide and nitrogen dioxide exposed), historical parchments and historical leathers using the SEM with X-ray capture facilities.

The distribution of sulphur layers in P435_16w is similar to that of historical parchment HP7 (Plate 5.7c,d) although the depth of penetration is higher for HP7. This layering effect could be the direct result of the important stretching process during parchment manufacture where the three-dimensional angular fibre network of the skin acquires horizontal layers. Generally, two layers of the skin dermis can be used to manufacture leather and parchment. The outermost (grain layer, with hair holes) containing a fine fibre structure and the more open Corium layer (larger collagen fibres and the layer near the flesh side). In some figures (5.1a,c and 5.4a,b) sulphur appears to be accumulating within the less dense layers of the parchment structure. A correlation between sulphur and calcium was expected for all parchments because of the reaction of sulphur acids with alkaline lime, a classical exothermic acid/base neutralization reaction.

However, modern parchments with low sulphur contents do not show this correlation. Many of the historical samples, particularly those with higher sulphur concentrations, show calcium and sulphur to be associated. The residues of calcium in modern parchments (Plates 5.1c, 5.2c and 5.3c) are much lower than historical parchments (Plates 5.5d, 5.7e, 5.8c and 5.9d). This seems to add evidence towards the premise that historical parchment liming processes and techniques were different to those used today. Higher calcium residues are thought to have remained in the skin of historical parchment during manufacture. Interestingly historical leather also contains calcium at high concentrations. However, calcium could have entered the leather from terrestrial sources if buried, as in our example of Roman leather ROM1 and ROM3.

Iron and copper are often found in historical parchments that are degraded. It is possible that this degradation is the direct result of the combined presence of sulphur, iron and copper leading to sulphuric acid formation. This is also seen in manuscripts where inks can increase the metal concentrations and cause considerable damage.

We reassessed an archived raw sulphur image of artificially aged new leather (Brimblecombe 1997) using Gaussian smoothing and spectral intensity colour mapping (Plate 5.6a,b,c). The sulphur concentration is high throughout the leather with a higher narrow band towards the edge. Although, it must be noted that this leather was exposed to 45 ppm of sulphur dioxide for four weeks which far exceeds the exposure of any historical leather.

Conclusions

Sulphur progressively accumulates in layers within parchment and leather when exposed to sulphur dioxide. This accumulation may be taking place within the less dense areas of the layered structure.

Calcium in modern parchments is not associated with any sulphur uptake, but there is a correlation between these elements in historical samples.

Highly degraded (gelatinized) parchment contains relatively high concentrations of calcium, iron and copper in the presence of moderately low sulphur concentrations.

The high calcium in historical parchment when compared to that of new (modern) parchment, may indicate that liming (degreasing) processes differ.

Historical leathers from two differing manufacturing processes and backgrounds – Roman, buried and Persian which remained above ground – are both highly degraded and have similar patterns of element accumulations of sulphur, calcium, iron and copper. This suggests that trace impurities have a similar effect on degradation.

Reducing further degradation of parchments and leathers is difficult because the damage has in effect already occurred. Conservators will have to decide whether the storage of the parchments and leathers in an inert atmosphere and/or in air with a specialist absorbent such as activated charcoal would be beneficial and prevent further sulphur dioxide accumulation, reducing further damage to the remaining collagen structure. Lowering the temperature would slow but not eliminate degradation reactions.

Acknowledgement

Dr N. K. Tovey (Reader in Environmental Sciences, University of East Anglia, Norwich, NR4 7TJ, England, UK) for his help with development of the image processing algorithms used during this research.

Endnotes

1. Digital SEM element maps available at http://www.uea.ac.uk/~e329/map.htm.
2. Hitachi – Nissei Sangyo, Merlin Building, Ivanoe Road, Hogwood Industrial Estate, Hogwood Lane, Finch Hamstead, Berkshire, RG11 4QQ, UK.
3. Link (Oxford Instruments), Microanalysis Group, Halifax Road, High Wycombe, Buckinghamshire, HP12 3SE, UK.
4. Struers, EPOFIX, Struers, Erskine Ferry Road, Old Kilpatrick, Glasgow, G60 5EU, UK.
5. Synoptics SEMPER 6 for Windows 3.1, Fortran extendible (1998), Synoptics Ltd, 271 Cambridge Science Park, Milton Road, Cambridge, CB4 4WE, UK.

References

Bowden, D. J. and P. Brimblecombe (2000) 'Sulphur distribution in parchment and leather exposed to sulphur dioxide', *Journal of the Society of Leather Technologists and Chemists* **84**, p. 177.

Brimblecombe, P. (1997) ENVIRONMENT Leather Project: Deterioration and Conservation of Vegetable Tanned leather, European Commission, EV5V-CT94-0514, Protection and conservation of European cultural heritage, Research Report No. 6, The Royal Danish Academy of Fine Arts, School of Conservation, Esplanaden 34, DK-1263, København K, Denmark, p. 25.

Gopfrich, J. (1998). Private communication, Deutsches Ledermuseum – Schuhmuseum, Offenbach, Germany.

Tovey, K. (1998) Private communication, School of Environmental Sciences, University of East Anglia, Norwich, NR4 7TJ, UK.

Vest, M. (1999) Private communication, The Royal Danish Academy of Fine Arts, School of Conservation, Esplanaden 34, DK-1263, København K, Denmark.

II Thermophysical and Thermochemical Analysis of Microsamples

6 The Hydrothermal Stability (Shrinkage Activity) of Parchment Measured by the Micro Hot Table Method (MHT)

René Larsen, Dorte V. Poulsen and Marie Vest

Introduction

When collagen hide fibres are heated in water they will deform over a distinct temperature interval. The deformation is seen as a shrinkage of the fibres, which is dependent on the strength or quality of the skin material and the degree of its deterioration. Thus, it is a measure of the combined chemical and physical stability of the material. The length of the shrinkage interval will depend on the distribution of the stability in the fibres – the more uneven the stability distribution, the longer the interval of shrinkage. Moreover, the hydrothermal stability of the fibres decreases proportional to the deterioration, and it has been shown that it is a very fine measure of the degree of the total of their deterioration. The micro hot table method (MHT) for measuring the shrinkage activity of microsamples of collagen fibrous materials has mainly been used in the study of vegetable-tanned leathers (Larsen *et al.* 1993, 1994, 1996a,b; Larsen 1995, 2000; Odlyha 1999; Odlyha *et al.* 2000). The method has shown to correlate well with both the standard method and differential scanning calorimetry (DSC) method (Larsen *et al.* 1994). The present paper demonstrates the use of the MHT method on new and historical parchment from the sample bank. Also included is an example of its use in a trial testing the effect of laser cleaning of parchment (Sportun *et al.* 2000; Cooper *et al.* 2000). Different from vegetable-tanned leathers, the chemical breakdown of parchment does not in general result in a powdering of the fibres. However, spontaneous transformation of Dead Sea Scroll parchments into gelatin has been reported (Weiner *et al.* 1980). The present study has shown that the fibres of some historical parchments with low hydrothermal stability are transformed into a gelatin structure by heating or immediate contact with water at room temperature. Apart from its general use as a method for measuring the stability and state of deterioration, this suggests that the MHT method may be used as an early warning system to prevent irreversible, fatal damage during storage and conservation treatments of cultural heritage parchment objects.

Experimental

A sample of around 0.3mg fibres from the corium part (flesh side) of the parchment is wetted with de-mineralized water for 10 minutes on a microscope slide with a concavity. The measurement can be performed on only a few fibres. However, a smaller sample size will be less representative of the general state of deterioration of the parchment. If the parchment has been treated with oils, fats or waxes, these should be removed by washing the fibre sample in acetone as these substances will influence the measurement. The fibres are separated in the water, eventual air bubbles are removed with a needle and the fibres are then dispersed well on the slide. The fibres are covered completely with distilled water and a microscope slide (Fig. 6.1). The slide is placed on the hot table (Mettler FP82 Hot Stage) and heated at a rate of 2°C/min. The hot stage is thermostatically controlled through a Mettler FP90 Central Processor. Azobenzene and benzil crystals are used for temperature calibration with a melting point of 68°C and 95°C, respectively. To record the shrinkage process the MHT is placed under a stereo microscope with a lamp using a magnification of around ×40.

As for leathers, the shrinkage of the parchment fibres can be described in three temperature intervals with the following characteristics:

- Interval A1/A2: Distinct shrinkage activity is observed in individual fibres.
- Interval B1/B2: Shrinkage activity in one fibre (occasionally more) is immediately followed by shrinkage activity in another fibre.

Figure 6.1 Fibre sample before inserting in the micro hot table.

Figure 6.2 Fibres from new parchment at 20°C before shrinkage.

Figure 6.3 Fibres from new parchment after shrinkage. $T_s = 57.8$.

Figure 6.4 Fibres from historical parchment at 20°C before shrinkage.

Figure 6.5 Fibres from historical parchment after shrinkage. $T_s = 37.3$.

- Interval C: At least two fibres show shrinkage activity simultaneously and continuously. The start temperature of this main interval of shrinkage is the shrinkage temperature, Ts.

As a function of temperature a new parchment fibre sample undergoes the following changes:

no activity → A1 → B1 → C → B2 → A2 → complete shrinkage

The start of A1 is defined as T_{first} (first observed shrinkage) and the end of A2 as T_{last} (last observed shrinkage). The total interval of shrinkage activity = $\Delta T_{total} = T_{last} - T_{first}$

In the first two intervals (A1 and B1) the shrinkage occurs discretely in individual fibres with the highest activity (highest amount of shrinkage per unit of time) in the B interval. In the main shrinkage interval (C), the majority of the fibre mass shrinks and the start of the C interval is defined as the shrinkage temperature, T_s. Normally, the shrinkage levels off through the B2 and A2 intervals. However, for some historical parchments neither of these intervals may be observed.

Figures 6.2 and 6.3 show fibres of new parchment before and after shrinkage. Figures 6.4 and 6.5 show examples of historical parchment fibres before and after shrinkage. Fibres of deteriorated parchments are, in general, more fragmented than new fibres. Moreover, they normally shrink to a lesser extent.

The accuracy of the measurement of the shrinkage temperature (T_s) is ± 2°C. It is recommended that at least two measurements are performed. In case these deviate more than the accuracy of the method, a third measurement should be performed and the mean of the two closest observations used as the reported result.

Samples

New parchments

To test the variation in hydrothermal stability in different locations of identical new parchments, triplicate measurements were made in ten different locations on parchment NP7. The sampling locations are shown in Figure 6.6.

To determine the variation in hydrothermal stability between different new parchments measurements were made on five other parchments (NP1–NP5).

Historical parchments

To get an overview of the hydrothermal stability of the historical parchments from the sample bank, one shrinkage measurement was performed on 40 samples (HP1–HP40). In order to get an idea of the variations in the hydrothermal stability in different positions of the same historical parchment, measurement was performed in two different locations on 16 of the samples. The samples for these

HYDROTHERMAL STABILITY OF PARCHMENT MEASURED BY MHT

Table 6.1 Shrinkage temperature in °C from ten locations on new parchment NP7. Mean values with standard deviations in parentheses. n = number of observations.

Sample	n	T_s	T_{first}	T_{last}	ΔT_{total}
A	3	60.2 (1.47)	56.8 (0.82)	77.7 (2.73)	20.9 (2.93)
B	3	58.7 (0.61)	54.5 (0.82)	76.2 (2.78)	21.7 (3.59)
C	3	57.7 (0.31)	53.5 (1.01)	76.4 (0.35)	22.9 (1.30)
D	3	57.7 (1.01)	53.8 (0.96)	77.0 (0.62)	23.2 (0.76)
E	3	58.1 (0.36)	53.5 (0.10)	77.6 (0.91)	24.1 (1.00)
F	3	57.9 (0.47)	54.0 (0.25)	77.0 (0.84)	23.0 (1.04)
G	3	57.5 (0.61)	54.3 (0.53)	75.1 (0.72)	20.8 (1.25)
H	3	57.5 (0.70)	53.5 (0.31)	75.4 (1.35)	21.9 (1.19)
I	3	56.4 (0.25)	52.5 (0.70)	77.6 (1.02)	25.1 (0.90)
J	3	57.5 (0.50)	54.0 (0.21)	76.1 (1.97)	22.1 (1.79)
All	30	57.9 (1.11)	54.0 (1.21)	76.6 (1.58)	22.5 (2.07)

Figure 6.6 Locations of samples taken from the new parchment NP7.

measurements were taken in positions that visually appear to be in different states of deterioration (a = more deteriorated; b = less deteriorated). In all cases where no C interval was observed the start of the B1 interval is reported as the T_s.

Selected historical parchments

For a more detailed and informative picture of the hydrothermal stability in historical parchments with different degrees of deterioration, 12 of the HP samples from the sample bank were selected for analysis as widely representative of a range of deterioration from a high degree (low hydrothermal stability/gelatinization) to a low degree (hydrothermal stability close to new parchment) of deterioration. Moreover, the samples were taken from locations of the parchments which (a) visually appeared homogeneous with respect to the degree of deterioration and (b) were of a size large enough to be source of samples for the other analytical methods presented in this book.

Test of the effect of laser cleaning

To assess the effect of laser cleaning, shrinkage temperature measurements were performed on new parchment samples exposed to laser radiation at 1064nm, 532nm and 266nm (Sportun *et al.* 2000), and on a historical parchment document at 1.06µm (Cooper *et al.* 2000) in pulses of 10ns duration, respectively. The equipment used was a Lynton Lasers Q-switched Nd:YAG laser with second and fourth harmonic generation. The new parchment was exposed to laser radiation at fluence (energy density) levels of 0.1, 0.5, 1.0, 2.0 and 3.0 J/cm^2, at a repetition rate of 2 Hz. The historical document was exposed to radiation at fluence levels of 0.4, 0.6, 1.3 and 2.4 J/cm^2 and at a repetition rate of 17Hz and 1.25Hz in areas with script to minimize the risk of ink loss or fading.

Results

New parchments

Table 6.1 shows the observed T_s, T_{first}, T_{last} and ΔT_{total}, Table 6.2 the mean length of the of the shrinkage intervals in the ten different locations of NP7 and Table 6.3 shows the shrinkage temperatures of samples from six new reference parchments including NP7.

Historical parchments

Table 6.4 shows the results of measurements performed on the historical parchments from the sample bank (HP1–HP40). Table 6.5 shows the observed T_s in two positions in different states of deterioration and the calculated difference between the two measurements of the 16 historical samples.

Table 6.2 The mean length in °C of the shrinkage intervals in the ten locations of parchment NP7.

	T_{first}	A1	B1	C	B2	A2
A	56.8	2.0	1.4	5.5	0.9	11.1
B	54.5	2.9	1.3	5.6	1.9	10.0
C	53.3	2.8	1.6	5.4	1.1	12.2
D	53.8	2.6	1.3	6.1	0.6	12.6
E	53.3	3.6	1.2	6.2	1.1	12.2
F	54.3	2.7	1.2	6.4	0.4	12.3
G	54.3	2.3	0.9	4.4	0.9	12.3
H	53.5	1.8	2.2	6.5	0.6	10.8
I	54.6	1.2	0.6	7.7	0.6	12.9
J	54.0	2.9	0.4	7.1	0.4	12.1

Table 6.3 Shrinkage temperatures in °C of samples from six new reference parchments. n = number of samples.

Sample	n	T_s	T_{first}	T_{last}	ΔT_{total}
NP 1	2	53.4 (0.57)	46.2 (3.04)	68.0 (1.84)	21.9 (4.88)
NP 2	3	55.3 (0.71)	51.2 (2.97)	68.8 (1.71)	17.7 (3.23)
NP 3	3	61.9 (0.64)	57.3 (1.57)	79.9 (1.70)	22.6 (1.38)
NP 4	3	60.4 (0.30)	57.2 (0.72)	78.3 (4.18)	21.2 (3.95)
NP 5	3	52.5 (1.25)	46.5 (2.04)	77.3 (0.35)	30.8 (2.34)
NP 7	30	57.9 (1.11)	54.0 (1.21)	76.6 (1.58)	22.5 (2.07)

Table 6.4 Shrinkage temperature in °C of the samples represented in the ample bank. Grey shading marks the 12 samples selected for detailed analysis (based on one measurement).

Sample	T_{first}	T_{last}	T_s	ΔT_{total}
HP 1a	***			
HP 1b	39.9	64.3	48.1	24.4
HP 2a	***			
HP 2b	33.1	67.2	43.6	34.1
HP 3a	31.2	48.4	36.5*	17.2
HP 3b	37.1	69.8	46.0	32.7
HP 4a	***			
HP 5a	***			
HP 6a	**			
HP 6b	47.3	62.8	50.1	15.5
HP 7	44.3	66.3	55.9	22.0
HP 8	32.0	64.3	40.5	32.3
HP 9	39.3	71.0	49.4	31.7
HP 10	33.8	58.3	41.6	24.5
HP 11	32.4	66.2	49.3	33.8
HP 12	33.9	52.9	39.6	19.0
HP 13	31.7	61.7	38.4	30.0
HP 14	36.0	61.8	47.6	25.8
HP 15	34.3	63.3	46.0	29.0
HP 16	31.4	68.1	37.3	36.7
HP 17	33.2	65.7	44.5	32.5
HP 18	32.5	67.5	40.9	35.0
HP 19	31.7	55.9	40.6	24.2
HP 20	46.3	70.7	52.8	24.4
HP 21	41.4	63.5	48.6	22.1
HP 22	56.2	74.0	62.8	17.8
HP 23	39.4	64.9	45.6	49.6
HP 24	37.4	69.0	44.4	31.6
HP 25	31.8	60.2	43.9	28.4
HP 26	37.2	71.1	41.3	33.9
HP 27	33.6	68.3	41.5	34.7
HP 28	29.2	48.7	33.8	19.6
HP 29	32.4	50.6	35.6*	18.2
HP 30	34.0	63.1	37.2	29.1
HP 31	48.3	76.7	53.4	28.4
HP 32	35.9	49.6	38.2	13.7
HP 33	40.7	69.6	49.0	28.9
HP 34	44.7	58.5	48.9	13.8
HP 35	43.7	74.7	53.5	31.0
HP 36	**			
HP 37	56.2	81.4	64.2	25.2
HP 38	49.4	77.3	56.1	27.9
HP 39	36.6	66.3	52.6	29.7
HP 40	39.1	66.8	49.2	27.7

* Start B1-interval, no shrinkage activity observed in C-interval
**Dimensional changes of the sample is observed and the sample is transformed into jelly in contact with water
***The sample gelatinizes and no shrinkage can be observed in contact with water

Table 6.5 T_s in °C in two different locations of the same historical parchment and the difference between the observed values. T_s (1) appears visually more deteriorated than T_s (2).

Sample	T_s (1)	T_s (2)	$\Delta T_s = T_s (2) - T_s (1)$
HP1	***	48.1	48.1
HP2	***	43.6	43.6
HP3	36.5*	46.0	–9.5
HP6	**	50.1	50.1
HP7	55.9	56.3	0.4
HP8	40.5	40.5	0.0
HP16	38.9	37.3	1.6
HP18	37.0	40.9	3.9
HP20	47.2	52.8	5.6
HP22	64.2	62.8	1.4
HP26	41.3*	41.3	0.0
HP28	34.1*	33.8	–0.3
HP31	42.8	53.4	10.6
HP36	***	**	
HP37	35.5	64.2	28.7
HP38	48.7	56.1	7.4

* Start B1-interval, no shrinkage activity observed in C-interval
**Dimensional changes of the sample is observed and the sample is transformed into jelly in contact with water
***The sample gelatinizes and no shrinkage can be observed in contact with water

Table 6.6 Mean values and standard deviations in °C for the 12 selected historical parchments (based on three measurements).

	T_s	T_{first}	T_{last}
HP 7	56.3 (2.14)	46.4 (5.02)	65.5 (2.8)
HP 8	40.2 (0.59)	32.0 (1.10)	64.1 (0.64)
HP 16	37.3 (1.40)	31.4 (1.51)	68.1 (8.02)
HP 18	40.9 (1.27)	32.5 (1.36)	67.5 (2.67)
HP 20	52.8 (0.17)	46.3 (0.96)	70.7 (1.97)
HP 22	62.8 (0.73)	58.9 (0.95)	72.4 (3.29)
HP 26	41.3 (0.71)	37.2 (2.50)	71.1 (5.90)
HP 28	33.8 (0.47)	29.2 (1.44)	48.7 (1.35)
HP 31	53.4 (0.23)	48.3 (2.52)	76.7 (4.45)
HP 36	**	**	**
HP 37	64.2 (0.29)	56.2 (5.42)	81.4 (2.28)
HP 38	56.1 (0.46)	49.4 (2.36)	75.8 (2.86)

**Dimensional changes of the sample is observed and the sample is transformed into jelly in contact with water

Table 6.7 The mean length in °C of the shrinkage intervals for the 12 selected historical parchment samples. 0 is T_{first}.

	0	A1	B1	C	B2	A2
HP 7	44.3	5.4	2.1	6.1	1.1	2.0
HP 8	32.0	5.0	3.5	7.0	1.4	15.4
HP 16	31.4	2.9	3.0	8.7	2.2	19.9
HP 18	32.5	5.8	2.6	6.1	3.1	17.4
HP 20	46.3	4.4	2.1	4.7	0.7	12.5
HP 22	56.2	5.1	1.5	3.1	1.2	6.9
HP 26	37.2	3.0	1.1	11.7	1.3	16.8
HP 28	29.2	2.8	1.8	4.4	2.4	8.1
HP 31	48.3	3.3	1.8	4.7	1.7	18.9
HP 36	0.0	0.0	0.0	0.0	0.0	0.0
HP 37	56.0	5.3	2.7	4.5	1.5	11.2
HP 38	49.4	4.9	1.8	6.2	1.1	13.9

Selected historical parchments

The mean values and standard deviations of the T_s, T_{first}, T_{last} and ΔT_{total} of the 12 historical samples selected to be tested by the full analytical program are given in Table 6.6. Table 6.7 shows the length of all shrinkage intervals of the 12 samples.

Discussion

New parchments

Figure 6.7 shows the shrinkage intervals for the ten locations of parchment NP7. As seen, the pattern for all the samples indicates an evenly distributed hydrothermal stability of the fibres in the whole parchment. The T_s lies about 10°C below that of raw hide (65°C–67°C) with a mean value of 57.9°C. It varies within 3°C with the exception of location A (60.2°C). The T_{first} is close to the T_s, whereas T_{last} is around 10°C above the T_s of raw hide. The latter indicates that some of the fibres may be stabilized by cross-links within the collagen peptide chains. With a standard deviation on the T_s of 1.11°C, 95% of the observations in this case fall close within the accuracy of the method (see Table 6.1). In all cases relatively long A2 intervals can be seen starting around the T_s for raw hide. The variations and standard deviations of T_{first} and T_{last} are higher than for the T_s. This should be expected as these represent only a single shrinkage event in a single fibre. This is combined with a higher randomness compared to the T_s, which represents at least two or more of the start of the major mass of shrinkage events. As opposed to new leather, the shrinkage takes place over a rather long interval with a mean ΔT_{total} of 22.6°C.

The T_s of the six new parchments differs by up to 9.4°C (Table 6.3) ranging from 52.5°C for NP5 to 61.9°C for NP3. As for most of the NP7 samples, the standard deviations of other new samples, except NP5, are below 1°C, and the total interval of shrinkage of all the five samples is similarly high. The highest ΔT_{total} of 30.2°C is found for NP5. Together with its relatively low T_s and high standard deviation, this indicates a generally low and non-uniform fibre stability.

Historical parchments

For those of the 40 samples of historical parchments from the sample bank (HP1–HP40), in which the T_s could be detected, this varied from 35.5°C to 64.2°C. However, only one sample had a T_s above 60°C and only four above 50°C. The ΔT_{total} varies from 13.8°C to 34.8°C. Five of the samples were transformed into gelatin by contact with the water and in one sample no activity was observed at all. In addition, no main shrinkage interval (C interval) was observed in four samples. Moreover, no C interval below 35°C has been observed. The results can be divided into the following four categories:

1. The fibre structure is intact and comparable to new parchment. The sample shows shrinkage activity in all five shrinkage intervals.
2. The fibre structure is intact and the main shrinkage interval (C interval) is present, but the shrinkage activity is low.
3. The fibre structure is partly intact, but the main shrinkage interval (C interval) is no longer present and shrinkage activity is very low.
4. The fibre structure is considerably disintegrated and transformed into a 'pre-gelatin form'. No shrinkage activity is observed and the collagen gelatinizes partially or completely when immersed in water.

Gelatinization has been observed during the measurement of the hydrothermal stabilities of very deteriorated leathers tanned with condensed vegetable tannins. However, this may occur spontaneously during normal storage conditions (Larsen et al. 1996b). Spontaneous transformation of Dead Sea Scroll parchments into gelatin has been investigated by X-ray diffraction, infrared-spectrometric and racemization analysis and is reported to be due mainly to unfolding of the collagen molecule (Weiner et al. 1980). However, the present studies using amino acid analysis, steric exclusion chromatography, 2D-electrophoresis and Fourier transform infrared- (FTIR-)Raman spectroscopy strongly indicates that chemical cleavage of the collagen peptide chains plays an important role in connection with the loss of hydrothermal stability and transformation of the collagen into gelatin (Larsen et al. 2002a,b; Juchauld and Chahine 2002; Garp et al. 2002). Figure 6.8 shows pieces of

Figure 6.7 Shrinkage intervals in °C for the ten samples taken at different locations on parchment NP7.

Figure 6.8 Deteriorated parchment fibres before setting with water.

Figure 6.9 Deteriorated parchment fibres gelatinized after wetting with water.

deteriorated parchment before wetting with water. The parchment is so deteriorated that single fibres can no longer can be separated without being destroyed.

Figure 6.9 shows how deteriorated parchment has partly gelatinized after wetting with water (intact fibres can be observed to the left). The fibre structure is less prominent and when observed in the microscope before exposure to water, the fibres in some cases appear as colourless transparent crystal-like structures. However, it is important to be aware that it may be difficult to detect or foresee this state of deterioration in the dry state by visual means.

Sample variations

The difference in T_s given in Table 6.5 shows a very mixed situation with at the one end gelatinization by contact with the water to T_s values above 50°C and at the other end no or only a few degrees difference in the measured values. The former are samples taken from the spine (more deteriorated – gelatinized) and the board (less deteriorated) of parchment bookbindings. Although the spines of these bookbindings appear visually more deteriorated, the difference in hydrothermal stability is surprisingly high. Also surprising is the large difference in the T_s values of HP 37. The samples are taken from a parchment document decorated with red colour and written with ink. In general, these results indicate that very large local variations in the degree of deterioration, and therefore in the hydrothermal stability of individual parchment objects, should be expected. It is therefore important to take this into consideration by sampling for analytical purposes. Thus, sampling for more analysis and measurements should be done within a small area in the same location of the parchment. In this area the parchment should visually appear to be in the same state of deterioration. Moreover, to avoid unwanted damage in connection with conservation treatments and to predict the deterioration of parchment in storage, it is important that samples are taken from the locations that appear to be the most deteriorated. If only single samples can be taken, these should always be taken from the most deteriorated location. An 'average' T_s can be obtained by mixing a sample from minor sub-samples taken in different locations of the parchment.

Due to the deterioration, the standard deviations obtained for 11 of the selected historical parchments are, as expected, in several cases larger with respect to T_{first} and T_{last} compared to those of NP7. The standard deviations for T_{first} ranges from 0.92 to 5.42 (1.21 mean for NP7) and T_{last} from 0.64 to 5.90 (1.58 mean for NP7). However, with respect to T_s, the standard deviations in all cases lie close to those of NP7 with the exception of HP7 (2.14). Although the tendencies in most cases are weak, it is interesting to note that for the historical parchments there seems to be no relation between the size of the T_s, value and its standard deviation, but there is a tendency for an increase in standard deviation with decreasing T_{first} and T_{last} (higher shrinkage activity and greater spread in hydrothermal stability due to deterioration).

However, there is agreement between the observed difference in visual appearance and the shrinkage activity for the 16 parchments where the samples were taken in two different locations that appeared to be different states of deterioration. Apart from two samples in which no difference was observed, the locations which appeared more deteriorated (T_s (1)) have a significantly lower hydrothermal stability than the locations that appeared to be in a better state (T_s (2)). In three cases, the difference in T_s is extreme ranging from gelatinization to T_s above 40°C and 50°C. In the case of HP36, gelatinization was observed in both samples. In three other cases, the C interval has disappeared. In these cases the difference between the start of the B1 interval and the T_s is less than 10°C. In the remaining nine cases the C interval was observed in both sub-samples, the differences ranging from zero to 28.7°C. In general, it was observed that in the very deteriorated samples, where the C interval had disappeared and only weak shrinkage activity was observed in individual fibres, the shrinkage took place very slowly. Therefore, it can be very difficult to detect the start of each interval. Finally, the results of the measurement in the two locations of the 16 historical parchments emphasize the importance of a strict sampling procedure based on a thorough examination of the visible condition and physical appearance of the parchment.

Selected historical samples

Figure 6.10 shows the shrinkage intervals for the 12 selected HP samples. As it appears, these reflect a pattern with falls in

Figure 6.10 Shrinkage intervals in °C for the 12 selected HP samples.

the T_s and increases in the length of the shrinkage intervals with increasing deterioration. In the extremely deteriorated parchments, T_s is relatively low, and the shrinkage intervals are contracted as a sign of a uniform decomposition of the entire fibre mass. This follows the pattern observed on historical vegetable-tanned leathers (Larsen *et al.* 1993). However, as for the new parchment samples, the A2 interval is in most cases rather large even for the two samples with a T_s above 60°C. This, together with the large ΔT_{total} observed for most of the samples, indicates a generally greater inhomogeneity in the hydrothermal stability of parchment fibres than is observed for leather. HP36 in this case also turns into gelatin by contact with the water. On the other hand, a T_s of 33.8°C and C interval of 4.4°C is observed for HP28, confirming that main shrinkage intervals may be observed below 35°C.

Based on the observed Ts, the 12 samples can be divided into five groups with group I as the best preserved with T_s above 60°C. The next group (II) has T_s values in the range of the new reference parchments. The 'slightly' deteriorated samples have T_s below 55°C, 'medium' below 45°C and the 'most' deteriorated below 40°C. The last group (VI) contains HP36 which gelatinizes in contact with water. This state, where shrinkage activity no longer takes place, is assumed to be the final or end state of deterioration. Table 6.8 shows the mean T_s and standard deviations of the grouped parchments.

Test of the effect of laser cleaning

The following are some results obtained from a laser cleaning experiment as examples of the use of the measurement of hydrothermal stability in testing conservation methods. The effect of the treatment at 1064nm is shown in Figure 6.11. A cleaning at 532nm was also carried out but the results are not shown as the higher fluence level shows no significant change in the T_s (Sportun *et al.* 2000). Even at the higher fluence levels no significant change in T_s is observed. Figure 6.12 shows the effect of cleaning at 266nm. Cleaning at the lowest fluence (0.1 J/cm²) results in an almost significant fall in T_s compared to the untreated sample. The damaging effect is obvious at 0.5 J/cm². The main shrinkage interval has disappeared and the start of the B interval has fallen considerably compared to the untreated reference. At higher fluence levels the effect is dramatic. Here the shrinkage activity is almost lost. Only single fibres shrink (interval A) and the first shrinkage begins at only 37°C, more than 20°C lower than the untreated parchment. It should be noticed that no gelatinization of the worst damaged fibres has been observed.

Figure 6.13 shows the shrinkage intervals for the historical 18th-century parchment document. The T_s of the uncleaned reference sample was measured at 47.9°C indicating moderate deterioration. The T_s of the laser cleaned samples lies 2.7–3.8°C below the reference sample. This is within the variations to be expected from different locations across the parchment. That the difference is due to sample variation and not the effect of the laser is supported by the fact that the decrease in T_s does not follow the increase in

Table 6.8 Mean T_s and standard deviations in °C for the selected historical parchments divided into five groups based on the T_s value.

Group	Samples	T_s	Standard deviation
I	HP22, HP37	63.5	0.99
II	HP7, HP38	56.2	0.14
III	HP20, HP31	53.1	0.42
IV	HP8, HP18, HP26	40.8	0.56
V	HP16, HP28	35.6	0.60
(VI)	HP36	Gelatinize	

Figure 6.11 Shrinkage intervals in °C for new untreated and laser-treated parchment (1064nm).

Figure 6.12 Shrinkage intervals in °C for new and laser-treated parchment (266nm).

Figure 6.13 Shrinkage intervals in °C for the untreated and laser-treated historical parchment document (1.06μm).

fluence used for the laser cleaning, and that the sample treated at the highest fluence actually has the highest T_s of the cleaned samples.

Conclusions

The hydrothermal stability measured by the visual MHT method provides very useful information on the state of, and spread in, the hydrothermal stability of the observed parchment. As demonstrated, the method can be used for detection of the overall state of deterioration and the effects of conservation. The MHT method is effective also for controlling the quality of new parchments to be used in restoration or binding of bookbindings etc. However, as large variations in the hydrothermal stability in different locations of historical parchments can be expected, the sampling and measurement procedure must be very strict and based on thorough examination of the visible condition and physical appearance of the parchment. To avoid damage in connection with conservation treatments and predict damage of parchment in storage, it is recommended that samples are taken from the locations that appear to be the most deteriorated. If only single fibres can be taken, these should be taken from the most deteriorated location. An 'average' T_s can be obtained by mixing a sample from minor sub-samples taken in different locations of the parchment.

In contrast to other methods, the gelatinization phenomena linked to some historical materials with a low hydrothermal stability can be observed using the MHT method. The main part of the historical parchment samples in this study has a hydrothermal stability including a T_s that lies significantly below that of new parchment. Some of these samples are spontaneously turned into gelatin by exposure to water. In most cases this fatal state of deterioration is not visible from the physical appearance of the parchment. It must be considered probable that chemical deterioration has turned many historical parchments in archives, libraries and museum collections into this pre-gelatin state. Thus, these are in danger of total destruction by exposure to water or a high relative humidity. The fact that spontaneous shrinkage and gelatinization may take place by humid storage or water-based cleaning and conservation treatments makes the MHT method particularly important as an early warning system to prevent irreversible fatal damaging of cultural heritage objects. Moreover, as the T_s parameter is relatively simple to measure it is recommended that measurement of T_s by the MHT method is performed routinely in connection with material diagnosis and control of conservation.

References

Cooper, M., S. Sportun, A. Stewart, M. Vest, R. Larsen and D. V. Poulsen (2000) 'Laser cleaning of an eighteenth century parchment document', *The Conservator* 24, pp. 71–9.

Garp, T., K. Nielsen and S. Boghosian (2002) 'Study of the chemical breakdown of collagen and parchment by Raman spectroscopy'. This volume, pp. 109–16.

Juchauld, F. and C. Chahine (2002) 'Determination of the molecular weight distribution in parchment collagen by steric exclusion chromatography'. This volume, pp. 123–31.

Larsen, R. (1995) *Fundamental Aspects of the Deterioration of Vegetable Tanned Leathers*, PhD Thesis, The Royal Danish Academy of Fine Arts, School of Conservation, Denmark, ISBN 8789730208.

Larsen, R. (2000) 'Experiments and observations in the study of environmental impact on historical vegetable tanned leathers', *Thermochimica Acta* 365, pp. 85–99.

Larsen, R., C. Chahine, J. Wouters and C. Calnan (1996a) 'Vegetable tanned leather: evaluation of the protective effect of aluminum alkoxide treatment', *International Council of Museums Committee for Conservation (ICOM). 11th Triennial Meeting* 1–6 September 1996, Edinburgh, UK, Vol. II, , ISBN 1 873936 50 8, pp. 742–50.

Larsen, R., D. V. Poulsen, M. Vest and A. L. Jensen (2002a) 'Amino acid analysis of new and historical parchments'. This volume, pp. 93–9.

Larsen, R., D. V. Poulsen and M. Vest (2002b) 'SDS-PAGE and 2D-electrophoresis'. This volume, pp. 133–47.

Larsen, R., M. Vest and K. Nielsen (1993) 'Determination of hydrothermal stability (shrinkage temperature) of historical leathers by the micro hot table technique', *Journal of the Society of Leather Technologists and Chemists* 77, p. 151.

Larsen, R., M. Vest and K. Nielsen (1994) 'Determination of hydrothermal stability (shrinkage temperature)'. STEP Leather Project. European Commission DG XII, Research Report No. 1. The Royal Danish Academy of Fine Arts, School of Conservation, Denmark, ISBN 8789730011, p. 151.

Larsen, E., M. Vest, D. V. Poulsen and U. B. Kejser (1996b) 'Determination of hydrothermal stability by the micro hot table method', Environment Leather Project. European Commission DG XII. Research Report no. 6. The Royal Danish Academy of Fine Arts, School of Conservation, Copenhagen, ISBN 87 89730 07 0, p. 145.

Odlyha, M., G. M. Foster, N. S. Cohen and R. Larsen (1999) 'Evaluation of deterioration effects in leather samples by monitoring their drying profiles and changes in their moisture content', *ICOM Committee for Conservation, 12th Triennial Meeting Preprints*, Lyon, pp. 702–7.

Odlyha, M., G. M. Foster, N. S. Cohen and R. Larsen (2000) 'Characterisation of leather samples by non-invasive dielectric and thermomechanical techniques', *Journal of Thermal Analysis and Calorimetry* 59, pp. 57–60.

Sportun, S., M. Cooper, A. Stewart, M. Vest, R. Larsen and D. V. Poulsen (2000) 'An investigation into the effect of wavelength in the laser cleaning of parchment', in R. Salimbeni and G. Bonsanti (eds) *Proceedings of Lacona III conference, 26–29 April 1999, Florence. Journal of Cultural Heritage* 1, Elsevier, pp. 225–32.

Weiner, S., Z. Kustanovich, E. Gil-Av and W. Traub (1980), 'Dead Sea Scroll parchments: unfolding of the collagen molecules and racemization of aspartic acid', *Nature* 287, p. 820.

7 The Thermal Response of Parchment and Leather to Relative Humidity Changes

Derek Bowden and Peter Brimblecombe

Introduction

Relative humidity (RH) cycles and the water content of materials are important parameters affecting the behaviour and preservation of organic artefacts. Thus it is a frequently studied subject in the conservation field.

When skins (parchment and leather) are subjected to hygrometric (RH) changes the gain or loss of unbound water results in a temperature change, exothermic and endothermic respectively. Degraded and new leather exhibit different thermal responses suggesting thermohygrometric analysis might be a tool for understanding the degradation of leather (Calnan and Thornton 1996). Although leather and parchment are manufactured from similar base materials (skin), tanning or liming during production influences their individual characteristics and properties. For this reason, parchment could have different hygrometric cycling responses compared to leather (selected physical properties of leathers are listed in Table 7.1).

The object of our research is to apply and extend the use of a microanalytical thermal sensing technique to determine the behaviour and condition of historical parchment at ambient temperatures. The method investigated in this study was previously used to a limited extent by Calnan and Thornton (1996) to study the condition of historical leather.

In this paper, we present a brief background on aspects of parchment relevant to our study before treating the thermal response of parchment, with the development work associated with the microanalytical technique. There appears to be some implications of the measurements for historical parchment conservation; this work has been published in a shortened form (Bowden and Brimblecombe 1999).

Background

Parchment documents and charters are of great historic relevance, cultural value, social and increasingly economic importance. Pollution, mass tourism and inappropriate conservation techniques all add to the degradation of irreplaceable parchments. Under stable conditions, where the frequency and extremes of RH are not encountered and the parchment has not been folded, parchment documents have survived many centuries in excellent condition (Vodopivec 1995). Conversely, other parchments are in a poor condition. Parchment degradation is caused by mechanical wear (folding), microbiological growth (fungal) and chemical attack from atmospheric pollutant gases. Under high RH conditions parchment can absorb a significant mass of water aiding mycological degradation and dissolving any absorbed gases such as sulphur dioxide. Over time, many parchments have converted to soluble gelatin (Larsen *et al.* 2002). This is evidently undesirable as the structure of the parchment is lost and the resulting shorter protein chains aid microbiological assimilation in the presence of moisture.

Gelatin is commercially manufactured using neutral, acid or alkaline hydrolysis of tendons, ligaments or skin. Therefore, it is understandable that parchment gelatinization is accelerated by acids formed in the integral parchment water from the uptake and oxidation of pollutant gases such as sulphur dioxide (SO_2) and nitrogen dioxide (NO_2).

Parchment consists mainly of insoluble collagen fibre. The degree of flexibility and malleability associated with parchment will depend on the condition of the collagen and the amount of integral water present (Horie 1990). This water is present in three forms (Dernovskova *et al.* 1995):

(i) *bound* – only lost when the collagen is denatured and therefore irreversibly lost (i.e. high temperature oven drying)
(ii) *associated* and
(iii) *free* water which can be considered reserve sources that are loosely bound between the macro collagen structure. The ability of the parchment to exchange this reserve water to air under ambient temperature conditions will depend on the RH of the air, collagen condition and proximity of the fibres.

Parchments in poor condition lose the well-ordered triple helical conformation of the collagen to form random coils (gelatin). Ageing of parchment by either artificial means or by the passage of time (historical) will affect the capacity

and rate of water exchange. Loss or gain of water from the parchment is endothermic and exothermic respectively, and is the basis of our experimental method.

Experimental

Apparatus

The apparatus (Fig. 7.1) consisted of a transparent plastic cabinet (A) with a rubber sealed door, insulated with plastic wrap (B) containing multiple air pockets ('bubblewrap'). Internal RH was controlled by trays (I) of saturated salt solutions and recorded using an RH probe (C). Equilibration within the internal atmosphere of the humidity cabinet was aided by a small electric fan (D). Test samples were in turn suspended from three, needle thermocouples (F). The internal air temperature of the cabinet was recorded using a fourth identical needle thermocouple (G). A calibrated mercury thermometer (E) was used for initial testing purposes. All data from the probes were stored in the data logger (J) and retrieved and displayed on a personal computer (K).

Method

Parchment was cut and measured using a metal template with a fixed area (6.0 × 6.0mm) selected as the minimum area (area fixed unless otherwise stated) in which the needle thermocouples fit (Table 7.2). The small size optimized the use of scarce historical samples. Each sample was suspended from three, type-T needle thermocouples; triplicated to improve the accuracy for this inhomogeneous material. RH and the temperature inside the humidity cabinet were monitored using a RH probe (Rotronic[1]) with an internal platinum resistance thermometer. The combined RH and temperature probe has a considerably larger thermal mass, i.e. slower response time, than the needle probes and was used as a secondary monitor of the cabinet air temperature trend.

Control of the RH within the chamber was maintained by two trays containing a saturated solution of an analytical grade salt[2] in distilled water (Table 7.3). Saturated salts have a known water activity and water vapour pressure for a

Figure 7.1 Ambient temperature thermal cycling apparatus. A: transparent plastic humidity cabinet; B: sealed air packaging insulation; C: combined RH and platinum resistance thermometer probe; D: small 12v DC fan; E: calibrated mercury thermometer; F: needle thermocouples (sample); G: needle thermocouple (air); H: sample; I: plastic trays for saturated salt RH solutions; J: data logger; K: personal computer.

given concentration and temperature so the RH above the solution is known.

All the above transducers (probes) were connected to a Campbell CR10 data logger[3] fitted with a calibrated thermistor as the second thermocouple junction. The data were recorded at 1-minute intervals using a data logger, programmed via a personal computer to sample the following measurements:

(i) time (minutes)
(ii) temperature of the data logger (to monitor stability)
(iii) temperature of the needle thermocouples (1 to 4)
(iv) RH (%)
(v) cabinet temperature (all temperatures expressed as °C)
(vi) data logger battery voltage (additional stability monitor).

All the thermocouples were within ±0.05°C when compared to each other and to a certified calibrated thermometer (NAMAS, 1994[4]).

The parchment sample was then subjected to RH changes (typical cycles are listed in Table 7.3) for a total of six (usually) to ten hours. Saturated salt solutions were changed every two hours, the optimum time for equilibration of the parchment (Calnan and Thornton 1996). Nearly all of the experiments used the three-stage RH cycle set (11-86-11% RH) as this RH range gives a larger thermal response when

Table 7.1 Selected physical properties of leather and associated materials.

Material	Heat of dehydration[a] ΔH kJ mol^{-1}	Heat of hydration[b] ΔH kJ mol^{-1}	Reference
Vegetable-tanned sole leather	50.7	–	Jahn & Witnauer (1967)
Vegetable-tanned leather	–	−90.9	Kanagy (1954)
Chrome-tanned side upper leather	46.1	–	Jahn & Witnauer (1967)
Chrome leather	–	−131.9	Kanagy (1954)
Acetone dehydrated calfskin	47.7	–	Jahn & Witnauer (1967)
Reconstituted collagen	43.1	–	Jahn & Witnauer (1967)
Collagen	–	−155.3	Kanagy (1954)
Gelatin	77.5	–	Jahn & Witnauer (1967)
Water (71–121°C range)	40.8	–	Jahn & Witnauer (1967)

(a) Conditioned at 50% RH at 23°C. (b) Dry materials.

Table 7.2 Parchment and leather samples investigated.

Code	Date
P1	Modern
P2	Modern
NP3	Modern
NP4	Modern
P435 (NP5)	Modern, artificially aged
HP7	17th C
HP8	1797–1799
HP9	1641
HP13	Unknown
HP38	Unknown
Leather	1994 (Sumac tanned skin No. 6)[5]

Table 7.3 Relative humidity above aqueous saturated salt solutions of known water activity.

3-stage RH cycle	
11% – lithium chloride, LiCl	Carotenuto & Dell'Isola (1996); Hamer & Wu (1972)
86% – potassium chloride, KCl	Hamer & Wu (1972); Cohen & Lorimer (1991)
11% – lithium chloride	
5-stage RH cycle	
35% – magnesium chloride, MgCl$_2$.6H$_2$O	Lobo & Quaresma (1981)
51% – calcium nitrate, Ca(NO$_3$)$_2$.4H$_2$O	Ewing (1963)
35% – magnesium chloride	
86% – potassium chloride	
35% – magnesium chloride	
(20–22°C)	

compared to the five-stage cycle set (51-35-51-86-51% RH) as shown in Figure 7.2 (a and b). The output from the thermocouples compares the parchment temperature with that of the air temperature surrounding the sample in the cabinet. These large RH changes reduce the error associated with processing small signals. In all of the thermal cycle graphs a small peak is present before the major thermal response. This artefact peak is due to the time taken to change the saturated solutions in the cabinet (two momentary door opening stages with a 4-minute delay in between, during every humidity change).

Initially leather was used to test the correct functioning of the apparatus by comparing the thermal profiles with those previously obtained by Calnan and Thornton (1996). Work on parchment began on completion of these initial tests. The samples were measured throughout 2-hour RH changes at room temperature. In some cases the parchment was taken through many cycles in order to gain an understanding of longer term effects.

Understanding the apparatus

Figure 7.2 (a and b) shows an exponential decay in the temperature change of the parchment. It was not known whether this was because of a decrease in heat change from hydration reactions or due simply to a cooling or heating of parchment, or cabinet effects. Therefore, an additional test experiment was undertaken. A new parchment sample was attached to the thermocouples and heated with a small electrical resistor (2°C corresponding to the observed rise in humidity cycles). The resistor heater was removed and the parchment allowed to cool. The thermal response is shown in Figure 7.2 (c). The cooling graph is very steep, quite unlike that of the humidity cycled parchments. Therefore the observed exponential decay during humidity cycling is the result of hydration reactions within the parchment.

We were additionally concerned about the boundary layer effects in the air near the surface of the parchment sample. Two further experiments allowed this to be examined: (1) the humidity equilibration fan was placed close to the parchment sample, and (2) the fan was switched off. The results of this testing are displayed in Figure 7.3 and listed

Figure 7.2 Measured thermal response of parchment P1 with RH cycling as a function of time. (a) 3-salt–5-cycle system; (b) 2-salt–3-cycle system (c) measured thermal decay of parchment P1 heated using a small electrical resistor in the presence of 11% RH as a function of time. (α – equilibrating to 11% RH, β – heating of the parchment, γ – heater switched off and removed from the parchment.)

in Table 7.4. When the fan is switched off, the RH in the cabinet leads to an increase in the time required for equilibration. Parchment gradually responds to this humidity gradient and the corresponding thermal response is evident in the increased thermal decay half-life (Figure 7.3γ and Table 7.4).

Moving the fan in close to the parchment sample would minimize any build-up of the boundary air layer and allow the rate of moisture transfer to increase. The expected decrease in half-lives is not observed when the fan is close (Table 7.4, Fig. 7.3α and β). The position of the fan for all the experiments, apart from those used to test the apparatus, remained a fixed distance offset from the sample and the attached thermocouples. The thermal decay of the parchment is not related to the cabinet RH decay (Table 7.4, prefix RH – graph). Thermal response results from this optimized fan position (Fig. 7.3α) are similar to the close fan results considering the fan's close proximity (Fig. 7.3β), Therefore, the influence of the boundary layer is small when the fan is on.

These experiments suggested that under the normal fan operating conditions, parchment hydration was not limited by eddy diffusive transport of water to the surface.

During the experiments it became clear that great care needed to be taken to ensure that the salt solutions were at the

Table 7.4 Thermal analysis data for parchment and leather. All parchment 6.0 × 6.0mm unless stated. Leather 10.0 × 10.0mm. Saturated LiCl–KCl–LiCl cycling used for all samples unless stated (Table 7.3).

Material	Mass (g)	T2[a] (°C)	T3[a] (°C)	S2[a] (°C)	S3[a] (°C)	A2[b]	A3[b]	$t_{0.5}(2)$ (s)	$t_{0.5}(3)$ (s)
P1 (No Fan)†	0.0109	1.11	−1.07	0.42	−0.89	32.11	−32.93	744	897
P1 (Close to sample) †	0.0109	0.65	−1.13	0.15	−0.66	10.06	−11.39	416	300
P1 †	0.0108	0.90	−1.58	0.19	−0.87	17.32	−16.84	569	301
P1 (Repeat) †	0.0109	0.89	−1.59	0.23	−0.70	14.84	−18.53	512	310
P1 (35/86/35 RH%)†	0.0107	0.68	−1.02	0.11	−0.47	8.65	−10.09	306	270
P1 (51/35/51/86/51 RH%)†‡	0.0103	−0.26	0.18	−0.20	0.01	−6.11	3.30	327	244
P1 (51/100/51) †	0.0109	0.81	−1.77	0.05	−0.79	16.83	−18.54	620	234
P1 (12.0 × 12.0mm) †	0.0430	1.06	−1.97	0.17	−1.17	23.40	−26.90	677	346
P435 (16 W. SO$_2$)[c] † First Cycle Set	0.0082	0.89	−1.06	0.16	−0.84	8.98	−10.59	401	225
P435 (16 W. SO$_2$)[c] † Second Cycle Set	0.0082	0.79	−1.14	0.22	−0.50	8.49	−9.37	314	214
P435 (16 W. SO$_2$)[c] † Third Cycle Set	0.0082	0.85	−1.18	0.30	−0.47	7.85	−9.95	288	218
HP9 †	0.0047	0.31	−0.78	0.22	−0.82	4.99	−6.38	311	258
HP9 (Repeat) †	0.0048	0.41	−0.79	0.18	−0.39	4.54	−5.34	161	254
HP9 (Second Cycle Set) †	0.0047	0.30	−0.53	0.07	−0.38	3.74	−4.79	248	304
HP9 (Third Cycle Set) †	0.0047	0.28	−0.58	0.11	−0.31	4.19	−3.68	194	268
New Leather[d] (First Cycle Set)†	0.0876	3.48	−2.69	1.45	−1.43	42.14	−46.18	351	486
New Leather[d] (Second Cycle Set)†	0.0876	3.17	−2.70	1.65	−0.93	44.15	−48.43	433	482
New Leather[d] (Third Cycle Set)†	0.0876	2.95	−2.53	1.34	−0.85	41.02	−44.68	454	508
86% RH graph[e]	–	–	–	–	–	–	–	8601	2439
11% RH graph[e]	–	–	–	–	–	–	–	20921	4145
	–	–	–	–	–	–	–	2193	250
P1 2 × (6 × 6mm) layers	0.0156	1.32	−2.11	0.57	−0.63	27.23	−25.25	545	378
P1	0.0082	1.05	−1.71	0.37	−0.42	13.09	−12.28	255	264
P2	0.0109	0.90	−1.61	0.33	−0.54	15.64	−14.71	468	302
NP3	0.0035	0.75	−1.23	0.66	−0.30	5.93	−5.83	85	170
NP4	0.0036	0.86	−1.23	0.39	−0.34	6.17	−6.19	124	170
P435 (Ref.)[c]	0.0068	0.84	−1.38	0.37	−0.34	10.12	−10.42	243	263
P435 (2 W. SO$_2$)[c]	0.0062	0.88	−1.24	0.26	−0.61	9.20	−9.85	199	253
P435 (4 W. SO$_2$)[c]	0.0069	1.02	−1.32	0.25	−.62	10.96	−9.94	293	266
P435 (8 W. SO$_2$)[c]	0.0073	1.00	−1.36	0.53	−0.66	11.62	−10.09	304	253
P435 (16 W. SO$_2$)[c]	0.0062	0.94	−1.50	0.61	−0.43	9.74	−11.15	233	250
HP7	0.0074	0.66	−1.11	0.20	−0.43	11.07	−9.81	430	296
HP8	0.0133	0.54	−0.98	0.20	−0.46	10.40	−10.13	432	319
HP9	0.0049	0.42	−0.61	0.11	−0.57	6.12	−5.07	260	277
HP13	0.0096	0.85	−1.39	0.45	−0.56	13.29	−13.99	481	319
HP38	0.0062	0.75	−1.06	0.33	−0.27	6.83	−6.00	212	228
Gelatin	0.0178	0.56	−1.27	0.17	−0.41	20.49	−23.69	1085	459

The number associated with the column headings refers to the peak analyzed. † Denotes the use of saturated salt solutions at laboratory ambient temperature, not humidity cabinet air temperature compensated (see footnote). [a] Mean thermocouple temperature – air thermocouple temperature. [b] Area under the thermal peak (combined small and large peak). [c] French parchment P435 exposed to 25 ppm SO$_2$ and 10 ppm NO$_2$ at 40°C and 30% RH for the stated number of weeks. [d] Sumac tanned skin No. 6, 1994[5]. [e] Half-life of the RH accumulation and decay. ‡ 3 salt, 5 cycle additional data: T4, 0.43; S4, −0.24; A4, 8.50; T5, −0.87; S5, −1.0; A5, −10.69.

Final testing of the apparatus used modern parchment samples. A small rise in the air temperature of the humidity cabinet during the experiment was found to exceed the corresponding temperature rise of the saturated salt solutions on the laboratory bench. This is the result of the low thermal heat capacity of air in comparison to that of the saturated salt solutions. When these saturated salt solutions are placed in the humidity cabinet, the air is cooled. A final modification of the technique involved the adjustment of the saturated salt solution temperature to match the air temperature in the humidity cabinet at the change over time of the RH cycling solutions. Initial results obtained during the testing of the technique were not compensated but as the difference in the thermal peak 2 and peak 3 temperatures were consistent at 0.3–0.2 and 0.1°C, respectively, calculated from the drop in the cabinet air temperature. These preliminary data are considered valid for the experimental technique investigation stage. Parchment P1 results obtained during this experimental phase are thus marked (†).

same temperature as the air in the cabinet (Fig. 7.4) to avoid erroneous temperature changes in the parchment (see Table 7.4 footnote). Additionally, the gradual increase of the experimental start and end point temperature (nominally 1–2°C) of the humidity cabinet during the experiment (Fig. 7.4) had a minimal effect on the thermal response. This is because the difference between the parchment and air temperature, recorded every minute, is used in the final analysis.

Extended humidity cycling for HP7, HP8 and HP9 of 7 hours at 11% RH and 17 hours at 86% RH with 86% RH over the weekends allowed the effect of RH cycling on historical parchment to be observed over longer time periods and frequencies.

Figure 7.3 Measured thermal response of parchment P1 with RH cycling for a 2-salt–3-cycle system as a function of time: α – predetermined humidity cabinet fan position, β – fan close to sample, γ – fan off.

Examples and results

Parchment geometry

The peak profiles obtained from testing the apparatus with leather compared well with those previously measured by Calnan and Thornton (1996). Our major improvements include a faster air temperature response in the humidity cabinet from using a needle thermocouple as opposed to the internal thermometer within the large RH probe. In addition, we attained a vast reduction (× 100) in the recorded graphical noise by using a calibrated reference junction thermistor.

Thermal response was determined together with the extent of the thermal measurements (area of the peaks) and the thermal decay half-lives, calculated from the results obtained from the hygrometric cycling are presented in Figures 7.5 to 7.7.

First, the thermal response data of modern parchments were collected. Parchment P1 and a repeat experiment using a separate new portion – P1 (repeat) – gave reasonable correlation despite parchment being a non-homogeneous material.

Figure 7.4 Measured humidity cabinet internal air temperature as a function of time. a) saturated salt solutions uncompensated for temperature fluctuations; b) saturated salt solutions compensated for temperature fluctuations. Both traces are from independent experiments and are shown on one graph for presentation only.

Figure 7.5 (a) Bars – measured thermal response of peaks 2, 3 and mass (hexagon symbol) expressed as parchment sample type. (b) Symbols – measured parchment sample peak 3 thermal response as a function of the thermal response of peak 2. Line represents an equal thermal response of peaks 2 and 3, sign corrected.

Figure 7.6 (a) Bars – measured thermal peaks 2, 3 area and mass (hexagon symbol) expressed as parchment sample type. (b) Symbols – parchment thermal peak 2 area as a function of thermal peak 3 area. Line represents an equal thermal peak area for peaks 2 and 3.

Figure 7.7 (a) Bars – measured thermal decay half-life of peaks 2, 3 and mass (hexagon symbol) expressed as parchment sample type. (b) Symbols – parchment sample thermal peak 3 decay half-life as a function of thermal peak 2 decay half-life. Line represents an equal half-life for peaks 2 and 3.

The two major peaks of parchment P1 (Fig. 7.2b) are dissimilar. These differences, thermal response intensities and thermal decay half-lives, are directly related to the water uptake and release from the parchment. This is expected to depend on the parchment condition as proposed by Calnan and Thornton (1996). The mass of water gained and lost in the cycling process is equal (see Table 7.5) and compares well with the peak areas (Fig. 7.6b). Thus mass and heat transfer for selected samples were correlated.

Thermal decay half-lives and thermal response of peak 2 is not equivalent to peak 3 (Fig. 7.2b). These differences depend on whether water is gained or lost. This is probably related to the extent of cohesion of collagen fibres because dehydration causes fibres to stick together (Dernovskova *et al.* 1995) and the uptake of water during rehydration is slow

Table 7.5 The mass of water gained and lost by the parchment during RH cycling (11–86–11 RH%).

Material	Mass of water gained (g) (11–86 RH% cycle)	Mass of water lost (g) (86–11 RH% cycle)
P1	0.00162	0.00168
P1 (12.0 × 12.0mm)	0.00737	0.00745
P2	0.00161	0.00177
NP3	0.00018	0.00026
NP4	0.00031	0.00027
New Leather (10.0 × 10.0mm)	0.00646	0.00644

All parchment 6.0 × 6.0mm unless stated. The samples, of known mass, were suspended from enamelled copper wire only in the humidity cabinet. At the end of each RH cycle the samples were removed and suspended in individual sealed weighing bottles. The weighing bottles of known mass contain an atmosphere of equivalent RH. The total mass was noted and the above method was repeated using the next RH in the cycle.

obtained for 6.0 × 6.0mm P1 samples (the larger sample being only 1.29× greater). Hence, the thermal response is independent of the sample area.

By contrast we expected temperature change to be sensitive to parchment thickness. An increase in the thermal response was found for two stacked 6.0 × 6.0mm layers of parchment P1. The thermal peak areas for the double layer were twice that of a single layer of P1. Therefore, these temperature changes are dependent on mass of parchment per unit area, which obviously related to the mass of water gained and subsequently lost. If the parchment is very thick transfer of water will be restricted. This is confirmed by the increased thermal decay half-life in the thicker parchment sample (Fig. 7.7). Sample mass per unit area influences the thermal response, half-life (Fig. 7.7b) and peak area.

Figure 7.8 displays the thermal response, peak area and thermal peak decay half-life as a function of the mass per unit area of the parchment sample. The fitted lines indicate the response of the new parchments for comparison purposes. The historical samples and gelatin deviate from the line and, most interestingly, the artificially aged P435 set is located on the lines. Artificial ageing of new parchment (P435) was expected to induce a thermal change when compared to the unexposed reference sample – none was observed.

Modern parchments

Parchment samples P1 and P2 were of similar colour (white/opaque), flexibility (rigid) and sheet thickness, resulting in similar responses. NP3 and NP4 are dissimilar in colour (beige/sand), very flexible (can be rolled) and thinner than parchments P1 and P2, and show quite different thermal responses. It is possible that NP3 and NP4 have a coating composed of natural materials from the skin, i.e. blood.

Leather

Leather samples selected typically have 8× the mass per unit area resulting in a thermal response of ±1 to 3.5°C and thermal decay half-lives that do not markedly exceed those for parchment (Table 7.4). Thus the mass-based response is relatively small when compared to those for parchment and therefore leathers behave very differently to parchment.

Artificially aged modern parchments

The degradation of historical parchments is often assessed using artificially aged modern parchment as a guide. The results obtained from the French parchment P435 aged (0, 2, 4, 8 and 16 weeks) in a pollutant atmosphere (25 ppm SO_2 and 10 ppm NO_2 at 40°C and 30% RH (Juchauld and Chahine 2002), are displayed in Figures 7.5, 7.6 and 7.7. Artificial ageing using these conditions over a period of 16 weeks does not lead to dramatic changes in the thermal response for parchment samples of similar mass. This observation is reinforced by the lack of variation in the

Figure 7.8 *(a) Symbols – measured parchment sample thermal response as a function of sample mass. Lines – fitted to the new parchment samples only for each peak. (b) Symbols – parchment thermal peak area as a function of sample mass. Line – fitted to the new parchment samples only. (c) Symbols – parchment sample thermal peak decay half-life as a function of sample mass. Line dashed – fitted to the new parchment samples peak 2. Line solid – fitted to the new parchment samples peak 3.*

because fibres have to be separated. Thus we see longer thermal decay in rehydration.

Our concerns were to establish the effect of the size of the piece of parchment on the response of the apparatus. The expectation was that increasing the parchment sample area would have little effect on the recorded temperature profiles. Indeed, the 12.0 × 12.0mm parchment sample P1 (× 4 the area normally selected) showed results similar to those

Table 7.6 Thermal analysis data for selected historical parchment using extended RH cycling, 11% RH – 7 hours and 86% RH – 17 hours with temperature corrected saturated salt solutions.

Material	Cycle no.	T2[a] (°C)	T3[a] (°C)	A2[b]	A3[b]
HP7	1	0.85	–	9.82	–
HP7	2	–	–1.23	–	10.56
HP7	3	0.82	–	9.96	–
HP7	4	–	–1.24	–	10.45
HP7	5	0.81	–	11.02	–
HP7	6	–	–1.37	–	10.31
HP7	7	0.79	–	9.96	–
HP7	8	–	–1.32	–	10.05
HP7	9	0.87	–	10.31	–
HP7	10	–	–1.23	–	10.19
HP7	11	0.84	–	10.5	–
HP7	12	0.85	–	11	–
HP7	13	–	–1.34	–	10.26
HP7	14	0.8	–	10.64	–
HP7	15	–	–1.2	–	10.23
HP7	16	0.86	–	10.42	–
HP7	17	–	–1.2	–	10.14
HP7	18	–	–1.16	–	9.93
HP8	1	0.56	–	7.7	–
HP8	2	–	–0.84	–	8.04
HP8	3	0.56	–	8.02	–
HP8	4	–	–0.88	–	7.77
HP8	5	0.55	–	8.95	–
HP8	6	–	–0.94	–	8.50
HP8	7	0.55	–	8.03	–
HP8	8	–	–0.88	–	7.18
HP8	9	0.61	–	8.6	–
HP8	10	–	–0.83	–	6.84
HP8	11	0.54	–	7.82	–
HP8	12	0.59	–	9.34	–
HP8	13	–	–0.96	–	8.21
HP8	14	0.6	–	8.93	–
HP8	15	–	–0.8	–	7.95
HP8	16	0.6	–	9.25	–
HP8	17	–	–0.85	–	8.36
HP8	18	–	–0.81	–	6.97
HP9	1	0.43	–	5.53	–
HP9	2	–	–0.6	–	4.93
HP9	3	0.44	–	5.05	–
HP9	4	–	–0.68	–	4.72
HP9	5	0.43	–	5.78	–
HP9	6	–	–0.72	–	4.85
HP9	7	0.45	–	5.08	–
HP9	8	–	–0.76	–	4.33
HP9	9	0.48	–	5.55	–
HP9	10	–	–0.62	–	3.72
HP9	11	0.42	–	4.91	–
HP9	12	0.46	–	6.18	–
HP9	13	–	–0.71	–	4.63
HP9	14	0.5	–	5.94	–
HP9	15	–	–0.6	–	4.77
HP9	16	0.48	–	6.07	–
HP9	17	–	–0.69	–	4.61
HP9	18	–	–0.63	–	4.24

shrinkage temperature (T_s) for these samples (Larsen *et al.* 2002). There is a trend in the peak 3 thermal response. This increase in thermal response (ΔT) with artificial ageing is in agreement with Calnan and Thornton's (1996) work on historically degraded leather. Similar trends are found for the thermal peak areas and thermal decay half-lives. The water uptake of the degraded parchment (artificially aged) would be expected to be reduced in proportion to the ageing, as the collagen structure degrades reducing interstices available to trap water molecules. However, there is no trend in our observations of peak area. A plausible explanation for the artificially aged samples is that the parchment structures are not subsequently changed to any marked degree under these artificial ageing conditions. It seems that the artificially ageing conditions were too 'mild', although compared to ambient pollutant concentrations the conditions used were harsh.

Caution is required with conditions when artificially ageing, as increasing the pollution exposure – and especially vast increases in temperature conditions – will produce 'aged' samples which are remote from true historic parchments.

Comparison of new and historical parchment results

The thermal response and peak areas of the historical parchments (prefix HP), except HP13, are low when compared to all the other parchment samples. The historical parchments naturally aged by the passage of time have degraded collagen structures that are less flexible. Water uptake and loss has equally diminished. This is confirmed by the increased thermal decay half-lives of peak 2.

As historical parchment can eventually change to gelatin (an end product of highly degraded collagen), the RH cycling of a 6.0 × 6.0mm wafer of gelatin was included (the gelatin sample was prepared by the ambient temperature air drying of a solution of granular gelatin – dissolution temperature 50°C). The thermal responses of gelatin peak 2 and 3 are low when considering the mass of the sample. However, the thermal responses are comparable to the historical parchments. The thermal decay half-lives indicate that the rate of uptake and subsequent release of water is also slow for gelatin.

Figure 7.9 Symbols (triangles – HP7; hexagons – HP8; diamonds – HP9) thermal response peak area (open symbols peak 2; solid symbols peak 3) as a function of the number of continuous RH cycles (7 hours at 11% RH and 17 hours at 86% RH).

Extended cycling

Degradation may be assisted by the number, or possibly frequency, of RH cycles. Ideally, the cycling should span a large time scale to artificially emulate the RH cycling encountered by historical parchments. However, in our short-term experiments new leather and 16-week artificially aged parchment (P435_16w) were taken through 16 cycles over a 3-day period (Table 7.4). There was no dramatic change in the thermal behaviour.

Historical parchments were subjected to similar extended humidity cycling, but again there was little change in the thermal properties (Table 7.6). Although, at cycle 10-11 in Figure 7.9, there appeared a slight recovery in peak area when left to rehydrate at 86% RH over a weekend. This suggests that any change is reversible.

Data analysis

The effect of parchment sample thickness could be compared after normalizing the thermal response, peak area and thermal decay half-life with respect to mass of parchment per unit area (area density) and setting parchment P1 to unity (Fig 7.10 to 7.12).

Figure 7.10 – modern parchments, those not designated HP, all show fairly similar peak areas (filled and unfilled squares) when normalized to area density. The historical parchments have peak areas generally below 1.0. This difference parallels two other measurements of ageing (1) a decline in basic/acidic amino acid (B/A) ratio (triangles) and (2) shrinkage temperature (stars). Gelatin also shows reduced peak areas.

Figures 7.11 and 7.12 – it is difficult to observe any conclusive trends in the data from these two graphs as all the data are scattered and some of the new parchments impinge into the historical areas of the graphs. However, in Figure 7.11, the P435 artificially aged set does not deviate far from unity (similar to the P435 series in Fig. 7.10).

Conclusions

The magnitude, duration and decay of the thermal response of modern and historical parchments have been determined. The thermal response for historical parchments is different to new materials. Generally, relaxation times are slower for rehydration when compared to dehydration. Historical parchments seem to be gradually changing from a collagen-like structure to a structure with a more gelatin-like thermo-hygrometric response.

No significant change in the thermal response was observed within an artificially aged set of modern parchments using this method. This suggests that artificial ageing does not reproduce the changes found in historical parchments. Thermal response and thermal decay half-life of leather is considerably smaller than that of parchment on a mass per unit area basis.

We have refined this previously used technique of Calnan and Thornton (1996) improving its reliability, repeatability

Figure 7.10 Squares – thermal response peak area normalized to parchment P1 and compensated for mass as a function of sample type. Stars – shrinkage temperature. Triangles – basic/acidic amino acid ratio (Juchauld and Chahine 2002).

Figure 7.11 Squares – thermal response normalized to parchment P1 and compensated for mass as a function of sample type and mass (hexagons). Stars – shrinkage temperatures (T_s). Triangles – basic/acidic amino acid ratio.

Figure 7.12 Squares – thermal decay half-life normalized to parchment P1 and compensated for mass as a function of sample type and mass (hexagons). Stars – shrinkage temperatures (T_s). Triangles – basic/acidic amino acid ratio.

and stability. This thermal parchment technique gives specialized information about the thermal response of parchments undergoing humidity changes. Thermohygrometric response is different for new (modern) and historic parchments. Historical parchments are progressing gradually towards a gelatin state more than new parchments at this point in time. Characteristic times of rehydration are slower than those for dehydration.

An historical parchment or leather with a shrinkage temperature (T_s) just exceeding that of ambient, would be significantly affected by a rise in temperature on rehydration.

There is very little variation in the thermal response for the artificially aged parchments. Accelerated ageing in degradation assessment experiments must be used with care.

Endnotes

1. Campbell Scientific Ltd, 14–20 Field Street, Shepsted, Leicestershire, LE12 9AL, UK.
2. Aldrich Chemical Company (1998), The Old Brickyard, New Road, Gillingham, Dorset SP8 4XT, UK.
3. Campbell Scientific Ltd, 14–20 Field Street, Shepsted, Leicestershire, LE12 9AL, UK.
4. NAMAS, 1994 National Measurement Accreditation Service Certificate of Calibration, Calibration No. 0072, Serial No. 48436T, Universal Calibration Laboratories Limited, Universal House, Romsey Industrial Estate, Greatbridge Road, Romsey, Hants, SO51 0HR, UK.
5. C. Calnan (1997), The National Trust, 36 Queen Anne's Gate. London SW1H 9AS, UK.

References

Bowden, D. J. and P. Brimblecombe (1999) 'The thermal response of parchment to hygrometric changes', *Journal of the Society of Leather Technologists and Chemists* 83, p. 252–60.

Calnan, C. and C. Thornton (1996) 'Determination of moisture loss and regain', *ENVIRONMENT Leather Project: Deterioration and Conservation of Vegetable Tanned Leather*, Research Report No. 6, European Commission, EV5V-CT94-0514, Protection and conservation of European cultural heritage, The Royal Danish Academy of Fine Arts, School of Conservation, Esplanaden 34, DK-1263, Kobenhaven K, Denmark, pp. 17–22.

Carotenuto, A. and M. Dell'Isola (1996) 'An experimental verification of saturated salt solution-based humidity fixed points', *International Journal of Thermophysics* 17, pp. 1423–39.

Cohen, A. D. and J. W. Lorimer (1991) *Solubility Data Series* Vol. 47, Pergamon.

Dernovskova, J., H. Jirasova and J. Zelinger (1995) 'An investigation of the hyroscopicity of parchment subjected to different treatments', *Restaurator* 16, pp. 31–44.

Ewing, W. W. (1927) 'Calcium nitrate II. The vapour pressure-temperature relations of the binary system calcium nitrate-water', *Journal of the American Chemical Society* 49, pp. 1963–73.

Hamer, W. J. and Y-C. Wu (1972) 'Osmotic coefficients and mean activity coefficients of univalent electrolytes in water at 25°C', *Journal of Physical and Chemical Reference Data* 1, p. 1047.

Horie, C. V. (1990) 'Deterioration of skin in museum collections', *Polymer Degradation and Stability* 29, pp. 109–33.

Jahn, A. S. and L. P. Witnauer (1967) 'Water binding in hide materials', *Journal of the American Leather Chemists Association* 62, 5, pp. 334–45.

Juchauld, F. and C. Chahine (2002) 'Determination of the molecular weight distribution in parchment collagen by steric exclusion chromatography'. This volume, pp. 123–31.

Kanagy, J. R. (1954) 'Heats of wetting of collagen, leather, and other organic and fibrous materials', *Journal of the American Leather Chemists Association* 49, pp. 646–58.

Larsen, R., D. V. Poulsen and M. Vest (2002) 'The hydrothermal stability (shrinkage activity) of parchment measured by the micro hot table method (MHT)'. This volume, pp. 55–62.

Lobo, U. M. M. and J. L. Quaresma (1981) *Electrolyte Solutions: and Transport Literature Data on Thermodynamic Properties*, Vol. II, Colmbra, Portugal.

Vodopivec, J. (1995) 'The preservation and protection of medieval parchment charters in Slovenia', *Internationale Arbeitsgemeinschaft der Archiv – Bibliotheks und Graphikrestauratoren*, p. 39.

8 Characterization of Historic and Unaged Parchments using Thermomechanical and Thermogravimetric Techniques

Marianne Odlyha, Neil Cohen, Gary Foster and Roberto Campana

Introduction to thermomechanical and thermogravimetric techniques

Thermomechanical and thermogravimetric techniques were used to measure the parchment samples provided by the School of Conservation, Copenhagen. The thermomechanical technique used was dynamic mechanical thermal analysis (DMTA). This provides information on the viscoelastic properties of the material which are dependent on its chemical composition. The presence, temperature and intensity of the observed transitions provide valuable markers for the physicochemical state of the material. Previous work on dehydrated gelatin using thermomechanical analysis demonstrated that two glass transitions were observed (Fraga and Williams 1985) and the interpretation of the observed thermal properties was based on known aspects of the primary structure of gelatin. Thus information on the viscoelastic properties of parchment samples may provide a means of determining the actual state of the collagen block copolymer in the parchment samples, and give an insight into the extent of cross-linking and the degree of crystallinity in the samples.

DMTA was also used in another way, which represents a completely novel method of measurement for parchments. The instrumentation had been previously adapted for studying the behaviour of textiles in water (Foster *et al.* n.d.). In this project it provided useful data both on percentage displacement (expansion or contraction) of the samples on immersion in water, which relates to ease of sample wettability, and then the measurement of the amount of shrinkage when the parchment samples were immersed in water and heated through the shrinkage temperature.

The second thermoanalytical technique, thermogravimetry analysis (TGA), provides information on the thermal stability (TS) of materials. It records the weight loss of samples with temperature. This again is dependent on their chemical composition. A measure of the change in TS can then be related to the chemical composition of the parchment samples presented elsewhere in this book. In the TGA measurements heating occurred over a broad temperature range from room temperature to 750°C. The first part of the observed weight loss can be directly related to the moisture content or the physically adsorbed moisture. This is followed by a two-stage degradation process of the parchment where the amino acid residues (Olafsson and Bryan 1970), together with any cross-linked entities and any degradation products which may form, will undergo decomposition. The variation in the thermal degradation profile provides a valuable fingerprint for each parchment.

The interpretation of the thermomechanical data, in particular, will be based on what is generally accepted about the primary structure of collagen and gelatin. The primary structure is defined as the sequence of the amino acid residues in its polypeptide chain(s) (Ramachandran and Reddi 1976). In terms of primary structure this sequence has been described as a block copolymer mainly made up of the imino acids (proline and hydroxyproline) with glycine at every third position. The size and chemical structure of imino acids will have some effect on the mechanical properties due to the restriction on rotation imposed by the imino acids in the peptide linkage. This leads to a certain rigidity of blocks containing proline and hydroxyproline (pyrrolidone rings). Two such rings determine one complete turn of the polyproline helix (secondary structure). Hence the imino acid content determines the extension of the protein secondary structure. Mammalian gelatins, for example, have a high imino acid content leading to a well-developed secondary structure, while gelatin obtained from cold water fish has the lowest imino acid content and a weak secondary structure (Fraga and Williams 1985). This will affect the viscoelastic properties as will be shown later in the discussion of the thermomechanical data.

The main objective of using these techniques is to provide valuable markers of change due to ageing of the parchment samples. Measurements of differences in viscoelastic properties can be related to changes at the macromolecular level, i.e. changes in cross-linking and sample crystallinity (expressed in terms of glass transition temperatures). The novel method of DMTA measurement of the amount of shrinkage in water at shrinkage temperature can also provide a valuable indicator for the hydrothermal stability of the material. These data can then be compared to the data obtained on the TS of the samples by TGA. The complete set of thermal data can in turn be related to the chemical composition of the samples.

Table 8.1 Description of modern and historic parchments (note: thickness measured before removal of any backing/coating layers).

Parchment	Thickness (mm)	Description
NP5	0.19	Pale, mottled underside, slightly translucent
NP6	0.24	Beige furry upperside, pale brown speckled underside
NP7	0.16	Beige, soft, thin, flexible, smooth, speckled underside
HP7	0.25	Dark brown painted surface, light brown underside, stiff, flexible
HP8	0.28	Grey/brown face with ink marks, white ground backing, curled, brittle
HP16	0.43	Pale upperside, pale brown underside, stiff, slightly translucent
HP18	0.46	Brown, discoloured, stiff
HP20	0.26	Beige upperside, yellow/brown underside, flexible
HP22	0.36	Brown/white markings, roughened, flexible, curled, slightly translucent
HP26	0.12	Yellow/brown mottled upperside, pale (ground residue?) underside
HP28	0.24	Yellow/brown upperside, pale underside, flexible
HP31	0.29	Pale yellow/brown upperside, fibrous appearance, slightly translucent
HP36	0.20	Pale brown, backing and glue attached, uneven texture, brittle
HP37	0.20	Beige, upper and lower sides similar, flexible
HP38	0.24	Beige upperside, pale brown mottled underside, flexible

In most cases the age of the parchments is not known, though a few are dated from the 17th, mid-to-late 18th and mid-19th centuries. The majority have been taken from old bookbindings, but two of the provided samples were taken from old documents. The historical parchments are based on animal hide which is either of calf, sheep, or goat origin; modern parchments which were used as reference materials were based on calf hide. They are described in Table 8.1.

Dynamic mechanical thermal analysis (DMTA): stress–strain measurements

Introduction

The initial test that was used to characterize the parchment samples was to examine the stress–strain response under the application of an increasing load. The data usually derived from stress–strain measurements are important from a practical point of view as they provide information on the modulus, the brittleness, and the ultimate yield strength of the polymer (Cowie 1973). By subjecting the sample to a tensile force applied at a uniform rate and measuring the resulting deformation, a typical stress–strain graph can be obtained (Cowie 1973). The stress–strain response can be represented in mechanical terms by the model of a weightless spring where the stress is directly related to the strain, and the slope of the line gives the value for the elastic or Young's modulus. The initial portion of the curve is linear and the tensile modulus is obtained from its slope.

The aim of the measurements was to determine the region of linear viscoelastic behaviour, i.e. the region in which samples still obey Hooke's law, and to obtain a measure of the Young's modulus of the sample.

Experimental

Stress–strain experiments were conducted on a rectangular sample (20mm × 10mm). It was clamped in the DMTA analyser (Rheometric Scientific Mk.III) in tensile mode (Fig. 8.1). A force was applied that increased in value from 0 to 10N at a ramp rate of 1N/min at 25°C.

Results and discussion

Stress–strain curves are shown for samples NP7, HP26, HP31 and HP38 (Fig. 8.2). The stress (MPa) is plotted on the vertical axis and strain (% change in length) is plotted on the horizontal axis. Values for the Young's modulus were

Figure 8.1 Sample clamped in tensile mode.

Figure 8.2 Stress–strain curves for selected parchment samples.

Table 8.2 Young's modulus and thickness for parchment sample series (note: thickness measured before removal of any backing/coating layers).

Sample	Thickness (mm)	Young's modulus (MN m^{-2})
NP7 ∥	0.16	2289
NP7 ⊥	0.16	1330
HP7	0.24	2760
HP8	0.16	2430
HP16	0.43	2964
HP18	0.46	2131
HP20	0.26	1915
HP22	0.36	1030
HP26	0.12	1246
HP28	0.24	1731
HP31	0.29	2949
HP36	0.20	970
HP37	0.20	1360
HP38	0.24	1940

calculated from the slope of the lines. The numerical values for the moduli of the parchment samples are given in Table 8.2. Low values of the modulus imply that the material stretches considerably more than those for which the modulus values are high. The linearity of response indicates that testing has been performed in the linear viscoelastic region.

The value for HP16 is high indicating that the strain for the applied load is small. Small values of strain may point to high levels of cross-linking or of regions of crystallinity in the collagen polymer which develop on ageing, possibly by virtue of the amino acid residue sequence or of the placement of cross-linkages (Haines 1995). Where values are lower, this points to a greater proportion of the amorphous phase in the material. The significant aspect is the coexistence of crystalline and amorphous phases in collagen and the change in their proportion with ageing.

The calculated values for Young's modulus places samples into groups according to whether (1) the value exceeds 2500 MN m^{-2}; (2) the value is lower than 2500 but greater than 1500 MN m^{-2} and (3) the value is less than 1500 MN m^{-2}. The samples are described as follows:

1. HP7 (17th century), HP16, HP31
2. NP7, HP8 (1797–99), HP18, HP28, HP38, HP20
3. HP22, HP26, HP36, HP37 (1841)

The following observations can be made. The lowest values include the aged sample HP37 (1841) and other parchments such as HP26 and HP36. This is confirmed by other measurements in this book. Some of these values can also be used to explain observed differences in parchment behaviour. In the case of HP36 and HP7, in particular, there are significant differences in behaviour as measured by other techniques, e.g. HP7 has a high shrinkage temperature but low basic/acidic amino (B/A) ratio whereas HP36 has both low shrinkage temperature and low B/A ratio. Our data show evidence of differences between HP36 and HP7. HP36 has a higher proportion of amorphous phase than HP7 and HP16 where there is a higher degree of crystallinity. The latter may account for differences in shrinkage temperature and shrinkage ratios (R). In the case of these samples, however, it needs to be noted that the direction in which the sample is measured may influence the measured modulus values. There is a significant difference in modulus for NP7 depending in which direction it was measured (i.e. it is stiffer in the direction of the backbone of the calf hide).

Hence, the conclusions to this section have revealed the following: (1) measurements have been made in the linear viscoelastic region (2) samples have been classified in terms of proportions of amorphous and crystalline regions. These will also affect the data which are described in the next section, where DMTA measurements are made using a sinusoidal load which is applied to the sample over a temperature range encompassing liquid nitrogen temperatures to onset of parchment degradation temperatures.

DMTA: Measurement of viscoelastic properties

Introduction

The measurements made by DMTA using an applied sinusoidal load are able to resolve the contributions from the elastic and viscous components of the collagen polymer, i.e. hard and soft blocks. The application of a static load as in the previous section is not possible and measurements simply give us information on the elastic component. With the application of a sinusoidal force, the elastic component remains in phase with the applied force while the viscous component is out of phase (Figs 8.3 and 8.4). The resultant

Figure 8.3 The sinusuidal stress (σ) and the strain response (ε) which lags by a phase angle (δ) because of the viscoelastic behaviour of the sample (after Haines 1995).

Figure 8.4 Argand diagram.

complex mechanical modulus is then measured and resolved into the two components as shown in the Argand diagram (Fig. 8.4). Tan δ is calculated from the ratio of the viscous or loss modulus (E″) to the elastic modulus (E′). Samples are generally cooled to liquid nitrogen temperatures to bring them into the glassy state. Here the cooperative molecular motion along the chain is frozen causing the material to respond like an elastic solid to stress. As the temperature is increased some motion commences in the flexible side chains and this causes the modulus of the sample to fall. The modulus continues to decrease as the sample approaches its glass transition temperature, T_g, where it changes from the glassy to the rubbery state. This change is associated with the cooperative rotational motion involving a large number of atoms (20–25) along the main chain of the polymer. In DMTA studies of synthetic polymers, e.g. polyethylene and polymethacrylate, these transitions have been shown to be sensitive to structure type, e.g. linear or branched and the length of side chain (Flory and Spurr 1960).

The DMTA curve for the unaged parchment NP7 measured in the tensile mode (Fig. 8.3) provides information on the variation of E′ and tan δ with temperature. For ease of comparison between samples the tan δ parameter will be used in discussion of the results as this is a ratio, and variations due to sample thicknesses will be minimized. The changes in the tan δ curve for NP7 can be described in the following manner. From liquid N_2 temperatures there is a broad low intensity temperature transition which, at the molecular level, is associated with side chain motion; from about 0°C and approaching room temperature there are two transitions to 120°C and these include the denaturation temperature of collagen. The temperature at which these transitions occur and their intensities provide information on the viscoelastic response of the parchment samples. Transitions which lie at room temperature or slightly above mean that the sample is soft and flexible at room temperature. Where higher temperature values of the glass transition temperature occur then the material is hard and inflexible at room temperature; this can be due to the presence of cross-linking or crystalline phases present in the polymeric material. If the accompanying value for the intensities of the transitions are low then the material approaches the behaviour of an elastic solid where tan δ value would be zero. Higher values indicate a viscoelastic response where the proportion of viscous component is high.

Figure 8.5 DMTA curves (log E′ and tan δ) of unaged parchment NP7 as a function of temperature.

In the case of collagen, which is described as a block copolymer, several transitions would be expected. Some measurements on polypeptides have reported the following: Gly-Val-Gly-Gly-Leu (66°C); Pro-Val-Gly (103°C) (Megret 1988). As mentioned in the introduction, the presence of imino acids will affect the temperature of the transition due to restriction which they will cause in the rotation of the polymer backbone. Thus as described in the case of gelatin (Fraga and Williams 1985) the temperature at which transitions are observed will reflect the nature of the polypeptide sequence present.

Experimental

Samples (20mm × 10mm) (in some cases reused after stress–strain measurements) were clamped in the tensile mode (same as Fig. 8.1 but with the application of a dynamic load) and measured over the temperature range –130 to 120°C at 3°C/min and at a frequency of 1Hz and a force of 4N. The applied strain (× 4) corresponds to a peak to peak displacement of 64μm. A second heating of the parchment samples was performed from –130 to 220°C at 3°C/min to remove the physically adsorbed moisture. This was done to ensure that on second heating all samples had the same moisture content.

Results

The tan δ curves for some of the historic samples are shown together with the unaged sample (Figures 8.6a and b). The two sets of tan δ curves situate the samples according to the intensitites of the observed transitions associated with relaxation processes occurring in particular polypeptide sequences. For ease of comparison the data have been shifted vertically to a common point – i.e. zero tan δ value at –10°C. Data are summarised in Table 8.3, for first and second heats respectively.

NP7 shows two peaks in tan δ on the second heating at 25°C and 65°C. The peak at 25°C occurs also on the first heating but with increased intensity. Its intensity appears to be dependent on the residual physically adsorbed moisture. The peak below room temperature can be linked to side chain motion. Its intensity is related to the free moisture content of the sample; this was previously observed in cellulosic materials where intensity of the peak increased on exposure to environments of high relative humidity (RH) (Odlyha 1998). The peak at 65°C can be interpreted as the temperature at which motion of the collagen polymer backbone occurs. In comparison, sample HP16 shows a very weak transition at 65°C. This indicates that the collagen is more cross-linked or has more crystalline regions and is therefore more elastic than NP7. In stress–strain measurements this sample had one of the highest Young's modulus values and this supports the tan δ result in terms of its mechanical properties.

Some of the aged parchment samples exhibit an additional peak in the region of 130 to 180°C (labelled peak 4 in Table 8.3b) as well as a shift in the main lower temperature

Figure 8.6 Tan δ peaks (labelled P_1 to P_4) for samples (a) NP7, HP16, HP22 and HP31 (b) NP7, HP36, HP26 and HP38 on second heating.

Table 8.3 Tan δ values for parchment samples.

Sample	Peak 1 T1	tan δ1	Peak 2 T2	tan δ2	Peak 3 T3	tan δ3	Peak 4 T4	tan δ4
a. First heating								
RSG	−78.0	0.0115	30.1	0.0126	80.6	0.0345		
NP6	−100.6	0.0049	25.7	0.0054	69.9	0.0172		
NP7 ∥	−106.7	−0.0040	14.6	0.0129	62.5	0.0225		
NP7 ⊥	−101.9	0.0030	19.5	0.0171	60.1	0.0280		
HP7	−95.8	0.0003	17.9	0.0248	80.8	0.0330		
HP8	−86.7	0.0087	37.5	0.0294	73.6	0.0332		
HP16	−114.5	0.0063	21.9	0.0081	83.2	0.0259		
HP18	−85.0	0.0052	29.2	0.0118	81.2	0.0289		
HP20	−101.2	0.0020	28.1	0.0201	71.3	0.0283		
HP22	−83.2	−0.0056	15.7	0.0143	71.1	0.0261		
HP26	−102.0	0.0020	25.9	0.0139	57.9	0.0206		
HP28	−100.5	0.0087	26.5	0.0057	89.2	0.0266		
HP31	−85.2	0.0046	22.4	0.0114	84.1	0.0267		
HP36	−93.0	0.0062	19.2	0.0193	65.0	0.0232		
HP37	−98.3	0.0025	21.3	0.0285	55.9	0.0352		
HP38	−92.6	0.0042	27.0	0.0196	57.6	0.0222		
b. Second heating								
RSG	−74.8	0.0157	30.1	0.0126	77.5	0.0338		
NP6	−70	0.0098	41.8	0.0084			116.7	0.0155
NP7 ∥	−93.2	0.0111	24.6	0.0127	65.2	0.028		
NP7 ⊥	−85.7	0.0117	37.1	0.0209	73.2	0.0288		
HP7	−55.6	0.0114	29.8	0.0169	74.5	0.0305		
HP8	−65.4	0.0112	29.8	0.0147	79	0.0207		
HP16	−60.4	0.0112	26.7	0.0006			137.6	0.0211
HP18	−71.4	0.0083			73.6	0.0227	148.8	0.0318
HP20	−63.4	0.0092	35.2	0.02	81.9	0.0223		
HP22	−69.4	0.0129			75.4	0.0324	148.1	0.0547
HP26	−59.1	0.0085	27.2	0.0048			147.6	0.0198
HP28	−87.3	0.0118			90.5	0.0277	139.7	0.0294
HP31	−66.2	0.0161			85.8	0.0194	146.3	0.0386
HP36	−61.1	0.0035	24	0.0198	82.5	0.0076		
HP37	−55.8	0.0129	41.8	0.0248			178.6	0.0467
HP38	−42.7	0.0063	34.4	0.0079			150.3	0.0155

Data were shifted vertically to give common tan δ of zero at −10°C. RSG refers to sample of rabbit-skin glue film. Intensity of high temperature tan δ is in reality low, but the effect is increased by the onset of decomposition. NP7 was measured both parallel and perpendicular to marked direction on sample. NP6 is another unaged parchment.

feature to higher values (peak 3). HP22 and HP31 as shown in Figure 8.6(a) particularly exemplify this. These transitions can be assigned to those observed in gelatin (Fraga and Williams 1985). So it is possible to say that the collagen in some of the aged parchments has converted to gelatin. The samples HP36, HP26, HP38 and HP37, shown in Figure 8.6(b) (alongside NP7) are a group where the predominant feature lies in the region between 0 and 50°C and there is no visible high temperature peak. In these samples there must be a low imino acid content and therefore a weak secondary structure (Fraga and Williams 1985). There must be more soft blocks containing alpha amino acids and glycine at

Table 8.4 Tan δ values after second heating and after levelling of tan δ peak. (Note: Data were vertically shifted to give common tan δ of zero at −10°C; intensity of high temperature tan δ is in reality low, but the effect is increased by the onset of decomposition; NP7 was measured both parallel and perpendicular to marked direction on sample; NP6 is another unaged parchment.)

Sample	Peak 2 T2	tan δ2	Peak 3 T3	tan δ3	Peak 4 T4	tan δ4
RSG	30.5	0.0043	71.3	0.0119	–	–
NP6	38.0	0.0031	–	–	–	–
NP7 ∥	30.8	0.0062	66.5	0.0127	–	–
NP7 ⊥	39.4	0.0124	65.9	0.0138	–	–
HP7	38.3	0.0097	64.5	0.0118	–	–
HP8	26.0	0.0082	70.3	0.0058	–	–
HP16	–	–	–	–	133.8	0.0044
HP18	–	–	77.1	0.0100	137.7	0.0063
HP20	35.2	0.0128	80.6	0.0072	–	–
HP22	–	–	70.5	0.0114	140.7	0.0102
HP26	27.2	0.0023	–	–	–	–
HP28	–	–	75.5	0.0170	130.9	0.0108
HP31	–	–	82.8	0.0077	137.8	0.0120
HP36	24.0	0.0209	–	–	–	–
HP37	39.1	0.0180	–	–	–	–
HP38	33.3	0.0064	–	–	–	–

every third position rather than the rigid blocks which contain proline and hydroxyproline along with the glycine.

The data for the second heating of the samples were further processed by removing the baseline slope in the region of interest (Table 8.4). This enables direct comparison of the magnitude of the tan δ values. Only the transitions above room temperature are considered. The intensity of the tan δ peak gives a measure of the viscoelastic response of the material. It relates both physical mechanical properties to changes at the molecular level, i.e. stiffness to crystallization and cross-linking. Three general peak positions are shown. It can be seen that NP7 has features in the first two regions, i.e. 30 and 65°C whereas HP28 has features in the higher two temperature regions. The values of the tan δ peaks give an indication of the integrity of the collagen polymer and its viscoelastic properties.

From the tan δ values the parchment samples can be further allocated into groups according to the number and intensities of peaks observed, and then further divided within each group according to the ratio of observed intensities.

The first group contains the samples NP7, HP7, HP8 and HP20, which have the 1st and 2nd peaks. This group includes the unaged parchment as well as HP7 (17th century) and HP8 (1797–1799). The difference within this group is expressed through the ratio of intensities of those two peaks (tan δ3/tan δ2) to give the following: NP7 (2.1), HP7 (1.2), HP8 (0.7), HP20 (0.6). The reduction in the value of the peak ratio distinguishes between NP7 and the historic parchments.

The second group contains HP18, HP22, HP28, HP31 and these exhibit the two peaks at higher temperatures, i.e. 2nd and 3rd peaks. The ratio of those peaks (tan δ4/tan δ3) gave the following: HP18 (0.63), HP28 (0.64), HP22 (0.89), HP31 (1.56). Clearly there are similarities between HP18 and HP28, and their similarity in chemical composition is confirmed by the ^{13}C solid state nuclear magnetic resonance (NMR) spectra. DMTA now shows that there is a further similarity also in their viscoelastic response. These temperatures are in the range of those which occur in dehydrated gelatin (Fraga and Williams 1985). There is therefore the possibility that conversion of the collagen in the parchment to gelatin has occurred. In both cases prolonged standing in water caused complete solubilization of both HP18 and HP28 which confirms this result. Prolonged immersion in water of sample HP31, however, did not cause solubilization. On the contrary, it remained intact and on drying formed a translucent material. So in the case of HP31, and probably HP22, the collagen polymer is cross-linked and so the temperature of the transitions is higher.

HP16 appears in a group on its own as it shows only the 3rd peak. This may also be due to the presence of cross-linking and crystallinity in the sample as discussed in the NMR section.

The fourth group shows the presence of only the 1st peak and contains samples HP36, HP37, HP38, and HP26. Of these HP37 is the only dated (1841) sample. It is interesting that their behaviour is similar to NP6, a second unaged parchment and reference material. This may indicate that there is a similarity in the method for preparation, e.g. concentrated aqueous solutions of alkaline earth metals, particularly calcium, are known to disorder the poly(L-proline) chain structure (Odlyha 1998). Another point to note is that HP37 and HP38 are both samples from documents.

Conclusion

Samples have been characterized according to their viscoelastic response and in some cases evidence for gelatinization has been found. The samples have been separated into four main groups:

- Group 1: NP7, HP7, HP8 and HP20. The ratio of peaks (tan δ3/tan δ2) distinguishes between NP7 and the historic parchments: NP7 (2.1), HP7 (1.2), HP8 (0.7), HP20 (0.6).
- Group 2: HP18, HP22, HP28, HP31. The ratio of peaks (tan δ4/tan δ3) gave the following HP18 (0.63), HP28 (0.64), HP22 (0.89), HP31 (1.56). (Evidence for some gelatinization in HP18 and HP28.)
- Group 3: HP16 appears in a group on its own as it shows only the 3rd peak. This may also be due to the presence of cross-linking and crystallinity in the sample as discussed in the NMR section.
- Group 4: The fourth group shows the presence of only the 1st peak and contains samples HP36, HP37, HP38, and HP26. Of these HP37 is the only dated (1841) sample.

Creep measurements discussed in the following section will now assist in further characterization of these samples.

DMTA: Underwater heating creep measurements

Introduction

The DMTA analyser was used in a different orientation for this experiment to represent a completely novel method of measurement. The instrumentation had been previously adapted for studying the behaviour of textiles in water (Foster *et al.* n.d.). In this project it provided useful data both on percentage displacement (expansion or contraction) of the samples initially on immersion in water, which relates to ease of sample wettability, and then the measurement of the amount of shrinkage when the parchment samples were immersed in water and heated through the shrinkage temperature. A low static force was used (0.1N) so that the measured sample shrinkage was not overwhelmed by the applied force. The method of measurement used here is referred to as creep since the change in displacement of the sample is recorded as a function of time (Cowie 1973).

Experimental

The sample (20mm × 10mm) was mounted in the tensile mode as for the previous tests. However, in place of a sinusoidal force, a small (0.1N) static force was applied to the sample. This would enable any expansion or contraction of the sample during immersion or drying to be measured. Where a particular direction was given for the parchment then the sample was clamped with that direction along its length.

The experiment commenced with the sample initially in air to give a starting baseline. After 10 minutes, the sample was immersed in the beaker of water at a temperature of 30°C (Fig. 8.7). Subsequently the temperature of the water bath was increased in 5°C steps every 10 minutes until a maximum temperature of 90°C was reached. The sample was then removed from the water bath and left to dry at room temperature.

The resulting graph was plotted as % displacement (*y*-axis) against time (*x*-axis), with the temperature profile superimposed (*y*2-axis). From the data the following parameters could be measured:

Figure 8.7 Expanded view of sample immersed in beaker. The drive shaft and pillar extension connect to the DMTA analyser.

- % Displacement change (expansion or contraction) on initial immersion in water. This enabled the extent of wettability of each parchment sample to be determined.
- Temperature of initial shrinkage, T_i. This is taken as the temperature step at which the measured displacement begins to decrease.
- Temperature of main shrinkage, T_m. This is taken as the temperature step during which the largest percentage shrinkage occurs.
- Main shrinkage (%). The amount of shrinkage that occurs within 10°C (two temperature steps) of the main shrinkage temperature.
- Total shrinkage (%). This is the total overall displacement change which occurs in the sample.
- Temperature range of shrinkage ($T_m - T_i$). The difference between the initial shrinkage temperature and the main shrinkage temperature ($T_m - T_i$). This range was used in preference to the whole shrinkage range since it was not possible to accurately define a final shrinkage temperature T_f. A larger temperature range $T_m - T_i$ can be taken as an indicator of degraded collagen and thus a more aged parchment.
- Amount (%) of shrinkage at T_m as a fraction of the total shrinkage (Ratio R). i.e. R = main shrinkage/total shrinkage. In unaged parchment samples most of the shrinkage occurs within a narrow temperature region (i.e. at or close to T_m) and so this value will be high. In more aged samples the shrinkage is spread over a wider temperature range and this value will be lower.
- Recovery on drying. The displacement change on removal from water and drying in air.

Results

Curves for NP7 and HP28 are shown in Figure 8.8 and the data for all parchment samples are summarized in Table 8.5.

The data in the first column showed that the unaged sample NP7, together with HP7, HP37 and HP38 gave a small negative displacement (contraction) on immersion in water. The other samples gave a positive displacement (expansion), indicating that the sample had softened and could be stretched more readily on absorption of water. The effect was particularly strong in HP22 and HP26.

On heating, before the initial shrinkage temperature, samples generally showed a very small expansion (<1%). In the unaged sample NP7 there was no change until a temperature of 65°C at which point the sample started to shrink rapidly (Fig. 8.8(a)). The main shrinkage was complete at 70°C. The measurement was repeated five times and the same temperatures were recorded. At the other extreme, samples HP28 (Fig. 8.8(b)) and HP36 showed signs of shrinkage immediately on immersion in water at 30°C.

From the data in Table 8.5 samples can be discriminated according to their onset or initial temperature of shrinkage. This provides the following groups:

1. NP7, HP7, HP22 (>60°C)
2. HP31, HP37 (55°C)

Figure 8.8 Percentage displacement change on heating plotted as a function of time for (a) NP7 and (b) HP28. Temperature is calculated as shown in (a).

Measurement of the temperature at which the main shrinkage occurred also proved informative. Again, for the less aged or unaged samples such as NP7, the main shrinkage occurred at high temperatures (c.70°C), and close to that of the initial shrinkage. By contrast the more aged parchments show greater variability in the temperature of maximum shrinkage.

The clearest simple method of quantifying the manner in which the amount of shrinkage varied as a function of temperature was to take the ratio of the amount of shrinkage measured at T_m against the total shrinkage over the whole temperature range. The unaged sample NP7 has a narrow range of shrinkage, with a large amount occurring at T_m, and thus will have a high ratio. Samples HP26, HP28 and HP36 again lie at the other extreme, since the shrinkage occurs evenly across a broad temperature range with a smaller proportion occurring at T_m. These samples therefore have a low ratio. The ratio expressed as R is plotted against sample type and the results appear in Figure 8.9.

From the R values samples can again be placed into the following groups:

1. HP7, NP7, HP38, HP22, HP37, HP31 (ratio > or equal to 0.6 in descending order)
2. HP20, HP16, HP18, HP8 (0.50 < ratio < 0.60)
3. HP28, HP36, HP26 (ratio < 0.50)

This difference between NP7 and HP28 can be seen in Figure 8.9. They show the extremes in behaviour, i.e. NP7

3. HP20, HP38 (50°C)
4. HP26 (45°C)
5. HP8, HP16, HP18 (35°C)
6. HP28, HP36 (30°C)

Overall there is a large difference between sample NP7, the unaged reference, and samples in groups 5 and 6 where the shrinkage temperature is significantly lower than in NP7. Within groups 5 and 6 it is interesting to note that samples HP18 and HP28 show similar behaviour. This was already observed in the solid state NMR data and in their viscoelastic response as measured by DMTA in the previous section. This confirms the possibility that in these two parchments conversion of the collagen to gelatin has occurred. HP16 also falls into this group.

Figure 8.9 Bar graph of shrinkage ratio R for parchment samples.

*Table 8.5 Summary of displacement (%) on immersion in water and then (%) shrinkage on heating in water and (%) recovery on drying (*figure approximate as sample split towards end of experiment; actual value therefore slightly higher).*

	Change on immersion %	Temp of initial shrinkage T_i (°C)	Temp of main shrinkage T_m (°C)	$T_m - T_i$ (ΔT) (°C)	Main shrinkage (%)	Total shrinkage (%)	Shrinkage ratio R	Recovery on drying (%)
NP5	5.0	60	65	5	17	30	0.57	16
NP7	−1.0	65	70	5	20	30	0.67	10
HP7	−0.3	60	70	10	30	44	0.68	14
HP8	1.5	35	55	20	16	30	0.53	10
HP16	1.4	35	55	20	18.5	34	0.54	8
HP18	1.8	35	55	20	19.5	37	0.53	7
HP20	0.4	50	65	15	22	38	0.58	14
HP22	10.0	65	70	5	14	19	0.64	×
HP26	7.0	45	60	15	13	31	0.42	6
HP28	3.2	30	45	15	7	15*	0.47	×
HP31	5.0	55	60	5	18	30	0.60	3
HP36	1.0	30	40	10	6.5	14*	0.46	×
HP37	−1.0	55	75	20	28	44	0.64	21
HP38	−0.4	50	65	15	31	47	0.66	15

Table 8.6 Creep data for HP8 on initial heating and reheating.

	Change on immersion (%)	Temp of initial shrinkage T_i (°C)	Temp of max shrinkage T_m (°C)	$T_m - T_i$ (ΔT) (°C)	Amount of max shrinkage (%)	Total shrinkage (%)	Amount of max shrinkage/total shrinkage R	Recovery on drying (%)
1st heat	1.5	35	55	20	16	30	0.53	10
2nd heat	11.0	35	60	25	4	15	0.27	3

gives a large shrinkage over a small temperature range whereas HP28 gives a more gradual shrinkage across a broader temperature range. Low values for HP16, HP18, HP26 and HP28 are also confirmed by thermomicroscopy and these are described elsewhere in this book.

Rehydration

A further measurement was made of the behaviour of a selected parchment sample (HP8) on rehydration, i.e. on re-immersion. Data are shown in Figure 8.10 and Table 8.6.

Sample HP8 was allowed to dry overnight but it was not removed from clamps before re-immersion in water and reheating. The initial displacement (expansion) was significantly larger than on the first measurement, showing greater softening and ability to stretch as a result of water absorption. Some shrinkage did occur on heating, but the overall percentage shrinkage was half of that seen during the first measurement. Additionally, there was no clearly defined temperature of maximum shrinkage. The shrinkage measured at 60°C was only 0.5% greater than that found at adjacent temperatures. This fact was reflected in the calculation of the ratio R of maximum shrinkage to total shrinkage, which is 0.27, compared to 0.53 in the original sample, and 0.67 in the unaged NP7.

The behaviour on removal from water was also different. There was an initial expansion in length, as previously observed, but this was followed by a significant contraction. It can be seen that the overall length of the sample returned close to that measured at the start of the experiment. This is unlike the behaviour of the samples on first heating, where the shrinkage that occurred during heating irreversibly altered the sample dimensions.

Drying profiles

The drying profiles of selected samples were measured after a short period of immersion in water at 30°C (i.e. without heating). Results are shown in Figure 8.11 for unaged parchment P3 and historic parchment HP22. Samples were left to dry under ambient atmospheric conditions.

On immersion, P3 and HP22 responded in a different manner: P3 contracted by 3–4% and HP22 expanded by about 4%. On removal from water (at 25 min) P3 was left to dry. No change was observed in its displacement until at 70 minutes when it started to expand by a small amount before shrinking by 9.6%. HP22, on the other hand, just before 70 minutes, did not expand but immediately started to shrink. The amount of shrinkage was less (4.7%) and the rate of shrinking, as measured by the downward slopes of the curves, was slower than in the modern parchment.

Drying profiles (dielectric spectroscopy)

Further characterization of drying profiles was performed using the 8720C Hewlett Packard Network Analyser system with a semi-rigid coaxial probe. The methodology and measurement technique have been described elsewhere (Rao *et al.* 1983; Odlyha *et al.* 1996). The non-invasive technique measures the moisture content of materials. It measures the response of the sample in the microwave region at a frequency (2.45GHz) where the static relative permittivity (or dielectric constant) for water is high (80.1 at 20°C) and low for other materials such as parchments. However, after immersion of the parchment samples in water for selected periods of time they will show higher values and this will reflect the amount of moisture absorbed by the parchment samples. Thus the value for the relative permittivity ε' of materials in this frequency range is highly correlated with the moisture content of materials.

The experimental cell as shown in Figure 8.12 was used to monitor the drying of parchment samples previously immersed in water for 24 hours. Samples were placed on the wire gauze in the sample cell and the coaxial probe was positioned on the sample with optimum contact. The initial values for sample complex permittivity were recorded and then the measuring system was activated to read complex permittivity values of the sample continuously as a function

Figure 8.10 Percentage displacement change during heating of HP8 on re-immersion compared with original measurement.

Figure 8.11 Creep test using DMTA in 'upside down' configuration for unaged and historic parchments.

Figure 8.12 Modified glass sample cell for the drying of parchment samples.

of time. (The complex permittivity $\varepsilon^* = \varepsilon' - i\varepsilon''$; in Fig. 8.13 both ε' [real] and ε'' [imaginary components] are plotted as a function against time.)

For the drying of the samples, a solution of H_2SO_4/H_2O (w/w) was used to generate a controlled environment of RH (33%). The solution was introduced through the side arm with a teat pipette, and the temperature was maintained by immersion of the sample cell in a water bath. A low RH humidity value was used to enhance the drying behaviour of the samples. In the mechanical creep experiment the parchment samples were left to dry in normal laboratory conditions.

Figure 8.13 summarizes the results for historic parchments HP8 (a) and HP31 (b). Other samples were measured and the results are given in Table 8.7. Values for their initial moisture content were calculated from the ratio of the initial relative permittivity (ε') values (as shown at the start of the drying) to that of water ($\varepsilon' = 80.1$) at 2.45GHz at the same temperature. Similarly values for final moisture content were also obtained. These values were also checked by thermogravimetric techniques described in the next section. Drying times were calculated from the onset of decrease in the permittivity curves (ε'). Sample thicknesses are given in Table 8.8.

Table 8.7 Drying times for selected modern and historic parchment samples.

Sample	Initial moisture content (%)	Final moisture content (%)	Drying time (mins)
P3	35	6	15
P4	50	9	12
HP22	29	8	30
HP31	38	8	54
HP8	48	5	40
HP35	35	6	32

Table 8.8 Dry and wet thicknesses of selected modern and historic parchment samples.

Sample	Dry thickness (%)	Wet thickness (mm)	Swelling (mm)
P3	0.19	0.27	42
P4	0.16	0.26	63
HP22	0.34	0.47	38
HP31	0.29	0.48	66
HP8	0.33	0.44	33
HP35	0.36	0.54	50

Figure 8.13 Drying curves (v time) for historic parchments. (a) HP8 is the historic parchment sample dated 1797–1799 from the National Archive, Denmark and (b) HP31 is an undated sample from the Royal Library, Denmark.

The results of these measurements can be summarized as follows. The initial moisture content of historic and unaged samples after immersion (24 hrs) is comparable; both modern (P4) and historic samples (HP8) show values that are higher than the range 30–38 which is exhibited by four of the parchments. The drying times are clearly shorter for the unaged samples. The use of the controlled environment for drying appears to differentiate between unaged and aged samples more clearly than the previous mechanical creep measurement. There is an interesting difference between HP31 and HP22 where the drying time for HP22 is shorter. This would indicate that HP22 is less aged than HP31 and this is confirmed by the TGA data in the next section where the TS of HP31 is lower than that of HP22. As the sample ages its structure becomes more hydrophilic and this would encourage the retention of moisture and cause longer drying times.

Conclusions

From the data in Table 8.5 samples can be discriminated according to their onset or initial temperature of shrinkage. This provides the following groups:

1. NP7, HP7, HP22 (>60°C)
2. HP31, HP37 (55°C)
3. HP20, HP38 (50°C)
4. HP26 (45°C)
5. HP8, HP16, HP18 (35°C)
6. HP28, HP36 (30°C)

From the R values samples can be placed into the following groups:

1. HP7, NP7, HP38, HP22, HP37, HP31 (ratio > or equal to 0.6 in descending order)
2. HP20, HP16, HP18, HP8 (0.50 < ratio < 0.60)
3. HP28, HP36, HP26 (ratio < 0.50)

Thermogravimetry analysis (TGA)

Introduction

The technique thermogravimetry analysis (TGA) monitors continuously the change in mass with temperature or time when the sample is subjected to a linear temperature programme and controlled atmosphere (Chan et al. 1994). It is a virtually non-destructive technique as it requires only very small sample size (c.0.1 to 0.5mg). The sample can be subjected either to an oxidizing or inert atmosphere. An oxidizing atmosphere was selected in this study since the resulting thermo-oxidative curve will be more sensitive to changes in the chemical composition of the sample. The method is widely used in thermal analysis for stability testing of materials and monitoring stages of deterioration due to ageing (Widmann and Riesen 1987). In addition to the sensitivity to chemical composition of the sample, the first part of the thermogravimetric curve in a thermal scan provides information on the amount of physically adsorbed moisture by the sample.

Experimental

Samples were taken by scraping the parchment samples supported on a glass slide with a sharp scalpel blade. The scraping was performed through a section of the sample to obtain a mixture which was representative of the whole sample. The resulting sample was in fine powder form. In two cases there were obvious traces of backing material, which was removed before any sampling was attempted. Once the sample had been taken it was transferred with the help of a scalpel blade to a small platinum crucible (5mm OD). For each analysis at least three and in most cases up to seven samples were measured to test the reproducibility of the analysis.

A Shimadzu TGA 50 Thermogravimetric Analyser was used, and samples of parchment (of the order of 1mg) were heated at 10°C/min in a flow of purge gas (O_2) over the sample at 60cm^3/min. A temperature range 30 to 750°C was selected in order to obtain the complete curve for the thermo-oxidative degradation of the sample.

Results

The data are presented in terms of both TGA and DTGA curves. A TGA curve has units of mass on the vertical scale (mg or % wt.) and temperature (°C) or time on the horizontal scale. A typical TGA curve for unaged parchment (Fig. 8.14) has three distinct stages of weight loss: the first is due to physically adsorbed moisture and the next two are due to oxidative degradation. The calculated DTGA curve is also shown and this measures the rate of mass change (% wt./min) (vertical axis) with temperature (horizontal axis). The DTGA curve is frequently used to assist in marking the start and end temperatures of weight loss processes.

Observed weight changes and the temperatures at which the processes start and are complete, as defined by the DTGA curve, and the width of the temperature intervals over which they occur, were calculated and appear in Table 8.9. They

Table 8.9 Summary of TGA data for unaged and historic parchments.

Sample	Moisture content (%)	T_1 (°C)	T_2 (°C)	$T_2 - T_1$ (°C)	Percentage loss	T_3 (°C)	T_4 (°C)	$T_3 - T_4$ (°C)	Percentage loss	Residue (%)
NP7	4.0	196	426	230	43.4	457	624	166	39.3	11.8
HP7	3.1	196	403	207	49.3	410	537	127	29.5	11.9
HP8	4.8	187	418	231	40.4	424	649	225	37.7	17.2
HP16	2.1	201	408	207	43.9	430	621	190	35.4	15.4
HP18	3.2	182	421	240	50.4	446	676	230	35.7	11.8
HP20	3.0	200	436	236	44.9	456	624	168	31.4	19.4
HP22	3.7	185	426	242	48.5	436	614	178	34.1	13.1
HP26	3.4	191	412	220	45.4	425	608	182	34.9	15.9
HP28	3.4	175	416	241	50.5	433	663	230	34.2	14.7
HP31	3.0	170	414	244	48.6	421	605	184	38.1	10.7
HP36	2.0	204	425	221	42.4	433	637	204	37.1	16.0
HP37	2.7	217	428	212	44.1	438	600	162	36.2	14.0
HP38	2.7	181	425	243	47.1	432	658	226	34.8	13.7

Figure 8.14 TGA and DTGA curves for unaged parchment NP7. The main weight loss regions are marked.

represent the average of four repeat measurements and are used to characterize and quantify the thermal behaviour of parchment samples.

The unaged or reference sample NP7 (Fig. 8.14) showed an initial weight loss of 4.0% between 35 and 200°C. This represents the loss of physically adsorbed moisture in the sample. The next stage follows on and is complete at 426°C and has a value of 43.4%. The third weight loss proceeds from 457°C to 624°C and has a value of 39.3%. This stage as seen more clearly in the DTGA curve can be almost resolved into two processes. In the historic samples e.g. late 18th century (HP8) this region in some cases extended up to 650°C. Most historic samples showed a small additional weight loss between 560 and 620°C. This was assigned to the loss of CO_2 due to the presence of calcium carbonate in the samples present from the liming process.

An example of a historic parchment is given by sample HP26 (Fig. 8.15). This showed an initial weight loss of 3.4% between 35 and 160°C, 45.4% between 191 and 412°C, and 34.9% between 422 and 610°C. The ash residue in this case was 15.9% and higher than that of the unaged parchment (11.8%).

Differences between unaged and historic parchments were found to occur in terms of:

1. initial weight loss which can be related to the physically adsorbed moisture in the samples
2. the onset temperatures and the weight losses at both stages of decomposition
3. the width of the temperature range over which degradation occurs
4. the content of $CaCO_3$
5. the percentage of ash residue remaining at the completion of the thermo-oxidative degradation.

Moisture content (physically adsorbed moisture)

Moisture content as measured from the first weight loss varies between 2 and 5% (Fig. 8.16). The unaged sample (NP7) has the highest value with the exception of HP8 (late 18th century) where residues from the ground layer could have influenced the moisture content. The sample with the least moisture content is HP36, which was noticeably dry and brittle to the touch. Samples HP31 and HP22 were also measured after immersion in water (24 hrs) and differences in moisture content values were similar to those obtained from dielectric analysis in the previous section.

Figure 8.16 Moisture content of parchment samples.

Thermal stability (TS)

The temperatures and corresponding weight losses of the two oxidative degradation processes reflect differences in the TS of the samples, which arise from differences in chemical composition. As seen in Figure 8.17 this can be most clearly distinguished and measured by focusing on the central region of the curve. The following calculation was

Figure 8.15 Comparison of DTGA curves of NP7 and HP26, showing reduction in thermal stability.

Figure 8.17 Measurement of thermal stability for HP26.

Table 8.10 Thermal stability (TS) of historic parchment samples relative to NP7 as measured at temperature corresponding to a residual mass of 48.2%.

Sample	Temp (°C)	TS (°C)
NP7	490.4	0.0
HP7	399.2	–91.2
HP8	464.0	–26.4
HP16	452.9	–37.5
HP18	431.8	–58.6
HP20	487.5	–2.9
HP22	441.6	–48.8
HP26	433.0	–57.4
HP28	410.6	–79.8
HP31	426.9	–63.5
HP36	470.9	–19.5
HP37	461.1	–29.3
HP38	431.8	–58.6

Figure 8.18 Division of TGA curve between 200°C and 600°C for principal component analysis.

performed. The temperature of the onset of the second degradation process was measured for NP7, which corresponded to a residual weight of 48.2%. Then the temperature corresponding to this residual weight was found for the historic parchments, and the value for NP7 subtracted from it, i.e.

$$TS = T_{NP7} - T_{HPx}$$

(where HPx represents historic parchments). The value for NP7 is therefore zero. The results for all the parchments are shown in Table 8.10.

All samples showed a decrease in temperature and a reduction in TS. This was greatest for HP7 and HP28 and least for HP20. The calculated value (TS) gives a comparison of the TS, calculated at only one temperature. It provides a grouping of the samples according to the following (based on magnitude of TS):

- Group 1: NP7, HP20
- Group 2: HP8, HP16, HP22, HP36, HP37
- Group 3: HP7, HP28, HP31, HP38, HP18, HP26

To obtain a more complete picture of the variation across the temperature range a principal component analysis was performed of the data. This was achieved by subdividing the TGA curve between 200°C and 600°C curve into 50°C intervals, and measuring the corresponding weight losses as shown in Figure 8.18. This is the temperature region that corresponds to the degradation of the amino acid residues (Olafsson and Bryan 1970}. The values were then entered into MINITAB (version 10.2) for calculation.

The results of the principal component analysis (PCA) of the TGA data are given in Figures 8.19 and 8.20. Along the direction of the first and most significant principal component it can be seen that HP26 is the most altered and HP20 is the least altered in comparison with NP7. This corresponds to the grouping based on magnitude of TS, the TS parameter.

After HP20 follows HP22. Then there is a cluster of samples (Figs 8.19 and 8.20) which include (1) in direction

Figure 8.19 Principal component analysis of TGA data for unaged and historic parchment samples.

Figure 8.20 Principal component analysis of TGA data showing groupings of parchment samples according to their 1st principal component value. Group 1: NP7; Group 2: HP20, HP22; Group 3a: HP8, HP16, HP36, HP38; Group 3b: HP7, HP18, HP28, HP37, HP31, HP37; Group 4: HP26.

above NP7 along PC2, HP36, HP8, HP16 and HP38 and (2) in direction below NP7 along PC2 HP7, HP28, HP37, HP31, HP37 and HP18. Of these HP7 and HP37 are dated samples from the 17th and 18th centuries respectively. The direction along the PC1 axis starting from NP7 and moving

85

to the right-hand side appears to follow the progression of sample ageing. There is in comparison relatively small deviation along the direction of PC2 axis, which indicates that the second principal component is less significant. The scatter in the data for some of the samples (e.g. HP8) could be related to the presence of residual backing or varying levels of $CaCO_3$ content. Figure 8.19 shows the data points for the individual samples, while Figure 8.20 shows the samples assigned into groups, based on their value along the PC1 axis.

CaCO$_3$ content

In the unaged parchment this was below detectable limits. Levels were highest in samples HP20 (7.99%) and HP8, HP36 and HP37 (Table 8.11). As an example, the loss corresponding to the decomposition of calcium carbonate in HP26 was measured as 1.60% between 566 and 609°C. The $CaCO_3$ content of HP26 could then be calculated by comparing this weight loss with the expected weight loss of CO_2 from $CaCO_3$ alone (44%).

$$\begin{aligned}\text{Expected loss} \atop \text{from } CaCO_3 &= \frac{\text{Formula weight of } CO_2}{\text{Formula weight of } CaCO_3} \times 100 \\ &= \frac{44}{100} \times 100 = 44\%\end{aligned}$$

$$\begin{aligned}\text{Calculated } CaCO_3 \atop \text{in HP26} &= \frac{\% \ CO_2 \text{ loss from HP26}}{\% \ CO_2 \text{ loss from } CaCO_3} \times 100 \\ &= \frac{1.601}{44} \times 100 = 3.64\%\end{aligned}$$

Values for the $CaCO_3$ content for the rest of the historical parchments are given in Table 8.11.

Summary

TGA analysis has shown marked differences between the unaged and the historic parchments in the amount of physically adsorbed moisture, the temperatures at which degradation occurs, the accompanying weight losses and the amount of ash which remains after oxidative degradation. The physically adsorbed moisture (or moisture content) for aged samples, in general, is lower than for the unaged sample (NP7). The TS parameter shows large differences between the samples e.g. in comparison to NP7 the temperature of degradation of HP7 (dated as from the 17th century) is lowered by 91.2°C, the temperatures of HP37 (from 1841) and HP8 (1797–1799) are lowered by 29.3 and 26.4°C. The larger the (negative) value for TS, the less thermally stable are the samples.

The ash residue of historic samples also generally increases. It is largest in HP20 where the ash residue is 7.6% higher than NP7. However, the historic sample, HP7, for example, has the same ash residue as NP7. The $CaCO_3$ content of HP20 is high and in HP7 it is low which accounts for the difference. In the case of HP37 and HP18, however,

Table 8.11 Calcium carbonate content of parchment samples.

Sample	Temp range (°C)	Weight loss (%)	CaCO$_3$ (%)
NP7		0.00	0.00
HP7	560–600	0.18	0.40
HP8	569–636	2.42	5.50
HP16	586–623	1.60	3.63
HP18	573–615	2.21	5.01
HP20	554–625	3.51	7.99
HP22	571–616	1.73	3.92
HP26	566–609	1.60	3.64
HP28	580–619	1.38	3.13
HP31	–	0.00	0.00
HP36	568–635	2.71	6.16
HP37	548–602	2.75	6.25
HP38	581–614	1.65	3.76

the $CaCO_3$ contents are high (6.25% and 5.01% respectively) yet the ash residue is only 2.2% higher in HP37 (than in NP7) and it is the same in HP18 as it is in NP7. At present there is no explanation for this discrepancy and further studies on more historic parchments need to be made. Correlations between calculated $CaCO_3$ content and determination of calcium content by X-ray analytical techniques could be made.

To summarize, the most valuable marker from thermogravimetric studies is the TS parameter. It distinguishes between parchments according to the following groupings:

- Group 1: NP7, HP20
- Group 2: HP36, HP8, HP37, HP16, HP22 (in order of decreasing thermal stability)
- Group 3: HP26, HP38, HP18, HP31, HP28, HP7 (in order of decreasing stability)

On this basis HP7 is the least thermally stable and NP7 is the most thermally stable. Group 3 contains the least thermally stable samples, including HP26. This appears in the PCA (Figs 8.19 and 8.20) as the most altered with respect to NP7. PCA also denotes HP20 as the least altered and according to the TS parameter it is as thermally stable as NP7. PCA also shows that HP22 is less altered than HP31 and it is also, according to the TS parameter, more thermally stable.

The PCA further distinguishes according to the following groups:

- Group1: NP7
- Group 2: HP20, HP22
- Group 3a: HP8, HP16, HP36 and HP38
- Group 3b: HP7, HP18, HP28, HP37 and HP31
- Group 4: HP26

This grouping has strong similarities with differentiation according to the TS parameter and may be more precise since the weight losses over the TGA curve in the broad region between 200 and 600°C have been included. The TS parameter was just calculated at the temperature at which residual weight corresponded to 48.2%.

Overall conclusions from thermomechanical and thermogravimetric measurements

The observations made on the parchments are summarized as follows. A description of the data collected is brought together with the observed physical characteristics.

NP7 physically is soft, flexible and smooth to the touch and beige in colour. Its moisture content is 4% and on heating it is the most thermally stable of the samples, with the oxidative degradation occurring at a higher temperature than the historic parchments. From the NMR data (discussed elsewhere in this book) it has the highest ratio of the peaks at 60/71, corresponding to a high ratio of (Pr +Hyp/Hyp) and also the highest ratio of peaks 43/71 (Gly/Hyp). In terms of its thermomechanical response, NP7 has two tan delta peaks at 25°C and 65°C. The latter corresponds, in polymer terms, to the glass transition temperature. At this temperature molecular motion of the intact polymer backbone in collagen occurs because of the amorphous phase. It has a high Young's modulus (but not the highest of the samples). It also has a high initial shrinkage temperature and high shrinkage ratio R. There is no evidence for the presence of $CaCO_3$.

HP20 was in many respects little changed from NP7. Physically it was also fairly flexible, with a beige upperside and yellow/brown underside. It was also thermally stable, with a TS only 2.9°C less than NP7 and was close to it on the PCA plot of the TGA data (Figs 8.19 and 8.20). Its moisture content was intermediate among the samples as were its NMR ratios (60/71) and (43/71). Its tan δ peaks and Young's modulus were similar to NP7. This indicates that there is a similar proportion of amorphous phase present. Its initial shrinkage temperature and R ratio from the creep measurements were lower than those of NP7, but intermediate in terms of the historic parchments. It also has a high (8.0%) $CaCO_3$ content.

HP22 was a sample similar in some of its measured properties to NP7 but different in others. Physically it was thicker, roughened and slightly translucent and it had a low Young's modulus. This indicates either that there is some cross-linking or crystallinity in the sample. Its two tan δ peaks occurred at higher temperatures than in NP7 (75,148 compared to NP7 25,65). In polymeric terms the presence of the tan δ peaks indicates that the sample contains some amorphous phase; the fact that transitions occur at higher temperatures indicates that the amorphous regions are cross-linked. It had intermediate values for (60/71) and (43/71) ratios from NMR, $CaCO_3$ content and TS parameter, although from the PCA plot of the TGA data (Figs 8.19 and 8.20) it was close to NP7. Its moisture content was also similar to NP7 as was its shrinkage behaviour. It had a high initial shrinkage temperature and shrinkage ratio R. Its drying time, as measured by dielectric techniques, was lower compared to HP8 and HP31, but not as low as for the unaged parchments tested, as expected from a cross-linked polymer.

HP7 (17th century) was interesting as in some parameters it was very similar to NP7 but in others completely different. Physically thicker than NP7, it was stiff and had a very high Young's modulus. It had the lowest TS, being 91.2°C less than NP7. Therefore in its chemical composition it is more altered than the other historic parchments. However, it had similar tan δ transitions to NP7 and a high initial shrinkage temperature and shrinkage ratio R. The similarity in mechanical behaviour suggests that the arrangement of the triplet sequence in collagen (Glyp-Pro-Hyp) has been retained. This may be due to its low $CaCO_3$ content and intermediate values of moisture content and NMR ratios (60/71) and (43/71).

HP26 was among the samples that differed greatly from NP7. This was a thin parchment with a mottled upperside and pale underside. It was among the less thermally stable samples according to TS and was clearly the most changed according to PCA of the TGA data (Figs 8.19 and 8.20). It also had one of the lowest (60/71 and 43/71) NMR ratios, i.e. low imino acid content. Its low value for Young's modulus indicates the presence of some non cross-linked amorphous phase. The peaks in tan δ are barely measurable which indicates presence of cross-linked and some crystalline phases. The presence of a tan δ peak of low intensity at the higher temperature 148°C indicates behaviour similar to transitions in dehydrated gelatin. Its low intensity can be due to low imino acid content. It has a higher than average moisture content (3.4%) with an intermediate $CaCO_3$ content. It also exhibits low initial shrinkage temperature (confirms gelatinization) and the lowest shrinkage ratio R. A low shrinkage ratio indicates a more random and disordered structure. Shrinkage occurs over a broad temperature range.

Sample HP28 is also highly changed compared with NP7. Physically it had a yellow/brown upperside and pale underside like HP26. It had a very low TS of −79.8°C, and was among the more changed according to PCA of the TGA data, although with a higher than average moisture content and average $CaCO_3$ content and an intermediate value for Young's modulus. It also had the lowest 60/71 ratio from the NMR data, implying higher hydroxyproline content than NP7. Its two tan δ peaks occurred at higher temperatures than in NP7 (90,140 compared to NP7 25,65). Its shrinkage behaviour was also very different to that of NP7, with initial shrinkage starting as soon as the sample was immersed in water at 30°C. It also had a low shrinkage ratio R (confirms gelatinization). A low shrinkage ratio again indicates a more random and disordered structure. Shrinkage occurs over a broad temperature range. Therefore to summarize these observations HP28 shows evidence of gelatinization. This is supported by transmission electron microscopy (TEM) observations reported elsewhere. Its raised level of Hyp determines the presence of more hard blocks and is responsible for the tan δ peak at 140°C.

HP36 was physically different to the other samples as it was thin and brittle, with an uneven texture and a low moisture content. Although it did not have a particularly low TS, it did have the lowest Young's modulus of the samples and a low (60/71) ratio from NMR (low imino acid ratio). In thermal DMTA scans it showed a large peak close to room temperature but less structure at higher temperature, implying the presence of more soft blocks (due to low imino acid ratio). From creep measurements it also had a very low initial shrinkage temperature, as HP28 (which confirms gelatinization, also reported by TEM) and a low shrinkage ratio R. It also has a high $CaCO_3$ content.

HP8 was unusual in that it originally had a thick white ground backing, which had to be removed, and was brittle. The protection of this backing may have contributed to the high moisture content that was measured. With the backing removed the $CaCO_3$ content was 5%. In most respects, however, it showed only moderate signs of ageing. The TS parameter (–26.4°C) shows a reduction in TS though not as great as in HP7 (–91.2). Its Young's modulus value was high and similar to that of NP7; its tan δ response was similar to NP7. This may mean, as in the case of HP7, that the triplet sequence in collagen (Glyp-Pro-Hyp) has been retained. The high modulus value may indicate some crystallinity. It was among the least changed according to NMR measurements. It did, however, have, as in the case of HP36, a low initial shrinkage temperature, but its shrinkage ratio R was higher than in HP36, which means that it has retained some behaviour that mechanically is similar to NP7.

HP16 was a much thicker parchment than NP7, stiff and slightly translucent, and had a low moisture content, although it had high NMR ratios (60/71 and 43/71), similar to NP7 and intermediate TS parameter. However, the Young's modulus was the highest of the samples and the DMTA thermal response showed only a single high temperature peak, indicating high crystallinity or cross-linking of the collagen. The presence of the high temperature tan δ peak is due to its imino acid content (hard blocks). Additionally, it had a low shrinkage temperature (35°C, also similar to HP8) and shrinkage ratio (0.54, similar to HP8) but greater than HP26, HP28 and HP36. It also has an average $CaCO_3$ content.

HP18 was another thick parchment (0.46mm), discoloured and stiff. Its moisture content and Young's modulus were average for the group, and its NMR ratios and TS parameter slightly lower than average, indicating that it had changed with respect to NP7. Its shrinkage temperature and ratio were also low (evidence for some gelatinization; confirmed by TEM). Its DMTA response showed two high temperature tan δ peaks, indicating the presence of more hard blocks in the gelatin or evidence of cross-linking. Its $CaCO_3$ content was higher than average.

HP31 was a pale, fibrous and slightly translucent parchment, with a very high Young's modulus but an average moisture content and NMR ratios. Its TS parameter, however, showed significant change from NP7 and its DMTA response gave two tan δ peaks of reasonable intensity (Fig. 8.6(a)) in the 86°C and 146°C temperature region. The intensity of the peaks indicates the presence of an amorphous phase and the higher temperature indicates cross-linking. Average NMR ratios suggest the presence of sufficient imino acids to give the hard blocks for the observable transitions. Its shrinkage temperature and ratio were fairly high, confirming its cross-linked nature. Like NP7, there was no measurable $CaCO_3$ content. Its drying time, measured by dielectric techniques, was higher than both HP22 and HP8.

HP37 (1841) was a thin, flexible parchment, with upper and lower sides similar. The moisture content was lower than average, as was the Young's modulus. However, the thermal stability was only slightly lowered compared to NP7, as were the NMR ratios; the shrinkage temperature and ratio were similar to NP7. The DMTA tan δ response, however, showed a dominant peak in the low temperature region (similar to HP36) and some indications of a peak at higher temperature. This indicates that there may be more soft blocks and lower imino acid content. The $CaCO_3$ content was also higher than most of the other samples.

HP38 was a thin and flexible parchment with beige upperside and mottled underside. The moisture content was lower than average, as was the thermal stability, although the Young's modulus and $CaCO_3$ content were average. The NMR ratios were intermediate, with the 60/71 ratio being slightly lower than average, and the 43/71 ratio higher than average. The DMTA thermal response was similar to HP37 though weaker in the lower temperature region (Fig. 8.6(b)). It may be more cross-linked or more crystalline. The initial shrinkage temperature at 50°C was average, but the shrinkage ratio R was high, being similar to that of NP7 (the triplet sequence in collagen (Glyp-Pro-Hyp) as in HP7 may be retained).

Principal component analysis (PCA)

Principal component analysis using MINITAB (Version 10.2) has been performed on the data obtained from the various measured thermomechanical, thermogravimetric and NMR parameters in order to reduce dimensionality of the data to a more readily interpretable form. The parameters act as descriptors yielding a multi-dimensional space that reflects the perturbed profile of the historic parchments in relation to the unaged sample. By analyzing all the data from the different measurements in one combined calculation, it was possible to get an overall picture of the degree of change between the modern and historic parchments.

The parameters used in the calculation were:

- Young's modulus
- Moisture content
- Thermal stability (TS)
- $CaCO_3$ content
- Initial shrinkage temperature (DMTA creep)
- Shrinkage ratio R
- Percentage displacement change on immersion
- NMR ratio 60/71
- NMR ratio 43/71
- NMR ratio (174+171)/71
- NMR ratio 174/171

The result is shown in Figure 8.21. The modern parchment NP7 is in the top right-hand corner of the plot. Variation along both the first and second principal components has significance in this case, although PC1 is of more importance. It can be seen that samples HP36, HP28 and HP7 are the most separated from the unaged parchment NP7, indicating that the overall degree of change in these samples was the greatest. HP28 is the most separated along both PC1 and PC2. By comparison, HP20 and HP22 show the least difference, with HP20 in particular showing little change along the PC1 axis.

HP7 and HP22 are differentiated from NP7 only along the PC1 axis and not the PC2 axis, since they differ from

Figure 8.21 PCA of the complete set of parameters from thermomechanical, thermogravimetric and solid state ^{13}C NMR data.

NP7 in their TS, for example, but in thermomechanical terms (e.g. shrinkage) they are all similar. HP36 differs in the opposite manner, since it has a similar TS but different shrinkage to NP7. It is therefore placed in the opposite corner of the plot to HP7. HP28, which has a much lower shrinkage temperature and TS than NP7, is therefore the most separated from it along both axes. The samples in the bottom left corner, such as HP28, HP18 and HP26, could also be among the most gelatinized samples.

References

Chan, T. Y. A., M. Odlyha and M. Scharff (1994) 'In situ non-invasive spectroscopy for monitoring conservation treatment of canvas paintings', Deutsche Gesellschaft für Zerstörungsfreie Prüfung, Berlin, pp. 510–20.

Cowie, J. M. G. (1973) *Polymers: Chemistry and Physics of Modern Materials*. Intertext, London, p. 232.

Flory, P. J. and O. K. Spurr (1960) *American Chemical Society* 83, pp. 1308–16.

Foster, G. M., R. Ibbett and M. Odlyha (n.d.) Birkbeck College, London, and Courtaulds Textiles, Coventry, UK, Internal Report.

Fraga, A. N. and R. J. J. Williams (1985) *Polymer* 26, pp. 113–18.

Haines, P. J. (1995) *Thermal Methods of Analysis: Principles, Applications and Problems*. Blackie Academic & Professional.

Megret, C. (1988) Thèse d'Université, Toulouse.

Odlyha, M. (1998) *Characterisation of Cultural Materials by Measurement of their Physicochemical Properties*, PhD Thesis, Birkbeck College, University of London.

Odlyha, M., G. M. Foster and M. Scharff (1996) 'Non-invasive evaluation of moisture sorption and desorption processes in canvases', *ICOM Committee for Conservation Preprints* 1, pp. 297–303.

Ramachandran, G. N. and A. H. Reddi (1976) *Biochemistry of Collagen*. Plenum Press, New York, pp. 1–40.

Rao, Ch. P., P. Balaram and C. N. R. Rao (1983) *International Journal of Biological Macromolecules* 5, pp. 290–95.

Sperling, L. H. (1986) *Introduction to Physical Polymer Science*. J. Wiley & Sons.

Widmann, G. and R. Riesen (1987) *Thermal Analysis Terms Methods Applications*, Dr A. Hüthig (ed.), Verlag Heidelberg.

III Chemical and Structural Characterization of Collagen and Palaeogenetics of Parchment

9 Amino Acid Analysis of New and Historical Parchments

René Larsen, Dorte V. Poulsen, Marie Vest and Arne L. Jensen

Introduction

Amino acid analysis performed by the very accurate high-performance liquid chromatography (HPLC) method based on post-column derivatization can be used in the study of oxidative breakdown patterns of proteins and individual amino acids. In connection with the hide protein collagen, this method has mainly been used in studies of the deterioration and conservation of vegetable-tanned leathers (Larsen 1987, 1994a, 1995, 1997; Larsen *et al.* 1989, 1994, 1997; Halpine 1998). These studies have shown that the amino acid distribution of tanned and untanned hide collagen may undergo drastic changes by exposure to electromagnetic radiation, heat and other oxidative environmental factors. Contrary to the oxidative breakdown, hydrolysis produced by acid pollution has proved not to lead to any significant changes of the amino acid distribution. On the other hand, it has been proved that acid pollution inhibits the oxidative breakdown of the collagen in general, and it may influence an oxidation pattern of individual amino acids (Larsen 1994a; Larsen *et al.* 1994).

The oxidative changes observed for tanned and untanned collagen are first of all significant decreases in the content of the basic amino acids Arg, Hyl, Lys and often in the amount of the imino acids Pro and Hyp. These decreases are accompanied by the formation of a significant amount of the acidic amino acids Asp and Glu and small amounts of several other breakdown products in the form of new amino acids. The type of these breakdown products strongly indicates that oxidative degradation takes place in both the main and side chains of the collagen. This leads to cleavage of the main chain into smaller peptide fragments as well as modification of chemical and physical nature of the collagen side chain including changes of the charge balance and cross-linking capabilities. Until now, no proper study has been made of the amino acid distribution of historical parchment.

This paper presents amino acid analyses made on microsamples taken directly from the corium part of the parchment. In addition, analyses are presented on soluble materials extracted from the parchment and standard reference collagen isolated by electrophoresis and blotting to a polyvinylidenefluoride (PVDF) membrane (Larsen *et al.* 2002). It was found that the analysed corium samples of parchment deviate significantly from vegetable-tanned leathers in their oxidative breakdown patterns. These and other results represent a good basis for a more detailed and systematic study of the causes and mechanisms of the deterioration, as well as for the development of optimal storage conditions and conservation methods of historical parchment objects.

Experimental

Sample preparation and hydrolysis

About 0.1mg of the parchment corium (flesh side) sample is taken out for analysis. Only the corium part of the material should be used as it consists mainly of collagen type I fibres. It is important to avoid the grain layer which may also contain elastin as well as keratin from remains of hairs and hair follicles. Parchment consists of almost horizontal layers of corium fibres which have to be separated from the grain layer, if this has not been scraped away during production. The sampling from heavily scraped parchment and thin parchment from small animals containing only a small amount of corium should be performed by taking out the corium fibres under a microscope.

The sample is hydrolyzed for 24 hours in an evacuated and sealed glass ampoule at 110°C in a solution consisting of 300µl 6M redistilled HCl, 15µl 2% 3,3'-dithiodipropionic acid (DTDPA) in 0.2 M NaOH and 15µl 1% phenol in water. Peptide bands cut from a PVDF membrane (Larsen 2002) are transferred into the glass tube and hydrolyzed according to the same procedure. However, the volumes are only 100µl with respect to HCl, 5µl DTDPA and 5µl phenol solution.

HPLC separation

After hydrolysis the amino acids are separated by ion exchange HPLC (Waters, USA) with two Waters high pressure pumps, equipped with high sensitivity pulse dampers

and micro-flow modules, Waters M 710, refrigerated auto sampler, two Eldex reagent pumps and a column oven. Separation takes place on a 12.5 × 0.46 steel column packed with MCI CK 10 U resin (Mitsubishi Chemical Industries) using a pH gradient system with two buffers (A, pH 3.10: 0.20 sodium citrate containing 0.05 % phenol and 5 % isopropanol. B, pH 10.20: 0.210 M sodium borate, 5 % isopropanol). The eluated amino acids are quantified after derivatization with ortho-phthaldialdehyd (OPA). The detector is a Waters M 420 fluorescence detector with 338-nm bandpass excitation filter and 455nm long-pass emission filter. The amino acids are identified and quantified on the basis of an external standard mixture of amino acids (Beckman no 33 1018, added Hyp, Hyl, α-Ada, α-Abu, β-Ala, γ-Abu, 6-Aha and Orn).

The deviation of the total analysis is normally below 3%. The determined amino acids and their standard abbreviations are listed in Table 9.1. The results are reported as % mol. In addition is reported the ratio between the sum in % mol of basic (B) and the sum in % mol of acidic (A) amino acids B/A =ΣArg, Hyl Lys /ΣAsp, Glu (Larsen *et al.* 1989). The B/A ratio is about 0.7 for intact hide and leather collagen and the value decreases with increasing oxidation. Thus, B/A values below 0.5 have been observed in very deteriorated leathers. Figure 9.1 shows a HPLC chromatogram of corium collagen from a historical parchment.

Table 9.1 Amino acids determined by amino acid analysis and their standard abbreviations.

Alanine	Ala
Arginine	Arg
Aspartic acid/Asparagine*	Asp
Cysteine/half cystine**	(TPC)
Glutamic acid/Glutamine*	Glu
Glycine	Gly
Histidine	His
Hydroxylysine	Hyl
Hydroxyproline	Hyp
Isoleucine	Ile
Leucine	Leu
Lysine	Lys
Methionine	Met
Phenylalanine	Phe
Proline	Pro
Serine	Ser
Threonine	Thr
Tyrosine	Tyr
Valine	Val
α-amino adipic acid	α-Ada
α-amino buteric acid	α-Abu
β-alanine	β-Ala
γ-amino buteric acid	γ-Abu
6-amino hexanoic acid	6-Aha
Ornithin	Orn
(Arg + Hyl + Lys)/(Asp + Glu)	B/A

*Determined as aspartic and glutamic acid
**Determined as Thio Propionic Cystein (TPC) (Barkholt and Jensen 1989)

Results

New parchment

Collagen is especially characterized by its high content of glycine (about one-third of the amino acids); it also contains hydroxyproline and hydroxylysine. Table 9.2 shows the amino acid distribution of seven new calfskin parchments. In Table 9.3 the mean amino acid distribution of the seven new parchments is compared with calfskin collagen type I model (Larsen 1994b, 1995) and the mean values of new leathers and untanned skins (Larsen *et al.* 1997).

Historical parchments

Table 9.4 shows the amino acid distribution range of 52 samples of historical parchments from the sample bank

Figure 9.1 HPLC chromatogram showing the amino acid distribution of historical parchment.

Table 9.2 Amino acid distribution in % nmol of new reference parchment from the sample bank with the standard deviation in parentheses.

	NP1	NP2	NP3	NP4	NP5	NP6	NP7	Mean
Hyp	9.64	9.73	9.62	9.85	9.80	9.27	9.34	9.59 (0.23)
Asp	4.60	4.62	4.79	4.71	4.59	4.56	4.65	4.65 (0.08)
Thr	1.70	1.73	1.75	1.72	1.92	1.72	1.71	1.75 (0.08)
Ser	3.41	3.51	3.62	3.59	3.30	3.49	3.54	3.50 (0.11)
Glu	7.40	7.46	7.25	7.24	7.19	7.50	7.64	7.37 (0.17)
Pro	12.41	12.21	12.03	11.96	11.92	11.95	11.92	12.01 (0.16)
Gly	33.01	32.75	33.08	33.27	33.67	33.61	33.30	33.30 (0.31)
Ala	10.77	10.92	10.64	10.67	10.83	10.69	10.34	10.67 (0.18)
Val	2.07	2.09	2.05	2.00	2.00	2.16	2.09	2.06 (0.06)
Met	0.60	0.59	0.69	0.66	0.64	0.66	0.68	0.65 (0.03)
Ile	1.23	1.23	1.25	1.22	1.10	1.25	1.27	1.22 (0.06)
Leu	2.47	2.52	2.61	2.56	2.52	2.52	2.56	2.54 (0.04)
Tyr	0.31	0.32	0.45	0.44	0.32	0.36	0.42	0.38 (0.06)
Phe	1.28	1.29	1.33	1.31	1.25	1.30	1.32	1.30 (0.03)
His	0.62	0.59	0.58	0.54	0.55	0.63	0.63	0.59 (0.04)
Hyl	0.67	0.69	0.73	0.77	0.54	0.72	0.73	0.69 (0.08)
Lys	2.62	2.60	2.60	2.55	2.70	2.58	2.68	2.62 (0.05)
Arg	5.03	4.99	4.90	4.94	5.01	4.86	4.98	4.95 (0.06)
α-Ada	0.00	0.00	0.00	0.00	0.00	0.00	0.00	0.00 (0.00)
α-Abu	0.00	0.00	0.00	0.00	0.00	0.00	0.00	0.00 (0.00)
β-Ala	0.00	0.00	0.00	0.00	0.01	0.00	0.00	0.00 (0.00)
γ-Abu	0.00	0.00	0.04	0.02	0.04	0.06	0.08	0.04 (0.03)
6-Aha	0.00	0.00	0.00	0.00	0.00	0.02	0.02	0.01 (0.01)
Orn	0.16	0.15	0.04	0.04	0.10	0.10	0.09	0.09 (0.04)
B/A	0.69	0.69	0.68	0.69	0.70	0.68	0.68	0.69 (0.01)

Table 9.3 The amino acid distribution of calf collagen type I model, new calfskin parchment and new leather and untanned skins. Standard deviations in parentheses.

	Model Count	Model (%)	Parchment (%)	Leather and skin (%)
Hyp	297	9.42	9.59 (0.23)	9.42 (0.15)
Asp	139	4.41	4.65 (0.08)	4.61 (0.05)
Thr	53	1.68	1.75 (0.08)	1.69 (0.03)
Ser	110	3.49	3.50 (0.11)	3.20 (0.05)
Glu	229	7.26	7.37 (0.17)	7.49 (0.06)
Pro	388	12.31	12.01 (0.16)	12.34 (0.09)
Gly	1037	32.89	33.30 (0.31)	33.28 (0.61)
Ala	355	11.26	10.67 (0.18)	10.89 (0.12)
Val	72	2.28	2.06 (0.06)	2.13 (0.04)
Met	19	0.6	0.65 (0.03)	0.61 (0.04)
Ile	36	1.14	1.22 (0.06)	1.21 (0.03)
Leu	77	2.44	2.54 (0.04)	2.50 (0.05)
Tyr	14	0.44	0.38 (0.06)	0.41 (0.03)
Phe	41	1.3	1.30 (0.03)	1.31 (0.03)
His	18	0.57	0.59 (0.04)	0.54 (0.02)
Hyl	23	0.73	0.69 (0.08)	0.72 (0.05)
Lys	83	2.63	2.62 (0.05)	2.62 (0.05)
Arg	162	5.14	4.95 (0.06)	5.04 (0.06)
B/A		0.73	0.69	0.69 (0.004)

and two sets of 20 samples of historical vegetable-tanned leathers. Some of the historical parchments are dated from the Middle Ages to 1790. Although several are of unknown age, their dates are estimated to be within the same time period according to their visual appearance. The historical leathers are dated from around 1550 to 1890 (I) and 1932 (II), respectively (Larsen *et al.* 1994, 1997; Larsen 1995). The most prominent differences between the parchments and the leathers are marked by grey shading.

Selected historical parchments

Table 9.5 shows the amino acid distribution of the 12 selected historical parchments from the sample bank.

Discussion

New parchment

In general, the results of the analysis of the seven new parchment samples presented in Table 9.2 are very close to the amino acid distribution of the collagen model and mean values of leather and raw hide shown in Table 9.3. However, the standard deviations on some of the amino acids are higher than those of new leathers and untanned skins. This indicates a greater variation in the amino acid distribution of the collagen. The cause of this may be the method of traditional parchment production which is based on prolonged liming under not very controllable conditions. This may lead to oxidative changes of the collagen as indicated by the relative low B/A and Pro values as well as the amount of breakdown products observed in some of the samples.

Historical parchments

The historical parchment samples analysed constitute a good source for future analyses to provide more information on the oxidative changes of the collagen. In general, the samples show relatively high variations in the degree of

oxidation. Thus the B/A ratio ranges from 0.52 to 0.68 (Table 9.4). The B/A of the older historical vegetable-tanned leathers varies from 0.45 to 0.60. Moreover, there are some clear connections between the degree of oxidation of the parchment collagen and their hydrothermal stability measured by the micro hot table (MHT) method. The lowest B/A ratios are observed for the most damaged parchments (those which gelatinize on contact with water and have no detectable shrinkage activity, and those which have no detectable main shrinkage interval). The B/A of the former

Table 9.4 Range in amino acid distribution in % nmol of historical parchments and historical vegetable-tanned leathers. The amino acids which differ most in historical parchment compared to historical leather are marked by grey shading.

Reference	New parchment		Historical parchments (HP1–HP48) Middle-age	Historical vegetable tanned leathers (I) 1550–1890	Historical vegetable tanned leathers (II) 1932
Hyp	9.59	(0.23)	8.89–10.37	8.92–10.02	8.64–9.41
Asp	4.65	(0.08)	4.41–5.37	4.69–5.25	4.54–4.73
Thr	1.75	(0.08)	1.66–2.03	1.68–2.00	1.84–1.91
Ser	3.50	(0.11)	3.16–3.86	3.11–3.64	2.86–3.02
Glu	7.37	(0.17)	6.75–7.64	7.54–8.34	7.51–7.94
Pro	12.01	(0.16)	10.01–12.58	11.43–12.42	12.17–12.67
Gly	33.30	(0.31)	32.19–36.08	32.67–34.06	33.47–34.45
Ala	10.67	(0.18)	10.31–11.92	10.95–11.44	10.63–11.05
Val	2.06	(0.06)	1.96–2.78	1.98–2.31	2.09–2.18
Met	0.65	(0.03)	0.40–0.68	0.31–0.59	0.52–0.62
Ile	1.22	(0.06)	1.08–1.44	1.17–1.40	1.08–1.14
Leu	2.54	(0.04)	2.20–3.03	2.39–2.77	2.39–2.55
Tyr	0.38	(0.06)	0.09–0.59	0.21–0.41	0.31–0.41
Phe	1.30	(0.03)	1.09–1.49	1.21–1.36	1.24–1.31
His	0.59	(0.04)	0.10–0.59	0.40–0.56	0.49–0.56
Hyl	0.69	(0.08)	0.43–0.73	0.40–0.61	0.43–0.55
Lys	2.62	(0.05)	1.68–2.54	1.57–2.27	1.89 2.54
Arg	4.95	(0.06)	4.09–4.99	4.11- 4.79	4.65–5.04
α-Ada	0.00	(0.00)	0.00–0.08	n.d.	0.00–0.07
α-Abu	0.00	(0.00)	0.00–0.72	n.d.	0
β-Ala	0.00	(0.00)	0.00–0.20	0.01–0.10	0.01–0.03
γ-Abu	0.04	(0.03)	0.00–0.46	n.d.	0.02–0.43
6-Aha	0.01	(0.01)	0.00–0.03	0.02–0.68	n.d.
Orn	0.09	(0.04)	0.05–0.28	0.06–0.34	0.10–0.24
B/A	0.69	(0.01)	0.52–0.68	0.45–0.60	0.58–0.66

Table 9.5 Amino acid distribution in % nmol of the 12 selected historical parchments from the sample bank.

	Ref. (std)		HP7	HP8	HP16	HP18	HP20	HP22	HP26	HP28	HP31	HP36	HP37	HP38
Hyp	9.59	(0.23)	8.89	9.61	9.65	9.93	9.82	9.71	10.02	9.89	9.69	9.58	9.95	10.02
Asp	4.65	(0.08)	5.37	4.74	4.94	4.70	4.66	4.68	4.76	4.88	4.66	5.16	4.72	4.62
Thr	1.75	(0.09)	1.78	1.71	1.67	1.93	1.93	1.82	1.98	1.97	1.67	1.95	1.93	1.91
Ser	3.50	(0.11)	3.37	3.50	3.34	3.18	3.28	3.39	3.24	3.20	3.47	3.27	3.25	3.26
Glu	7.38	(0.17)	7.49	7.22	7.56	7.60	7.44	7.59	7.64	7.80	7.43	7.52	7.44	7.44
Pro	12.0	(0.16)	10.23	12.17	11.92	12.08	12.30	12.20	11.64	11.73	12.18	11.42	12.66	11.98
Gly	33.30	(0.30)	35.83	33.50	34.47	33.88	34.04	33.36	33.84	33.79	33.85	35.22	33.71	34.13
Ala	10.67	(0.18)	11.73	10.88	10.94	10.90	10.86	10.81	10.88	10.69	10.56	11.12	10.78	10.96
Val	2.06	(0.6)	2.06	2.07	2.08	2.06	2.04	2.10	2.12	2.13	2.02	2.10	2.04	2.06
Met	0.65	(0.03)	0.40	0.59	0.53	0.60	0.59	0.60	0.64	0.62	0.62	0.49	0.61	0.60
Ile	1.22	(0.06)	1.15	1.23	1.21	1.14	1.13	1.19	1.19	1.21	1.20	1.13	1.12	1.10
Leu	2.54	(0.04)	2.30	2.52	2.43	2.50	2.58	2.62	2.60	2.64	2.46	2.45	2.46	2.46
Tyr	0.38	(0.06)	0.12	0.32	0.20	0.20	0.30	0.35	0.22	0.23	0.40	0.20	0.22	0.27
Phe	1.30	(0.03)	1.17	1.29	1.23	1.20	1.23	1.29	1.23	1.23	1.28	1.23	1.20	1.21
His	0.59	(0.04)	0.17	0.47	0.09	0.34	0.46	0.52	0.38	0.21	0.46	0.14	0.45	0.41
Hyl	0.69	(0.08)	0.70	0.65	0.59	0.55	0.52	0.60	0.54	0.57	0.66	0.44	0.50	0.55
Lys	2.62	(0.05)	1.96	2.52	2.22	2.28	2.26	2.23	2.30	2.44	2.38	1.85	1.96	1.90
Arg	4.95	(0.06)	4.19	4.92	4.72	4.69	4.39	4.80	4.51	4.47	4.96	4.29	4.87	4.87
α-Ada	0.00	(0.00)	0.07	0.00	0.07	0.00	0.00	0.00	0.00	0.00	0.00	0.12	0.00	0.00
α-Abu	0.00	(0.00)	0.59	0.00	0.01	0.00	0.00	0.00	0.00	0.02	0.00	0.13	0.00	0.00
β-Ala	0.002	(0.006)	0.19	0.01	0.02	0.00	0.00	0.00	0.00	0.02	0.00	0.07	0.00	0.01
γ-Abu	0.038	(0.03)	0.10	0.03	0.08	0.03	0.04	0.02	0.02	0.03	0.00	0.10	0.00	0.06
6Aha	0.005	(0.008)	0.01	0.00	0.00	0.00	0.01	0.01	0.02	0.02	0.00	0.01	0.02	0.02
Orn	0.088	(0.04)	0.18	0.11	0.08	0.22	0.12	0.11	0.22	0.29	0.05	0.09	0.11	0.14
B/A	0.69	(0.009)	0.53	0.68	0.60	0.62	0.59	0.62	0.59	0.59	0.66	0.52	0.60	0.61

ranges from 0.52 to 0.57 (4 samples). For the latter (5 samples) the B/A ranges from 0.56 to 0.59. However, there are samples with a very low hydrothermal stability (10 samples) which have rather high B/A ratios. The T_s values range from 31.2°C to 39.6°C and the B/A from 0.60 to 0.67. For these samples the main reason for the low hydrothermal stability must be hydrolysis rather than oxidative breakdown of the collagen.

As for the vegetable-tanned leathers, a decrease in the values of Pro, His, Hyl, Lys and Arg is observed. These are followed by an increase in Asp and Glu and the formation of small amounts of breakdown products in the form of new amino acids. However, there are strong indications that the oxidative breakdown pattern of parchment collagen differs from that of vegetable-tanned leathers. The large decreases in His and Tyr in several parchment samples are far beyond those observed for vegetable-tanned leathers. In some cases the content of His is decreased by 4/5 and Tyr by more than ½. In addition, the low His and Tyr values are not always followed by corresponding low values of Pro, Hyl, Lys and Arg, indicating variations in the oxidative breakdown pattern. The decrease in Tyr is interesting, as this amino acid, apart from one residue in the helical part of the α2-chain, is normally present only in the telopeptides (N- and C-terminals of the α1 and the C-terminal of the α2 chain). Tyr appears in position C4 in both chains, therefore, there may be good possibilities for cross-linking by the formation of di- or tri-tyrosin (Waykole *et al.* 1976). This would probably cause increased insolubility as observed for some of the samples. The decrease in His and Hyl indicates that a relative higher degree of oxidation may take place in the α2- compared to the α1- chain, as these appear in greater numbers in the α2-chain (12/3 for His and about 10/4 for Hyl). Moreover, the content of Pro is in general lower in the parchments than in the leather samples. On the other hand, the Hyp values are, in several cases, higher than that of the new parchment reference. This indicates that Hyp may be formed by hydroxylation of Pro. This is supported by the fact that the value of Pro is lower than in the new reference in most of the samples, and that the sum of Hyp and Pro is only in a few cases significantly lower than the reference value, indicating that the rate of the further deterioration of these may be low.

Figure 9.2 Plot of the T_s (Co) versus the B/A ratio.

Selected historical parchments

The results for the selected historical parchment samples in Table 9.5 confirm the previous analyses. This also includes very low values of Tyr and His in several of the samples, in particular the extremely low His value of HP16 (0.09). The selection of these samples was made on the basis of their hydrothermal stability to ensure that they represent a broad variation in the degree of deterioration. This is also the case with respect to the general degree of oxidation represented by the B/A ratio which ranges from 0.52 to 0.68. However, apart from sample HP36, which has the lowest B/A and gelatinizes by contact with water, there is no simple correlation between the B/A and T_s of the samples. Figure 9.2 shows a plot of the T_s versus the B/A ratio. As seen, the samples are grouped into six groups. These can roughly be grouped according to whether combinations of B/A and T_s are high (H), medium (M) or low (L) (Table 9.6).

The condition of the samples with high B/A and T_s are comparable to new parchments. For the samples with high and medium B/A values, hydrolysis is probably the main reason for the fall in T_s. Low B/A indicates higher influence

Table 9.6 Grouping with the values of T_s, B/A, Pro, Tyr, His, Hyl, Lys and Arg. For the two groups M/H and M/L the values are given as means.

Group B/A/Ts	H/L	L/H	H/M	M/H	M/L	L/M
Sample	HP8	HP7	HP31	HP22, HP37, HP38	HP16, HP18, HP26, HP28	HP20
B/A range	0.68	0.53	0.66	0.60–0.62	0.59–0.62	0.57
Ts range	40.2	56.3	53.4	56.1–64.2	33.8–41.3	52.8
B/A	0.68	0.53	0.66	0.61	0.6	0.57
Ts	40.2	56.3	53.4	61.0	38.3	52.8
Pro	12.17	10.23	12.18	12.28	11.84	12.3
Tyr	0.32	0.12	0.40	0.28	0.21	0.30
His	0.47	0.17	0.46	0.46	0.25	0.46
Hyl	0.65	0.70	0.66	0.55	0.56	0.52
Lys	2.52	1.96	2.38	2.03	2.30	2.26
Arg	4.92	4.19	4.96	4.85	4.60	4.39

on the hydrothermal stability from oxidation. However, decrease in the B/A value may also reflect inter- and intra-molecular cross-links formed in the collagen (Waykole *et al.* 1976; Tanzer 1973; Heidemann and Linnert 1984; Gorham *et al.* 1992). These may lead to less drastic falls in the hydrothermal stability. In general, the groups of samples represent different patterns of oxidative modification of the collagen. This is clearly reflected in the variations of the values of the individual amino acids. However, there seems to be some connection between the decrease in Pro, Tyr, His and Arg. The different oxidative patterns are also reflected in the variations in the content of breakdown products as seen in Table 9.5.

Oxidative breakdown of parchment

As mentioned, the oxidative breakdown can be measured by amino acid analyses, as this form of deterioration, contrary to hydrolytic deterioration, involves a modification of the amino acids in the collagen. The oxidation of parchment collagen may occur in many ways. Cleavage of the peptide main chain may be due to oxidation of the α-carbon atom, and this may lead to the formation of some of the breakdown products detected by the amino acid analysis. However, oxidative decomposition of the side chains of the amino acids also takes place as indicated by other types of breakdown products. The possible oxidative reaction ways are outlined below in a simple form:

1. Lys → alloHyl → Asp, α-Aaa, 6Aha, Glu
2. Arg → Orn → Glu
3. Pro → 3Hyp → γ-Abu → β-Ala
4. Arg → Orn → γ-Abu → β-Ala
5. His → Asp, γ-Abu, Glu, 2-Iea, Orn

where α-Aaa = α-amino adipic acid; 6Aha = 6amino hexanoic acid; γ-Abu = γ-amino butyric acid; β-Ala = β-alanine; 2-Iea = 2-imidazole ethanoic acid; Orn = Ornithine.

The formation of 6-Aha in reaction 1), β-Ala and γ-Abu in reactions 3) and 4) and 2-Iea in reaction 5) are only possible by the oxidation of the α-carbon atom, which leads to cleavage of the peptide chain. The formation of other types of breakdown products in the form of amino acids may be possible. Many of the above mentioned breakdown products contain acidic side chains. This means that the charge balance of the collagen is altered and the isoelectric point of the collagen is shifted further towards the acidic area. This may weaken the physical stability of the parchment leading to, for example, a decrease in the hydrothermal stability.

bution of the collagen model and mean values of leather and raw hide shown. However, the larger standard deviations of some of the amino acids indicate a greater variation in the amino acid distribution of the collagen in the parchment samples. This may be due to the traditional method of parchment production, which in some cases may lead to oxidative changes of the collagen as indicated by the relatively low B/A, Pro values and the relatively high amounts of breakdown products observed in some of the samples.

Detailed information on the oxidative deterioration based on the amino acid analysis of the corium collagen from historical parchments have been obtained. Some of the oxidative breakdown patterns are similar to those observed for historical vegetable-tanned leathers. First of all these are decreased values of the basic amino acids and in some cases proline and hydroxyproline. This is followed by increased values of the acidic amino acids, aspartic acid and glutamic acid together with the presence of small amounts of breakdown products in the form of non-genetic amino acids. However, in general the decrease in the B/A ratio, which reflects the overall degree of oxidation of the collagen, tends to be less for the historical parchment than for the leather. On the other hand, the decrease in Pro tends to be greater in the parchment samples. In addition, very drastic decreases in the values of Tyr and His are observed in several of the analysed parchment samples. These changes are normally not observed in historical leathers, and indicate that a relatively higher degree of oxidation may take place in the α2- compared to the α1- chain of the collagen. Moreover, the main parts of Tyr are present only in the telopeptides, and their locations in these provide good possibilities for intra- and inter-molecular cross-links. This would probably cause increased insolubility as observed for some of the samples. In general, the results show that the present method of amino acid analysis provides a very fine tool in a detailed and systematic study on the causes and mechanisms of the oxidative deterioration, as well as for the development of optimal storage conditions and conservation methods of historical parchment objects.

References

Barkholt, V. and A. L. Jensen (1989) 'Amino acid analysis: determination of cysteine plus half-cystine in proteins after hydrochloric acid hydrolysis with a disulfide compound as additive', *Analytical Biochemistry* 177, p. 318.

Gorham, S. D., N. D. Light, A. M. Diamond, M. J. Willins, A. J. Bailey, T. J. Wess and N. J. Leslie (1992) 'Effect of chemical modifications on the susceptibility of collagen to proteolysis. II. Dehydrothermal crosslinking', *International Journal of Biological Macromolecules* 14, p. 129.

Halpine, S. M. (1998) 'HPLC application in art conservation', in E. Katz (ed.) *Handbook of HPLC*. New York, ISBN 0-8247-9444-3, p. 903.

Heidemann, E. and N. Linnert (1984) 'Participation of the á2(I) chain of bovine skin collagen in the formation of mature crosslinks', *Zeitschrift für physiologische Chemie* 365, p. 781.

Larsen, R. (1987) 'Similarities and differences in the amino acid composition of new, historical and aged leather', *Sixth International Restorer Seminar 13–23 July 1987*, Vezprem, Hungary, pp. 205–21.

Conclusion

The HPLC method based on post-column derivatization and the pH gradient system offers very accurate amino acid analysis of parchment with sample amounts around 0.1mg. In general, the results of the analysis of the new parchment samples presented are comparable to the amino acid distri-

Larsen, R. (1994a) 'Summary, discussion and *conclusion*', *STEP Leather Project, European Commission DG XII*, Research Report No.1, The Royal Danish Academy of Fine Arts, School of Conservation, Denmark, 1994, ISBN 87-89730-01-1, p.165.

Larsen, R. (1994b) 'The possible link between the collagen sequence and structure and its oxidative deterioration pattern', *STEP Leather Project, European Commission DG XII*, Research Report No.1, The Royal Danish Academy of Fine Arts, School of Conservation, Denmark, ISBN 87-89730-01-1, p. 59.

Larsen, R. (1995) 'The mechanisms of deterioration', *Fundamental Aspects of the Deterioration of Vegetable Tanned Leathers*, PhD Thesis, The Royal Danish Academy of Fine Arts, School of Conservation, Denmark, 1995. ISBN 87-89730-20-8, p. 69.

Larsen, R. (1997) 'General discussion in deterioration and conservation of vegetable tanned leathers', *ENVIRONMENT Leather Project, European Commission DG XII*, Research Report No. 6, The Royal Danish Academy of Fine Arts, School of Conservation, Denmark, ISBN 87-89730-07-0, p. 167.

Larsen, R., V. Barkholt, and K. Nielsen (1989) 'Amino acid analysis of leather: preliminary studies in deterioration, accelerated ageing and conservation of vegetable tanned leather', *Das Leder* 40, p. 153.

Larsen, R., D. V. Poulsen and M. Vest (2002) 'SDS-PAGE and 2D electrophoresis'. This volume, pp. 133–47.

Larsen, R., M. Vest, K. Nielsen and A. L. Jensen (1994) 'Amino acid analysis', *STEP Leather Project, European Commission DG XII*, Research Report No.1, The Royal Danish Academy of Fine Arts, School of Conservation, Denmark, ISBN 87-89730-01-1, p. 39.

Larsen, R., M. Vest, D. V. Poulsen, U. B. Kejser and A. L. Jensen (1997) 'Amino acid analysis in deterioration and conservation of vegetable tanned leathers', *ENVIRONMENT Leather Project, European Commission DG XII*, Research Report No. 6, The Royal Danish Academy of Fine Arts, School of Conservation, Denmark, ISBN 87-89730-07-0, p. 39.

Tanzer, M. L. (1973) 'Cross-linking of collagen', *Science* 180, p. 561.

Waykole, P. *et al.* (1976) 'Die Veränderung des Kollagens bei Einwirkung von Oxidationsmitteln, 2. Mitteilung', *Das Leder* 29, p. 190.

10 ^{13}C and ^{15}N Solid State Nuclear Magnetic Resonance (NMR) Spectroscopy of Modern and Historic Parchments

Marianne Odlyha, Neil Cohen, Gary Foster, Roberto Campana and Abil Aliev

Introduction

Unaged parchment, derived from animal hide, contains the viscoelastic polymeric material collagen. The preparation of parchment involves the following. After liming the skin is washed, stretched under tension on a frame and any remaining flesh is smoothed with chalk (Bowden and Brimblecombe 1999). On drying, the material becomes rigid and inflexible. The degree of flexibility and malleability associated with parchment will depend on the condition of the collagen and its moisture content. On ageing, parchment loses the well-ordered triple helical conformation of the collagen to form random coils (gelatin) (Mills and White 1994); it has also been observed that many parchments have converted completely to soluble gelatin (Larsen *et al.* 2002).

Collagen molecules consist of polypeptide chains where every third position is usually occupied by the amino acid residue glycine. Other imino acid residues that play an important role in the assembly of the helix are proline and hydroxyproline (Nakamura 1987; Young 1999). Collagen structure (Type I) has a triplet amino acid repeat (Gly-X-Y) where X and Y are often proline and hydroxyproline. The presence of glycine as every third residue of the molecule allows formation of the triple-helical structure which constitutes more than 95% of the molecule (Traub and Piez 1971). Because of steric considerations only glycyl residues are able to occupy positions within the core (backbone) of the molecule where they participate in interchain hydrogen bonds that stabilize the helix. In contrast, the side chains of the X and Y residues are on the surface of the molecule. The intermolecular interactions of these amino acid side chains on the surface of the molecule are thought to be important for fibril formation and for the stability and structure of collagen fibrils. Collagen as -(Gly-A-B)x- (Gly-Pro-HyPro)y- with glycine at every third position are known as soft blocks and with proline every third position are known as rigid blocks.

Nuclear magnetic resonance (NMR) spectroscopy is a non-destructive technique that can yield information on the chemical environment and mobility of the nuclei in a system (Harris 1993). It has previously been used to study organic compounds in non-metallic historical seals (Cassar *et al.* 1983). In this project, solid state ^{13}C and ^{15}N NMR was used to study parchment samples as received to determine the state of deterioration through analysis of changes in the chemical environment of the carbon and nitrogen atoms of the collagen polymer.

Experimental

Fourier transform high resolution solid state NMR spectra were obtained under conditions of magic angle spinning (MAS) (the sample is spun at an angle of 54°44' to the magnetic field to remove all anisotropy effects from the spectrum) with first, cross polarization and secondly with power dipolar decoupling. Cross polarization (CP) involves the transfer of polarization from proton to carbon nuclei by spin diffusion. CP of carbons by protons is a practical way of obtaining high sensitivity natural abundance ^{13}C NMR spectra of solids. The dipolar decoupling experiment generates the carbon magnetization by a single 90° pulse on the carbons followed by a decoupling pulse on the protons for the duration of the acquisition. In general, these two experiments discriminate between mobile and immobile nuclei on the basis of their relaxation times.

CPMAS and single-pulse MAS/decoupling ^{13}C NMR spectra were recorded at 75.5MHz (7.05T) on a Bruker MSL300 spectrometer using a standard Bruker magic angle sample spinning (MAS) probe with double-bearing rotation mechanism. The samples were fitted into the cylindrical zirconia rotor (7mm external diameter) and then spun at MAS frequency 4.5–7kHz (with stability better than ca. ±2Hz). All spectra were recorded at ambient probe temperature, except for HP16, where additional spectra were collected at 353°K and 373°K. The ^{13}C and ^{15}N chemical shifts are given relative to tetramethylsilane and nitromethane respectively.

Results (^{13}C NMR spectra)

Standard material: typical CPMAS spectrum of collagen

In Figure 10.1 the ^{13}C CPMAS spectrum of a modern parchment NP7 is presented. The features are similar to those of a rabbit-skin glue film (10% by weight) previously tested in our laboratory and also to published work on canine Achilles tendon (Fyfe 1983). The spectral peaks may be assigned to functional groups of the component amino acid residues (Fyfe 1983). Assignation of carbon resonances of the various amino acid residue carbons were made on the basis of ^{13}C chemical shifts for amino acids in aqueous media at various pH values (Kalinowski et al. 1988). When an amino acid is incorporated into a peptide, the more distant carbons of the side chain are only slightly affected, whereas the C-2 carbon is shifted by about –1 ppm, the C-3 carbon by about +1 ppm and the CO of the peptide bond by between 0.1 and –0.5 ppm (Kalinowski et al. 1988).

The ^{13}C NMR spectrum can be subdivided, based on chemical shift considerations, into specific regions. The aliphatic carbon region from about 10 to 70 ppm contains the peptide aliphatic carbons and this gives rise to the amino acid carbon resonances. The peaks, apart from the one at 71 ppm, are not fully resolved. Initial assignment was based on ^{13}C chemical shifts for amino acids in aqueous media at various pH values, as shown in Table 10.1 (a and b) (Kalinowski et al. 1988) and for those known to be present in collagen at concentration levels above 5%.

As shown in Table 10.1 (a) the sharp peak at 43 ppm can be attributed to the C-2 of glycine.

The resolved peak at 71 ppm was allocated to C-4 of hydroxyproline. Its neighbouring peak at 60 ppm contains contributions from the C-2 of both proline and hydroxypro-

Figure 10.1 Typical ^{13}C NMR CPMAS spectrum of parchment (NP7).

Figure 10.2 CPMAS ^{13}C NMR spectra for solid proline (upper spectrum) and NP7 (lower spectrum).

line. Smaller broader shoulder peaks at (1) 55 and (2) 47 ppm contain contributions from (1) alanine (C-2), arginine (C-2) aspartic acid (C-2), hydroxyproline (C-5), glutamic acid (C-2) and (2) proline respectively (C-5).

The peak at 43 ppm also contains a contribution from the C-5 of arginine. It has a shoulder peak at 38 ppm that contains contributions from aspartic (C-3) and glutamic acid (C-4) and hydroxyproline (C-3). The next two features appear as two sharp peaks at 30 and 25 ppm respectively. The peak at 30 ppm contains arginine (C3) glutamic acid (C-3) and proline (C-3) and that at 25 ppm contains proline (C-4) and arginine (C-5). The small peak at 17 ppm contains the contribution from C-3 of alanine. The sharp peaks of solid proline can be seen in Figure 10.2, in comparison to NP7.

Some samples showed an additional sharp and intense peak at 33 ppm. It is most evident in samples HP18 and HP28 and is also clearly evident in HP26. It appears to a lesser extent in HP7, HP20, HP22, HP31, HP36 and HP38. It is not clearly visible in NP7, HP16 and HP37. An explanation for this peak is not readily available. It could arise from internal pH changes which would cause contributions from glutamic acid (C-3) to appear at 33 ppm, or from the presence of some impurity, e.g. a small molecule with a long relaxation time, hence the sharp peak.

Beyond the aliphatic region lies the region 100–160 ppm which includes double bond (alkenic) and aromatic carbons, e.g. C-6 of arginine. In the unaged parchment sample (NP7)

Table 10.1 (a) NMR peak assignations (ppm) for glycine (b) NMR peak assignations (ppm) for proline and hydroxyproline (after Kalinowski et al. 1988).

(a)

Glycine		pH	C-1	C-2
H$_2$C—COOH, NH$_2$		0.45	171.2	41.5
		4.53	173.6	42.8
		12.01	182.7	46.0

(b)

		C-1	C-2	C-3	C-4	C-5
Proline	saturated solution zwitterion form	175.2	62.4	30.3	25.0	47.4
Hydroxyproline	saturated solution zwitterion form	175.2	61.1	38.7	71.3	54.2

small peaks occur at 130 and 158 ppm. The peak at 130 ppm can be allocated to C-5 tyrosine (130 ppm) and C-4 of histidine; the peak at 158 ppm can be allocated to C-6 of arginine. Additional peaks present should be ignored as they are sidebands due to instrumental effects from the spinning of the sample.

The third region (δ 170 to 190) contains the carbon of the carbonyl group which includes carbonyl peptides and carboxyl resonances (e.g. C-1 carbons of amino acid residues), and also esters ($-CO_2R$), acids (CO_2H) and ionized acids (CO_2^-) in that order in increasing ppm. The carbon atom of the calcium carbonate, which is present in the samples, will also contribute in this region. In sample NP7 there is an intense sharp peak at 174 ppm with an indication of a shoulder at 171 ppm. This is also the case for NP6, P4 and rabbit-skin glue. It is similar in HP16, HP26, HP31 and HP7. The shoulder peak is slightly more evident in HP8, HP22, HP37, HP38, HP36, and HP20. In samples HP18 and HP28 the shoulder peak is more apparent. The 174 ppm peak is due to the carbon of the carboxylic acids and the 171 ppm peak is due to ester and amide carbonyls.

The effects of ageing and degradation of the parchment were quantified by analyzing changes in the most clearly defined of these components. This followed from our earlier work, where qualitative differences were also observed in ^{13}C NMR spectra between unaged and aged leather samples. In particular, variation was seen in intensities of the carbonyl carbon of the amino acid residues relative to the C-2 carbon of the major component amino acid residue, glycine; the ratio of C-2 carbons of proline to hydroxyproline; the relative intensities of C3 and C-4 carbons of mainly proline and glutamic amino acid residues (Odlyha 1998).

Figure 10.3 Fitted ^{13}C NMR spectrum of unaged parchment (NP7).

Figure 10.4 Bar chart showing the ratios for the 12 historic samples and standard of the peak areas at (60 ppm/71 ppm), (C-2 Pro+Hyp)/(C-4 Hyp).

Effects of ageing: quantification

For the parchment samples, these differences were quantified by fitting the observed peaks in the peptide aliphatic carbon region using GRAMS/32 (Version 4.02) software. This was followed by calculation of the area ratios of the main peaks. Figure 10.3 shows the fitted NMR spectrum, between 0 and 80 ppm, of the unaged NP7 sample. This region was fitted using 12 peaks, each of which had a combined Lorentzian/Gaussian (70/30) peak shape. The same peaks were used for fitting all the parchment ^{13}C NMR spectra.

The labelling is based on the component amino acid residues of the collagen itself, without consideration of alteration and degradation products. As can be seen from Figure 10.3 most of the peaks contain contributions from several amino acid residues.

The amino acid residues labelled were those that are present in collagen in concentrations above 5%. For the purposes of quantification, the three peaks that could be most clearly defined and reliably fitted were those at 43 ppm, 60 ppm and 71 ppm. These corresponded to the major collagen amino acid residues of glycine, proline and hydroxyproline. For example the C-2 of proline and hydroxyproline gives a peak at 60 ppm. The peak at 71 ppm, however, is solely due to the C-4 of hydroxyproline, i.e. the carbon attached to the hydroxyl group. The main glycine contribution (from its C-2 peak) occurs at 43 ppm. This overlaps with a contribution from the C-5 of arginine residue although this is present in lower proportion (5%) than the glycine (33%).

To enable comparison between spectra, ratios of areas were used. Calculation was made for peak area ratios, e.g. (60/71), (43/71) and (60/43) and these ratios were compared for the different parchment samples. The results will be discussed in turn.

Figure 10.4 shows the plot of the area ratios of the peaks at 60 and 71 ppm against sample type. It can be seen that NP7 has the highest ratio whereas HP26, HP36 and HP28 have the lowest ratio. The numerator represents the state of the chemical environment of the C-2 of both proline and hydroxyproline and the denominator the chemical environment of the C-4 of hydroxyproline. NP7 represents the intact collagen state in the non-degraded parchment. A change or decrease in this ratio indicates a change in one or other or both components, i.e. decrease in C2 proline and hydroxyproline, increase in C-4 hydroxyproline or both. Samples NP7 and HP28 represent maximum and minimum values in the graph. A similar trend in samples can be found from calculations using the measured amino acid concentrations, discussed elsewhere in this book. Alteration of proline on ageing, with the formation of hydroxyproline as an intermediate product has previously been described (Larsen 1995).

The results can be classified into groups of similar value, giving the following:

1. NP7
2. HP37, HP16, HP8
3. HP22, HP7, HP20, HP31
4. HP18, HP38
5. HP26, HP36
6. HP28

Figure 10.5 shows the plot of the area ratio of the peaks at 43 and 71 ppm against sample type. This represents the peak area of the glycine C-2 (and C-5 arginine) to that of the hydroxyl carbon (C-4) of the hydroxyproline. The order appears similar to the previous calculation which again

Figure 10.5 Bar chart showing the ratio of the areas of the peaks (43 ppm/71 ppm, i.e. C-2 Gly & C-5 Arg / C-4 Hyp).

Figure 10.6 Bar chart showing the ratio of the areas of the carbon of the peak (C1) (174+171) to the carbon (C-4) of hydroxyproline at 71 ppm.

Figure 10.7 Bar chart showing the ratio of the areas of the peaks at (174 ppm/171 ppm, i.e. C-1 of amino acid residues ; carboxylic acid contribution to peptide carbonyl contribution).

suggests an increase in hydroxyproline on ageing or possibly a reduction in glycine (or arginine) content. The ratio was found to be a useful marker for the chemical state of collagen as it showed a significant change in some of the parchment samples. It indicated that there was an increase in levels of hydroxyproline (C-4) with respect to C-2 glycine (and C-5 arginine), particularly in samples HP28, HP36, HP26 and HP18.

The samples can be grouped according to decreasing value of the ratio:

1. NP7
2. HP16
3. HP8, HP37, HP38
4. HP7, HP31, HP20, HP22, HP18, HP26, HP36
5. HP28

Variations in hydroxyproline were further investigated by calculation of the ratio of the major peak in the ^{13}C spectrum, the carbon (C1) in the region 170–175 ppm, to that of the C4 of hydroxyproline (71 ppm) as shown in Figure 10.6. The large peak (170–175 ppm), as mentioned before, incorporates the carbonyl peptide (171 ppm) and any free carboxylic acidic degradation products (174 ppm) which form as well as the carbon from any calcium carbonate which is present. The decrease in ratio reflects possibly both a decrease in the large carbonyl peak and an increase in C-4 hydroxyproline of the material. The large scale of change between NP7 and HP28 indicates that there is some difference in the contribution of the large carbonyl peak (i.e. a decrease). Further investigation of this peak was carried out by curve fitting it with two separate components, centred at 174 ppm and 171 ppm. These represent contributions from carbon (C-1) associated with free carboxylic acids and peptide carbonyls in the polypeptide chain respectively. A ratio of (174/171) should therefore provide a marker for the ratio of free acids/peptide carbonyls (Figure 10.7).

NP7 is the unaged sample; changes which result in an increase in the ratio imply that the sample is becoming more acidic, i.e. HP18, HP7, HP16, HP36 and HP26. Of these, HP7, HP36 and HP26 also have a low basic/acidic amino (B/A) ratio (as discussed elsewhere in this book). Samples in which a decrease in ratio occurs are HP31, HP20, HP22, HP37, HP38 and HP28.

Effect of heating

The effect of heating on the amino acid residues was also quantified by curve fitting, using HP16 as an example. The ratio (60/71) has the value at room temperature of 2.8, it has a value of 3.0 at 353°K and a value of 3.1 at 373°K. There is therefore a small decrease in hydroxyproline due to dehydroxylation effects on heating the sample.

The results from the calculation of the ratio 43/71 (glycine/hydroxyproline) for HP16 are also interesting. At room temperature the ratio is 3.5, and this falls to 3.0 at 353°K and rises again to 3.4 at 373°K. The effect of heating sample beyond its denaturation will cause conversion to gelatin. At 353°K (at denaturation temperature) we have

incomplete conversion to gelatin and only loss of hydroxyproline due to dehydroxylation effects. Therefore there is a decrease in the ratio. On further heating and with the complete conversion to gelatin there is a decrease in glycine which accompanies a further decrease in hydroxyproline, with the result that the overall ratio is increased (from collagen to gelatin there is a decrease in glycine and also in hydroxyproline (Mills and White 1994)).

Effect of water immersion of parchments on the ^{13}C NMR spectra

The effect of water immersion on ^{13}C NMR spectra was investigated using a sample of modern parchment P4. The ratio (60/71) was 2.5 in air but decreased to 2.1 in water. This implies an increase in C-4 of hydroxyproline, as expected, with further hydroxylation of the sample. It can also be seen as an increase in the area of the shoulder peak at 38 ppm (C-3 of hydroxyproline). The growth of the shoulder at 38 ppm affects the resolution of the peak at 43 ppm. This disturbs the ratio (43/71) (Gly/Hyp) which changes in value from 3.1 to 2.2 (in water).

MAS/decoupling

In addition to the CPMAS spectra, MAS/decoupling spectra were also collected for the parchment samples. Comparative spectra are shown for NP7 in Figure 10.8 and for HP16 in Figure 10.9. The peaks at 30 and 25 ppm both show an increase in intensity in the MAS decoupling spectra for all samples, and in general become more intense than the C-2 of glycine at 43 ppm, except for HP16. The peak at 30 ppm is due to the C-3 carbon of proline and arginine and the peak at 25 ppm is due to the C-4 of proline and arginine. There is also a feature from glutamic acid at 28 ppm whose position is pH-dependent and can also occur in the range up to 33 ppm. This indicates that these are more mobile entities of the collagen molecule. While the relative intensities of the peaks at 30 and 25 ppm vary, they are of equal intensity in HP16 where they also remain lower than the glycine, indicating fewer mobile species. This behaviour, which places HP16 apart, was also observed in the stress–strain response where its modulus value was the highest and then in the DMTA section where its tan δ response was very low.

Results: ^{15}N solid state NMR spectra

^{15}N spectra were collected to determine the extent of change in the environment of the nitrogen atoms in the peptide bonds. ^{15}N chemical shifts extend over a range of about 1500 ppm. There is a certain similarity to ^{13}C NMR shifts, insofar as the resonances of aliphatic amines and related compounds occur at relatively low frequencies (between –380 and –280 ppm) whereas ^{15}N carrying electronegative groups appear at higher frequencies (–280 and –130ppm) (Berger et al. 1997). The main features visible in the spec-

Figure 10.8 Comparative ^{13}C NMR spectra for NP7. CPMAS (lower) and MAS/decoupling (upper).

Figure 10.9 Comparative ^{13}C NMR spectra for HP16. CPMAS (lower) and MAS/decoupling (upper).

Figure 10.10 Selected ^{15}N NMR spectra of parchment samples.

tra obtained for the parchments were broad peaks in the region of –240 to –280 ppm (Figure 10.10).

This regions falls into that of ^{15}N chemical shifts of the amide N (NHCO) in di- and tri-peptides and carboxylic acid amides which have resonances in the range from –290 to –240ppm (Berger et al. 1997). High resolution and solid state ^{15}N NMR have been increasingly applied to the investigation of polypeptides, proteins and biopolymers (Shoji et al. 1993). This is because, particularly in polypeptides and

proteins, nitrogen is very often functionally important due to its ability to form hydrogen bonds, and most of the nitrogen sites are in the amide linkage of the backbone (Shoji et al. 1993).

The modern parchment NP7 showed a peak maximum at −258.1 ppm with smaller peaks at −272.8 and −250.4 ppm. The position of the peak with its maximum at −258.1 ppm and the fact that it was very broad negated attempts to assign the feature to individual amino acid residues. For comparison, ^{15}N chemical shifts for the amino acids glycine and proline are −347.3 and −323.2 ppm respectively. In the amide form these resonances are moved upfield to less negative values. Values for a number of polypeptides have been measured; the ^{15}N chemical shifts for glycine and proline within polypeptides are −272 ppm and −240 ppm respectively. Many of the others, e.g. alanine and valine, are approximately −255 ppm. Assignation of peaks was based on ^{15}N chemical shifts of polypeptides relative to standard nitromethane (Shoji et al. 1993; Martin et al. 1981). As mentioned previously, collagen contains -(Gly-A-B)x- (Gly-Pro-HyPro)y- with glycine at every third position (soft blocks) and proline every third position (hard blocks). The resulting ^{15}N signal will be determined by the arrangement and integrity of these linkages. Any perturbation to the peptide environment will be reflected in changes to these broad features.

In the samples examined, the greatest change was apparent in HP36, HP26 and HP37 in comparison to NP7. Essentially a loss in the left-hand peak (in the upfield direction) occurs together with a shift of the right-hand peak downfield. This implies that the chemical environment of the N atoms in the peptide bonds is becoming more electronegative with formation of more polar entities, e.g. carboxylic acid amides. This indicates that some degradation has occurred. The increased levels of acidity are confirmed by the lower B/A values (e.g. NP7 = 0.7, HP26 = 0.6) and reported for the complete set of samples elsewhere in this book.

Further evaluation of data using principal component analysis

The results obtained from all the area ratios discussed for the various amino acid residues were incorporated in a data reduction programme (MINITAB version 10.2) and principal component analysis was performed. The area ratios included the following: (60/71), (43/71), (174+171)/71, (174/171), together with additional calculated ratios (60/43), (60+71)/43, (71+60)/33, (25/33) and (43/33). The peaks at (1) 25 and (2) 33 ppm represent contributions from (1) proline (C-4) and arginine (C-5) and (2) glutamic acid (C-3) respectively. A single plot was produced of the two main principal components (Fig. 10.11). This shows that discrimination occurs mainly along the direction of the first (most significant) principal component (PC1). The unaged parchment NP7 lies on the left-hand side and historic samples e.g. HP7 (17th century) lie on the right-hand side of the graph. HP16 is the least changed with respect to NP7 and HP28 appears the most changed. HP28 is clearly separated from the other historic samples. This was observed in the plot of carbonyl peak intensity to the hydroxyproline (C4 peak) (Fig. 10.6) and may indicate that degradation processes have occurred to a more advanced state in HP28 than in HP18 and HP26. From Figure 10.7, HP28 shows that it is lower in free acids than HP18 and HP26. It may indicate that other types of degradation processes have occurred to those in HP18 and HP26. These results at a later stage can be compared with the data obtained from the thermomechanical and thermogravimetric techniques.

A further PCA was performed removing the calculations which involve the peaks at 25 and 33 ppm. The rationale for this is that they are poorly resolved and in some samples, in particular HP18 and HP28, the intensity of the peak at 33 ppm was dominant and this could bias the calculation. Figure 10.12 gives the recalculated PCA of the NMR data. It can be seen that there is more discrimination between the samples. Discrimination occurs not only along PC1 but also PC2. PCA of the NMR data gives a distribution which places samples according to the following groups: NP7 lies at the right-hand side of the graph. To the middle of the plot samples HP36 and HP26 lie at centre top of the graph. These from other observations in this book represent samples that

Figure 10.11 Principal component analysis of measured parameters from ^{13}C NMR spectra.

Figure 10.12 Revised principal component analysis of measured parameters from ^{13}C NMR spectra.

have degraded by acidic hydrolysis. Towards middle centre there is a cluster of samples HP7, HP18, HP31, HP20, HP22, HP38. Samples HP16, HP37 and HP8 do not fall into any groups. They are, according to this classification (on the basis of calculated amino acid residue ratios (NMR)), less altered in their chemical composition than the middle clusters. Towards the lower left-hand corner sample HP28 appears as the most altered.

Conclusions

The ^{13}C NMR spectra showed the expected amino acid residue profile with reasonable resolution. This enabled peaks to be assigned to particular amino acid residues, curve fitting procedures to be used and relative intensities of areas to be compared. Of particular interest is the imino acid residue content since it contributes to the integrity of the collagen structure and it will affect the thermomechanical measurements as mentioned elsewhere in this book. In fact, the imino acid residue content – in particular of the hydroxyl carbon (C-4) of the hydroxyproline and its variation relative to the C-2 of the glycine and C-5 arginine residue content (43/71) – was found to be a useful marker for the chemical state of collagen as it showed a significant change in some of the parchment samples including those dating from the 17th (HP7) and mid-19th centuries (HP8 and HP37). It indicated that there was an increase in levels of C4-hydroxyproline with respect to C2 glycine and C5 arginine, particularly in samples HP28, HP36 and HP26. The ratio of C-2 peak carbons of proline and hydroxyproline and C4 hydroxyproline (60/71) was also calculated. The most altered samples were found to be the same as those previously mentioned. Hydroxyproline has been characterized as an intermediate product in the alteration of proline (Larsen 1995). This indicates that the samples mentioned are more degraded or altered than the remainder.

A comparison of the data obtained from solid state NMR and amino acid analysis (high-performance liquid chromatography (HPLC)) was made. Calculated values for (60/71) and (43/71) (NMR) are shown in Table 10.2, as are the calculated values for similar ratios obtained from HPLC amino acid analysis (60/71). There appears to be a good comparison between the measurements. For future analyses this indicates that measurements which are non-destructive can be performed by solid state NMR alone where sample size allows.

Other differences which were observed are summarized as follows:

1. The ratio of the areas of the C1 of the amino acid residues of carboxylic acids and peptide carbonyl to C4 of hydroxyproline (174+171)/71. Decreases in 174 or 171 or both and/or increases in C4 of hydroxyproline, for example, will reduce values of this ratio.
2. The ratio of the free carboxylic acids and peptide carbonyls (i.e. 174/171) will indicate changing levels of acidity of the parchment samples and can be used to complement B/A ratios (Table 10.2) and mentioned elsewhere in the book.
3. The presence of an additional strong peak at 33 ppm, particularly in HP18 and HP28, which served as a marker to separate these from other samples.

Further information could also be obtained from the MAS/decoupling spectra, particularly in the region of 30 and 25 ppm associated with the carbon atoms of proline, arginine and glutamic acid. The increased relative intensity of these features in all the parchment samples, except for HP16, indicates that these are more mobile entities in the collagen polymer. HP16 was found to contain the lowest levels of mobile species. This complements the mechanical measurements described elsewhere in this book where it was found that for sample HP16 (from the stress–strain response) its modulus value was the highest, and the DMTA data

Table 10.2 Comparison between solid state NMR peak ratios of selected amino acid residues and HPLC amino acid analysis.

	A				B	C	
	NMR	HPLC	NMR	HPLC	NMR	NMR	B/A
	(C2 pro+hyp)/ C4 hyp 60/71	(pro+hyp)/ hyp	(C2gly+C5arg)/ C4 hyp 43/71	(gly+arg)/ hyp	(C1 174+171)/ C4 hyp 71	(C1 174/171)	
NP7	3.16	2.276	3.94	4.099	8.80	1.96	0.68
HP7	2.45	2.151	2.40	4.504	6.62	2.32	0.53
HP8	2.81	2.266	3.09	3.998	7.72	0.76	0.68
HP16	2.83	2.236	3.48	4.064	8.26	2.74	0.60
HP18	2.27	2.217	2.21	3.884	6.39	2.08	0.62
HP20	2.44	2.253	2.28	3.913	6.83	1.81	0.57
HP22	2.55	2.256	2.27	3.93	6.26	1.74	0.62
HP26	2.02	2.162	2.10	3.827	6.89	3.50	0.60
HP28	1.53	2.185	1.48	3.867	4.04	0.98	0.59
HP31	2.43	2.257	2.30	4.005	7.21	1.95	0.66
HP36	1.89	2.192	2.08	4.123	6.19	3.32	0.52
HP37	2.92	2.272	2.80	3.877	7.92	1.50	0.60
HP38	2.21	2.196	2.59	3.892	7.06	1.44	0.60

A: solid state NMR peak ratios of (1) Pro&Hyp/C4 Hyp (60/71) (2) C2gly&C5arg/C4 Hyp. B: solid state NMR peak ratios of carbonyl C-1 peak and C4-hydroxyproline amino acid residue. C: comparison between ratio of C1 free carboxylic acids amino acid residues to C1 peptide carbonyl and B/A ratios (obtained from HPLC).

where its tan δ value was low indicating highly elastic behaviour and the presence of crystallinity or cross-linking in the sample.

A PCA of the overall observed differences in the solid state NMR spectra expressed in terms of area ratios of the selected peaks indicated that the samples which had undergone most change relative to NP7 were HP28, HP36, HP26 and HP18.

The combination of solid state NMR spectroscopy with data reduction techniques is a powerful approach to describing the parchments in terms of their degree of chemical alteration with respect to the chemical environments of carbon and nitrogen atoms in NP7, the unaged parchment.

References

Berger, S., S. Braun and H. Kalinowski (1997) *NMR Spectroscopy of the Non-Metallic Elements*. J. Wiley & Sons, pp. 229–33.

Bowden, D. and P. Brimblecombe (1999) 'The thermal response of parchment to hygrometric changes', *Journal of the Society of Leather Technologists and Chemists* 83, pp. 252–60.

Cassar, M., G. V. Robbins, R. A. Fletton and A. Alstin (1983) 'Organic components in historical non-metallic seals identified using ^{13}C-NMR spectroscopy', *Nature* 303, pp. 238–9.

Harris, R. K. (1993) 'State of the art for solids', *Chemistry in Britain* July, pp. 601–4.

Fyfe, A. C. (1983) *Solid State NMR for Chemists*. C.F.C. Press, Guelph.

Kalinowski, H., S. Berger and S. Braun (1988) *Carbon-13 NMR Spectroscopy*. J. Wiley & Sons, pp. 221–31.

Larsen, R. (1995) *Fundamental Aspects of the Deterioration of Vegetable Tanned Leathers*, PhD Thesis, The Royal Danish Academy of Fine Arts, School of Conservation, p. 109.

Larsen, R., D. V. Poulsen and M. Vest (2002) 'The hydrothermal stability (shrinkage activity) of parchment measured by the micro hot table method (MHT)'. This volume, pp. 55–62.

Martin, G. J., M. L. Martin and J. -P. Gouesnard (1981) *15N-NMR Spectroscopy*. Springer-Verlag, Berlin, p. 150.

Mills, J. S. and R. White (1994) *The Organic Chemistry of Museum Objects*. Butterworth-Heinemann, Oxford, pp. 74–5.

Nakamura, Y. (1987) 'Structure of type-I collagen dimers', *International Journal of Biological Macromolecules* 9, pp. 281–90.

Odlyha, M. (1998) *Characterisation of Cultural Materials by Measurement of their Physicochemical Properties*, PhD Thesis, Birkbeck College, University of London.

Shoji, A., S. Ando, S. Kuroki, I. Ando and G. A. Webb (1993) 'Structural studies of peptides and polypeptides in the solid state by nitrogen-15 NMR', in G. A. Webb (ed.) *Annual Reports on NMR Spectroscopy*, Vol. 26, pp. 55–98.

Traub, W. and K. A. Piez (1971), 'The chemistry and structure of collagen', *Advances in Protein Chemistry* 25, pp. 243–52.

Young, G. S. (1999) *The Application of Thermal Microscopy, Differential Scanning Calorimetry and Fourier Transform Infrared Microspectroscopy to Characterise Deterioration and Physicochemical Change in Fibrous Type I Collagen*, PhD Thesis, University of London.

Plates

Plate 3.1 Optical microscopy: ten pictures representing ten successive thin sections from a microcylinder, drilled from a red-coloured decoration of a Javanese shadow puppet; transmitted/reflected light, 100×, cross-sections.

Plate 3.2 Optical microscopy of HP15_2. Left: transmitted/reflected light, 320×, cross-section. Right: transmitted light, 160×, cross-section.

Plate 3.3 Optical microscopy of MX3. Left: transmitted/reflected light, 120×, cross-section. Right: transmitted light, 120×, cross-section.

Plate 3.4 Optical microscopy of MPK19. Left: transmitted/reflected light, 250×, cross-section. Right: transmitted/reflected light, 320×, parallel section, 5µm thin section.

Plate 3.5 Optical microscopy of HP38; transmitted/reflected light, 200×, cross-section.

Plate 3.6 Optical microscopy of HP38; transmitted/reflected light, 160×, cross-section.

Plate 3.7 Optical microscopy of HP37; transmitted/reflected light, 100×, cross-section.

Plate 3.8 Optical microscopy of HP37; transmitted/reflected light, 100×, cross-section.

Plate 3.9 PAB: video picture showing holes left after drilling.

Plate 3.10 Optical microscopy of PAB; transmitted/reflected light, 200×, cross-section.

Plate 3.11 Optical microscopy of PAB; 200×, parallel section.

Plate 3.12 HvB. Visual photography of gilt leather fragment.

Plate 3.13 Optical microscopy of HvB dull yellow; transmitted light, 320×, cross-section.

Plate 3.14 Optical microscopy of HvB bright yellow; transmitted light, 320×, cross-section.

Plate 3.15 HvB. Radiography of gilt leather fragments.

Plate 3.16 Optical microscopy of DD. Top: transmitted/reflected light, 100×, cross-section. Bottom: transmitted/reflected light, 400×, cross-section.

Plate 4.1 Minimum Spanning Tree for the 60 vegetable gum samples.

Plate 5.1 Parchment P435_0w reference sample.
(a) Reference parchment mask and scale, the result of rotation and vertical orientation of the SEM image, with resin block areas masked, processed using the SEMPER routines written for this work. The line is the parchment smooth edge, vertical right.
(b) Sulphur distribution map, Gaussian smoothed. The colour map key indicates pixel (sulphur) intensity.
(c) Calcium distribution map, Gaussian smoothed. The colour map key indicates pixel (calcium) intensity. Iron and copper images for this parchment contained no detail to permit filtering.

Plate 5.2 Parchment P435_2w artificially aged 2 weeks.
(a) Mask and scale, rotated and vertically orientated SEM image, with resin block areas masked. The line marks the smooth surface, vertical right.
(b) Sulphur distribution map, Gaussian smoothed. The colour map key indicates pixel (sulphur) intensity.
(c) Calcium distribution map, Gaussian smoothed. The colour map key indicates pixel (calcium) intensity.

Plate 5.3 Parchment P435_4w artificially aged 4 weeks.
(a) Mask and scale, rotated and vertically orientated, with resin block areas masked. The line marks the smooth surface.
(b) Sulphur distribution map, Gaussian smoothed. The colour map key indicates pixel (sulphur) intensity.
(c) Calcium distribution map, Gaussian smoothed. The colour map key indicates pixel (calcium) intensity.
(d) Iron distribution map, Gaussian smoothed. The colour map key indicates pixel (iron) intensity.
(e) Copper distribution map, Gaussian smoothed. The colour map key indicates pixel (copper) intensity.

Plate 5.4 Parchment P435_8w, 16w artificially aged 8 and 16 weeks.
(a) P435_8w mask and scale, the result of rotation and vertical orientation.
(b,c) P435_8w, 16w. Sulphur distribution map, Gaussian smoothed. The colour map key indicates pixel (sulphur) intensity. Other P435_16w images are in the main text (Fig. 5.1).

Plate 5.5 Historical parchment HP6b.
(a) Rotated and vertically orientated mask and scale.
(b) Backscatter (BSE) topological image.
(c) Sulphur distribution map, Gaussian smoothed. The colour map key indicates pixel (sulphur) intensity.
(d) Calcium distribution map, Gaussian smoothed. The colour map key indicates pixel (calcium) intensity.
(e) Iron distribution map, Gaussian smoothed. The colour map key indicates pixel (iron) intensity.
(f) Copper distribution map, Gaussian smoothed. The colour map key indicates pixel (copper) intensity.

Plate 5.6 Artificially aged new leather.
(a) Original backscatter (BSE) topological image (128 × 128 pixels) of artificially aged leather depicting the cross-section and the resin SEM block (triangle areas, top left and bottom right).
(b) Raw sulphur image (128 × 128 pixels) uncompensated for electron beam fluctuation as no titanium reference image was captured when this archive file was previously scanned.
(c) Sulphur distribution map, Gaussian smoothed. The colour map key indicates pixel (sulphur) intensity.

Plate 5.7 Historical parchment HP7.
(a) Mask and scale, rotated and vertically orientated. The line marks the bookbinding edge exposed to the atmosphere.
(b) Backscatter (BSE) topological image.
(c) Raw sulphur image, only compensated for electron beam fluctuation.
(d) Sulphur distribution map, Gaussian smoothed. The colour map key indicates pixel (sulphur) intensity.
(e) Calcium distribution map, Gaussian smoothed. The colour map key indicates pixel (calcium) intensity.
(f) Iron distribution map, Gaussian smoothed. The colour map key indicates pixel (iron) intensity.
(g) Copper distribution map, Gaussian smoothed. The colour map key indicates pixel (copper) intensity.

Plate 5.8 Historical parchment HP8.
(a) Mask and scale orientated vertically. The line marks the outer edge of the parchment.
(b) Sulphur distribution map, Gaussian smoothed. The colour map key indicates pixel (sulphur) intensity.
(c) Calcium distribution map, Gaussian smoothed. The colour map key indicates pixel (calcium) intensity.

Plate 5.9 Historical parchment HP9.
(a) Mask and scale. The line marks the outer edge.
(b) Backscatter (BSE) topological image.
(c) Sulphur distribution map, Gaussian smoothed. The colour map key indicates pixel (sulphur) intensity.
(d) Calcium distribution map, Gaussian smoothed. The colour map key indicates pixel (calcium) intensity.

Plate 5.10 Roman leather ROM3.
(a) Mask and scale. The dashed line (large) marks the edge near to an integrated iron rivet. Short dashed line – area in contact with the rivet.
(b) Backscatter (BSE) topological image.
(c) Sulphur distribution map, Gaussian smoothed. The colour map key indicates pixel (sulphur) intensity.
(d) Calcium distribution map, Gaussian smoothed. The colour map key indicates pixel (calcium) intensity, calcium rescaled to display areas of high intensity.
(e) Iron distribution map, Gaussian smoothed. The colour map key indicates pixel (iron) intensity.
(h) Copper distribution map, Gaussian smoothed. The colour map key indicates pixel (copper) intensity.

Plate 5.11 Persian leather PER.
(a) Mask and scale rotated and vertically orientated. The line marks the edge containing copper pigmentation.
(b) SEM topological backscatter image.
(c) Sulphur distribution map, Gaussian smoothed. The colour map key indicates pixel (sulphur) intensity.
(d) Calcium distribution map, Gaussian smoothed. The colour map key indicates pixel (calcium) intensity, calcium rescaled to display areas of high intensity.
(e) Copper distribution map, Gaussian smoothed. The colour map key indicates pixel (copper) intensity.

11 Study of the Chemical Breakdown of Collagen and Parchment by Raman Spectroscopy

Thomas Garp, Kurt Nielsen and Soghomon Boghosian

The principles and methods of Raman spectroscopy

The Raman effect

Raman spectroscopy is named after the Indian scientist Venkata Raman, who in 1928 discovered that matter, exposed to a beam of monochromatic light, may exchange energy with the light and emit light of several frequencies (Raman and Krishnan 1928). For this discovery he was awarded the Nobel prize for physics in 1930. The energy exchange takes place between the light and the molecular vibrations. All molecules vibrate, and these vibrations are quantified, i.e. there is a discrete set of ways in which the molecule can vibrate, each with a specific energy. The molecule may absorb energy and be transferred to a vibrational state of higher energy, while emitting light of a lower frequency (energy), or the opposite may happen. In Raman spectroscopy, these processes are described by two steps. First, the molecule absorbs energy from the light and is transferred to a virtual and unstable state. Secondly, the molecule relaxes to a stable state of vibration by emitting light. If the start and end states are the same no energy exchange has taken place – the frequency of light is as before the scattering (Rayleigh scattering). If, however, the energy of the final state is higher than the energy of the initial state, the molecule has absorbed energy from the light, and the frequency of light will decrease corresponding to the energy difference between the two vibrational states (Stokes scattering). If the energy of the final state is lower than the energy of the initial state, the frequency of the scattered light will increase correspondingly (anti-Stokes scattering). The processes described are visualized in Figure 11.1.

Usually, only the Stokes side of the spectrum is reported, since it is the most intense at room temperature. With increasing temperatures, the population of higher vibrational states is thermally excited according to the Boltzmann distribution law. Thus, the possibility for a transition starting from a higher (i.e. excited) vibrational state to a lower final state is enhanced and the intensity of the bands in the Anti-Stokes spectrum increases. In nearly all forms of vibrational spectroscopy, the frequencies are given in wavenumbers v (cm^{-1}).

Example

In a molecule, two atoms are vibrating with a frequency of $v_1 = 1600$ cm^{-1}, and another two with $v_2 = 3000$ cm^{-1}. A laser with a frequency of 15453 cm^{-1} (corresponding to wavelength: $v_0 = 647.1$nm) illuminates the molecule. The scattered light is measured and the spectrum consists of lines with the following frequencies: 12453 cm^{-1}, 13853 cm^{-1}, 15453 cm^{-1}, 17053 cm^{-1}, 18453 cm^{-1}.

Only the Raman shift in the Stokes side (i.e. $v_0 - v_i$) is reported. The Raman spectrum now consists of two lines with the frequencies 1600 cm^{-1} and 3000 cm^{-1}, which are the vibration frequencies of the atoms in the molecule.

The Raman spectrometer

All Raman spectrometers are based on a laser, which is the most reliable source of monochromatic light. Theoretically,

Figure 11.1 Schematic diagram of the Raman effect.

any light frequency can be used for producing Raman scattering, but there is a proportionality between the intensity of the Raman scattering and the frequency of the laser. A comprehensive treatment of the principles and the instrumentation of Raman spectroscopy is given in Strommen and Nakomoto (1984). However, the higher the frequency, the higher the energy of the light, and at some point, the molecules will fluoresce. The light emitted from fluorescence is far more intense than the Raman scattering, and should be avoided.

Most lasers operate with visible light. This produces a very intense Raman scattering, but there is a risk of fluorescence. Therefore, some spectrometers use a laser, which operates in the near-infrared area. These lasers have the advantage that they are able to produce Raman spectra of coloured and bio-organic samples, and the fluorescence problem is almost eliminated because of the low energy of the light. A Raman spectrometer with a near-infrared laser uses a technique called Fourier transformation (FT) for collecting the Raman scattering. This is a mathematical way of collecting all the frequencies in the light at the same time, and transforming them into lines, as we see them in the Raman spectrum (as opposed to a scanning spectrometer, which scans the scattered light, frequency by frequency). Figure 11.2 shows the set-up of a FT-Raman spectrometer.

Figure 11.2 An FT-Raman spectrometer.

Raman spectroscopy on collagen

FT-Raman spectroscopy is an excellent form of analysis for investigating polypeptides such as collagen. As X-ray diffraction reveals information of the structure, Raman spectroscopy will provide information about bonding, vibrational modes and structural alterations depending on reaction paths of the collagen. Polypeptide chains are detected as one uniform molecule when measured by Raman spectroscopy. This is due to the repetitive structure of the backbone. There are several characteristic vibrations in polypeptides, arising from the atoms involved in the peptide bonds. Raman spectroscopy should therefore be a useful tool in describing hydrolysis of the peptide bond. Also a few of the side chains in the amino acids have characteristic frequencies, which makes them easily detectable. These frequencies are summarized below:

- **The amide I-band (1670 cm⁻¹):** This is mainly a C=O stretching vibration, although other atoms are involved in the vibration.
- **The amide III-band (1270 cm⁻¹):** This is a more complex vibration, which also has a bending character. It involves several atoms in the peptide backbone.
- **The COO- vibration (1415±10 cm⁻¹):** Polypeptides exist mainly as zwitterions in the solid phase, and therefore the acid groups are not protonized. The great stability of the carboxylate ion makes it visible in the Raman spectrum.
- **The backbone** of the polypeptide has a specific C-C-vibration at 920 cm⁻¹.
- **Specific amino acids:** Some of the amino acids have very distinct features, which makes them visible in the Raman spectrum:

Figure 11.3 The amide I, II and III vibrations. The amide II vibration is either Raman inactive or very weak.

- **Phenylalanin** has an aromatic ring, which features bands at several frequencies:
 – 3020 cm⁻¹, the aromatic C-H stretching vibration.
 – 1003 cm⁻¹, ring deformation of the aromatic ring.
- **Proline** has a five-membered aliphatic ring, with a specific C-C vibration at 855 cm⁻¹.

FT-Raman spectroscopic studies of parchment

The parchment spectrum

Figure 11.4 shows the Raman spectrum of a piece of newly prepared parchment made from calfskin. As seen, the highest peak lies at 2940 cm⁻¹. This peak is assigned to aliphatic C-H vibrations, and it originates from all aliphatic C-H

Figure 11.4 Full-range Raman-spectrum of a fresh piece of calfskin parchment (sample NP).

bonds in the entire collagen molecule. The most interesting frequency range is shown in the enlarged area, which contains the most important structural information. Most of the peaks in this region may be assigned to a vibrational or bending motion in the collagen molecule (Frushour and Koenig 1975). In the range 0–500 cm^{-1}, information on structural bonding, such as hydrogen bonding and S-S bridges can be deduced. Table 11.1 summarizes the most prominent peaks in the region 800–3000 cm^{-1}, in most cases together with their assignment. All important peaks, which have been observed in other polypeptides, are present. There are two amide I and III peaks, and previous studies (Frushour and Koenig 1975) suggest that these peaks originate from different parts of the collagen molecule, presumably with different polarity.

The parchment spectrum contains a peak, which has nothing to do with collagen itself. It originates from calcite, $CaCO_3$, as a result of treatment of parchment either by liming or by direct treatment of the flesh side with calcite. The peak is located at 1085 cm^{-1}, and the intensity is usually higher on the flesh side than on the grain side (Fig. 11.5). Even if the flesh side has not been treated with calcite, this will mostly be observed. In this case it is attributed to migration of calcite to the more porous flesh side. An important source of information lies in the 1000–1060 cm^{-1} range, where the 1003 and 1032 cm^{-1} bands are observed. The 1003 cm^{-1} band can readily be attributed to the ring deformation of the phenyl ring, but that is exactly where the symmetric stretching of the sulphate group lies as well. Although the sample NP is a fresh parchment sample, the possibility cannot be ruled out that a partial deterioration, leading to sulphate formation, has occurred. The peak at 1032 cm^{-1} may be due to either HCO_3^-, HSO_4^-, phenylalanine or proline.

Figure 11.5 Sample NP. Top: flesh side, Bottom: grain side.

Deterioration of parchment – an example

In contact with polluted and humid air and/or exposed to heat and light, parchment will degrade. An example is a bookbinding from AD 1609 stored at The Long Room, Library of Trinity, Dublin. Two samples were taken from this bookbinding: HPa from the spine, which was in a poor condition, and HPb from the more protected board side of the binding. The shrinkage temperatures, measured by the technique described in Larsen *et al.* (1993), were 50.1°C for HPb and < 20°C for HPa (it shrinks immediately in contact with water). Raman spectra were recorded for both samples on both sides (Figs 11.6 and 11.7). The spectra of HPb are very similar to that of new parchment (Fig. 11.5) and this leads to the conclusion that this sample has not deteriorated as far as the Raman spectra can determine. There is a large $CaCO_3$ peak on the flesh side, and a smaller peak on the grain side. However, the differences between HPa and HPb are prominent. In the spectrum of the grain side of HPa, the amide I band, which is assigned to C=O stretching, appears broadened and poorly defined. This indicates a severe degree of hydrolysis of the peptide bonds. Furthermore, in contrast to HPb, HPa, on both flesh and grain side, contains peaks (1007 and 1145 cm^{-1}) that may be assigned to gypsum, $CaSO_4 \cdot 2H_2O$. These bands are due to the symmetric and antisymmetric stretching modes of the sulphate group. A band at 1043 cm^{-1}, which may be assigned to HSO_4^-, has emerged. This pattern suggests that air polluted with SO_2 is the main cause of the deterioration.

An attempt has been made to model the effect of SO_2 pollution. New parchment was exposed to air at 100% RH and polluted with 10% SO_2, and Raman spectra were obtained from both sides (Fig. 11.8). First, it is noticeable that the $CaCO_3$ band at 1085 cm^{-1} has vanished completely from both sides of the parchment. Secondly, peaks at about 1003 cm^{-1}, 1145 cm^{-1} and 1028 cm^{-1} have emerged. The increase in peak intensity in the 1003 cm^{-1} band and the appearance of the 1145 cm^{-1} band indicate formation of sulphate, and we have therefore assigned these peaks to gypsum. The 1145 cm^{-1} peak may also contain contributions from the symmetric stretching of SO_2, adsorbed on the surface of the parchment. The peak at 1028 cm^{-1} originates either from HSO_4^- or HCO_3^- being formed as an intermediate by acid dissolution of calcite. At the present stage we can only make guesses about the mechanism of deterioration. SO_2 is a reducing agent and is oxidized to SO_3, which in contact with water forms sulphuric acid. The SO_2 molecule is fairly stable in air, but it seems very unlikely that any part of the collagen molecule should be able to oxidize SO_2. We may postulate that SO_2 is oxidized by O_2, and that this oxidation one way or the other is catalyzed by the collagen molecule. Sulphuric acid will react with $CaCO_3$ and form gypsum, $CaSO_4 \cdot 2H_2O$. Excess of sulphuric acid will lead to formation of HSO_4^-, and excess of $CaCO_3$ will lead to formation of HCO_3^-.

The increase in acidity, especially from sulphuric acid, may then cause hydrolysis of the peptide bonds. As shown below, the Raman spectrum of SO_2-treated parchment indicate some degree of randomly coiled peptide chains.

Figure 11.6 HPb (board), Top: flesh side, Bottom: grain side.

Figure 11.7 HPa (spine), Top: flesh side, Bottom: grain side.

The effect of shrinkage

When heated in water, parchment will shrink. Some authors have postulated that this phenomenon is due to an absorption of water into the helix, leading to a disordering of the triple helix (Goheen et al. 1978). Others have suggested that the helical structure is transformed into a random coil. The last postulation may be tested by Raman spectroscopy. Compared to the spectrum of an α-helix, a random coil has amide I and III frequencies shifted up and down, respectively. Figure 11.9 shows the spectra of both sides of a dried sample of NP, heated in water at 70°C for 30 minutes. There is no indication of a random coil structure, the spectra being almost identical to those of new parchment. Small angle X-ray scattering on a similar sample shows that, compared to new parchment, the ordering has decreased with a shorter D-period of the ordered phase.

Statistical analysis

The present analysis is a first attempt to extract information on the deterioration of parchment by Raman spectroscopy. The analysis has not yet been completed, but, as pointed out below, the method is very promising, offering the possibility once and for all to map spectra of parchment in different states of deterioration, and subsequently to use this mapping for characterization of unknown samples. The next section sums up the present state of the project.

Raman spectra were recorded on samples from 39 historical and 2 newly prepared parchments. For some samples spectra were recorded on both the grain and flesh side, and some spectra were recorded on new samples exposed to SO_2 or denaturation.

The total of 71 measured Raman spectra are in many cases very similar, and an interpretation of the differences can be very difficult. We therefore decided to use principal component analysis (PCA) in the well-resolved region from 984 to 1742 cm^{-1} to analyse differences and similarities. Before using the PCA, a background was subtracted from all spectra, and subsequently these were scaled such that their square sum was unity. By the method of PCA we can construct a set of basis functions which, in decreasing importance, describe the differences from the average spectrum. We decided to evaluate only the most significant differences covering at least 97% of the sum of squared differences from the mean. The PCA gave the result that 11 basis functions (including the average spectrum) were sufficient to describe all 71 spectra within the required accuracy. Hence, the Raman spectra may be expanded as a linear combination of these basis functions:

$$R_l(\nu) = \sum_j a_{jl} B_j(\nu) \quad (j = 1, 2, \ldots, 11)$$

Here $R_l(\nu)$ is the value of the *l*'th Raman spectrum at frequency ν, $B_j(\nu)$ is the *j*'th basis function at the same frequency, and a_{jl} is the corresponding expansion coefficient. Unfortunately, this does not make the interpretation easier, because both expansion coefficients and basis functions may be negative. However, each Raman spectrum

Figure 11.8 Sample NP, treated with SO_2. Top: flesh side, Bottom: grain side.

Figure 11.9 Sample NP, shrunk $T_s = 61.9°C$ Top: flesh side Bottom: grain side.

Figure 11.10 Basis function P_1.

Figure 11.11 Basis function P_2, compared to NP.

Figure 11.12 Basis function P_3.

Figure 11.13 Basis function P_4.

is measured over a finite area and therefore represents spectra of collagen molecules in different states of deterioration. Each of these molecules gives a positive contribution to the Raman spectrum. It should therefore be possible to transform the 11 basis functions to a set of positive basis functions with positive expansion coefficients:

$$R_l(\nu) = \sum_j b_{jl} P_j(\nu)$$

where b_{jl} and P_j are positive. The success of this transformation depends on background subtraction and the number of samples. Wrong backgrounds may show up in the basis functions, and result in negative values for the coefficients as well as for the basis functions. In the present analysis only numerically small coefficients and function values in narrow regions are negative.

What may we expect to see by this transformation? First, since the content of $CaCO_3$ may differ in an unsystematic way from parchment to parchment, the $CaCO_3$ peak is not correlated to the collagen peaks, and it should emerge as a single peak in one of the basis functions. Secondly, most of the samples contain intact collagen molecules, which should result in a basis function very similar to the Raman spectrum of new parchment. Thirdly, we should be able to interpret some of the basis functions in terms of deterioration.

As expected the first basis function P_1 (Fig. 11.10) almost exclusively shows the $CaCO_3$ peak with almost no correlation to other bands, whereas the most prominent positive basis function, P_2 (Fig. 11.11) fulfils the second requirement. It is, apart from the $CaCO_3$ peak, very similar to the spectrum of new parchment. This comparison does, however, indicate that the background subtraction has not been optimal. Other differences may be partly due the fact that the new parchment sample is already deteriorating. Within the last three years the shrinkage temperature has dropped by 5 degrees. The major features of the third basis function P_3 (Fig. 11.12) consist of the $CaSO_4$ (1007 and 1145 cm^{-1}) and the HSO_4^- (1045 cm^{-1}) peaks. The presence of these peaks are correlated to a peak at 1411 cm^{-1}. The last peak is assigned to the carboxylate ions (-COO$^-$), which in the free amino acids have frequencies in the range 1407–1430 cm^{-1}.

We may conclude that the SO_2 pollution causes hydrolysis of the peptide bonds, which leads to a higher concentration of free carboxylate ions.

The last basis function which we will discuss is shown in Figure 11.13 (P_4). The three highest peaks are found at 1218, 1453 and 1696 cm^{-1}. The peak at 1453 cm^{-1} is assigned to CH_3/CH_2 movements. We have assigned the two other peaks to amide I and amide III. We observe a considerable shift in frequency compared to the amide frequencies in new parchment. Amide I is shifted up in frequency, and amide III is shifted down. This is in accordance with the random coil structure of peptide chains. Thus, parchments with a large expansion coefficient for this basis function do contain some degree of random coil structure. The larger peak at 1415 cm^{-1}, which we assign to the carboxylate ion, tells us that the presence of random coil structures and hydrolysis of the peptide bonds are correlated. The link to SO_2 pollution is established by examination of the expansion coefficient in all samples. It is observed that among the highest values we find the SO_2 polluted new parchment.

Conclusions

Obviously, Raman spectroscopy is a very useful technique for describing the hydrolytic breakdown of collagen. Spectra may be recorded in a very short time, and the possibility exists for performing non-destructive measurements. Future work in this field would consist in recording a large amount of spectra from historical parchment, spectra of new parchment exposed to different artificial ageing methods such as pollution, heat and enzymatic cleavage of specific peptide bonds. The ultimate objective will be to construct basis functions for the most common deterioration mechanisms, such that future parchment samples may be accurately described in terms of these functions.

The collagen-based material in this work is parchment. However, we do believe that the present technique may be applied to other materials such as bones and teeth.

Table 11.1 The assignment of the peaks for the parchment samples.

NP flesh side	NP grain side	HPa flesh side	HPa grain side	HPb flesh side	HPb grain side	NP, SO$_2$	Assignment
2980, vs,sh	2980, v s,sh	2980, vs,sh	2980, vs,sh	2980, vs,sh	2980, vs,sh	2977, vs,sh	ν(CH$_3$) symmetric
2939, vs	2938, vs	2939, vs	2939, vs	2940, vs	2940, vs	2939, vs	ν(CH$_3$) symmetric
2882, s,sh	2882, s,sh	2883, s,sh	2881, s,sh	2882, s, sh	2882, s,sh	2881, s, sh	ν(CH$_2$) symmetric
1802, vw		1802, m	1807, m	1808, m	1801, m	1802, w	
		1788, m	1796, m,sh	1798, m,sh	1793, m,sh		
1670, s	1668, s	1672, s	1664, s,sh	1666, s	1670, s	1667, s	Amide I
1642, m,sh	1642, m,sh	1646, m,sh	1651, m,sh	1645, m,sh	1640, m,sh	1639, m,sh	Amide I
			1606, m		1606, mw	1607, mw	Phe,Tyr
			1593, m				
			1570, mw				
1450, s	1449, s	1448, s	1449, s	1451, s	1451, s	1450, s	δ(CH$_3$, CH$_2$)
1422, m,sh	1422, mw	1416, m	1422, m,sh	1422, m,sh	1426, m,sh	1422, m,sh	ν(COO$^-$)
			1409				ν(COO$^-$) asymmetric?
					1396, mw		
					1377, mw	1380 m	
1340, w	1340, w	1335, w	1333, s		1341, w	1337 m	γ_w(CH$_3$, CH$_2$)
1314, mw	1316, mw		1320, s	1314 w	1321, m	1315, m	γ_t(CH$_3$, CH$_2$)
			1308, s				
		1286, m					
1270, s	1271, s	1273, m	1280, m	1269, s	1270, s	1268, s	Amide III
			1266, s				
1248, s	1243, s	1249, m	1245, m	1247, s	1245, s	1244, s	Amide III
					1206 mw	1206, w	Hyp, Tyr
					1184, w		Tyr
		1134, w				1146, m	ν_3(CaSO$_4$), SO$_2$
		1104, w		1103, w,sh	1099, m,sh	1098, m,sh	ν(C-N) ?
1085, s	1085, w	1086, s	1085, w	1086, s	1086, m	1084, m	CaCO$_3$
		1059, w,sh			1061, m		
		1043, s	1045, s	1045, s	1043, m		HSO$_4^-$
1032, mw	1031, m			1034, s	1033, m,sh	1028, m	HCO$_3^-$
1003, m	1002, m	1007, s	1007, s	1004, w	1003, m	1003, m	CaSO$_4\cdot$2H$_2$O/ Phe
		969, w			968, m,sh	971, m	Amide III$'$
936, m	936, m	934, m	937, m	940, mw	939, m	936, m	ν(C-C) protein backbone
919, m	919, m	921, m	919, m	921, mw	920, m	920, m	ν(C-C) Pro-ring ?
877, m	874, m	877, w	873, m	870, w, sh	879, m	873, m	ν(C-C) Hyl-ring
855, m	855, m	858, mw	855, w, sh	852, w	855, m	854, m	ν(C-C) Pro-ring
814, m	814, m	813, w	813, mw	813, w	814, m	815, w	ν(C-C) backbone

Abbreviations: s, strong; m, medium; w, weak; sh, shoulder; vw, very weak; ν, stretching; δ, deformation; γ_w, wagging; γ_t, twisting; Phe, phenylalanine; Hyp, hydroxyproline; Tyr, tyrosine; Pro, proline

References

Frushour, B. G. and J. K. Koenig (1975) 'Raman scattering of collagen, gelatin and elastin', *Biopolymers* 14, pp. 379–91.

Goheen, S.C., L. J. Lis and J. W. Kaufmann (1978) 'Raman spectroscopy of intact feline corneal collagen', *Biochemica et Biophysica Acta* 536, pp. 197–204.

Larsen, R., M. Vest and K. Nielsen (1993) 'Determination of hydrothermal stability (shrinkage temperature) of historical leather by the micro hot table technique', *Journal of the Society of Leather Technologists and Chemists* 77, pp. 151–6.

Raman, C. V. and K. S. Krishnan (1928) 'A new type of secondary radiation', *Nature* 121, p. 501.

Strommen, D. and K. Nakamoto (1984) *Laboratory Raman Spectroscopy*. J. Wiley & Sons, New York.

12 Detection of Radicals in Collagen and Parchment Produced by Natural and Artificial Deterioration, Electron Spin Resonance Spectroscopy (ESR) and its Implications for Artificial Ageing and Test of Conservation Treatments

Daniella Bechmann Hansen, Kurt Nielsen and Søren Birk Rasmussen

The principles and methods of electron spin resonance spectroscopy (ESR)

ESR spectroscopy

Electron spin resonance (ESR) or electron paramagnetic resonance (EPR) is used to study systems with unpaired electrons such as free radicals.

The principles of ESR have been known since the 1920s, when Stern and Gerlach showed that an electron magnetic moment in an atom can take on only one discrete orientation in a magnetic field. The first observation of an electron spin resonance peak was, however, made in 1945 by Zavoisky by applying a permanent magnetic field to a sample containing one or more unpaired electrons. An unpaired electron only possesses two spin states, α- and β-spin also called spin-up and spin-down. The two states will have different energies, and transition between the states can be induced by interaction with electromagnetic radiation. In order for this to occur, the electromagnetic field must have the same energy as the energy gap, ΔE, between the ground state and the excited state, e.g.

$$\Delta E = h\nu \quad [1]$$

Here h is Planck's constant, and ν is the actual frequency corresponding to the middle of peak. From quantum chemistry we can find the energy difference between the two states by looking at the energy for the electron with α-spin and the electron with β-spin. A free electron will have a single transition between the two levels α and β.

The energy for the α-spin state is $E_\alpha = ½g_e \beta B$ and $E_\beta = -½ g_e \beta B$ for the β-spin state, where $g_e = 2.0023$ is the electronic Landé factor or g-factor for the free electron, β is the Bohr magneton and B is the strength of the external field (measured in Gauss).

The separation between two adjacent energy levels becomes

$$\Delta E = g_e \beta B \quad [2]$$

for one unpaired electron.

From equations (1) and (2), the expression for the g-factor in a radical can be obtained by replacing g_e with g because of the change in the surroundings.

$$g = h\nu/\beta B \quad [3]$$

The shape and number of peaks in an ESR spectrum is dependent on the nuclear spin of the neighbouring atoms. An electron, which does not interact with any nuclei, will give a single peak, while an electron interacting with a nucleus with the nuclear spin number I = 1 (such as nitrogen) will give rise to three peaks according to N = 2nI + 1, where *N* is the number of peaks, and *n* is the number of neighbouring atoms. If the electron interacts with several nuclei, the number of peaks are found by

$$N = \sum_{i=1}^{r}(2n_i I_i + 1) \quad [4]$$

For molecules with a delocalized π-system all of the atoms involved in the delocalization have to be accounted for as neighbours.

The allowed transitions in ESR are those which obey the following rules:

1. The difference in spin quantum numbers, m_s, has to be 1, e.g. $|\Delta m_s| = 1$. The transition has to occur between two levels with different m_s. The possible values are $m_s = ±½$.
2. The nuclear spin is left unaltered, that means $\Delta m_I = 0$. For a nucleus with I = 1 the possible values for m_I are 1, 0, –1.

Examples
- The methyl radical, H₃C•: The unpaired electron will interact with the three hydrogen atoms and give 2 × 3 × ½ + 1 = 4 lines in the ESR spectrum.
- The methanol radical formed by proton abstraction, •CH₂OH: In this radical there are two different kinds of protons, the CH₂'s and the one on OH. This gives (2 × 2 × ½ + 1)(2 × 1 × ½ + 1) = 6 lines.
- The nitrobenzene radical, •C₆H₅NO₂: Nitrobenzene has four different groups of atoms with which the elec-

Table 12.1 Natural abundance and nuclear spin numbers for the most common atoms in organic compounds.

Nucleus	Natural abundance (%)	I
1H	99.99	½
^{12}C	98.89	0
^{14}N	99.63	1
^{16}O	99.963	0

Figure 12.1 Energy levels and transitions for one free electron.

Figure 12.2 Nitrobenzene radical.

Figure 12.3 ESR spectra of a) the methyl-radical and b) the methanol-radical.

tron can interact – the NO_2-group and 2 ortho-, 2 meta- and 1 para- protons. N = (2 × 1 × 1 + 1)(2 × 2 × ½ + 1)(2 × 2 × ½ + 1)(2 × 1 × ½ + 1) = 54 lines.

The ESR spectrum

The ESR spectra of the methyl and methanol radicals show exactly the predicted number of peaks. The relative intensities of the peaks are given by Pascals triangle for I = ½. This gives, for methyl radicals, a ratio of 1:3:3:1 (Fig. 12.3a). The distance between two adjacent peaks is called the hyperfine structure constant, a, and it is an indication of the delocalization of the electron. In the methanol radical there are two different types of hydrogen atoms and, because of this, two different a_H. The largest values arise from the two hydrogen atoms on carbon, while the small ones come from coupling with the hydrogen atom bonded to oxygen. This difference is due to the fact that the coupling is distance-dependent in saturated systems: the further away the proton the weaker the coupling.

All peaks in the ESR spectrum have an observed basic line width of approximately 10–20mG, which arises from inhomogeneities in the magnetic field. The normal line width lies from 40mG to several hundred, where the major contribution comes from phenomena called spin relaxation. There are two types of relaxation: spin-lattice and spin-spin. Spin-lattice relaxation is the dominant form in measurements of transition metals and organic radicals with two unpaired electrons. For organic radicals with one unpaired electron the predominant contribution comes from spin-spin relaxation. The latter effect is due to the different environments in which the unpaired electron may be distributed. This will lead to small energy differences, which emerge as a broadening of the ESR lines. In the spectrum of nitrobenzene we found that there should be 54 lines. By counting the lines in the spectrum (Fig. 12.4) we see that there are only 46. This is due to line broadening.

ESR analysis of calcite from parchment

Natural calcite from limestone quarries as well as from fossils and recent sea urchins contain a small amount of manganese instead of calcium. In contrast to synthetic calcite, natural

Figure 12.4 ESR spectrum of the nitrobenzene radical.

calcite, due to the presence of manganese, has a characteristic ESR spectrum. The nuclear spin of manganese is 5/2, and this gives a spectrum with 2 × 5/2 + 1 = 6 lines.

The ESR spectrum (Fig. 12.5) of calcite from a historical parchment clearly shows that the calcite originates from natural sources.

Figure 12.5 ESR spectrum of calcite from parchment sample.

The ESR spectrometer

All the parchment spectra have been recorded on a Bruker EMX spectrometer with a 12kW 10 magnet. The spectra were recorded in a Bruker ER4102ST cavity in X-band at 9.5GHz with a data acquisition program. The spectrometer is shown in Figure 12.6.

The microwave generator emits microwaves which are sent into the cavity via the circulator. The cavity is tuned using an iris-screw, so the cavity contains an even number of wavelengths. If this is done properly, the majority of the microwaves remain in the cavity as standing waves (resonance), while the reflected microwave is detected by the diode. The detected signal is mixed with a reference signal and sent through a low-pass filter to eliminate most of the noise. This is called phase sensitive detection (PSD), and by using this method, it is easy to detect even weak signals with a minimum of noise. The spectrometer is also equipped with an automatic frequency control (AFC) unit to stabilize the microwave resonance frequency in the cavity. If the cavity is not empty, some of the energy will be absorbed, and the ratio between incoming and outgoing radiation will be displaced. This will be detected as an integrated curve on the computer.

Figure 12.6 The ESR spectrometer.

ESR spectroscopy of collagen

Previous ESR measurements on collagen were performed after irradiation with γ-radiation or after mechanical degradation of the samples. The observed values for g lies between 2.005 and 2.007 (Dubinskaya *et al.* 1982; Fisher *et al.* 1971; Scandola and Reed 1979). There are two types of observed radicals: a triplet originating from a broken peptide bond involving glycine:

$$\text{ww CO—C}_\alpha\text{HH}_1$$

The free electron will be localized on C_α, with a = 22G. All other peptide bonds results in a doublet

$$\text{ww NH—}\overset{\bullet}{\text{C}}\text{R—COww} \quad \text{with a = 18G.}$$

Results and discussion: ESR spectroscopic study of parchment

The detection limit in ESR spectroscopy is ~10^{-9}M. For free radicals, a more practical limit probably is ~10^{-7}M. Thus ESR spectroscopy is extremely well suited to detect even very small amounts of free radicals, formed by artificial ageing of parchment. When exposed to light and heat, the degradation of parchment is believed to occur via free radical formation, whereas nothing is known about the effect of pollution.

Samples of parchment were cut in pieces in order to enhance the reaction surface. The samples were then treated with SO_2, NO_2 or heat to determine which factors influenced the formation of the free radicals. After these initial experiments the samples were treated with polluted air, a mixture of 10% SO_2, 11% O_2 and 79% N_2. To obtain a humid gas, this mixture was blown through SO_2 saturated water.

Initial ESR experiments

Three different methods for creating free radicals have been tested:

1. SO_2 pollution
2. NO_2 pollution
3. Heat

SO_2 pollution

It has turned out that the formation of free radicals is a slow process that may be accelerated by heat. However, since the radicals are fairly stable, prolonged treatment with SO_2 will increase the concentration of free radicals even at room temperature. A fair concentration is obtained by using the SO_2-gas mixture and 100% RH. The gas mixture was passed

Figure 12.7 ESR spectra. The curves 2,3 and 4 are scaled by a factor of 10, 100 and 500 relative to curve 1.

Figure 12.8 ESR spectra of A) NO-radical detected in collagen from a skin sample, a') Simulated spectra of the NO-radical, B) NO-radical detected in a parchment sample, C) Single broad line ESR spectra.

through the sample with a flow of 16 ml/min for 4 hours; after the flow was stopped the sample was kept in this atmosphere for another 18 hours. The consecutive ESR measurement resulted in spectrum 1 in Figure 12.7.

The radical formed was identified as a nitroxide radical, which must be formed by oxidation of either nitrogen atoms in the peptide bonds or nitrogen atoms in the side chains. The importance of oxygen and moisture was then examined by in turn omitting one of them. By omitting moisture only a reminiscence of a radical (spectrum 3, Fig. 12.7) was seen, probably due to moisture in the sample itself. When oxygen is removed there is no significant sign of radicals (spectrum 4, Fig. 12.7).

NO_2 pollution

The presence of NO_2 does not produce free radicals. The only effect observed was hydrolysis of the sample.

Heat

Only a single experiment has been carried out: air at 100% RH (25°C) was passed through a sample heated to 65°C (spectrum 2, Fig. 12.7). A small, but significant, amount of radical is formed. The radical is unknown, but different from the nitroxide radical.

Results of treatment with SO_2 polluted air

The mixture of humid atmospheric air and SO_2 produces two radicals with distinctly different ESR spectra. The free radical formation is determined by multiple kinetic parameters, which is yet not fully understood.

The first type of radical shows a typical powder spectrum of an axially symmetric nitroxide. Formation of nitroxide radicals in concentrations above the detection limit without adding NO spin traps is relatively rare and the stability of this radical is less than typical lifetimes for spin trapped NO-radicals. The half time is estimated to be ~ 6 hours. The parallel hyperfine coupling constant, $a_{||}$= 25.6 G, is significantly less than the expected 32-33 G for nitroxide powder spectra. This may be due to the presence of electron withdrawing neighbouring atoms giving a decreased spin density on the nitrogen atom.

The chemical environments that may cause this effect can be a protonated aromatic ring (histidine) or an amide group (>C=O). Due to the low concentration of histidine compared to that of amide groups, we find the latter explanation the most probable.

The second type of radical gives a broad single line with g = 2.0060 ± 0.0002. This spectrum is consistent with the formation of the SO_2^- radical, which involves a reduction of SO_2. On basis of the Raman experiments, which show an oxidation of SO_2, we find this possibility very unlikely. The spectrum is also consistent with the formation of -CO radicals, which may be formed by breaking of the peptide bonds.

Conclusion

Raman experiments have shown that SO_2 may lead to some degree of random coil structure in the parchment, and that SO_2 is oxidized to SO_3. We also know that the deterioration of collagen objects, stored in strongly polluted big cities, is mainly due to hydrolysis of the free peptide bond. The ESR

experiments have shown that in combination with oxygen, SO$_2$ causes oxidation of nitrogen atoms resulting in nitroxide radicals and possibly -CO radicals. The combination of this information strongly indicates that the impact, by SO$_2$, on the collagen molecule is the destruction of the peptide bonds. Further proof for this hypothesis may be provided by amino acid analysis of SO$_2$ polluted samples and possibly by small angle X-ray diffraction.

Note: These experiments have been very difficult to carry out. Due to external noise the signal-to-noise ratio occasionally may be very low, and occasional lack of reproducibility indicates that the kinetics of radical formation are not fully understood. Before these effects are under control, we do not recommend ESR as a routine experiment.

References

Dubinskaya, A.M., N. E. Segalova and A. D. Zlatopolsky (1982) 'Mechanical destruction of collagen', *Biofizika* 27, 2, pp. 225–9.

Fisher, B. V., R. E. Morgan, G. O. Phillips and H. W. Wardale (1971) 'Radiation damage in calcium phosphates and collagen – interpretation of ESR spectra', *Radiation Research* 46, pp. 229–35.

Pedersen, J. E. (1998) *Elektron Paramegnetisk Resonans spektroskopi: Endor og Trippel resonans.* Fysisk-Kemisk afdeling, DTU.

Scandola, M. and P. E. Reed (1979) 'ESR study of degraded bovine bone', *Journal of Materials Science* 14, pp. 541–8.

Weil, J.A., J. R. Bolton and J. E. Wertz (1994) *Electron Paramagnetic Resonance.* John Wiley and Sons, Inc.

13 Determination of the Molecular Weight Distribution in Parchment Collagen by Steric Exclusion Chromatography

Frédérique Juchauld and Claire Chahine

Introduction

Parchment is mostly composed of collagen which forms a network of fibres and fibrils. The fibrils consist of the association of three chains in triple helix and the primary structure is composed of the amino acids series. In order to keep the mechanical qualities of parchment, it is important to preserve the whole polypeptide chain both in composition and length.

Oxidation and hydrolysis induce breakdowns which occur in different parts of the molecules, creating fragments of different molecular weights. The purpose of this study was to assess the degradation by evaluation of the molecular weight fragments distribution using steric exclusion chromatography (SEC). The separation which results from interactions between the sample, the stationary phase and the mobile phase will establish the fragments' distribution versus the molecular weights.

Materials and methods

Materials

Parchments
NP5 modern parchment from a French manufacturer was artificially aged in our laboratory with heat at 80°C and 120°C, and in a pollution chamber with 10 ppm NO_2, 25 ppm SO_2, at 40°C, 30% relative humidity (RH). Modern parchments prepared by craftsmen – NP3, NP4, NP6, NP7 – and historical parchments from the sample bank HP series.

Chemicals
Sodium dodecyl sulphate SDS (Sigma), Brij 35 (Sigma), Triton X100 (Sigma), urea (Prolabo), guanidine (Sigma), sodium dihydrogen phosphate and disodium hydrogen phosphate (Sigma), Biuret reagent ready to use (Sigma), mercaptoethanol (Sigma), polystyrene sulfonate molecular weight standards (American Polymer Atandards Corporation), proteins and peptides (Sigma), Amberlite IRA 68 (Sigma), gelatins (SBI, Prolabo, Rousselot).

Methods

Dissolution of parchment
Parchment previously cut or ground was added to the solvent in hermetic flasks and put in a heating/stirring module (Reacti-therm Pierce) with the maximum stirring (magnetic stirrer) for defined times and controlled temperatures.

Grinding of parchment
Pieces of parchment were ground using a Retsch grinder with zirconium oxide cups. Cryo-grinding was performed on a Bioblock system with liquid nitrogen.

Biuret reaction
This is a method of quantifying proteins in plasma by reaction of copper ions with the peptide bonds to form a purple colour. The maximum absorbance is 540nm and the intensity is proportional to the total protein concentration for a defined protein. The measurements were performed using a UV/Vis spectrometer UV2 (ATI-Unicam). The ready-to-use solution was found to be more stable than our laboratory solutions.

Gel filtration
The analysis was performed on a system composed of a Beckman pump 168, a UV detector spectra Physics 100, detection at 220nm. Two sets of columns were used: 4 PL Aquagel columns (2 × 40 and 2 × 60) from Polymer Laboratories and 2 OH Pack columns (802 and 802.5) from Shodex. The second set is composed of 2 Asahipak columns from Shodex (GS 620 and 320 HQ). Temperature was controlled by keeping the columns in an oven at 50°C. Samples and calibration standards were filtered before injection on 0.4μm filters. The injected amount was 20μl.

Filtration on ion exchange columns
After dissolution of the parchment, the solution was passed through a column filled with Amberlite IRA 68 as an ion exchange stationary phase. This was used for the analysis of the special case of polluted samples.

Experiment

The SEC must be performed on soluble compounds. Collagen when intact is highly insoluble, but the dissolution is expected to be easier when deterioration has induced breaking. An important part of our study was devoted to the development of methods for dissolving as much as possible of the molecule and controlling the rate of dissolution.

Solubilization

Different methods of evaluation of the dissolution rate

a) Weight estimation This method is based on the calculation of the difference of weight between one quantity of solvent and the same quantity of solution containing the dissolved parchment. The estimation was performed after centrifugation, drying and stabilization at 50% RH and 23°C. It was established on new parchment regarding the large amount of material necessary to limit the error of weighing: 100mg/10ml of solvent. Unfortunately, detergents (Triton, Brij, SDS) can provoke the formation of micelles around the collagen molecules, increasing the weight and inducing overestimation of the rate of dissolution.

b) Biuret method We used the Biuret method with gelatin as standard (collagenous proteins completely soluble). The calibration curve, performed using various concentrations of gelatin, was found to be linear up to 5mg/ml. The problem with this method is that it cannot be applied to all kinds of parchments. In fact the concentration refers directly to the number of peptide bonds. But degraded parchments present fragments of lower molecular weights with a smaller number of peptide bonds (when compared to more intact parchment) while retaining the same total weight of soluble parchment.

For example:

Gly-Pro-X-Gly-Pro-X-Gly-Pro-X-Gly-Pro-X =
11 peptide bonds

Gly-Pro-X + Gly-Pro-X + Gly-Pro-X + Gly-Pro-X =
8 peptide bonds

For the same weight we have a decrease of 27% of the number of peptide bonds that will directly decrease the Biuret estimation. This phenomenon induces underestimation of the rate of dissolution.

In fact, we cannot apply this method to the estimation of the real weight of soluble parchment, but we found it helpful to optimize our dissolution conditions. For this purpose new parchment was used (for the obvious reason of available quantity), and the defined conditions were then applied to other parchments.

c) Surfaces of the chromatographic profiles In chromatography the detection is performed by using a spectrometer. The absorbance law of Beer and Lambert states that absorbance is directly related to the concentration:

Figure 13.1 *Chromatographic profiles of gelatins.*

$$A = \varepsilon \times C \times l$$

(where A = absorbance value, ε = molecular absorption coefficient, C = concentration, l = optical way) and normally the molecular absorption coefficient is specific for each molecule. We made use of gelatins of different qualities (Fig. 13.1), i.e. presenting collagenic molecules more or less damaged by hydrolysis, oxidation or cross-linking and consequently various molecular weight distribution, that induces different fragments with various molecular absorption coefficients. We noted that after calculation of the total surfaces under the peaks of the different chromatographic profiles versus the injected weight we obtained one unique ratio for the three gelatins.

Developing the law, it appears:

$$A = \varepsilon \times C \text{ mol L}^{-1} \Leftrightarrow A = \varepsilon \times \frac{\text{mass L}^{-1}}{\text{mass mol}^{-1}}$$

because C mol L^{-1} = mass L^{-1}/mass mol^{-1}. For different molecules we have:

$$A_i = \varepsilon_i \times M_i / m_i$$

In the case of gelatin the total mass is always the same so we have ΣM_i = constant and we observed on the chromatographic profiles that ΣA_i = constant.

For example for two distinct fragments of gelatin where weights are m_1 and m_2 per mole and M_1 and M_2 the concentration in mass L^{-1} for one gelatin and M_1' and M_2' for the other one.

$$A = \varepsilon_1 \times \frac{M_1}{m_1} + \varepsilon_2 \times \frac{M_2}{m_2} = \varepsilon_1 \times \frac{M_1'}{m_1} + \varepsilon_2 \times \frac{M_2'}{m_2}$$

$$M_1 + M_2 = M_1' + M_2' \Leftrightarrow M_1 = M_1' + M_2' - M_2$$

$$\varepsilon_1 \times \frac{\left(M_1' + M_2' - M_2\right)}{m_1} + \varepsilon_2 \times \frac{M_2}{m_2} = \varepsilon_1 \times \frac{M_1'}{m_1} + \varepsilon_2 \times \frac{M_2'}{m_2}$$

$$\varepsilon_1 \times \frac{M_2'}{m_1} - \varepsilon_1 \times \frac{M_2}{m_1} + \varepsilon_2 \times \frac{M_2}{m_2} = \varepsilon_2 \times \frac{M_2'}{m_2}$$

$$\frac{\varepsilon_1}{m_1} \times \left(M_2' - M_2\right) = \frac{\varepsilon_2}{m_2} \times \left(M_2' - M_2\right)$$

$$\varepsilon_1 = \varepsilon_2 \times \frac{m_1}{m_2}$$

Table 13.1 Effect of various solvents on the dissolution rate of new parchment.

Solvent	Water	Urea 3M	DMF 20%	Guanidine 3M	Brij 35	Triton X100
Dissolution rate	0.13	0.15	0.16	0.18	0.22	0.33

We can say that the molecular absorption coefficient is directly proportional to the weight of the molecule. We used this method to approximate the rate of dissolution.

Different methods of dissolution

We studied six parameters influencing the rate of dissolution:

- *Solvent nature*: affinity with collagen molecule, characteristic and concentration.
- *Temperature*: increasing temperature improves dissolution but is limited by the stability of the compound. It should be correlated with the shrinkage temperature of parchment.
- *Time of treatment*: The dissolution problem could be due to the kinetic of the reaction which is very slow, so we have to increase the time of contact as much as possible.
- *Preparation of the sample*: it is also well known that increasing the surface of contact with the solvent increases the dissolution (see Noyes and Whitney law: V = K × S × (Cs – Ct) where V = dissolution rate, S = surface in contact with the solvent, K = constant function of the stirring, solvent viscosity, temperature, Cs = saturated concentration, Ct = instantaneous concentration). We can cut or grind the parchment in order to increase the surface of contact with the solvent. But as the grinding can provoke degradation by heat, we also tested a cryo-grinding preparation.
- *Stirring:* with the same above-mentioned law we can see that stirring increases the K constant.
- *Concentration:* dissolution is also correlated with the ratio: mass of sample/mass of solvent. But in this case the sample mass is so weak that it cannot be the problem, since it remained largely below saturation.

Results and discussion

We tested seven solvents commonly used for the denaturation of collagen: hot water, sodium dodecyl sulphate (SDS) (anionic surfactive), Brij 35 (non-ionic surfactive), Triton X100 (non-ionic surfactive), dimethyl formamide, urea, guanidine (Table 13.1).

Each one was tested in different concentrations commonly described for dissolution in the literature. The method used was based on the difference of weight, after drying, between the sample contained in a certain volume of solvent, and the same volume of solvent. First attempts were made on new parchment at 60°C for 30 minutes.

The choice of solvent was also dependent on the chromatographic system and the detection mode in ultraviolet (UV) light. Triton X100 solution absorbs UV light, so it was rap-

Table 13.2 Effect of SDS concentration and time of extraction fixing the temperature at 60°C.

	SDS concentration					
	0.25%	0.5%	1%	1.8%	2.5%	5%
4 hours	54%	51%	57.5%	60%	57%	46%
16 hours		69%	86%	72%	86%	78%
20 hours	71%	75%	88%	84%	91%	87%
24 hours	76%	81%	87%	88%	92%	89%

Table 13.3 Effect of temperature and time of extraction fixing the SDS concentration at 1.8%.

temperature	40°C	50°C	60°C
16 hours			72%
24 hours	51%	79%	88%
48 hours	62%	83%	88%
72 hours	80%	91%	
96 hours	71%	107%	

idly eliminated. After various attempts we concluded that it was impossible to reach a good separation with Brij35 as eluant in the chromatographic system. We finally chose the SDS solution which both improves the dissolution and is recommended for the SEC technique.

The conditions of dissolution of new parchment were chosen using the Biuret method.

With reference to the concentration of SDS: the optimum was obtained between 1 and 2.5% (Table 13.2). We fixed the conditions at 1.8% but we also used 0.9% in order to decrease the perturbations induced by the excess of SDS in the chromatographic system.

Regarding the effect of temperature and time: increasing both parameters is a good way to improve the dissolution but we had to take precautions to avoid damaging the collagen molecules. For this reason we also controlled the effect of dissolution by using the chromatographic profiles (Fig. 13.2). The most difficult part to dissolve being that containing the high molecular weights, we focused on increasing this part of the chromatographic profiles as much as possible, while at the same time preserving it.

Figure 13.2 Chromatographic profiles of solubilized parchment at 50°C 48 hours and 60°C 2 hours.

Temperature was tested between 40°C and 80°C – obviously low temperatures require longer times (Table 13.3).

If too much time is allowed, some deterioration can occur as we have seen after 48 hours at 50°C. On the other hand if we increase the temperature to 80°C the first signs of deterioration occur after only 2 hours.

Applying our method on historical parchment we found low rates of dissolution so we decided to optimize the sample preparation.

There are two methods for the preparation of samples before the dissolution: cutting or grinding. Ground parchment generally presents better dissolution rates and we obtained good results, particularly for the historical parchments that are so difficult to dissolve. On the other hand, the heat induced by the grinder provokes some deterioration in the collagen molecules. Consequently, we tested a cryo-grinder but this did not decrease the deterioration. The heat effect is probably too localized to be avoided by a system of cooling.

The final conditions for the dissolution were chosen as follows: 60°C for 24 hours using cut parchment in 0.9% SDS solution under stirring performed with a magnetic stirrer at maximum speed.

Finally, in order to estimate the real value of dissolution for all parchments avoiding the problems due to the deterioration state, we used the method of calculation based on the surfaces under the chromatographic peaks (Tables 13.4, 13.5 and 13.6).

Dissolution rates vary, but generally they indicate that only part of the material can be dissolved. They depend on the state of deterioration, the quality and the making of the material, and they let us foresee difficulties with the interpretation of the results.

Steric exclusion chromatography analysis

Some methods of analysis of gelatin by SEC are described in the literature (Kanegae *et al.* 1994, 1996; Kobayashi *et al.* 1994; Butkowski *et al.* 1982). We applied them to parchment, but the most important difference is the dissolution, which is very weak in the case of parchment. This characteristic reduces our conclusion to the soluble part of the molecule only. The other problem arising with collagen is calibration, this protein having a specific hydrodynamical behaviour.

Pl Aquagel system

The system is composed of four columns covering a theoretical molecular weight range from 1 000 KDa to 200 Da. 0.9% SDS aqueous solution was used as eluant.

a) Calibration The mode of binding of SDS to various kinds of polypeptides is not unique and depends on the composition and sequence of the amino-acid residues. With most of the polypeptides, the binding of SDS induces the formation of α-helical structure, while collagen lacks this ability. The high content of imino acids creates restrictions in the rotation of the chains. These characteristics result in a different conformational and hydrodynamical behaviour of the collagen polypeptides which, occupying higher hydrodynamical radii, will elute more rapidly than the equivalent globular proteins. In fact not only the size but also the shape of the protein is important for the retention time.

Another difficulty in comparison with globular proteins lies in the fact that the collagenous polypeptides, due to their special amino acid composition with a high content of Gly, have a mean residue weight significantly lower than those of the standards proteins (around 91.8 versus 115).

Interactions (ionic and hydrophobic) with the stationary phase also influence the mobility of the proteinic fragments. This is particularly true for the smallest molecules as amino acids of which adsorption depends strongly on the chemical structure. This effect induces problems with the estimation of the peak of total permeation bed because small standards adsorbed on the stationary phase extend artificially the curve of calibration. On this system, below 700 Da it is difficult to evaluate the molecular weights.

Placed on the same calibration curve (Fig. 13.3), the all-different standards result in three segments with different slopes due to their different hydrodynamic characteristics. The smaller the fragments, the more rigid they are and consequently overestimation of their hydrodynamic volumes may result.

The evaluation of our results was based on the value of the α-chain, which is easy to define in gelatin and perfectly estimated in the literature. We obtained a result of 98540 Da. Although this is a slight overestimation, given the inherent errors in the method it is acceptable.

Table 13.4 Dissolution rates of various new parchments.

NP6	NP5	NP7	NP3	NP4
42%	38%	23%	16%	11%

Table 13.5 Dissolution rates of various historical parchments.

HP16	HP36	HP7	HP26	HP8
31%	30%	19%	19%	18%
HP38	HP20	HP37	HP22	HP31
7%	6%	3%	2%	0%

Table 13.6 Dissolution rates of NP5 aged at 120°C.

120°C 14 days	120°C 2 days	120°C 1 day
42%	26%	22%

Figure 13.3 Calibration curve on PL Aquagel system.

b) Results of the parchment analysis On the chromatographic profiles obtained with this system, we can easily determine the α-, β- and γ-chains, the higher molecular weight fragments (over 700 KDa), two characteristic peaks around 30 KDa and 12 KDa. Below this last value we have a few, very small peaks with the exception of one at 62 minutes (this peak is out of the calibration range therefore it is not possible to estimate its molecular weight) which has been found to be very high in some samples.

In the chromatographic profile of the reference NP5 (Fig. 13.4), we can observe peaks corresponding to these large range of molecular weights.

In the series of artificially aged parchments at 120°C we observed (Fig. 13.5):

- a first step with a decrease of the peaks corresponding to the high molecular weight fragments (α-, β- and γ-chains). The phenomenon is very fast, since it is apparent after only 4 hours. As the other peaks do not increase, this results in a smaller total surface under the peaks which can be interpreted as a decrease of dissolution.
- a second step occurring several hours after the first and which is marked by an increase of the peaks of lower MW around 30 and 12 KDa.

This evolution can be interpreted in terms of cross-linking, which decreases the dissolution rate and breakdowns, which slowly increase it. However this does not mean necessarily that cross-linking and breakdown phenomena occur one after the other; in fact they can occur simultaneously. What we want to focus on, in the case of the heat ageing, is that cross-linking starts more rapidly than breakdown, and therefore predominates at the beginning of the ageing. Then the phenomenon slows down, but meanwhile breakdowns take place slowly but continuously. It follows that rapid breakdown is the only phenomenon which is clearly observed, cross-linking seeming over.

After one week, even the peak at 30 KDa starts to decrease and most of the fragments are concentrated under the 12 Kda peak, as if the deterioration would not worsen any more (Fig. 13.6). Yet it would be logical that the next step following deterioration would be an increase of the smaller fragments. In spite of the visible worsening of our parchment aged at 120°C for several weeks, we did not see any new peak beyond it. For this reason we suspected that the total permeation bed could be located under this peak for the collagenic molecules.

In fact there are two possibilities:

- our system SDS/collagen products/columns is not efficient for the small molecular weights below 12 KDa, which would be the value of the total permeation bed and for this reason we do not see the further step of deterioration.
- this system is efficient for the separation of fragments below 12 KDa, but the deterioration is not visible because we may underestimate the small peaks after 52,7 min. On the other hand, small peptides could present much lower molecular absorption coefficients

Figure 13.4 Chromatographic profile of new parchment no. 5.

Figure 13.5 Chromatographic profile of parchment artificially aged at 120°C up to 1 day.

Figure 13.6 Chromatographic profile of NP5 artificially aged at 120°C for 1 day and 2 weeks.

Figure 13.7 Chromatographic profiles of parchment aged in the pollution chamber 16–32–48 weeks.

(see p. 125 on the solubilization rate calculated by the surface under the peak; but in this case, the analysis of gelatins which have not deteriorated sufficiently to produce a lot of very small peptides is of no help).

In the series of parchment aged at 80°C, we observed the same phenomenon but it was slower: some deterioration was produced after 2 weeks, but it did not reach the level of the 120°C treatment.

The series of parchment artificially aged with pollutants (Fig. 13.7) presents a very weak shift to low molecular weights with mostly an increase of the 12 KDa peak. Therefore these conditions do not provoke as many cross-links and breakdowns as the ageing at 120°C.

On these profiles, the most important change lies in the last eluted peak. This peak increases with the time of ageing in the pollution chamber. The compounds adsorbed on the stationary phase are thought to be nitrates. In fact filtration on the ion exchange column of the sample results in the disappearance of this peak. It has been observed that SO_2 is continuously adsorbed by the material as in vegetable-tanned leather, but unlike the latter, parchment also adsorbs NO_2 continuously.

In the series of historical parchments, we were confronted with the problem of dissolution. In fact, probably due to cross-links in the collagen molecule we observed very low rates of dissolution which created difficulties in the interpretation of the results. However, we obtained more or less the same chromatographic profiles as for the artificially aged parchment at 120°C. The similarity could be due to the limitation of the chromatographic profile because of cross-linking and also poor resolution of the system. In this case it is difficult to extend the results to the whole molecule.

At this stage we chose to focus our study on the small molecular weight fragments and we decided to add two columns OH Pack especially adapted for this purpose. There was no improvement in the results.

On the other hand we tried to analyse the different fractions by reversed phase analysis in order to determine the total amino acids content. But the results were considerably affected by the presence of SDS, a compound that is difficult to remove from the matrix. Taking these two problems into account, we decided to adapt our system in order to eliminate SDS and improve the efficiency of the separation of the low molecular weight fragments by using another set of columns.

Asahipak system

The system is composed of two Asahipak columns covering a theoretical separation range from 300 KDa to 100 Da (Kanegae *et al.* 1994, 1996; Kobayashi *et al.* 1994). Aqueous buffer with sodium phosphate 0.5M × 2, pH 6.5 and addition of sodium chloride 0.5M to prevent adsorption is used as eluant.

a) Calibration The same standards (polystyrene sulfonates and proteins) as previously used for the calibration on the PL Aquagel system resulted in two curves on the Asahipak system, but with a part in common with the low molecular weights (Fig. 13.8). To determine which curve would best correspond to the exact molecular weights, we decided to use as reference the α-chain of gelatin which is easy to determine on the chromatographic profiles (gelatin SBI with α-chains well preserved was chosen for the evaluation). Our choice was then determined by the best approximation given by these two calibration curves for the α-chain. We obtained

Figure 13.8 *Calibration curves with the two series of standards.*

two very different results, i.e. 600 KDa with the series of proteins standards and 104 KDa with the series of polystyrene sulfonates. So our final calibration curve was established with the polystyrene sulfonates to which we added small proteins and altogether they gave a value estimated at 93600 Da for the α-chain.

b) Results of the parchment analysis In the buffer solvent, the dissolution of the high molecular weight fragments (over 200 KDa) is considerably lower than in SDS, and moreover their resolution is weaker due to the poor efficiency of the column on this range of MW, but our purpose was to analyse preferentially the small fragments.

- In the new parchments (Fig. 13.9) the first observed peak (shoulder) is the β-chain (estimated at 193 KDa), which appears particularly in NP6 and also in small quantities in NP5 and NP7. In the two other references, we could only dissolve the α-chain as in NP3, and smaller fragments. Then there are differences already in new parchments. We observe different rates of dissolution (estimated by the total surface of the chromatographic profiles) so we can suppose that some of them are more cross-linked.
- For the series of aged parchments at 80°C and for the polluted series we obtained no additional information in comparison to the PL Aquagel system.
- For the aged parchments at 120°C (Fig. 13.10) we can estimate the first step of breaking at 34 KDa, after 24 hours. If the chromatographic profile is compared to the reference, it can be observed that the high molecular weight fragments, over 68 KDa, are not present, probably because of cross-linking resulting in a decrease of the dissolution rate.

Figure 13.9 *Chromatographic profiles of new parchments NP3 and NP5.*

Figure 13.10 Chromatographic profiles of parchments artificially aged at 120°C.

Figure 13.11 Chromatographic profiles of historical parchments HP7, 16 and 37.

After two weeks at 120°C, the degradation pursues its evolution and releases fragments at a maximum distribution of 13 KDa. The peak at 49 minutes is estimated at 1500 Da. This peak increases with the time of ageing.

- In the series of historical parchments (Fig. 13.11) we obtained several types of distinct profiles. In some of them high peaks appear at 49 minutes (estimated at 1500 Da) as for the 120°C ageing. Some others showed an important peak at the last retention time, beyond the 49 minute peak. This is probably due to nitrates adsorbed on parchment.

Unfortunately some profiles are too flat to allow any interpretation; they only reflect the low level of dissolution.

Correlation between the two chromatographic methods

The problem inherent to calibration is difficult to solve. There is always a doubt – particularly when using current standards to estimate collagenic fragments – regardless of which the method we used, especially for the small molecular weights. Nevertheless the two kinds of profiles that we obtained allow us to draw some conclusions.

We relied more on the PL Aquagel system than on the Asahipak because of difficulties encountered with the dissolution of parchment in the absence of SDS and the problems of separation in absence of the same. Nevertheless,

the Pl Aquagel system raises questions. If the separation on this system is not limited to 12 KDa, then the fragmentation path is preferential, releasing fragments close to this molecular weight. In fact the 12 KDa peak does not decrease, nor do any new peaks appear, even after the drastic treatment of four weeks at 120°C, which results in a totally destroyed, pulverized material. Could it be that the smallest fragments (<12 KDa) are readily transformed into very small peptides undetectable in UV light at 220nm with no intermediate species? This does not seem possible. On the other hand, if the separation on Pl Aquagel does not allow for the separation of fragments under 12 KDa, then it is actually the total permeation bed. This is in fact verified by the Asahipak system, which results in a separation range extending to 1500 Da, peak under which are packed all the small fragments below this molecular weight, representing the total permeation bed for this system.

As the separation of high molecular weights is better on PL Aquagel, and the Asahipak system extends to lower molecular weights, we will take into account the results obtained on the two systems which are complementary.

Correlation with differential scanning calorimetry (DSC) results

The measurements have been performed on all kinds of samples: new, artificially aged and historical (the results are shown in Tables 13.7 to 13.10). For some of them it has been possible to establish a comparison with the dissolution rates. Plotting Td versus dissolution, two curves are obtained: one for the historical and the artificially aged parchments and the other for the references (Fig. 13.12). The degraded parchment line exhibits a clear negative slope, while the slope of the others is close to zero. Considering the progression of the ageing in the 120°C series, where the lower the Td values, the higher the dissolution rates, we can assume that crosslinking is the first step of degradation, and in fact this phenomenon is obvious on the chromatographic profiles of this series (see Fig. 13.5).

On the other hand, some inconsistency has been observed between chromatographic behaviour and DSC results in some cases of deterioration. Although a signal is present on the DSC thermogram, no chain appears on the chromato-

Figure 13.12 Relation between dissolution rates and Td values.

Table 13.7 DSC measurements of new parchments.

New parchments	Onset	Max °C	HJ/g	Shape of the thermogram
NP3	64.0	67.0	31.9	2nd peak in the high temperatures
NP4	64.5	67.0	35.7	2nd peak in the high temperatures
NP6	60.5	64.0	41.7	2nd peak in the high temperatures
NP7	63.0	66.5	39.1	2nd peak in the high temperatures
NP5	56.0	60.0	33.6	–

graphic profile. Yet the peak of absorption energy is due to the collapse of the collagen triple helix, transforming the organized structure of collagen into a disorganized mixture of α-chains more or less attached. This phenomenon can be observed in almost all the historical parchments (except HP36 and HP8, HP16, HP38), and in the artificially heat aged samples at a certain state of deterioration. The 120°C series is particularly interesting (see Table 13.8 and Fig. 13.5). After 4 hours of ageing, the α-chain peak although decreased is still present, and in the same time the Td is reasonably lowered (−6°C), with a quite normal energy involved (it even looks a little higher), which could indicate some cross-linking. But after 24 hours, there is no α-chain left, while the clear DSC signal allows the measurement at 40°C and 29.4 J/g. On the contrary, in the pollution ageing (see Fig. 13.7 and Table 13.8) which is not very deteriorating, the α-chain is quite unchanged up to 32 weeks, and is only diminished after 48 weeks. In the same time, the Td's decrease regularly, but the values of ΔH remain remarkably stable.

This inconsistency between chromatographic profile and DSC could be due to deterioration induced in the chains, which at a certain state of ageing could occur in such a way that the crystalline structure of collagen is maintained; but in the denaturating medium used for dissolving the material prior to the chromatographic runs, the structure would burst, releasing smaller fragments. Another possibility is cross-linking in the chains resulting in insolubilization and consequently no access to any α-chain. Transposing this to natural ageing, we can assume that it is produced by simultaneous or successive cross-links and breakdowns completely rearranging the structure.

The modern parchments (Table 13.7) prepared by craftsmen (NP3, NP4, NP6, NP7) present a different thermogram when compared to the 'industrially' made parchment NP5. Besides higher Td's, they exhibit a second peak in the high temperatures, as has been reported in literature for fresh skin (Flandin et al. 1984), indicating that their preparation could be less deteriorating than the industrial one. This second peak is not seen so clearly in the 'industrial' parchments.

In general, the artificially aged samples show higher ΔH than the historical ones. Pollution produces a less deteriorating ageing with only slight falls of Td and ΔH values. This ageing has been performed in two ways: pollution alone, and pollution in cycles with heat at 80°C (H + 6P)n. The latter produces a slightly higher deterioration (41°C/27J/g versus 50°C/31 J/g after 16 weeks). Heat is more deteriorating, especially at 120°C, and large falls were observed of both Td and ΔH with time of exposure.

Historical parchments (Table 13.9) have, in general, low ΔH compared to their relatively high Td. In fact the mean ΔH is below 14 J/g for a mean Td of 53°C, while for new parchment it is respectively 35–40 J/g and 60–64°C (a little less for industrial ones, 35 J/g and 55°C). Td is defined as to be related to the size of cooperating units (interacting peptide units in the triple helix) which are involved in the shrinking reaction (Covington et al. 1998). The inter- and intra-molecular cross-links increase the size of the cooperatively interacting molecular units, and consequently increase Td. These cross-links could be due to dehydration during ageing, which brings chains bearing reactive groups prone to condensation close to each other. The case of HP22 and HP37 is particularly striking with Td of respectively 66 and

Table 13.8 DSC measurements of new parchment NP5 artificially aged.

Ageing	Level of ageing	Onset	Max°C	ΔHJ/g
	Reference	56.0	60.0	35.2
80°C	3 days	53.0	57.0	29.9
	10 days	51.0	58.0	28.9
	14 days	50.5	56.5	26.7
120°C	4 hours	49.5	54.0	41.0
	1 day	40.0	50.0	29.4
	2 days	38.5	49.0	23.2
	4 days	36.0	45.0	22.5
	2 weeks	34.5	44.0	5.6
Pollution	16 weeks	50.0	56.5	30.8
	48 weeks	48.5	54.0	32.2
	64 weeks	46.0	56.0	35.0
H_{80}+6P	4 weeks	50.0	55.0	27.8
	8 weeks	46.0	52.0	28.7
	16 weeks	41.0	49.0	27.0

Table 13.9 DSC measurements of historical parchments.

Historical parchments	Onset	Max °C	ΔH J/g	Classification according to the shape of the thermogram
HP 7	61	64	12.8	I
HP 7 (2)	57.5	66	11.9	I
HP 8	42.5	52	9.6	III
HP 8 (2)	45	53	8	III
HP 9	46.5	54	12.6	III
HP 9 (2)	very low signal phenomon	53–57°C		IV
HP 16	41	47	16.3	II
HP 20	53	58.5	9.5	I–II
HP 20 (2)	57.5	61.5	13.9	I
HP 22	65.5	69.5	14.3	I
HP 22 (2)	66	69.5	16.4	I
HP 26		no signal		IV
HP 26	44.5	54	16	II
HP 31	40	49	18.9	II
HP 31 (2)	60.5	63	17.9	I
HP 36	32	40	9.3	III
HP 37	68	70	14.2	I
HP 38	57.5	62	14.9	I

Figure 13.13 Relation between Td and ΔH.

68°C which is above new parchment. But at the same time, the low ΔH values of the historical parchments are indicative of modifications of structure.

The historical parchments have been classified into four groups according to the shape of their thermogram as indicated in Table 13.10.

It can be seen from Figure 13.13 that the 120°C ageing is the closest to natural ageing, although it matches more closely the most deteriorated parchments. It appears that to reproduce a deterioration similar to that of the less damaged parchments (with Td > 50°C), another deterioration agent should be used in combination with heat.

Conclusions

The SEC method we have developed is based on the use of two complementary chromatographic systems, one allowing the separation of high molecular weights, the other being more adapted to small fragments.

Although the distribution of the molecular weight fragments issued from the degradation is large and continuous, we could estimate the general state of degradation of the collagen molecule. The deterioration produces a disappearance of the high molecular weight fragments with a shift to lower molecular weights. But there is not necessarily a direct relation between these two characteristics. The Asahipak system allowed us to see fragments extending to 1500 Da, but as this molecular weight represents the total permeation bed, we could not point out smaller fragments; it would be difficult in any case to estimate their molecular weights because, due to interactions with the stationary phase, they are anomalously retained on the column and therefore they come out of the calibration curve. Nevertheless, nitrates which appear after the total permeation bed have been pointed out.

In fact the SEC method is designed to be used on soluble proteins, and we observed that, when deteriorated, parchment can be made partly insoluble due to cross-linking occurring in the material. This was particularly obvious in the samples aged with heat in which the dissolution rate decreased at the beginning of the ageing. On the other hand, natural ageing results from the action of different factors such as heat, excess of humidity, pollutants, light etc., causing both cross-linking and breakdown in the collagen molecule. One or the other of these phenomena are favoured by the prevalent deteriorating agents and they are therefore produced independently. This was highlighted by the estimation of the dissolution rates of the historical parchments which are, on the whole, quite low: even when very deteriorated, the material could be highly cross-linked and therefore insoluble. This is confirmed by the results obtained in DSC for these samples which show relatively high values of Td but at the same time comparatively low ΔH values indicating strong modifications of structure.

Considering all the results we can draw two conclusions:

1. There is not only one scheme of degradation – the different ageing factors are able to act independently.
2. Cross-linking seems to be an important phenomenon but unfortunately it limits the use of the SEC, which depends greatly on the dissolution of the studied compounds. In any case the analysis was limited to the soluble part, the state of the whole structure remaining unknown. Nevertheless it could be used – particularly the Asahipak system which contained no SDS – as a preparative technique for the analysis by other methods such as liquid chromatography-mass spectroscopy (LC-MS) after collecting fractions.

References

Butkowski, R. J., M. E. Noelken and B. G. Hudson (1982) *Methods in Enzymology*, Vol. 82. Academic Press, p. 410.

Covington, A. D., G. S. Lampard, R..A. Hancock and I. A. Ioannidis (1998) 'Studies on the origin of hydrothermal stability: a new theory of tanning', *Journal of the American Leather Chemists Association* 93, 4, pp. 107–20.

Flandin, F., C. Buffevant and D. Herbage (1984) *Biochemica and Biophysica Acta* 791, pp. 205–11.

Kanegae, M., S. Kou, Y. Okawa, H. Kobayashi, T. Ohno, T. Ohki and T. Kitayama (1996) IAG (Fribourg), Reports 1993–1994, p. 301.

Kanegae, M., Y. Okawa, H. Kobayashi, T. Ohno, T. Ohki, T. Kitayama and Y. Katoh (1994) IAG (Fribourg), Reports 1993, p. 39.

Kobayashi, T., T. Ohno, H. Kobayashi, Y. Okawa, T. Togawa, C. Komatsu and H. Asano (1994) IAG (Fribourg), Reports 1993, p. 59.

Table 13.10 Classification of the historical parchments according to the shape of the thermograms.

Class I	thin peaks well defined, some present a tail in the high temperatures high Td's (58–60°C) relatively low energy (ΔH 12–18 J/g)
Class II	broad peaks occurring on a large range of temperature lower Td's (< 45°C) same ΔH as group I
Class III	flatter peak with still occuring at relatively quite high temperature ΔH lower than in groups I and II (ΔH <9–10 J/g)
Class IV	very low signal which makes impossible to do any determination when the thermogram is completely flat

14 SDS-PAGE and 2D-Electrophoresis

René Larsen, Dorte V. Poulsen and Marie Vest

Introduction

Amino acid analysis of historical vegetable-tanned leathers indicates that the significant changes in the amino acid distribution caused by chemical deterioration do not correspond to the number of the individual amino acids present in the collagen (Larsen 1995; Larsen *et al.* 1994). This seems also to be a characteristic feature of historical parchments (Larsen *et al.* 2002). In general, it seems that the breakdown is closely associated with the collagen structure and the chemical nature of the individual amino acids. The helical part of the α-peptide chains in the collagen triple helix consists of tripeptide segments in the form Gly-X-Y. The sequences of the α-chains are characterized by clusters dominated by tripeptide segments (tripeptides) of hydrophobic amino acids, mainly Pro, Hyp and Ala, in the X and Y positions. These so-called collagen-typical tripeptides are considered to function as folding nuclei, and to stabilize the peptide chain and the tertiary helical structure (Dölz and Heidemann 1986; Thakur *et al.* 1986; Heidemann 1987) as well as the micro-fibrillar structure (Hulmes *et al.* 1973). Between these clusters less typical tripeptides are located. Most of these have charged amino acids (mainly Asp, Glu, Arg and Lys) in the X and Y positions. According to the »cluster theory« these areas (or some of the tripeptides) are unstable and may function as unfolding centres structure (Dölz and Heidemann 1986; Thakur *et al.* 1986; Heidemann 1987).

Thakur *et al.* (1986) have shown that the tripeptide Gly-Ala-Lys can destabilize a triple helical structure. In addition, Müller and Heidemann (1993) have found that collagen, by treatment in acid, preferably splits in the unstable areas between the stable clusters within the triple helical structure. By means of 2D-electrophoresis and sequence analysis they have identified 10 acid cleavage points, and 9 of these are found in the immediate vicinity of tripeptides segments containing Arg. To this may be added that tripeptide segments such as Gly-Ala-Lys, Gly-Lys-Ala and Gly-Ala-Arg are steric-favourable to chemical attack on the Lys and Arg side chains. However, segments such as Gly-Pro-Lys, Gly-Pro-Arg, Gly-Lys-Hyp etc. may be sensitive to oxidative breakdown, and thus account for the decrease in the Hyp and Pro value observed in some historical leathers and parchments.

In a collagen type I model based on published amino acid sequences (Dölz and Heidemann 1986; Heidemann and Ogawa 1973; Fietzek and Kühn 1976; Bernard *et al.* 1983; de Wet *et al.* 1987; Boedtker *et al.* 1985), at least 75 of this type of tripeptide are found in the clusters consisting of 3–8 charged tripeptide segments. On basis of these it is possible to estimate a theoretical amino acid distribution matching that of natural aged materials (Larsen 1994a, 1995). Isoelectric focusing of the soluble fraction of parchment has been performed by polyacrylamide gel electrophoresis for the purpose of animal identification (Füchs and Michon 1987; Porck and van Oosten 1989; van Oosten 1989). It was found that 200-year-old parchment focuses in a similar pH area as animal glue (van Oosten 1989). Oxidation of residues Arg, Hyp, Pro and Lys may in some cases lead to cleavage of the peptide main chain (Larsen 1994b) resulting in the formation of peptide fragments.

Peptide fragments are possible to detect as low molecular weight bands and spots by sodium dodecyl sulphate-polyacrylamid gel electrophoresis (SDS-PAGE) and 2-D electrophoresis gels, respectively. The present paper presents the preliminary results of both techniques performed on soluble corium collagen from new, artificially aged and historical parchments. The dissolution of the parchment is performed under mild conditions in order not to introduce significant alteration of the collagen and produce minor peptide fragments not originating from the natural breakdown. Moreover, identification of the α- and β- peptides from a new parchment and a collagen standard blotted to a PVDF membrane from a SDS-PAGE gel has been performed by amino acid analysis.

Disappearance of more of the cyanogen bromide (CNBr) bands after heat curing of collagen has been observed by SDS-PAGE (Gorham *et al.* 1992). CNBr digestion has been widely used in the study of the collagen structure (Gorham *et al.* 1992; Heidemann and Linnert (1984); Hayashi and Nagai 1979; von Chalepakis *et al.* 1985; Click and Bornstein 1970; Butler *et al.* 1967; Light 1985; Morris *et al.* 1987; Fujiwara and Nagai 1981; Benya 1981; Cheung *et al.* 1981; Fietzek and Piez 1969; Rauterberg *et al.* 1972; Fietzek

et al. 1970), as it cleaves specifically at the C-terminal side of methionine (Gross 1967). CNBr digested peptides have previously been characterized by SDS-PAGE (Gorham *et al* 1992; Heidemann and Linnert (1984); Hayashi and Nagai 1979; von Chalepakis *et al.* 1985; Click and Bornstein 1970; Butler *et al.* 1967; Light 1985; Morris *et al.* 1987) and 2D-electrophoresis (Fujiwara and Nagai 1981; Benya 1981; Cheung *et al.* 1981). In total 12 cleavage points have been identified, with cleavage of the α-1 chain resulting in 8 peptides and cleavage of the α-2 chain resulting in 6 peptides. However, the Met-Thr bond has shown to be resistant towards the CNBr reaction (Morris *et al.* 1987; Fujiwara and Nagai 1981; Benya 1981; Cheung *et al.* 1981; Fietzek and Piez 1969; Rauterberg *et al.* 1972; Fietzek *et al.* 1970), and changes in the band pattern may be expected due to formation of cross-links between individual peptide chains and cleavage of peptide chains caused by chemical ageing of the collagen.

New and artificially aged standard collagen type I and new and historical parchments have been digested with CNBr and analysed by SDS-PAGE and 2D electrophoresis. One band from the historical parchment HP31 has been isolated from the SDS gel and analysed by amino acid analysis. These preliminary results are presented in this paper.

Experimental

Samples

Samples of corium collagen from new calf parchment, artificially aged and historical parchment samples from the sample bank were analysed. The corium collagen (flesh site) was used to avoid the interference of remains of keratin and elastin left in the grain layer of the parchment. A standard collagen type I (Sigma) was used as reference. In addition, a mixture of low molecular weight globular proteins (LMW Electrophoresis Calibration Kit, Amersham Pharmacia Biotech) has been used although the proteins have a different mobility compared to fibrous proteins such as collagen.

Chemicals and gels

The following chemicals were used: Amberlite IRN-150 L, bromo phenol blue (BPB), 3-[(3-cholamidopropyl)-dimethyl-ammonio]-1-propane-sulfonate (CHAPS), dithiothretiol (DTT), ethylene diaminetetraacetic acid disodium salt (EDTA-Na$_2$•2H$_2$O), glycerol, IPG buffers, pharmalyte pH 3-10, sodium dodecyl sulphate (SDS), N, N, N', N'-tetramethylethylendiamine (TEMED), Tris, Triton X-100 and urea from Amersham Pharmacia Biotech.

Acetic acid 99.9% (Merck), 30% acrylamide/bis solution: 37,5:1 (2,6%) (BioRad), ammonium peroxodisulfate (Merck) Brilliant Blue G250 (Merck), 3-(cyclohexyl-amino)-1-propanesulfonic acid (Sigma), ethanol 96% (Kebo Lab), formaldehyde 37% (Merck), glutardialdehyde 25% (Merck), iodoacetamide (Acros), methanol 99.9% (Merck), Thiourea (Fluka), silver nitrate (Merck), sodium acetate anhydrous (J T Baker), sodium thiosulfate (Merck), sodium carbonate anhydrous (JT Baker).

All water used was demineralized and distilled.

The following gel types were used: ExcelGel SDS buffer strips, ExcelGel SDS 8-18%, ExcelGel SDS 12-14%, ExcelGel SDS homogeneous 12.5%, ExcelGel SDS homogeneous 15%, GelBond PAGfilm 203 x 260 mm, Immobiline Drystrips (IPG): pH 3-10, 11cm; pH 4-7, 11cm; pH 4-7, 18cm from Amersham Pharmacia Biotech. Polyvinylidene flouride (PVDF) membrane (Immobilon-P) (Millipore). 15% homogeneous gels with 6% stacking gels (homemade).

Buffers and solutions

Lysis buffer

Parchment is dissolved in a lysis buffer consisting of 30.0g urea (9.5 M), 1.0g CHAPS (2% w/v), 1.0ml pharmalyte pH 3-10 (0.8% w/v), 0.5g DTT (1% w/v) and water up to 50ml. The urea is dissolved in 50ml water, 0.5g of Amberlite IRN-150L added, stirred for 10 minutes and filtered (Görg *et al.* 1998). CHAPS can be replaced with 2% NP-40 with good results.

SDS buffer

The samples for SDS-PAGE analysis are mixed with a buffer consisting of 0.3g Tris (0.05M) and water up to 40ml. Adjust pH to 7.5 with acetic acid, make up to 50ml with water and add 0.4g SDS and a few grains of BPB. The solution can be stored at 4°C. Immediately before use add 1.0mg of DTT to 1.25ml of SDS-buffer.[1]

Rehydration buffer

For rehydration and introduction of the dissolved sample into the IPG strip a buffer consisting of 12g urea (8M), 0.5g CHAPS (2%), 125µl IPG-buffer and a few grains BPB is used. The IPG-buffer should match the pH gradient of the IPG strip (pI 3-10 or 4-7). The solution is increased to 25ml with water. The rehydration solution can be stored in small portions at –20°C. Immediately before use add 2.8mg of DTT to 1ml of rehydration solution (Berkelman 1998).

Equilibration solutions

Introduction of SDS to the sample is based on the following stock solution: 6.7ml Tris-HCl (1.5M, pH 8.8), 7.07g urea, 69ml glycerol (87%v/v), 4g SDS, a few grains of BPB and the solution is made up with water up to 200ml. The solution can be stored in aliquots of 50ml at –20°C. For preparation of equilibration solution a) 0.250mg of DTT is added to 25ml of equilibration solution. For preparation of equilibration solution b) 0.625mg of iodoacetamide is added to 25ml of equilibration solution (Berkelman 1998).

Gel casting solutions

6% stacking gel: 5.6g glycerol, 3.8ml 1.5M Tris-HCl pH 8.8, 3ml 30% acrylamide/bis solution, 3.8ml water, 7.5µl TEMED and 15µl 40% (w/v) ammonium persulfate solution.

15% separation gel: 6.0g glycerol, 12ml 1.5M Tris-HCl pH 8.8, 24ml 30% acrylamide/bis solution, 7.2ml water,

14.4µl TEMED and 48µl 40% (w/v) ammonium persulfate solution.

This is enough for casting two gels at size 200 × 260 × 0.5mm. For each gel use 6ml of the 6% stacking solution and fill up with the 15% separation solution (for the exact gel casting procedure see Görg et al. 1998).

Electro blotting buffers
The cathode buffer in the electro blotting sandwich consists of 2.21g CAPS (10mM) and water to 700ml. The pH is adjusted to 11 with NaOH, then 100ml of methanol and solution is made up to 1000ml with water. Finally, 1g SDS (0.1%) is added. The solution can be stored in the dark at 4°C for 14 days.[2]

Two anode buffers are used in the electro blotting sandwich. Anode buffer 1: 36,3g Tris (0.3M), 100ml methanol (10%), water to 1000ml and 1g SDS (0.1%). The solution should be stored in the dark at 4°C. Anode buffer 2: 3,6g Tris (25mM), 100ml methanol (10%), water to 1000ml and added 1g SDS (0.1%). The solution can be stored in the dark at 4°C for 14 days.[3]

Equipment

EPS 200 power supply, EPS-3500 XL power supply, Hoefer Automated Gel Stainer, IPGphor IEF unit, Multiphor II electrophoresis unit, Novablot electrodes, Staining tray 29x35cm PTFE complete, strip holder 18cm and strip holder 11cm from Amersham Pharmacia Biotech.

Sample preparation

With lysis buffer
About 10mg of corium collagen is cut into small pieces (> 1 × 1mm) and solubilized in 200µl lysis buffer. The sample is agitated for 24 hours at 37°C and then filtered through a microspin filter with a 0.45µm PVDF-membrane (Lida), leaving about 90µl of sample for analysis. By ageing, the solubility of parchment decreases until a high degree of deterioration has been reached. Then an increase in the solubility is found, e.g. samples that gelatinize by contact with water can be dissolved directly in the rehydration solution. The dissolution of the collagen may be improved by replacing the 9.5M urea with 7M urea and 2M thiourea (Rabilloud 1998). However, no significant effect has been observed in the present case.

To calculate the exact amount of collagen in solution a protein assay from Bio-Rad is used. The determination of the protein concentration of the 90µl sample is based on a colour reaction between an acidic solution of Coomassie Brilliant Blue G-250 and the protein, as the absorbency maximum for shifts from 465 to 595nm when a reaction between the dye solution and the protein occurs.[4]

CNBr-digestion
About 10mg of corium collagen is cut into pieces of 1 × 1mm and transferred to a small glass vial. The glass vial must have a large surface and a tight-fitting lid. To 10mg of sample is added 1ml of 70% (v/v) formic acid and 20µl of 5M CNBr in acetonitril. The glass vial is closed and wrapped in aluminium foil to exclude light and left at room temperature. After 24 hours the sample is placed at –80°C for 1 hour to avoid excessive boiling when drying the reaction mixture under vacuum. The dry residue is very acidic: to neutralize, dissolve the residue in 0.5ml MilliQ water followed by another freeze-drying. The dissolving/drying process is repeated until the pH is close to neutral.

The dry residue is kept at /–80°C until further use. Then it is dissolved with water and pipetted into plastic vials. The water is removed again by additional freeze-drying.

Electrophoresis

SDS-PAGE
SDS-PAGE separates peptides according to size. By introducing SDS to the sample the electrical charge of the peptides is masked and the peptides will only migrate through the electrical field in the gel according to their molecular weight (MW).

The sample is mixed with/or dissolved in SDS buffer. When the sample is dissolved with SDS buffer the relation between sample and buffer must be 1:3. Good results with silver staining may be obtained by loading between 0.5 and 3.75µg of protein to each well; about 20 times as much (20 to 70µg) must be loaded for Coomassie staining. The SDS-PAGE is performed on a Multiphor system.

The running conditions for the SDS-PAGE are given in Table 14.1. The presented running times are only approximate, as the run is terminated 5 minutes after the blue front has reached the anodic buffer strip.

2D-electrophoresis: isoelectric focusing
The first-dimension separation in 2D-electrophoresis is an isoelectric focusing (IEF), where the peptides are separated according to their isoelectric point (pI). In an electric field and along a pH gradient a charged peptide molecule will migrate towards the pI, where the net charge is zero. At its pI the peptide is no longer affected by the electric field, and will remain in a fixed position. The immobilized pH

Table 14.1 Running program, SDS-PAGE (second dimension program), 15°C

Gel type	12.5% homogene	15% homogene	15% homogene
Gel size (w × l × t)	250 × 110 × 0.5mm	250 × 110 × 0.5mm	245 × 180 × 0.5mm
Step one	80 min., 600V, 50mA, 30W	140 min., 600V, 30mA, 30W	45 min., 100V, 20mA, 50W
Step two*			3 hours, 800V, 40mA, 50W

* In connection with 2D-electrophoresis, the IPG strips must be removed after step one and the buffer strip moved forward to cover the former IPG strip application area.

gradient is built into a polyacrylamide gel and cast onto a plastic backing which is cut into thin strips (IPG strips).

Short IPG strips with a broad pI range (4–11) are used to get an overview of the analysed samples. For further analysis of the material, longer IPG strips with a more narrow pI range (5–8) are used to obtain a better separation of the peptides.

Using the IPGphor system, the sample application is performed as in-gel rehydration (Rabilloud et al. 1994; Sanchez et al. 1997), where the sample is mixed with the rehydration buffer (Table 14.2) for the IPG strips. For in-gel rehydration of an 18cm IPG strip a total volume of 350µl (rehydration buffer including the sample) is used in the strip holder. The sample volume is dependent upon the protein concentration where 50–100µg of protein is recommended to be applied onto a 18cm IPG strip with a pH range of 3 to 4 (Berkelman and Stenstadt 1998; Rabilloud 1998; Rabilloud et al. 1994; Sanchez et al. 1997; Görg et al. 1995).[5,6,7] In practice, considerable higher protein concentrations have been applied when loading around 600µg of protein to one 18cm IPG strip. A detailed description of the sample application and isoelectric focusing is given in Berkelman and Stenstadt (1998). For improving the penetration of large molecules into the IPG strip a low voltage is applied during rehydration. The rehydration time can be varied from a minimum of 10 hours of rehydration (Larsen 1994b). The running conditions for the isoelectric focusing using the IPGphor are given in Table 14.2. After focusing the strip is stored at –80°C until equilibration.

Table 14.2 Isoelectric focusing program (1 dimension), 18cm IPG strips, pI 3–10 and pI 4–7.

0.05mA per IPG strip at 20°C	
Step one (rehydration)	10–15 hours at 30V
Step two	1 hour at 200V
Step three	1 hour at 500V
Step four	30 minutes at 500 ⇒ 8000V
Step five	3 hours at 8000V

Equilibration of the IPG strip

Prior to running the second dimension, the IPG strip is equilibrated in order to introduce SDS to the peptides in the strip. The equilibration is performed in two steps each at 15 minutes; the first step (a) introducing DTT and the second step (b) introducing iodoacetamide. DTT preserves the fully reduced state of denatured, unalkylated proteins and iodoacetamide alkylates the thiol groups on proteins, preventing their reoxidation during electrophoresis (Berkelman and Stendstadt 1998).

2D-electrophoresis: second dimension (SDS-PAGE)

In the second dimension the isoelectric focused molecules are separated according to their molecular weight (MW) by SDS-PAGE on the horizontal Multiphor II system.

After equilibration the IPG strip is transferred to a precast SDS-polyacrylamide gel. The type of gel must be selected with reference to the expected molecular size of the peptides of interest. Start by analysing samples on small size gels (245 × 110mm) with a wide separation range. Further analysis may be done using large size gels (245 × 180mm) of more narrow range on which better separation is obtained. The running conditions for the second dimension using a large size gel (245 × 180 mm) are given in Table 14.1.

Detection of peptides

Visual detection of the separated peptides can be obtained by staining the gel with Coomassie Blue or silver, the latter being 10–100 times more sensitive than Coomassie staining (Görg et al. 1998). The stained gels can be compared visually, but for larger scale work and comparison of many gels, computer software is available.

Silver staining

Silver staining works on the principle that 'silver ions (Ag$^+$) are reduced to metallic silver on the protein, where the silver is deposited to give a black band'. By silver staining it is

Table 14.3 Silver staining program.

Step	Solutions		Time
Fixation	Ethanol 100ml, ice acetic acid 25ml	Water to 250ml	2 × 15 minutes
Sensitizing	Ethanol 75ml, glutardialdehyde (25%w/v) 1.25ml, Sodium thiosulphate (5%w/v) 10ml sodium acetate 17g	Water to 250ml	30 minutes
Washing	Water		3 × 6 minutes
Silver reaction	Silver nitrate (2.5%) 25 ml, formaldehyde (37% w/v) 0.1ml	Water to 250ml	20 minutes
Washing	Water		2 × 1 minutes
Developing	Sodium carbonate 6.25g, formaldehyde (37% w/v) 0.09ml	Water to 250ml	5–10 minutes
Stopping	EDTA-Na$_2$· 2H$_2$O 3.65g	Water to 250ml	10 minutes
Washing	Water		3 × 8 minutes
Preserving	Glycerol (87% w/v) 25ml	Water to 250ml	20 minutes /overnight

Table 14.4 Coomassie staining procedure.

Step	Solutions		Time
Fixation	250ml ethanol (96%), 60 ml acetic acid (99%)	Water to 500ml	30 minutes/ overnight
Staining	0.25g Serva Blue G, 100ml. acetic acid (99 %)	Water to 1 litre	1 hour
Destaining	100ml acetic acid (99%)	Water to 1 litre	until satisfaction
Softner	170ml ethanol (96%), 30ml glycerol	Water to 1 litre	minimum 20 minutes

possible to detect bands/spots consisting of ~1ng of protein (Wilson and Walker 1994).

A silver staining method[8] with slight modifications is used with an Automated Gel Stainer (the program is shown in Table 14.3). Due to the pumping time of the gel stainer each step becomes a little longer than is given in the table. Therefore, the developing must be stopped just before a satisfactory result is obtained. The developing time varies between 5 and 10 minutes dependent upon the peptides of interest.

Coomassie staining

By the less-sensitive Coomassie staining, bands/spots of ~100ng of protein can be detected (Wilson and Walker 1994; Walker 1986). The Coomassie staining method is widely used for detection of peptides or proteins blotted for further analysis. The staining is performed on the automated gel stainer. The Coomassie staining procedure is given in Table 14.4.

Blotting and amino acid analysis of peptide bands

Transfer of the SDS-PAGE resolved collagen proteins to a PVDF membrane was performed in a (Western) semi-dry electro blotting procedure (SDE). The blotting was performed using the Multiphor II system with two graphite plates between which the SDS-gel is enclosed in a sandwich with a discontinuous buffer system.[9] For new parchment, a running time of 2 hours at 1.0 mA/cm² was used. A shorter running time can be used for deteriorated samples with fragments of a lower molecular weight than for new parchment. Apart from the band isolated from the SDS-PAGE of CNBr-digested historical parchment, the blotting of peptide fragments of a molecular weight lower than the α-bands have so far been unsatisfactory because of insufficient amounts of sample. The blotted peptides and peptide fragment were visualized on the membrane with Coomassie Blue (Table 14.4) and amino acid analysis was performed directly on the bands cut from the membrane (Larsen *et al.* 2002).

Results and discussion

SDS-PAGE analysis

Analysis of new unaged and artificially aged parchment

Figure 14.1 shows a SDS-PAGE gel of the new parchment NP 7 before and after artificial ageing. The ageing was performed at 110°C in the dry for 1, 2 and 4 days in a ventilated laboratory oven. The protein concentration in the unaged sample was 0.268µg/µl. After mixing with the SDS buffer the protein concentration was 0.00335µg/µl. Each sample (aged and unaged) was loaded with 5, 10, 20 and 40µl, respectively. After 1 day the γ- bands are no longer visible and the β- and α2-bands are very weak. After 2 days only the α1 and very weak signs of the β- band are present, and after 4 days none of the main bands are visible. These characteristics are in line with those previously obtained by heat curing of collagen (Gorham *et al.* 1992). In addition, four weak bands, two around 60 and 70kDa and two around 20kDa, appear. The first two are still visible after 4 days of ageing, whereas the latter two disappear after 2 days.

Figure 14.2 shows the SDS-PAGE gel of the same samples. However, as an attempt to obtain a higher concentration of the low molecular weight peptide bands and avoid the overloading of the reference bands, the concentration of the two bands around 60 and 70kDa was increased and the loading amounts of the two around 20kDa decreased. As seen, the band pattern of the reference has been improved. Thus, it is clear that two γ-bands as well as two β-bands are present. However, the γ-bands are no longer visible and the β- and α2-bands are very weak in the 1-day aged sample. Moreover, the two bands around 60 and 70kDa are no longer visible at all and the two weak bands around 20kDa appear only in the sample aged for two days. This strongly indicates that the type and number of bands detected depends on the concentration and amount of peptides loaded to the gel.

Figure 14.1 SDS-PAGE gel (12.5%) of new parchment (NP7) before and after artificial ageing at 110°C for 1, 2 and 4 days.

Figure 14.2 SDS-PAGE gel (12.5%) of new parchment (NP7) before and after artificial ageing at 110°C for 1, 2 and 4 days. Increased loading of protein for the aged samples.

Figure 14.3 SDS-PAGE gel (15%) of CNBr-digested new and artificially aged collagen (I) standard, new parchment (NP7) and historical parchments (HP31, HP36, HP37) from the sample bank. The collagen standard has been aged at 120°C for 1, 2 and 4 days.

Analysis of CNBr-cleaved collagen peptides

Figures 14.3 and 14.4 show the SDS-PAGE analysis of CNBr peptides from new and artificially aged collagen (I) standard, new and historical parchments. The electrophoresis was carried out using a 15% homogeneous gel and loading an average amount of 23.3µg and 69.7µg of sample, respectively. The peptides and peptide fragments were detected by Coomassie staining.

The new parchment NP7 shows 10 bands in the range between ~14 and ~100kDa and the collagen (I) standard shows 17 bands within the range from ~10kDa to ~100kDa. The presence of less bands in NP7 indicates that the CNBr digestion is less effective in the fibrillar and highly cross-linked parchment collagen structure. Moreover, the band around 96kDa found in the samples N7, Coll. std. Sigma, Coll. std. ICN, HP7, HP 20 and HP 31 has previously been identified as the α1-band. The presence of this band is a clear sign of inadequate CNBr digestion.

In general, the deteriorated parchment shows less bands and more smears appear. HP7, HP22, HP31 and HP37 show a band pattern close to that of NP7. However, the bands below 40kDa are more prominent in the historical parchment samples. The gel pattern of HP8, HP16, HP18, HP20, HP26, HP28 and HP36 are very similar to those of the collagen standard artificially aged for 2 and 4 days, i.e. with a high degree of smear and very weak or almost no signs of bands.

Figure 14.3 shows the SDS-PAGE of the collagen (I) standard artificially aged at 120°C for 0, 1, 2 and 4 days. For

SDS-PAGE AND 2D-ELECTROPHORESIS

Figure 14.4 SDS-PAGE gel (15%) of a new collagen (I) standard, CNBr-digested new parchment (NP7) and CNBr-digested historical parchments (HP7, HP8, HP16, HP18, HP20, HP22, HP26 and HP28) from the sample bank.

each of these the same amount of sample was loaded to the gel. As can be seen, the band intensity decreases by increasing deterioration. After 4 days of ageing only weak indications of bands are present around 94, 43, 35 and 28kDa. As found by Gorham *et al.* (1992), when comparing bands from new and aged parchment a change in intensity of the different bands is seen. In the new and in the slightly deteriorated collagen a strong band around 43kDa is found together with a weaker band at ~25kDa.

Table 14.5 shows the molecular weights of peptides from a simulated CNBr cleavage of collagen type 1 (calfskin). Models of CNBr cleavage of collagen type 1 from rat (Fujiwara and Nagai 1981; Fietzek and Piez (1969) and human (Click and Bornstein 1970) collagen are not comparable with that obtained on calfskin.

The α1-CB6 peptide may be identical with the band just below 14.4kDa, and the band around 20.1kDa may be identical with the 1-CB8 peptide. Both the α1-CB5 and the α1-CB7 peptides have molecular weights close to 25kDa and may both be ascribed to the strong band below 30kDa. Furthermore, all the three large α2 peptides (CB3, CB5 and CB6 in Table 14.2) have molecular weights close to around 30kDa and may also be ascribed to the strong band at 30kDa. Light (1985) and Gorham *et al.* (1992) have previously ascribed the strong band between 67 and 94kDa to the α2-CB3,5 peptide. However, according to the model digestion this peptide has a molecular weight close to 63kDa.

Amino acid analysis of gel bands

Table 14.6 shows the two α-bands and the $\beta_{1,2}$-band of the reference parchment NP3 and the collagen type I reference separated by SDS-PAGE electrophoresis. For comparison,

Table 14.5 Molecular weight (Mw) of CNBr fragments obtained by simulated digestion of ±1 and ±2 peptides of the collagen (I) model.

CNBr peptide (CB)	Mw α1	Mw α2
CB 1	2030.24	1407.52
CB 2	3344.53	319.43
CB 3	4477.81	29433.60
CB 4	3512.69	2781.96
CB 5	25142.49	30679.74
CB 6	13476.18	31146.21
CB 7	24336.95	
CB 8	20316.50	

Table 14.6 Amino acid distribution of collagen peptide bands separated by SDS-PAGE electrophoresis: α2 (~ 95kDa), α1 (~ 96kDa) and β-bands (~ 190kDa), NP3 (new parchment) and collagen type I (soluble collagen standard).

	Collagen model			NP 3			Collagen type I		
	α1	α2	$\beta_{1,2}$	α1	α2	$\beta_{1,2}$	α1	α2	$\beta_{1,2}$
Hyp	10.66	8.07	9.37	9.14	8.27	9.05	9.36	9.20	8.82
Asp	4.25	4.52	4.39	4.94	5.02	4.91	4.78	4.84	4.83
Thr	1.60	1.92	1.76	1.85	1.87	1.88	1.84	1.85	1.90
Ser	3.59	2.98	3.29	4.59	3.67	3.97	4.30	3.75	4.15
Glu	7.45	6.82	7.14	7.91	7.11	7.66	7.69	7.22	7.46
Pro	12.45	12.2	12.32	9.83	10.93	10.23	11.42	11.03	10.94
Gly	32.55	33.43	32.99	34.42	33.39	33.53	33.08	33.26	33.13
Ala	11.79	9.99	10.89	11.19	10.09	10.89	10.79	10.43	10.58
Val	1.60	3.65	2.63	1.58	3.09	2.34	1.71	2.50	2.28
Met	0.66	0.48	0.57	0.59	0.47	0.52	0.76	0.61	0.61
Ile	0.85	1.73	1.29	0.88	1.69	1.16	1.11	1.38	1.35
Leu	2.08	3.07	2.58	1.94	3.45	2.58	2.35	2.85	2.81
Tyr	0.47	0.38	0.43	0.51	0.42	0.48	0.42	0.35	0.45
Phe	1.23	1.54	1.39	1.05	1.51	1.27	1.29	1.27	1.35
His	0.28	1.15	0.72	0.75	0.97	0.99	0.56	0.92	0.71
Hyl	0.38	0.96	0.67	0.63	0.91	0.81	0.58	0.81	0.74
Lys	3.11	1.73	2.42	2.89	1.95	2.41	2.96	2.48	2.63
Arg	5.00	5.38	5.19	5.03	5.10	5.12	4.89	5.01	5.00
Ada				0	0	0	0	0	0
α-Abu				0	0	0	0	0	0
β-Ala				0	0	0	0	0	0
γ-Abu				0.2	0.12	0.11	0.04	0.21	0.17
6-Aha				0.07	0	0.09	0	0.04	0
Orn				0	0	0	0.08	0	0.1
B/A*	0.73	0.71	0.72	0.58	0.66	0.66	0.68	0.69	0.68

* B/A = ΣArg, Hyl, Lys/ ΣAsp, Glu

the distribution of the collagen model α-bands and β$_{1,2}$ is given.

That amino acid analysis of SDS-PAGE separated bands is a useful technique for the identification of peptides is supported by the agreement in the amino acid distributions given in Table 14.5. On the basis of these, it can be concluded that the β-band isolated from both the parchment and the reference collagen must be the β$_{1,2}$. The deviations in the values may be due to modification of individual amino acids and the possible presence of several peptides of slightly different amino acid distribution and molecular weight in the same band. The presence of the breakdown products γ-Abu and 6-Aha (Table 14.6) indicates that some chemical deterioration has taken place. Moreover, some of the deviations between the model peptides on the one hand and the parchment and standard collagen bands on the other hand are probably due to differences in the Pro/Hyp and Lys/Hyl ratio. As the formation of Hyp and Hyl in the living animal is partly dependent on its state of health and its feeding conditions, some variations should be expected which cannot be accounted for in the model.

Amino acid analysis of gel bands from CNBr-digested historical parchment

The blotted band isolated from the SDS-PAGE of the CNBr-digested historical parchment HP31 has a molecular weight close to 90kDa. Table 14.7 shows the amino acid distribution of the blotted band and the theoretical peptide fragments obtained by CNBr cleavage of the α- peptides of the collagen (I) model with the molecular weight and chain length indicated by the number of the terminal amino acids.

Only the α-1 (56–1056) model fragment has a molecular weight close to 90kDa, but the amino acid distribution of the HP31 band is closer to the α-2 model band of 94kDa. The similarities lie particularly in the values of amino acid residues typically for the α-2 chain which are relatively low (Ala, Met, Lys) and relatively high (Val, Ile, Leu, Tyr, Phe, His and Hyl). Moreover, the presence of breakdown products and the high Asp and Glu in the isolated fragment indicates chemical modifications which may explain the lower molecular weight and differences in the amino acid distribution compared to the 94kDa α-2 model fragment.

The residues 60–63 in the α-2 chain constitute the tripeptide segment Gly-Lys-Ala which is placed in the beginning of the 18 residue long cluster of charged tripeptides. A chemical cleavage of the α-2 chain at the Lys residue in this position produces a fragment close to 90kDa. Furthermore, the number of Hyp, Met, Phe, His, Hyl and Arg in tripeptide segments which may be sensitive to oxidative modifications and which are placed in the large charged clusters may explain most of differences in the amino acid distributions compared to the model. Oxidative modification of Met may explain the low value of this amino acid residue and why the fragment is not digested by the CNBr. The low Arg value may be partly explained by hydrolysis of urea from its side chain as indicated by the presence of Orn, γ-Abu may arrive from oxidation of Hyp or Pro and 6-Aha from oxidation of Hyl which may have been transformed into Lys by dehydroxylation. The low Lys value in the HP31 band may also be due to lack of hydroxylation in vivo. Formation of Tyr by hydroxylation of Phe may explain the difference in the values of these. Oxidative modification may also explain the low His in the HP31 band. Finally, the increase in Asp and Glu may originate from oxidation of, e.g. Arg, Hyl and Hyp (Larsen 1995). Moreover, His and Met may be transformed into Asp by oxidative modification of their side chains.

Table 14.8 shows the amino acid distribution of the CNBr fragment of HP31, the α-2 (63–1041) model fragment unmodified as well as a theoretical chemical modification based on the above-mentioned considerations. The table also shows the number of residues in the two model fragments as well as the differences in residues between these. The grey shading indicates the amino acids which have been changed to model the chemical modification.

Apart from Thr, Ser, Val and Ile, the difference between the observed values of the CNBr band and the modified model fragment lies within, and for Ala it is close to, twice the standard deviations. There is no simple explanation for the large differences in the values of the four formerly mentioned amino acids. Seen in light of the fact that the opposite tendency (increased Thr, decreased Ile and Ser) is observed in the historical parchments (Larsen et al. 2002), this phenomena becomes more strange. However, explanations for this may be either that the reactivity of the amino acids is different in the two α-chains, or errors in the collagen model and/or that the isolated CNBr band contains

Table 14.7 Amino acid distribution in % mol and molecular weight of the blotted band and the theoretical peptide fragments obtained by CNBr cleavage of the α- peptides of the collagen (I) model.

α-chain	CNBr band	Collagen model			
		α-1	α-1	α-1	α-2
Fragment size		20–1056	56–1056	103–1056	19–1041
MW (kDa)	90	94	91	87	94
Hyp	7.37	10.32	10.09	9.96	8.11
Asp	5.33	4.34	4.50	4.40	4.50
Thr	1.69	1.54	1.60	1.57	1.96
Ser	3.98	3.38	3.30	3.46	3.03
Glu	7.65	7.43	7.29	7.34	6.84
Pro	12.18	12.54	12.39	12.37	12.12
Gly	33.00	32.98	32.97	32.91	33.43
Ala	10.38	12.05	12.29	12.58	9.97
Val	2.84	1.54	1.60	1.68	3.71
Met	0.12	0.58	0.50	0.42	0.29
Ile	1.44	0.77	0.80	0.84	1.76
Leu	3.14	2.03	2.00	1.89	3.03
Tyr	0.51	0.29	0.30	0.31	0.39
Phe	1.31	1.25	1.20	1.26	1.47
His	0.99	0.29	0.30	0.31	1.17
Hyl	0.57	0.48	0.50	0.52	1.08
Lys	1.80	3.09	3.20	3.14	1.66
Arg	4.50	5.11	5.19	5.03	5.47
Ada					
α-Abu					
β-Ala					
γ-Abu	0.05				
6-Aha	0.06				
Orn	0.58				
B/A*	0.53	0.74	0.75	0.74	0.72

*B/A = ΣArg, Hyl, Lys/ΣAsp, Glu

Table 14.8 Amino acid distribution % mol of the HP31 CNBr fragment, the unmodified and modified ±-2 model fragment. N = number of amino acid residues in the fragment and Difference N = the difference in residues between the unmodified and modified model fragment.

	CNBr band (%)	Collagen model (α-2 fragments)				
		Unmodified (%)	Modified (%)	Unmodified N	Modified N	Difference N
Hyp	7.37 (0.23)	7.76	7.35	76	72	−4
Asp	5.33 (0.08)	4.70	5.31	46	52	6
Thr	1.69 (0.08)	1.94	1.94	19	19	0
Ser	3.98 (0.08)	3.03	3.06	30	30	0
Glu	7.65 (0.17)	6.64	7.56	65	73	8
Pro	12.18 (0.16)	11.95	11.95	117	117	0
Gly	33.00 (0.31)	33.40	33.40	327	327	0
Ala	10.38 (0.18)	10.01	10.01	98	98	0
Val	2.84 (0.06)	3.88	3.88	38	38	0
Met	0.12 (0.03)	0.31	0.10	3	1	−2
Ile	1.44 (0.06)	1.84	1.84	18	18	0
Leu	3.14 (0.04)	3.17	3.17	31	31	0
Tyr	0.51 (0.06)	0.41	0.51	4	5	1
Phe	1.31 (0.03)	1.43	1.33	14	13	−1
His	0.99 (0.04)	1.23	1.02	12	10	−2
Hyl	0.57 (0.08)	1.12	0.61	11	6	−5
Lys	1.80 (0.05)	1.63	1.84	16	18	2
Arg	4.50 (0.06)	5.52	4.49	54	44	−10
B/A*	0.53	0.73	0.54			

* B/A = ΣArg, Hyl, Lys/ΣAsp, Glu

minor fragments of neighbouring chains cross-linked to the major fragment which would influence the amino acid composition. As an example, around 40% of the Ser and 33% of the Ile residues are found in the last 1/4 of peptide chain (N-terminal).

2D-PAGE analysis

New parchment

Figure 14.5 shows a 12–18% gradient 2D-PAGE gel of the new parchment NP3. The α-, β- and γ-chains are all present over a wide pI range (~5–6.75). However, only the two α-chains are represented as badly focused spots. The spread in pI may be due to slight chemical modifications as mentioned above (Larsen *et al.* 2002). This may include a different degree of deamidation of Asn and Gln, but also the existence of sub-samples of peptides of various structural conformation that may influence the pI.

Historical parchments

Figure 14.6 shows a 2D-PAGE gel of a moderately deteriorated (shrinkage temperature = 62.8°C) historical parchment from the sample bank. Only weak signs of the α-peptides are present. However, several peptide fragments with molecular weights from around 40–60kDa appear in pI range ~4.75–6.75. Moreover, a few very weak spots of fragments are present between 20 and 30kDa.

Figure 14.7 shows a 2D-PAGE gel of the more deteriorated parchment HP16, which has a shrinkage temperature of 37.3°C. None of the main bands are present, and the spot pattern of fragments between 40 and 60kDa is very similar to that of HP22. In addition, more very weak and discrete spots have appeared from around 30kDa to below 14kDa.

Both HP16 and HP22 are among the 12 historical parchments selected for analysis by all the analytical methods described in this book. 2D-PAGE analysis on the other samples (HP7, HP8, HP18, HP20, HP26, HP28, HP31, HP36, HP37 and HP38) confirms the typical pattern of the disappearance of the main chain bands (see Table 14.9) and the appearance of low molecular weight fragments between 40 and 60kDa. This fingerprint pattern has also been observed by 2D-PAGE electrophoresis of aged photographic gelatin (Kejser and Koch 1997).

As can be seen in Table 14.9, only 0.4 to 0.8% of the total sample comes into the solution. Moreover, of HP36, which is gelatinized by exposure to water, only 0.4% has dissolved. This indicates that a large fraction of gelatinized fibres apparently remains undissolved in contradiction to the hypothesis that the solubilization is greater for strongly deteriorated parchments.

The β-chains were only observed in the new parchment, and the α-chains in 7 of the 12 historical parchments. However, taken as a whole, there is no obvious connection between the disappearance of the main chains and the amount of parchment in solution on the one hand, or the state of deterioration on the other. This may be due to variations in the actual concentrations of peptides loaded to the SDS-PAGE gel. Examinations have shown that a large amount of peptides is left back in the IPG strip after the transference to the SDS-PAGE gel.

Figure 14.8 shows a plot of the percent parchment in solution as a function of the shrinkage temperature of the historical parchment samples. There seems to be a clear connection between decreasing solubility and decreasing shrinkage temperature, confirming the hypothesis that the solubility is decreased by deterioration. From the plot it is also obvious that the samples are grouped into two or more sub-populations. The reason for this grouping is not clear; it may be random.

Figure 14.5 2D-PAGE gel of new parchment (NP7), 12–14% gradient gel.

Figure 14.6 2D-Page gel of a moderately deteriorated historical parchment (HP22), IPG 4–7 (18cm), 12–14% gradient gel.

Figure 14.7 2D gel of a very deteriorated historical parchment (HP16), IPG 4–7 (18cm), 12–14% gradient gel.

In general, the number of spots on the SDS-PAGE gels vary a great deal. This may be due to variations in the deterioration pattern of the individual parchment samples and/or variations in the concentration and amount of peptides loaded to the gel. Moreover, the number and concentrations of minor fragments below 40kDa also vary from sample to sample. The cause of these variations may be clarified by optimization of the method. However, the present results strongly support the hypothesis that the cleavage of the collagen may take place in specific areas of the peptide chains sensitive to chemical attacks. Furthermore, the molecular weights obtained by a theoretical cleavage of peptide chains in specific locations in the charged clusters of the collagen model (Larsen 1994a, 1995) lie in the same range as those observed by the 2D-PAGE analysis. The identification of these specific cleavage points of the peptide chains may be determined by amino acid analysis, sequence analysis and mass spectrometry of the fragments isolated on the electrophoresis gels. This, however demands further development of the method to get more collagen into solution and a higher concentration of peptides isolated on the gels.

Table 14.9 Protein content in solution and presence of the main peptide chains in the 2D-PAGE gels of the new NP7 and the selected historical parchment samples.

Samples	Tot. sample g/200μl	in solution g/200μl	% into solution	Presence of main peptides β	α1	α2
NP 7	10018	42.0	0.4	×	×	×
HP 7	10037	78.8	0.8	–	–	–
HP 8	10035	46.2	0.5	–	×	×
HP 16	10032	53.2	0.6	–	–	–
HP 18	10007	69.4	0.7	–	×	×
HP 20	10016	53.6	0.5	–	×	×
HP 22	10011	78.6	0.8	–	×	×
HP 26	9989	59.0	0.6	–	×	×
HP 28	10021	34.8	0.4	–	×	×
HP 31	9995	50.0	0.5	–	×	×
HP 36	10008	41.6	0.4	–	–	–
HP 37	10021	73.8	0.7	–	–	–
HP 38	10028	64.0	0.6	–	–	–

Figure 14.8 Plot of % solubility as function of the shrinkage temperature (°C).

Figure 14.9 2D-PAGE of a CNBr-cleaved new parchment (NP7), 18cm IPG strip pI 4–7, 15% homogeneous gel. Silver stained.

Figure 14.10 2D-PAGE of a CNBr-cleaved historical parchment (HP31), 18cm IPG strip pI 4–7, 15% homogeneous gel. Silver stained.

Analysis of CNBr-digested parchments

Figure 14.9 shows a 15% homogeneous gel of the CNBr-cleaved NP7. As expected, there are no signs of the α2-, β- and γ-chains – only the α-chain is still detectable. Moreover, the most intense fragment spots are found near 90kDa. This may correspond to the fragment identified by amino acid analysis of the blotted SDS band isolated from the CNBr-digested HP31. The peptide fragments are present over a wide pI range from 4.5 to 10. Most spots of CNBr peptide fragments are found within the molecular weight interval between 50 and 90kDa, whereas fragments of lower molecular weight are present as a few discrete spots only. In the 2D gel of the CNBr-digested HP31, shown in Figure 14.10, the overall pattern is the same as for NP7. However, the discrete spots of lower molecular weight fragments are more intense. The intense accumulation of fragments at pI 7 indicates the presence of basic peptides. This has been supported by further analysis using an IPG strip with at pI range of 3–10.

Conclusions

SDS-PAGE and 2D-PAGE electrophoresis have proved to be promising techniques in the study of the deterioration of the corium collagen from historical parchments. The sample size of about 10mg corium sample does not allow sampling from cultural heritage objects. However, efforts will be made to reduce the sample size sufficiently to allow samples to be taken from, for example, the inside of bookbindings. One way to solve this problem is to optimize the amount of parchment dissolved by the mild dissolution procedure.

SDS-PAGE analysis

The SDS-PAGE analysis of new parchment and collagen (I) standard show the same pattern of high molecular weight bands corresponding to the α-, β-, γ-chains. Dry ageing at 110°C for 1, 2 and 4 days of new parchment leads to increasing disappearance of the high molecular weight bands, the occurrence of low molecular weight bands of low intensity and increasing smear with longer ageing time. The disappearance of the high molecular weight bands starts with the γ-band followed by the β- and α-bands in that order. These trends correspond to previous reported results. The band patterns of the historical parchment samples are very similar to those of the heat-aged new parchment and collagen standard. The SDS-PAGE band pattern of CNBr-digested artificially aged collagen (I) standard and the historical parchment samples follows the same trend. However, the low molecular weight bands are, in general, more intense due to the higher degree of digestion of the collagen.

Amino acid analysis of SDS-PAGE bands

It has been shown that amino acid analysis of SDS-PAGE separated bands is a useful technique for the identification of peptides in parchment. Using this method the α-1, α-2 and $β_{1,2}$ peptides from new parchment and a collagen standard have been identified. However, an optimization of the concentration of the amounts of peptides in the gel will aid in the identification of the low molecular weight peptides that appear in the samples of deteriorated parchments. SDS-PAGE analysis of artificially aged new parchment shows that the main peptide bands disappear with longer ageing time. This phenomena is followed by the appearance of weak bands of low molecular weight peptides around 60–70kDa and 20kDa.

By the use of CNBr digestion, concentrations of peptide fragments have been high enough for successful blotting from the SDS-PAGE gel and amino acid analysis has been possible. Thus, the band around 90kDa found in the sample HP31 has been identified as a fragment of the collagen (I) α-2 chain. Moreover, the altered amino acid distribution and collagen model simulation indicates a close relation between the oxidative breakdown pattern and the number of possibly sensitive tripeptide segments positioned in the charged areas (clusters) of the α-2 chain.

2D-PAGE analysis

The 2D-PAGE analysis of new parchment shows the presence α-, β-, γ-chains over a pI range from around 5 to 6.75. This spread of peptide spots of the same molecular weight may be due to a slight chemical modification of some of the peptides as well as a different degree of deamidation of the Asn and Gln residues in these. The 2D-PAGE analysis of the historical parchments confirms the pattern of the artificially aged sample. Only the α-chains are left in 7 of the 12 samples analysed. In all the samples, an identical pattern of fragment spots are visible in the 40–60kDa area, and in some samples more weak and discrete spots appear in the molecular weight area below this. The variations in the intensity and number of spots found in the 2D gels of historical parchments may be ascribed to variations in the breakdown pattern and difference in the solubility of the individual parchment samples, as well as variations in the amount of samples loaded to the gels. However, a tendency for a relation between the shrinkage temperatures and the percentage of the historical parchment in solution is found. This should be confirmed by further analysis.

The 2D-PAGE analysis of the CNBr-digested samples of new and historical parchment show only signs of the α1-chain and lower molecular weight fragments between 50 and 90kDa. In both samples the most intense fragment spots are found near 90kDa, corresponding to the fragment identified by amino acid analysis of a blotted SDS band isolated from the CNBr-digested HP31. In addition, fragments below 50kDa are, in both cases, present as a few discrete spots only. Moreover, in both samples the peptide fragments are present over a wide pI range from 4.5 to 10.

In general, it can be concluded that the similarity in the 2D-PAGE pattern of the historical parchments supports the theory that cleavage of the collagen peptides may take place on specific locations in the chains. Further development and optimization of the analytical procedure and method may allow for a better 2D-PAGE mapping of the peptide fragments and an identification of the cleavage points by help of amino acid analysis, sequence analysis and mass spectrom-

etry. However, at the present stage of development this should already be possible with some peptide fragments isolated from CNBr-digested parchment.

Acknowledgements

The authors would like to thank Vibeke Barkholt, Department of Biochemistry and Nutrition, Technical University of Denmark, Lyngby for performing the CNBr digestion.

Endnotes

1. Multiphor II Electrophoresis System, User Manual, Pharmacia Biotech.
2. Communication, University of Copenhagen, Department of Protein Chemistry.
3. Millipore, Immobilon-P, Transfer Membrane User Guide.
4. Bio-Rad, Bio-Rad Protein Assay, Instruction Manual.
5. Communication, University of Copenhagen, Department of Protein Chemistry.
6. Millipore, Immobilon-P, Transfer Membrane User Guide.
7. Bio-Rad, Bio-Rad Protein Assay, Instruction Manual.
8. Amersham Pharmacia Biotech, Hoefer TM Automated Gel Stainer. User Manual. Rev A/6-96.
9. Millipore: Protein Blotting Protocols, Lit. No. TP001, 1991 Millipore Corporation.

References

Benya, P. D. (1981) 'Two-dimensional CNBr peptide patterns of collagen Types, I, II and III', *Collagen and Related Research* 1, pp. 17–26.

Berkelman, T. and T. Stenstadt (1998) *2-D Electrophoresis – Using Immobilized pH Gradients, Principles and Methods*. Amersham Pharmacia Biotech.

Bernard, M. P., M. L. Chu, J. C. Myers, F. Ramirez, E. F. Eikenberry, D. Prockop (1983) 'Nucleotide sequences of complementary deoxyribonucleic acids for the Pro 1 chain of human type I procollagen. Statistical evaluation of structures that are conserved during evolution', *Biochemistry* 22, p. 5213.

Boedtker, H., M. Finer, S. Aho (1985) 'Part II. Collagen genes, structure & regulation. The structure of the chicken a2 collagen gene', *Annals of the New York Academy of Sciences* 486, p. 85.

Butler, W. T., K. A. Piez and P. Bornstein (1967) 'Isolation and characterization of the cyanogen bromide peptides from the a chain of rat skin collagen', *Biochemistry* 6, 12, pp. 3771–80.

Cheung, D. T., P. D. Benya, D. P. Hofer and M. E. Nimni (1981) 'The use of 2-dimensional CNBr peptide maps for the analysis of crosslinked peptides in bone collagen', *Collagen and Related Research* 1, pp. 247–56.

Click, E. M. and P. Bornstein (1970) 'Isolation and characterization of the cyanogen bromide peptides from the a1 and a2 chains of human skin collagen', *Biochemistry* 9, 24, pp. 4699–706.

Dölz, R. and E. Heidemann (1986) 'Influence of different tripeptides on the stability of the collagen triple helix. I. Analysis of the collagen sequence and identification of typical tripeptides', *Biopolymers* 25, p. 1069.

Fietzek, P. P. and K. Kühn (1976) 'The primary structure of collagen', *International Review of Connective Tissue Research* 7, p. 1.

Fietzek, P. P. and K. A. Piez (1969) 'Isolation and characterization of the cyanogen bromide peptides from the α2 chain of rat skin collagen', *Biochemistry* 8, 5, pp. 2129–33.

Fuchs, R. and S. Michon (1987) 'Von Pergament und Farben', *Zeitschrift für Kunsttechnologie und Konservierung* 1, p. 57.

Fietzek, P. P., M. Münch, D. Breitkreutz and K. Kühn (1970) 'Isolation and characterization of the cyanogen bromide peptides from the a2 chain of calf skin collagen', *Febs Letters* 9, 4, pp. 229–31.

Fujiwara, S. and Y. Nagai (1981) 'Basement membrane collagen from bovine lung: its chain associations as observed by two-dimensional electrophoresis', *Collagen and Related Research* 1, pp. 491–504.

Görg, A., G. Boguth, A. Harder, C. Obermaier, B. Scheibe, R. Wildgruber and W. Weiss (1998) *Two-Dimensional Electrophoresis of Proteins using Immobilized pH Gradients: A Laboratory Manual*. Technical University of Munich, Weihenstephan.

Görg, A., G. Boguth, C. Obermaier, A. Posch and W. Weiss (1995) 'Two-dimensional polyacrylamide gel electrophoresis with immobilized pH gradients in the first dimension (IPG-Dalt): the state of the art and the controversy of vertical versus horizontal systems', *Electrophoresis* 16, p. 1079.

Gorham, S. D., N. D. Light, A. M. Diamond, M. J. Willins, A. J. Bailey, T. J. Wess and N. J. Leslie (1992) 'Effect of chemical modifications on the susceptibility of collagen to proteolysis. II. Dehydrothermal crosslinking', *International Journal of Biological Macromolecules* 14, p. 129.

Gross, E. (1967) 'The cyanogen bromide reaction', *Methods in Enzymology* XI, pp. 238–55.

Hayashi, T. and Y. Nagai (1979) 'Separation of the a chains of Type I and II collagens by SDS-polyacrylamide gel electrophoresis', *Journal of Biochemistry* 86, pp. 453–9.

Heidemann, E. (1987) 'Programmierte Bruchstellen der Kollagenstruktur', *Das Leder* 38, p. 81.

Heidemann, E. and N. Linnert (1984) 'Participation of the α-2(1) cabin of bovine skin collaged in the formation of mature crosslinks', *Zeitschrift für physiologische Chemie* **365**, pp. 781–9.

Heidemann, E. and K. Ogawa (1973) 'Wo werden Gerbstoffe und Hilfsmittel im Hautfasergeflecht Fixiert?', *Das Leder* 24, p. 186.

Hulmes, D. J. S. *et al.* (1973) 'Analysis of the primary structure of collagen for the origins of molecular packing', *Journal of Molecular Biology* 79, p. 137.

Kejser, U. B. and M. S. Koch (1997) 'Degradation of gelatin in historical photographs', *The Imaging Science Journal* 45, p. 260.

Larsen, R. (1994a) 'The possible link between the collagen sequence and structure and its oxidative deterioration pattern', in *STEP Leather Project, European Commission DG XII*, Research Report No.1, The Royal Danish Academy of Fine Arts, School of Conservation, Denmark, ISBN 87 89730 01 1, p. 59.

Larsen, R. (1994b) 'Summary, discussion and conclusion', in *STEP Leather Project, European Commission DG XII*, Research Report No.1, The Royal Danish Academy of Fine Arts, School of Conservation, Denmark, ISBN 87 89730 01 1, p.165.

Larsen, R. (1995) 'The mechanisms of deterioration', in *Fundamental Aspects of the Deterioration of Vegetable Tanned Leathers*, PhD Thesis, The Royal Danish Academy of Fine Arts, School of Conservation, Denmark, ISBN 87 89730 20 8, p. 69.

Larsen, R., D. V. Poulsen, M. Vest and A. L. Jensen (2002) 'Amino acid analysis of new and historical parchments'. This volume, pp. 93–9.

Larsen, R., M. Vest, K. Nielsen and A. L. Jensen (1994) 'Amino acid analysis', in *STEP Leather Project, European Commission DG XII*, Research Report No.1, The Royal Danish Academy of Fine Arts, School of Conservation, Denmark, ISBN 87 89730 01 1, p. 39.

Light, N. D. (1985) 'Collagen in skin preparation and analysis', in D. Skerrow and C. J. Skerrow (eds), *Collagen in Skin: Preparation and Analysis, Methods in Skin Research*. John Wiley & Sons Ltd., pp. 559–86.

Morris, G. E., L. C. Frost, P. A. Newport and N. Hudson (1987) 'Monoclonal antibody studies of ceratine kinase – antibody-binding sites in the N-terminal region of creatine kinase and effects of antibody on enzyme refolding', *Biochemistry* 248, pp. 53–9.

Müller. H. T. and E. Heidemann (1993) 'Unterscuhung der Gesetzmäßigheiten für den Säureabbau von Hautkollagen und Idenifizierung der Kollagenspaltstelen beim sauren Gelatineprozeß', *Das Leder* April, pp. 69–79.

Porck, H. J. and T. van Oosten (1989) 'Identification of parchment using isolelectric focusing' in *International Leather and Parchment Symposium 8–12 May 1989*, ICOM CC Working Group Leather and Related Objects, Deutsches Ledermuseum, Offenbach am Main, p. 60.

Rabilloud, T. (1998) 'Use of thiourea to increase the solubility of membrane proteins in two-dimensional electrophoresis', *Electrophoresis* 19, p. 758.

Rabilloud, T., C. Valette and J. J. Lawrence (1994) 'Sample application by in-gel rehydration improves the resolution of two-dimensional electrophoresis with immobilized pH gradients in the first dimension', *Electrophoresis* 15, p. 1552.

Rauterberg, J., R. Timpl and H. Furtmayr (1972) 'Structural characterization of N-terminal antigenic determinants in calf and human collagen', *European Journal of Biochemistry* 27, pp. 231–7.

Sanchez, J-C., V. Rouge, M. Pisteur, F. Ravier, L. Tonella, M. Moosmayer, M. R. Wilkins and D. F. Hochstrasser (1997) 'Improved and simplified in-gel sample application using reswelling of dry immobilized pH gradients', *Electrophoresis* 18, p. 324.

Thakur, S., D. Vadolas, H. P. Germann, and E. Heidemann (1986) 'Influence of different tripeptides on the stability of the collagen triple helix. II. An experimental approach with appropriate variations of a Trimer model oligotripeptide', *Biopolymers* 25, p. 1081.

van Oosten, Th. B. (1989) 'Characterisation of parchments and animal glues from different kinds of animals by thin layer isoelectric focusing', *Leather Conservation News* 5, 2, p. 1.

Von Chalepakis, G., I. Tanay and E. Heidemann (1985) 'Wie spezifisch ist der Kollagenabbau bei der Gelatineherstellung?', *Das Leder* 36, 2, pp. 2–10.

Walker, J. M. (1986) 'SDS polyacrylamide gel electrophoresis of proteins, determination of protein molecular weights and high-resolution silver staining', in Robert J. Slater (ed.) *Experiments in Molecular Biology*. Humana Press Inc., ISBN: 0-89603-082-2, p. 152.

de Wet, W., M. Bernard, V. Benson-Chanda, M. L. Chu, L. Dickson, D. D. Weil and F. Ramirez (1987) Organization of the human Pro–α2(I) collagen gene', *Journal of Biological Chemistry* 262, p. 16032–6.

Wilson K. and J. Walker (1994) *Principle and Technology of Practical Biochemistry*. Cambridge University Press.

15 Analysis of Collagen Structure in Parchment by Small Angle X-ray Diffraction

Timothy J. Wess and Kurt Nielsen

Background to collagen structure

In the context of this section it is probably best to consider parchment as a collagen-based material since collagen is by far the most abundant molecule (by weight). Collagen molecules are triple helical containing a characteristic amino acid composition of which around 33% of the amino acids are glycine. It also contains high levels of proline and the unusual amino acid hydroxyproline. The reason for the high levels of glycine residues is apparent from the structure of the collagen where the rope-like triple helix requires a very small amino acid at every third position.

The collagen molecules are very long (300nm) and this allows the strength of the collagen molecules to be transferred between molecules due to a specific staggered molecular interaction. This in turn leads to the formation of a collagen fibril. The axial structure of fibrillar collagen is well documented. Studies using X-ray diffraction (XRD), neutron diffraction and electron microscopy have provided most of the data that have allowed relatively detailed maps of the molecular packing to be produced. Collagen molecules when associated in fibrils have a molecular alignment based on relative staggers of 67nm repeats. The staggered molecules result in a projected structure that contains the characteristic gap/overlap feature based on a 67nm periodicity.

Figure 15.2 shows the relationship between the collagen helical structure and the formation of the axial structure into a fibril. The amino acid side chains protrude from the helical core and present surfaces that dictate the interaction between adjacent collagen triple helices. The 67nm axial periodicity corresponds to a molecular stagger of approximately 234 amino acids.

Figure 15.1 The triple helical structure of collagen in a number of representations. The helix is only about 1.0nm wide. Each polypeptide chain has a left-handed helical nature, the chains are then intertwined in a right-handed super helical fashion.

X-ray diffraction

The process of XRD diffraction allows molecular structure to be probed. The size of molecules and their internal features often mean that the molecules cannot be viewed by microscopic techniques. Many reviews of XRD of macromolecules and fibres are available; mathematical detail will be kept to a minimum here. The process of XRD can be compared with transmission electron microscopy (TEM); in both systems, radiation is scattered by atoms and modulated by the arrangement of the molecules – the combined effects are diffraction. In TEM the scattered electrons are refocused to create a virtual image of the sample, but with XRD there is currently no method of refocusing the X-rays scattered by the sample to regain an image of molecule and its interaction with other molecules.

The interpretation of the structure has to be made mathematically. In many cases it is possible to make a series of models of the proposed molecular structure and to then determine the suitability of each model by simulation of the diffraction data that would be obtained from each model. The process of turning a model into diffraction data and vice versa is through the Fourier transform, where the reciprocal relationship between the diffracted structure and the molecular structure (real space electron density) is converted.

XRD is appropriate for studies of parchment since it can study a number of parameters associated with structure of

Figure 15.2 The relationship between the collagen helical structure and the formation of the axial structure into a fibril.

the collagen molecules, their integrity and the molecular packing within a fibril. The collagen molecules can be analysed at a number of hierarchical levels from the high resolution of the helical structure within the collagen molecule to the relative orientation of the fibrils. The technique requires model building but also analyses a statistically significant number of molecules at any one time. Data are therefore averaged and significant observations by diffraction indicate that millions of molecules are behaving in a particular way. Diffraction can also provide information about the degree of disorder within the system which is of particular relevance in the study of parchment degradation.

Drying a collagen-rich sample has three major effects which can be observed by XRD:

1. The periodicity of the axial repeat is shortened from 67nm to approximately 64nm.
2. The intensity of Bragg reflections changes radically indicating changes in electron density.
3. The number of diffraction peaks is curtailed after only 15 diffraction orders in the dry state and indicates a relatively high degree of static disorder in the sample.

These features can be quantified by XRD and the relevance to ageing and decay of parchment samples assessed.

Figure 15.3 A schematic diagram of the XRD process.

Figure 15.4 The relationship of a real structure on the left and the intensity terms of the Fourier transform right. The inter-conversion between the two also requires the 'phase' term, an essential part of information that cannot be recorded directly by XRD.

Synchrotron radiation

For large-scale data collection, and especially for small angle scattering, large scale X-ray sources are preferred for the intense highly collimated X-rays that can be produced. The synchrotron consists of a beam of charged particles (electrons or positrons) that are held by magnets in a near circular orbit. By accelerating electrons to near relativistic speeds the electrons give out a broad spectrum of radiation,

Figure 15.5 A schematic diagram of the synchrotron and beamline 2.1 at Daresbury. Polychromatic radiation is filtered by a monochromator and focused by allowing the X-rays to hit a mirror at a glancing angle.

X-rays can be filtered out and used for diffraction experiments.

The advent of third generation synchroton sources provides high brilliance X-ray intensity with a corresponding small spot size (500 micron × 2000 micron) and well-focused diffraction image at the detector. These features are ideal for analysis of parchment structure – the process of diffraction is non-destructive and allows the overall structure of a statistically significant population of fibrils to be examined at one time. A large number of samples (more than 100) can be analysed during one day of synchrotron beam time with exposure times of around 5 minutes for a typical dry parchment sample.

Data were collected at beamline 2.1 of the CCLRC Daresbury Laboratory. A 4.5 metre camera allowed adequate resolution of the first 15 individual axial Bragg peaks which correspond to the meridional series that can be observed with dried collagen-based tissues. The diffracted X-rays were detected with a two-dimensional gas-filled detector with a very large dynamic range (it can collect weak and strong diffraction features at the same time). Data were corrected for a detector response (the noise created by the detector itself) in order to normalize each pixel of the detector. Background diffraction images were removed in order to remove camera-dependent scattering effects.

Data analysis and parameters

The nature of skin, and therefore parchment, requires the tissue to resist the two-dimensional stretching forces exerted on it. The distribution of fibrils in the plane of the parchment therefore is usually a network of fibrils with low levels of preferred orientation. The diffraction data appear as a series of arcs; since the diffraction data contains mirror symmetry, it is not necessary to obtain all the diffraction data and the peak resolution can be obtained by offsetting the beam centre. The diffraction is relatively weak compared to the main X-ray beam; the latter is trapped with a block of lead or a backstop in order to prevent it destroying the detector. The distribution of intensity around an arc corresponds to the fibril orientation, and the variation of diffraction intensity in each arc corresponds to the structure within a fibril. The intensity only extends to approximately 15 peaks of diffraction. In wet samples of tendon over 100 orders of diffraction can be obtained. It appears that upon drying, the diffraction is limited by the disordering that occurs, the repeating units along the fibril (the unit cell) adopt slightly different conformations that distort the structure between

Figure 15.6 Typical diffraction data can be seen here indicating a variety of intensity distribution. The range of diffraction that can be seen represents the 2nd to 15th orders of diffraction. The 6th and 9th orders are particularly strong and the samples also exhibit a variety of fibril distributions. The distance of the diffraction peaks from the centre of diffraction depends on the length of the fundamental axial periodicity.

unit cells. This effect appears to be accentuated in some cases of degradation.

In order to maximize the diffraction data intensity above the background noise, the data were converted to a linear intensity distribution over a fixed angular range that corresponded to the optimal fibril orientation in the sample. Diffraction peaks were integrated along the arcs by converting the intensity distribution from the Cartesian to the polar coordinate system.

The variety of samples collected produced a number of different diffraction profiles, however all those collected at the SRS Daresbury contained some characteristic and consistent features.

In almost all cases, the molecular spacing of the axial structure was around 64nm with only a small number of samples deviating significantly from this value. The length of the axial repeat may therefore provide an analytical tool with which to determine sample origin.

Figure 15.9 Data showing the differences in the fundamental periodicities of collagen fibrils in parchment before and after heating at 120°C for 1 day. The effect of heating is to decrease the molecular periodicity; this is reflected in a changing of the position of the diffraction peaks to greater values.

Figure 15.7 The relationship of one single fibril to diffraction and the variation in fibril orientation that smears the diffraction over an arc. The data can be converted to polar coordinates for convenience.

The diffraction intensity profiles contained a number of characteristic peaks. Typically, the diffraction series contained intense 6th, 9th and 11th peaks; these are also found to be characteristic of dry structures such as rat tail tendon. It is therefore reasonable to simulate the electron density profile of parchment and decayed parchment based on a starting model that uses data derived from rat tail tendon molecular packing in the wet and dry state.

Model building

The axially repeating structure of collagen fibrils has been investigated since it holds the key to how collagen molecules associate. Recent studies have interpreted the electron density and demonstrate that the axial structure contains three key regions: the gap, overlap and telopeptides. The effects of drying and ageing may vary to different degrees in each of the three regions due to the molecular topology and the molecular density in the pre-dried states. Diffraction of tendon samples in the wet state indicates the molecular structure at low angles to be dominated by strong 1st, 3rd and 5th orders of intensities; this corresponds to the distinct gap overlap function. These features are absent from the dried samples indicating that the gap overlap contrast density difference is weakened. This presumably relates to the effect of drying where the water occupying the void of the gap region is removed. The collapse of the structure is also concomitant with the reduction of axial period length, indicating a concerted series of changes in the axial structure that occur on drying. The XRD evidence also points to a larger degree of statistical disorder in the molecular organi-

Figure 15.8 XRD profile of the parchment diffraction data. The data is lying on a rapidly changing background which is derived from non-specific scattering in the parchment. The intensity distribution relates to the structure of the parchment axial periodicity. The position of the reflections corresponds to the length of the axial repeating unit within the fibrils.

Figure 15.10 The gap, overlap and telopeptide regions of the axial repeating structure.

zation within a fibril. This effect may also be compounded by deterioration of collagen in parchment samples where peptide bond cleavage may induce even larger degrees of disorder.

The electron density distribution of the axial repeat was defined by using the amino acid sequence of type I collagen to create the characteristic gap overlap structure. The electron density profile could then be divided into a number of sub-sections, allowing the molecular structure to be simulated by producing electron density maps and judging the correlation with experimental diffraction data. In an attempt to simulate the diffraction data, the first step was to alter the electron density difference between the gap and overlap regions. The contrast difference of gap overlap is 0.8; this corresponds to 4 segments per axial unit cell in the gap region and 5 in the overlap region. In order to improve a fit with the diffraction data from historic parchments, the contribution from the gap, overlap and telopeptides was weighted with static disorder factors which made the diffraction profile decay after only a few orders.

The molecular structure of parchment collagen contains features that closely resemble the structure of dry rat tail tendon. The static disorder is always found to be greatest in the telopeptide regions and this may even point to different levels of occupancy in different D periodic structures. The temperature factor RMS values for the gap and overlap are comparable (in the region of 5nm). Samples that exhibit less Bragg diffraction indicate that certain forms of deterioration relate to increased static disorder within the fibrils of a sample.

Principal component analysis

An alternative method of data analysis was to examine the key features of collagen diffraction from a large pool of data. The process involves the determination of the deviations of each individual diffraction profile from an average diffraction profile. The differences are then converted into a series of Eigen values and Eigen functions that are used to construct a series of orthogonal functions that deconstruct the diffraction profile. In the case of the data collected in this study, the functions correspond well with recognizable features within the diffraction profile such as the background, changes in peak position and intensity and also the presence of the lipid ring that appears in a large number of parchment samples.

Each diffraction profile consists of a discrete combination of the individual functions. The diffraction profiles can therefore be grouped together and the relationship between different component functions can be compared with other physical techniques of parchment analysis such as differential scanning calorimetry (DSC) or shrinkage temperature.

Conclusion

XRD provides an excellent method of analysing the changes in parchment structure with ageing. A number of parameters can be derived from the data that can also be correlated with other structural techniques. The method is relatively quick and also non-destructive.

Figure 15.11 The first three components of the principal component analysis of parchment diffraction. The functions indicate the contribution of diffuse scatter and changes in the relative intensity and position of peaks.

16 Pyrolysis Capillary Gas Chromatography (PY-CGC) of Historical Parchment Samples

Leopold Puchinger, Dietmar Leichtfried and Herbert Stachelberger

Introduction

In principle, the natural scientist should make a critical study of physical and chemical analytical methods before starting with the characterization of historical parchments. However, restorers need speedy, accurate, cost-effective results and the sample amounts made available by curators are limited. A technique which copes with both these limitations is pyrolysis capillary gas chromatography (PY-CGC).

As only small fragments of art objects are provided for analysis, the applied chromatographic method quickly reaches the lower limit of substance quantity for identification. PY-CGC is particularly suitable as its sample preparation takes very little time and the sample amounts required are very small (Puchinger and Stachelberger 1990). Moreover, objects which are hardly soluble in organic solvents can be analysed with this technique. In addition to a conventional CGC, PY-CGC is equipped with a pyrolysis unit including a control device for setting pyrolysis temperature and time (the pyrolysator oven as well as the sample keeper) with a quartz tube in a platinum coil which can be adjusted exactly. A very small piece of sample is pushed in the tube and after heating the products formed by pyrolysis under controlled condition are separated on a fused silica column with the aid of CGC. Identification of organic compounds in the sample material has succeeded if the peak pattern of the unknown object and the well-known reference material closely resemble each other. To underline its importance in connection with the organic analysis of art materials, the technique has supplied answers to three chemical analytical questions: (1) the search for organic substances on the metallic surface of the bronze statue, *Youth of the Magdalensberg* (2) material testing of a *Bunch of Flowers* from the Vienna Technical Museum, and (3) examination of lacquer of a paravent from the Napoleon Chamber of the Vienna Castle Schönbrunn (Puchinger *et al.* 1998).

To date, there are no applications mentioned in the literature with reference to pyrolysis of parchment collagen. Only biomedically interesting biopolymers such as α-chymotrypsin, trypsin, trypsinogen and haemoglobin have been studied successfully (Bayer *et al.* 1976). Precise differentiation can be achieved within all these groups, even in those cases where structural differences are exceedingly small.

It was considered worthwhile to investigate the fragment pattern obtained by PY-CGC with a series of old parchment samples to make a diagnosis as to the existence of certain organic pigments as well as other components, and also to determine the condition of the main material, collagen. The main goal in this study was to study the suitability of this technique for parchment assessment – its link to the results of the established methods in this area has also to be taken into consideration.

Materials and methods

Samples

PY-CGC studies on parchment were made with some new and a series of historical samples. For this analysis, sample pieces 0.74mm in diameter (ca. 87μg) were considered sufficient and were obtained by using a special microdrilling instrument (described in Chapter 1).

The following samples were investigated with PY-CGC: Lyophilized collagen, NP2, NP3, NP4, NP5, HP4A, HP6A, HP7*, HP8*, HP9B, HP10, HP11, HP12, HP13, HP15, HP16*, HP17, HP18*, HP20*, HP21, HP22*, HP23, HP24, HP25, HP26*, HP27, HP28*, HP29, HP30, HP31*, HP32*, HP33, HP34, HP35, HP36*, HP37*, HP38*, HP39, HP40, HP41, HP42, HP43, HP44, HP45, HP46, HP47, HP48.

Pyrolysis capillary gas chromatography (PY-CGC)

The sample amount required for PY-CGC is one cylinder, 0.74mm in diameter, so dependent on parchment thickness, 43–130μg is necessary.

(* described in greater detail in Chapter 1).

Defining features for CGC

CGC was conducted on a Carlo Erba Instruments Series 2350 and all analyses were performed using a 4m × 0.32mm fused silica DB-5 (J & W) column with 25μm film thickness. The pressure of Helium as carrier gas is set to 110kPa and the whole operation is done in split mode (1:3.3). Injector (split/splitless vaporizer injector) as well as detector temperature (flame ionization detector) was adjusted to 300°C. The oven temperature programme takes exactly 34 minutes, beginning with 90°C for 2 minutes before continuing at a heating rate of 5°C/min up to a final temperature of 250°C.

Table 16.1 Classification of parchment samples on the basis of pyrograms.

Category	Name of parchment
I	Lyophil. Collagen, NP5, HP33, HP38*
II	NP2, NP3, HP8*, HP10, HP11, HP12, HP13, HP15, HP17, HP22*, HP23, HP24, HP25, HP26*, HP29, HP31*, HP32*, HP34, HP36*, HP40, HP42, HP47, HP48
III	HP4A, HP7*, HP16*, HP30, HP35
IV	NP4, HP6A, HP37*, HP39, HP41, HP43, HP44, HP45
V	HP28*
VI	HP18*, HP20*, HP46
VII	HP9B, HP21, HP27

* samples described on pp. xix-xx.

Defining features for pyrolysis apparatus

Conventional CGC is adapted to PY-CGC by connecting the injector of CGC unit with an 120 Pyroprobe (Chemical Data Systems). During pyrolysis, the temperature of pyrolysator oven is kept to almost 270°C. The control unit for pyrolysis process taking place in the quartz tube of platinum coil is regulated to 700°C over a period of 5 seconds.

Discussion of the results obtained with PY-CGC

Forty-two mainly historical parchment samples were analysed with PY-CGC. Seven types of pyrograms were found with various sorts of fingerprints of their pyrolysis products (Table 16.1, Fig. 16.1). For example, there are great differences in the peak pattern of categories IV, VI and VII. The majority of parchments analysed could be related to category II. Currently, the information derived from category number (I-VII) does not allow for the determination of parchment condition; samples can only be summarized as being in the same category with specially defined substance groups as well as very similar peak intensity. Differences in fragment pattern are due to (a) collagen (Bayer *et al.* 1976) and (b) interference connected with other organic components and organic pigments occurring in parchment material. Precise identification of all substances in a pyrogram is possible by combining PY-CGC with mass spectrometry. This detector system allows us to determine the breakdown products belonging to collagen and to separate them from all other components. This may further our knowledge of what happens to collagen subjected to pollutants and age.

For this study, the selection of PY-CGC parameters was made with no reference to results from mass spectrometry; changes in these factors are to be expected in future. Currently, the most effective method of separating pyrolysis products is obtained by adjusting pyrolysis to 700°C over a period of 5 seconds; below this temperature fragmentation of parchment is too poor. A higher heating rate of the CGC oven as well as higher final oven temperatures will result in a poor resolution of substances. The analysis result may be improved by using longer capillary columns for reasons of longer interactions between the components and the column liquid film. If the determination of organic pigments comes to the fore, then their volatility influences the choice of the optimal oven setting. For example, analysis of light volatile cochineal is successful only when the starting temperature of the CGC oven is reduced. Sometimes the intensities of breakdown products fluctuate strongly between individual parchment samples owing to the thickness of cylindrical parchment pieces obtained with the hollow drill. Using the appropriate inner syringe diameter for sampling will compensate for this.

Discussion of the results from TEM and PY-CGC by comparison with other methods

The classification of historical parchment samples with PY-CGC into seven categories is not in accordance with the six classes obtained with TEM. This is not surprising as the TEM method's basic principle is the evaluation of the appearance of collagen fibres, while for the fingerprint pattern of PY-CGC, besides collagen, other organic components such as pigments (and perhaps lipids) are responsible. In the pyrogram of HP28, more components can be found than in the others; the fibrils are hardly wrapped in gelatine (Puchinger *et al.* 2002) and have the strongest diffraction from lipids (Wess and Nielsen 2002). This result leads one to suppose that lipids are present in the peak pattern and they are of crucial importance preventing collagen from oxidating. But this could not be verified by examination with TEM (Puchinger *et al.* 2002). Also determination of shrinkage temperature and ratio as well as B/A (Larsen *et al.* 2002a,b) and solid state NMR (Odlyha *et al.* 2002) confirm the poor condition of HP28 probably caused by oxidation processes. So lipids seem to be incorporated into the gelatine structure formed by collagen degradation, in this way preventing collagen fibres from excessive wrapping in gelatine (Puchinger *et al.* 20021).

Figure 16.1 Categories of historical and new parchment samples obtained with pyrolysis chromatography.

Conclusions

PY-CGC-studies on a series of historical parchment samples confirmed the qualification of this technique for evaluation of parchment condition. Many positive properties, which have high priority in parchment analysis, are testimony of its usefulness: a sample demand in the µg-range; very simple sample preparation; minimum amount of time required; and cost effective. PY-CGC is suitable for dividing the samples into seven categories of fragment patterns differing from each other. However, the peaks in the chromatograms not only come from pyrolysis of collagen, but also from other organic components such as pigments. To further our knowledge of the parchment damage processes, it will be necessary in the future to identify breakdown products by means of mass spectrometry in addition to PY-CGC.

References

Bayer, F. L., J. J. Hopkins and F. M. Menger (1976) 'Pyrolysis GLC of biomedically interesting molecules', in C.E.R. Jones (ed.) *Analytical Pyrolysis*, Vol. 3. Elsevier Scientific Publishing Company, p. 217.

Larsen, R. , D. V. Poulsen and M. Vest (2002a) 'The hydrothermal stability (shrinkage activity) of parchment measured by the micro hot table method (MHT)'. This volume, pp. 55–62.

Larsen, R., D. V. Poulsen, M. Vest and A. L. Jensen (2002b) 'Amino acid analysis of new and historical parchments'. This volume, pp. 93–9.

Odlyha, M., N. Cohen, G. Foster, R. Campana and A. Aliev (2002) '^{13}C and ^{15}N solid state nuclear magnetic resonance (NMR) spectroscopy of modern and historical parchments'. This volume, pp. 101–8.

Puchinger, L. and H. Stachelberger (1990) 'Pyrolyse-gas chromatographische Prüfung organischer Rohstoffe am Beispiel der Wachse', *Fat Science Technologynt:* 92/6, p. 243.

Puchinger, L., D. Leichtfried and H. Stachelberger 92002) 'Evaluation of old parchment collagen with the help of transmission electron microscopy (TEM)'. This volume, pp. 9–12.

Puchinger, L., S. Miklin-Kniefaz and H. Stachelberger (1998) 'Organic analysis used in art objects by means of PY-CGC', in *25 years of the School of Conservation – The Jubilee Symposium Preprints*, Det Kongelige Danske Kunstakademi, Konservatorskolen Copenhagen, p.167.

Wess, T. J. and K. Nielsen (2002) 'Analysis of collagen structure in parchment by small angle X-ray diffraction'. This volume, pp. 149–53.

17 Palaeogenetics of Parchment

Joachim Burger

Introduction

Ancient DNA (aDNA) can be detected in historical and prehistoric materials such as bones (Hummel *et al.* 1999; Krings *et al.* 1997), soft tissues (Higuchi *et al.* 1984) or coprolites (Poinar *et al.* 1998). The isolation of aDNA from historical animal specimens is a new approach that also can be applied to all sorts of hide-derived material, such as parchment (Woodward *et al.* 1996), leather, raw hide, pelt, etc. The difference between primary biomaterials, such as bones and teeth, and manufactured artefacts is that the latter have been subjected to physical and chemical treatments, such as defleshing, cooking, etc. and may bear traces of these treatments. And these treatments may have DNA degrading or preserving effects. Thus, it is always necessary to remove possible chemical agents from the nucleic acids during extraction so that they do not hinder further analysis. Aside from the manufacturing process, contamination with unwanted molecules can also occur during the diagenesis of a specimen. This is true especially for soil-embedded finds (e.g. archaeological hide) which usually contain a considerable amount of organic geopolymers, which also inhibit further analysis.

This chapter describes how DNA can be extracted from parchment and the significance of this new kind of data has for the restoration/museum area. The first question we pose is: from which animal does this sample come? Besides identifying the species of origin, the establishment of the so-called genetic fingerprint by DNA profiling of a sample also identifies the individual historical source animal.

Genetic background

Like every cell of a body, most of the cells in an animal skin contain the complete genetic information of the animal. In the cell there is the nucleus, which contains the chromosomes, on which almost the complete genetic information lies. A small portion of the DNA is situated outside the nucleus, in cell organelles called mitochondria. The mitochondrial DNA (mtDNA) is only about 16,500 bp long (reflecting its chemical structure, the length of the DNA is counted in 'base pairs (bp)'), while on the chromosomes in the nucleus there are approximately 3×10^3 bp. The mtDNA plays a central role for the metabolism of the cell and also contains information on the species of the animal. At specific mitochondrial loci (locus, pl. loci: lat. place, here: a genetic segment), there are sequence polymorphisms, i.e. variations in the base sequence of different animal species. Other loci in the nucleus exhibit a length polymorphism, i.e. they vary in the number of base pairs between chromosomes, individuals, populations, or species. A certain kind of length polymorphism is found in the so-called microsatellite-DNA in the form of short tandem repeats (STRs). The combination of several STR-loci provides the genetic profile of an individual. In historic or ancient tissues, some cells are preserved and with them, although badly damaged, the nuclear and mitochondrial DNA.

Methods (from Burger *et al.* 2000b)

DNA extraction

Usually, a DNA extraction proceeds by the following steps:

1. Cell lysis.
2. Denaturation of proteins.
3. Separation of DNA from cell and proteinaceous debris.
4. Precipitation of DNA.

InstaGene™ Matrix is a chelating resin which provides a quick extraction method for degraded specimens. The commercial QIAamp TissueKit provides an extraction method based on a silica membrane.

The hide and parchment samples were incubated for 3 hours in InstaGene™ Matrix (Bio-Rad). The incubation mixtures were vortexed for 10 seconds and then incubated at 97°C for 8 minutes. After 10 seconds of vortexing, the samples were spun down at 8,000 rpm for 3 minutes and the supernatant transferred to the amplification reaction (Walsh *et al.* 1991).

Specimens with possible tanning agent content were incubated in lysis buffer (ATL lysis buffer, Qiagen) for 12 hours. After physical separation of the tissue remnants from the lysis solution by spinning through a QIAshredder (Qiagen), the solution was processed according to the instructions of the QIAamp Tissue Kit (Qiagen).

Polymerase chain reaction (PCR)

Because there are only a few cells preserved in ancient material, the DNA segments carrying the desired information are copied and amplified by polymerase chain reaction (PCR). Thus, enough copies are produced to read the genetic code.

For species identification, the following loci are amplified:

- A 158 bp segment of the mitochondrial cytochrome b gene
 - Primers: CB3a: 5´TCT AAC AAT CCC TCA GGA AT 3´, CB3b: 5´GTG TAG TTG TCT GGG TCT CC 3´.
 - PCR concentrations and conditions: 60mM KCl; 12mM Tris-HCl; 2.5mM MgCl2; 150µM dNTPs; 0.18µM each primer; 2U AmpliTaq Gold™. 94°C 1 min, 56°C 1 min, 72°C 1 min.
- A 118 bp and a 101 bp segment of the 12S rRNA gene
 - Primers: rR4a: 5 AAC TGG GAT TAG ATA CCC CAC TA 3 , rR4c: 5 GAA GCA CCG CCA AGT CCT 3 , rR4d: 5 CTTGGAGTTCTAAGCTCTGGCT 3.
 - PCR concentrations and conditions: 60mM KCl; 12mM Tris-HCl; 2.5mM MgCl2; 150µM dNTPs; 0.18µ0M each primer; 2U AmpliTaq Gold™. 94°C 1 min, 56°C 1 min, 72°C 1 min.

Short tandem repeat (STR) loci are individually polymorphous. For STR profiling of animals, the following loci were amplified:

- ISAG microsatellite loci (ETH 225F IRD/700, ETH 225R; MTG 4BF IRD/700, MTG 4BR; INRA 23F IRD/700, INRA 23R; TGLA 227F IRD 800, TGLA 227R; TGLA 122F IRD 800, TGLA 122R; TGLA 53F IRD 800, TGLA 53R; BM 2113F IRD 800, BM 2113R; BM 1824F IRD 800, BM 1824R; SPS 113F IRD/700, SPS 113R; ETH 10F IRD/700, ETH 10R; ETH 3F IRD/700, ETH 3R; TGLA 126F IRD 800, TGLA 126R; primer sequences (Burger *et al.* 2000a) were used to establish the individual fingerprint from animal DNA. PCR concentrations and cycling conditions (Pfeiffer and Brenig 1998).

DNA sequencing

Reading the genetic code is done by a molecular genetic method called DNA sequencing. Afterwards, the obtained DNA sequence can be compared with existing sequences in a database on the WWW (GenBank, BLAST program (Altschul *et al.* 1997)) and the species of origin can be established.

PCR products were purified with QIAquick™ PCR Purification Kit (Qiagen). For direct sequencing of the PCR-amplified sample, 2–6µl of purified PCR product was added to a cycle-sequencing reaction. The sequencing reaction used 3 pmol of either forward or reverse primer and 4µl BigDye™ Terminator Ready Reaction Mix (PE, Applied Biosystems). HPLC water was added to 20µl. Cycle sequencing consisted of the following steps: 96°C for 30 s, 56°C for 15 s, 60°C for 4 min for 25 cycles. The cycle-sequencing products were cleaned and prepared for sequencing according to the ABI Genetic Analyzer 310 protocol (ABI Prism Tips 4) and then loaded onto the instrument.

STR profiling

PCR products were analysed on 8% denaturing polyacrylamide gels using an LI-COR Gene ReadIR 4200 automated sequencer. Irrespective of phenomena typically occurring in microsatellite analysis (especially with degraded DNA and even more with dinucleotide repeats; cf. Odelberg and White 1993), such as allelic dropout and stutterbands, the two highest peaks were determined to be alleles. If there was a clearly predominating peak, this allele was rated as homozygous. Only alleles that were obtained reproducibly three out of four times were taken into account for the final STR genotype of the individual animal (not shown).

Results and discussion

From which species did this come?

In 50% of the parchments we examined, mitochondrial DNA was preserved and the species of origin could be established. Besides the manufacturing process, the main factors for DNA preservation/degradation are the environmental conditions under which the sample has been stored. Dry and cool environments favour DNA preservation. Extreme pH-values and the presence of micro-organisms destroy DNA molecules (Burger *et al.* 1999). When examining historical parchment samples, we found DNA

```
                  10         20         30         40         50
                  |          |          |          |          |
Parchment     |tgtagttctc tggcgaataa ttttgttatg aaattatcaa agtttagggc taagca
O. cuniculus  |---------- ---------- ---------- ---------- ---------- ------
S. nuttallii  |---------- ------g--- ---------- -------tc- g--------- ------
S. palustris  |---------- ------g--- ---------- g------tt- ---------- ------
S. audobonii  |---------- ------g--- ---------- -------tc- g--------- ------
```

Figure 17.1 Comparison of a sequence obtained from a parchment with reference sequences from GenBank (20.04.99). The 56 bp sequence falls within the mitochondrial 12S rRNA gene and lies between the primers rR4d and rR4a. Dashes indicate identity to the parchment sequence. The comparison shows that the parchment sequence matches exactly with the rabbit (Oryctolagus cuniculus) sequence. The sequences of three closely related species (Sylvilagus nuttallii, S. palustris, S. audobonii) show four mismatches to the parchment sequence each.

Table 17.1 Microsatellite DNA profile from four fragments of two parchment samples (PA I and PA II).

Parchment	Fragment	MTG 4B	TGLA 122	TGLA 227	BM 2113	BM 1824	TGLA 53	ETH 225
PA I	1	134	143/(155)	93/97	129/137	182/190	156/158	(144)/148
	2	134	143/(155)	93/97	129/137	182/190	156/158	144/148
PA II	3	134/144	139/151	89/91	139/141	178/(188)	164/180	142/150
	4	134/144	139/151	89/91	139/141	178/(188)	164/180	142/150

fragmented to lengths of usually less than 200 bp. However, a fragment of 200 bp (or even less) is in any case sufficient for species determination. An example of species identification from a rabbit parchment is shown in Figure 17.1 (Burger et al. 2000a).

From which individual animal did this come? DNA profiling

For parchments, it is possible to increase the resolution of the methods by applying PCR-based STR profiling on the material. With the help of the DNA profile, pieces can be set in correspondence to their original parchment without any doubt. This is significant for palaeographic reconstructions. Table 17.1 shows an example of two early modern bovine parchments which were genetically typed for seven microsatellite loci (Burger et al. 2000b).

Comparing the data from the parchment with modern data from a cattle data base provides information about the genetic constitution of historic animals. In this case, most of the alleles found in the two historic parchments are very rare or absent in modern cattle (Burger et al. 2000b). The comparison of the allelic status of recent animals to that obtained from historical hide material enables us to obtain knowledge about further biological and cultural data such as the origins of domestication, ancient herding practices and the provenance of the source animal used for parchment/leather production.

Conclusion

With material of fairly recent origin and which has not been too badly damaged either by storage or handling, it is usually a simple matter to decide the animal species of the original skin on the basis of grain patterns by examining the surface (Reed 1972). This is not always true for old, especially archaeological, remains, where the material was usually stored under bad conditions. Here, palaeogenetic methods can help to establish the species of origin. Some museums and libraries have manuscripts and scrolls that have disintegrated into hundreds or thousands of fragments, e.g. the Dead Sea Scrolls; DNA profiling could pre-sort them. In the future, the characterization of genes that code for physical traits (e.g. hair colour) will increase our knowledge about (pre)historic animal skins and animals in general.

References

Altschul, S. F., T. L. Madden, A. A. Schäffer, J. Zhang, Z. Zhang, W. Miller and D. J. Lipman (1997) 'Gapped Blast and PSI-Blast: a new generation of protein database search programs', *Nucleic Acids Research* 25, pp. 3389–402.

Burger, J., S. Hummel, B. Herrmann and W. Henke (1999) 'DNA preservation: a microsatellite-DNA study on ancient skeletal remains', *Electrophoresis* 20, pp. 1722–8.

Burger, J., S. Hummel, I. Pfeiffer and B. Herrmann (2000a) 'Palaeogenetic analysis of (pre)historic artifacts and its significance for anthropology', *Anthropologischer Anzeiger* 58, 1, pp. 63–76.

Burger, J., I. Pfeiffer, S. Hummel, R. Fuchs, B. Brenig and B. Herrmann (2000b) 'Mitchondrial and nuclear DNA from (pre)historic hide-derived material', *Ancient Biomolecules* 3, pp. 227–38..

Higuchi, R., B. Bowman, M. Freiberger, O. A. Ryder and A. C. Wilson (1984) 'DNA sequences from the quagga, an extinct member of the horse family', *Nature* 312, pp. 282–4.

Hummel, S., T. Schultes, B. Bramanti and B. Herrmann (1999) 'Ancient DNA profiling by megaplex amplifications, *Electrophoresis* 20, pp. 1717–21.

Krings, M., A. Stone, R. W. Schmitz, H. Krainitzki, M. Stoneking and S. Pääbo (1997) 'Neandertal DNA sequences and the origin of modern humans', *Cell* 90, pp. 19–30.

Odelberg, S. J. and R. White (1993) 'A method of accurate amplification of poymorphic CA-repeat sequences', *PCR Methods and Applications* 3, pp. 7–12.

Pfeiffer, I. and B. Brenig (1998) 'A highly polymorphic microsatellite within intron 5 of the porcine 54/56 kDA vacuolar H(+)-ATPase subunit gene (V-ATPase)', *Animal Genetics* 29, pp. 464–5.

Poinar, H. N., M. Hofreiter, W. G. Spaulding, P. S. Martin, B. A. Stankiewcz, H. Bland, R. P. Evershed, G. Possnert and S. Pääbo (1998) 'Molecular coproscopy: dung and diet of the extinct ground sloth Nothrotheriops shastensis', *Science* 281, pp. 402–6.

Reed, R. (1972) *Ancient Skins, Parchments, and Leathers*. London and New York: Seminar Press.

Walsh, P. S., D. A. Metzger and R. Higuchi (1991) 'Chelex® 100 as a medium for simple extraction of DNA for PCR-based typing from forensic material', *Biotechniques* 10, 4, pp. 506–13.

Woodward, S.R., G. Kahila, P. Smith, C. Greenblatt, J. Zias and M. Broshi (1996) 'Analysis of parchment fragments from the Judean Desert using DNA techniques, Conference on the Dead Sea Scrolls', in D. W. Perry and S. Ricks (eds) *Current Research and Technological Developments on the Dead Sea Scrolls*, Leiden, pp. 215–38.

IV Complementary and Comparative Analysis

18 The Use of Complementary and Comparative Analysis in Damage Assessment of Parchments

René Larsen, Dorte V. Poulsen, Marianne Odlyha, Kurt Nielsen, Jan Wouters, Leopold Puchinger, Peter Brimblecombe and Derek Bowden

Introduction

Parchment is a highly complex and complicated material. Moreover, parchment objects like manuscripts are the bearer of ink, gilded and painted layers that also contain binding media and other compounds. The complex chemical and physical nature of the parchment objects has to be taken into consideration by the study of its deterioration and conservation. The fundamental studies providing the basis for this call for advanced knowledge, analysis and research techniques, which demand many resources to be joined in complementary research. Compared to new materials, historical materials are different in nature, often of precious cultural value and in general the possibility for sampling is rather limited. Analysis therefore needs to be based on very accurate micro or non-destructive methods that produce valid data. The aim of this chapter is to analyse the possible correlation of data and demonstrate how some of the analytical techniques presented in this book may be used in a complementary characterization and assessment of the state of damage of historical parchments.

Experimental

The materials providing the basis are the 12 selected historical parchments from the sample bank (see pp. xix–xx). New parchment NP7 is used as reference. Table 18.1 shows the visual assessment of the sub-samples. The macroscopic assessment was made by Birkbeck College, London (Odlyha *et al.* 2002a), the microscopical assessment by the School of Conservation, Royal Danish Academy of Fine Arts in connection with the measurement of the hydrothermal stability (thermomicroscopy), and the assessment in connection with TEM analysis was made by the Vienna University of Technology (Puchinger *et al.* 2002). Table 18.2 shows selected data from the high-performance liquid chromatography (HPLC) amino acid analysis (Larsen *et al.* 2002a). Table 18.3 gives a summary of shrinkage data obtained from the techniques of thermomicroscopy, dynamic mechanical thermal analysis (DMTA) and differential scanning calorimetry (DSC) (Larsen *et al.* 2002b). Table 18.4 presents the ratios for amino acid analysis (HPLC) data calculated to enable direct comparison with the ratios of amino acid residues calculated from ^{13}C solid state NMR, i.e. C2 Pro+Hyp to C4 of Hyp (60/71), C2 of glycine to C4 of Hyp (43/71), C1 amino acid residue carboxylic acid component to carbonyl component C4 of Hyp (174 +171)/71, C1 carboxylic acid component to carbonyl component (174/171) (Juchauld and Chahine 2002). Moreover, in order to obtain a more detailed picture of the state and deterioration of the parchment samples, additional analysis on the acidity and anions have been performed by the Royal Institute for Artistic Heritage, and Cu and Fe analysis by the School of Environmental Sciences, University of East Anglia.

These are described in the following text and the data are presented in Table 18.5 together with the content of moisture and parchment dissolved in 0.1M HCl.

Measurement of pH and determination of anions

Parchment samples were cut into 1mm^2 fragments and extracted in water for 24 hours at room temperature in closed polyethylene vessels (ratio: 1mg in 50μl). The supernatant was decanted and used as such for pH measurements. A small aliquot of the aqueous extract was properly diluted with a potassium phthalate buffer, pH 4.1 and subjected to anion chromatography on an Ionosphere-A column (100 × 4.6mm, 5μm; Chrompack, Antwerp, Belgium). The same buffer was used as eluent, pumped at 1.0ml/min (model 510 HPLC pump, Waters, USA). Anions were detected with a conductivity detector (Model 430, Waters, USA) and quantified with the help of calibration curves for chloride, nitrate and sulphate. Amounts were expressed as % by weight of the conditioned parchment samples (21°C, 50 % RH).

Determination of Cu and Fe

Around 25mg of parchment was ashed at 550°C as only small samples were available. The ash was taken up in 10%

Table 18.1 Description of modern and historic parchments based on visual observations. Roman figures in parentheses in TEM denotes the classification given in the chapter: I = intact fibres to V = most damaged. From class III and onwards the fibres get increasingly wrapped in gelatin.

Sample	Date	Macroscopic	Microscopic State of fibres before, during or after shrinkage (MHT)	TEM State of fibres during preparation and in TEM
NP 7	1998	Beige, soft, thin, flexible, smooth, speckled underside	Difficult to observe fibre structure in water. Fibres difficult to loosen from sample. Separated fibres stick together like burrs	Fibres intact with clearly visible cross bands (I)
HP 7	17th C.	Dark brown painted surface, light brown underside, stiff, flexible	Easily divided into layers	Collagen units bundled up. Contrast greatly reduced on the one side of the collagen fibres (IV)
HP 8	1598	Grey/brown face with ink marks, white ground backing, curled, brittle	Easily separated – do not stick together	Fibres give the impression of sticking to the Formvar. Bundled-up collagen units with visible cross bands (III)
HP 16	?	Pale upperside, pale brown underside, stiff, slightly translucent	Thick fibres look as though they could be divided into thinner ones. Discrete/ slow shrinkage activity	Sample appears badly damaged, more collagen units bundled up (V)
HP 18	?	Brown, discoloured, stiff – sample splits in the middle. Grain very yellow, perhaps varnished	Easily divided into single fibres. Sample turns 'opaque' when immersed in water (gets cloudy due to $CaCO_3$?)	Collagen fibres seem 'wrapped' a little in gelatin. Cross bands visible (II)
HP 20	?	Beige upperside, yellow/brown underside, flexible	After shrinkage the fibres have a helical structure	Collagen units bundled up. Contrast greatly reduced on the one side of the collagen fibres (IV)
HP 22	?	Brown/white markings, roughened, flexible, curled, slightly	Difficult to loosen from sample. Surface of sample difficult to open	Collagen units bundled up. Contrast greatly reduced on the one side of the collagen fibres (IV)
HP 26	?	Yellow/brown mottled upperside, pale (ground residue?) underside	Very thin fibres	Collagen units bundled up. Contrast greatly reduced on the one side of the collagen fibres (IV)
HP 28	?	Yellow/brown upperside, pale underside, flexible	Difficult to separate, gel-like, but still visible fibre structure	Collagen fibres seem 'wrapped' a little in gelatin. Cross bands visible (II)
HP 31	?	Pale yellow/brown upperside, fibrous appearance, slightly translucent	Easily separated from the sample, but stick together like burrs	Fibres give the impression of sticking to the Formvar. Bundled-up collagen units with visible cross bands (III)
HP 36	?	Pale brown, backing and glue attached, uneven texture, brittle	Sample easy to break into pieces, structure seems crystal-like, shrinks in contact with water. Gets gel-like and soft in water	Sample appears badly damaged. More collagen units bundled up (V)
HP 37	1841	Beige, upper and lower sides similar, flexible	Long straight fibres, easy to separate, do not stick together	Collagen units bundled up. Contrast greatly reduced on the one side of the collagen fibres (IV)
HP 38	?	Beige upperside, pale brown mottled underside, flexible	Thin fibres easy to separate when sample surface has been opened	Collagen units bundled up. Contrast greatly reduced on the one side of the collagen fibres (IV)

Table 18.2 Selected data from the amino acid analysis (HPLC) in % mol.

	Hyp	Pro	Tyr	His	Hyl	Lys	Arg	B/A
NP7	9.34	11.92	0.42	0.63	0.73	2.68	4.98	0.68
HP7	8.89	10.23	0.12	0.17	0.70	1.96	4.19	0.53
HP8	9.61	12.17	0.32	0.47	0.65	2.52	4.92	0.68
HP16	9.65	11.93	0.20	0.06	0.59	2.17	4.72	0.60
HP18	9.93	12.08	0.20	0.34	0.55	2.28	4.69	0.62
HP20	9.82	12.30	0.30	0.46	0.52	2.26	4.39	0.57
HP22	9.71	12.20	0.35	0.52	0.60	2.23	4.80	0.62
HP26	10.02	11.64	0.22	0.38	0.54	2.30	4.51	0.60
HP28	9.89	11.72	0.23	0.21	0.57	2.44	4.46	0.59
HP31	9.69	12.18	0.40	0.46	0.66	2.38	4.96	0.66
HP36	9.58	11.42	0.20	0.14	0.44	1.85	4.28	0.52
HP37	9.95	12.66	0.22	0.45	0.50	1.96	4.87	0.60
HP38	10.02	11.98	0.27	0.41	0.55	1.90	4.87	0.60

(v/v) nitric acid, dissolved completely in the nitric acid and made up to 25ml before analysis. The metals were determined by inductively coupled plasma emission spectroscopy (ICP).

Deterioration characterized by shrinkage phenomena

Summary of shrinkage data obtained from the three techniques

The rationale for using three techniques is the ability to optimize characterization of historical parchments by providing a larger set of parameters. Shrinkage has been determined not only in terms of temperature but also in

Table 18.3 Summary of shrinkage data obtained from the three techniques (figures in brackets are standard deviations).

	Thermomicroscopy (MHT)				DMTA				NMR	DSC		
	T_{first}	T_{last}	T_s	ΔT_{Total}	T_i	T_m	Δ_T	Amt. of max. shrinkage	R	60/71	T_s onset	ΔH
NP7	54.0 (1.21)	76.6 (1.58)	57.9 (1.11)	22.5 (2.07)	65	70	5	20	0.67	3.16	63	39.1
HP7	44.3	66.3	55.9	22.0	60	70	10	30	0.68	2.45	61	11.9
HP8	32.0	64.3	40.5	32.3	35	55	20	16	0.53	2.81	42.8	9.6
HP16	31.4	68.1	37.3	36.7	35	55	20	18.5	0.54	2.83	41	16.3
HP18	32.5	67.5	40.9	35.0	35	55	20	19.5	0.53	2.27		
HP20	46.3	70.7	52.8	24.4	50	65	15	22	0.58	2.44	53	9.5
HP22	56.2	74.0	62.8	17.8	65	70	5	14	0.64	2.55	65.5	14.3
HP26	37.2	71.1	41.3	33.9	45	60	15	13	0.42	2.02	44.5	16
HP28	29.2	48.7	33.8	19.6	30	45	15	7	0.47	1.53	–	–
HP31	48.3	76.7	53.4	28.4	55	60	5	18	0.60	2.43	40.0, 60.5	18.9, 17.9
HP36	xx				30	40	10	6.5	0.46	1.89	32	9.3
HP37	56.2	81.4	64.2	25.2	55	75	20	28	0.64	2.92	68	14.2
HP38	49.4	77.3	56.1	27.9	50	65	15	31	0.66	2.21	57.5	14.9

Table 18.4 Ratios for amino acid analysis (HPLC) data calculated to enable direct comparison with the NMR ratios (60/71, 43/71, (174 +171)/71, 174/171).

	NMR (C2 pro+hyp)/C4hyp 60/71	HPLC (pro+hyp)/hyp	NMR (C2gly+C5arg)/C4hyp 43/71	HPLC (gly+arg)/hyp	NMR (C1174+171)/C471	NMR C1 174/171	B/A
NP7	3.16	2.276	3.94	4.099	8.80	1.96	0.68
HP7	2.45	2.151	2.40	4.504	6.62	2.32	0.53
HP8	2.81	2.266	3.09	3.998	7.72	0.76	0.68
HP16	2.83	2.236	3.48	4.064	8.26	2.74	0.60
HP18	2.27	2.217	2.21	3.884	6.39	2.08	0.62
HP20	2.44	2.253	2.28	3.913	6.83	1.81	0.57
HP22	2.55	2.256	2.27	3.930	6.26	1.74	0.62
HP26	2.02	2.162	2.10	3.827	6.89	3.50	0.60
HP28	1.53	2.185	1.48	3.867	4.04	0.98	0.59
HP31	2.43	2.257	2.30	4.005	7.21	1.95	0.66
HP36	1.89	2.192	2.08	4.123	6.19	3.32	0.52
HP37	2.92	2.272	2.80	3.877	7.92	1.50	0.60
HP38	2.21	2.196	2.59	3.892	7.06	1.44	0.60

Table 18.5 pH values, content of anions, Cu, Fe, moisture and parchment dissolved in 0.1M HCl.

	pH	Cl^- (%)	NO_3^- (%)	SO_4^{--} (%)	Cu (mg/g)	Fe (mg/g)	$CaCO_3$ (%)	Moisture (%)	Dissolved (%)
NP7	9.05	0.82	0	0.07			0.00	4.0	0.4
HP7	4.02	0.72	0.57	0.66	0.01	0.66	0.40	3.1	0.8
HP8	7.11	0.16	0	0.28	0.07	0.28	5.50	4.8	0.5
HP16	6.71	0.06	0	0.23	0	0.15	3.63	2.1	0.6
HP18	6.70	0.04	0	0.11			5.01	3.2	0.7
HP20	6.98	0.33	0.1	0.23	0	0.29	7.99	3.0	0.5
HP22	8.10	0.20	0	0.21	0	0.06	3.92	3.7	0.8
HP26	7.41	0.05	0	0	0	0.39	3.64	3.4	0.6
HP28	6.67	0.08	0	0.13			3.13	3.4	0.4
HP31	6.43	0.10	0	0.05	0	0.06	0.00	3.0	0.5
HP36	7.04	0.17	0	0.47	0	1.51	6.16	2.0	0.4
HP37	9.44	0.05	0	0.07			6.25	2.7	0.70
HP38	7.61	0.06	0	0.15			3.76	2.7	0.6

terms of the amount of shrinkage (% displacement) and the enthalpy value accompanying this change. Shrinkage temperature alone does not accurately reflect the state of the parchment. For example HP37 has a high T_s but other parameters such as the width of temperature range over which shrinkage occurs and the enthalpy value indicates that it does differ from the unaged parchment NP7. HP7 is another example which behaves similarly to HP37. The sample that behaves as expected for a historic parchment and has overall consistently low values is HP28. From thermomicroscopy (the micro hot table method (MHT)) sample HP28 has a low T_s and broad temperature range over which

it shrinks. In DMTA creep tests it also displays a low shrinkage temperature and amount of maximum shrinkage and low R ratio (ratio of amount of maximum shrinkage to total shrinkage).

The correlation between the MHT and DMTA methods

The hydrothermal stability represents the total of the deterioration of the parchment. The T_s measured by thermomicroscopy and the T_i measured by DMTA are both assumed to represent the start of the main shrinkage interval. Figure 18.1 shows plot of T_i against T_s with the 95% confidence interval (HP36 is not included as no T_s has been measured due to its gelatinization by exposure to water). The correlation is not significant (correlation coefficient = 0.9172). However, sample HP37 is an outlier, and by omitting this from the analysis the correlation becomes significant with a correlation coefficient of 0.9502. If the two other outliers NP7 and HP26 are omitted the correlation coefficient is improved to 0.9712 and the 95% interval becomes more narrow, leaving HP8 as an outlier (Fig. 18.2). The outliers may represent deviations in the state of deterioration of the sub-samples, which may also be reflected in the other chemical and physical data. This may be tested by measurement of the hydrothermal stability and thus sub-sample deviations may be detected and taken into consideration in the data analysis.

The shrinkage ratio (R) vs. shrinkage temperature

From the shrinkage data some correlation can be made between the measured parameters. An example of this is shown in Figure 18.3 where the shrinkage ratio (R) (the ratio calculated from main shrinkage to total shrinkage as measured from DMTA creep section) is plotted against the shrinkage temperature (T_i) measured from DMTA. In this figure, a reasonable correlation exists between R and T_i, i.e. samples with high shrinkage temperatures also give a high shrinkage ratio. NP7, the unaged sample, appears in the upper left-hand corner and samples HP28 and HP36 appear in the lower right-hand corner, i.e. they show the lowest shrinkage temperatures and lowest shrinkage ratios. From the thermomicroscopy data the grouping of the samples according to average T_s (Odlyha et al. 2002b) also places samples HP28 in the lowest category and in HP36 no shrinkage activity is detected since the sample gelatinizes on contact with water. In addition, thermomicroscopy places sample HP26 in a group with higher shrinkage temperatures than HP28 and which contain HP8 and HP18. This corresponds with the data in Figure 18.3. Sample 26 is an example where although shrinkage temperature is middle of the range, shrinkage ratio is lower than expected – even lower than samples HP28 and HP36. Figure 18.3 also highlights the fact that HP7 (17th century) and HP37 (1841) which are aged parchments behave similarly to NP7.

Figure 18.1 T_i (DMTA) versus T_s (MHT).

Figure 18.2 T_i (DMTA) versus T_s (MHT) excluding the outliers NP7, HP26 and HP37.

Figure 18.3 Shrinkage ratio (R) against initial shrinkage temperature (T_i) (from DMTA creep measurements).

The impact of chemical deterioration on the hydrothermal stability

B/A ratio versus T_s and T_i

As the B/A ratio calculated from the amino acid analysis represents the overall degree of oxidation of the parchment corium collagen, a plot of this against T_s and T_i should in

both cases result in a grouping of the samples according to the degree of influence of the oxidative breakdown on the hydrothermal stability. A low B/A together with a low hydrothermal stability represents a high influence from oxidation which has led to reduction of the collagen peptides. A high hydrothermal stability together with a low B/A may represent the formation of cross-links within the collagen and/or cross-linking with oxidized lipids. Cross-linking will lead to changes in the amino acid distribution and a decrease in the B/A ratio without a decrease in hydrothermal stability. Figures 18.4 and 18.5 show the plots of T_s against B/A and T_i against B/A, respectively. The latter includes sample HP36. This and HP28 are the samples most affected by oxidation. The grouping is most clear in Figure 18.4 (T_s versus the B/A) showing four main groups. However, in both plots the samples with medium and high B/A (> 0.60) and low hydrothermal stability should represent a deterioration mainly caused by hydrolysis (HP16, HP26, HP18 and HP8).

Figure 18.4 T_s (MHT) versus B/A ratio from amino acid analysis (HPLC).

Solid state ^{13}C NMR data vs. B/A ratio

As described above, factors which affect the loss of hydrothermal stability may be considered as arising from chemical changes in the peptide chain. Chemical changes in the peptide chain may also be revealed in changes in the solid state NMR peak with maxima in the region 174–171 ppm. This is the most intense peak in the spectrum: at 171 ppm there is contribution from the carbon involved as the carbonyl of the peptide bond and at 174 ppm there is contribution from the carbon associated with free carboxylic acids. By means of curve-fitting procedures, contributions from these peaks could be quantified and expressed as a ratio (174/171). If this is then plotted against (B/A) ratios the resulting graph is shown in Figure 18.6.

Figure 18.5 T_i (DMTA) versus B/A ratio from amino acid analysis (HPLC).

In this graph, NP7 appears at the left-hand side and HP7 is on the far right-hand side, separated according to B/A values. Samples HP16, HP26 and HP36 move upwards and away from the horizontal axis through NP7, and HP7 is also removed by a small extent along the vertical axis. Increasing values represent increases in contributions from the 174 ppm peak, i.e. more carboxylic acids, and supports the idea that hydrolysis has occurred in these samples, e.g. to a greater extent in HP36 and to a lesser extent in HP16 and HP7. Sample HP28, in this respect, behaves differently to HP36; its value decreases along the vertical axis. The graph can be interpreted in terms of NP7 at the intersection of two lines; one which goes from NP7 to HP36 and the other which proceeds from NP7 to HP28. Samples that lie in the proximity of these lines may represent those in which different mechanisms of degradation have occurred; HP16, HP26 and HP36 (acidic hydrolysis) and HP28 (oxidative processes). Together with the low B/A value, the increase in the 174 ppm peak of HP36 indicates that this sample may suffer from both oxidation and hydrolysis.

From N^{15} NMR the greatest change was apparent in samples HP36, HP26 and HP37 in comparison to NP7. Essentially a loss in the left-hand peak (in the upfield direction) occurred together with a shift of the right-hand peak downfield. This implies that the chemical environment of the N atoms in the peptide bonds is becoming more electronegative with formation of more polar entities, e.g. carboxylic acidic amides. This indicates that some degradation has occurred. The increased levels of acidity are confirmed by the lower B/A values, e.g. by the lower B/A value of HP26

Figure 18.6 Data for the (174/171) NMR ratio plotted against B/A value showing different trends in the behaviour of the historic parchment samples.

Figure 18.7 NMR peak area ratio (174/171) against pH.

Figure 18.8 NMR peak area ratio (174/171) against % sulphate concentration.

(0.60) compared to that of NP7 = (0.68) and reported for the complete set of samples elsewhere in this book.

NMR 174/171 ratio vs. pH and sulphate content

Further plots of the ratio (174/171) against pH and sulphate content also show similar trends (Figs 18.7 and 18.8). It can be seen that NP7 has a high pH and low sulphate content and there is a tendency towards lower pH and higher sulphate in the historic samples, particularly for HP7, which has extreme values in both cases. HP36 has an increased sulphate content along with the high NMR (174/171) ratio, although HP26, with a high NMR (174/171) ratio, has a negligible sulphate content.

Relations between imino acid content and thermal behaviour

4-Hyp is believed to play an important role in the overall helical structure of the collagen stabilizing water-collagen hydrogen bonding (Ramachandran and Ramakrishnan 1976). Burjanadze and Kirsiya (1982) found a positive correlation between the thermal stability and the increasing number of 4-Hyp of invertebrate collagens of different species. In addition, they found that this relationship is restricted only to the presence of 4-Hyp in the Y position of the Gly-X-Y sequence. On the other hand, they found that

the formation of Hyp in the X position neighbouring to 4-Hyp in the Y position prevents the involvement of the latter in water bridge formation. No simple relation between the hydrothermal stability and the content of Hyp has been observed in previous studies of historical leathers (Larsen 1995a) and in the present study of historical parchment. However, several derivatives of Hyp have been detected in deteriorated historical vegetable-tanned leathers (Richardin and Copy 1994). These may derive from hydroxylation of Pro in the X position of the Gly-X-Y sequence. Moreover, the general trend in deteriorated leathers and parchment is a fall in the content of Pro as detected by amino acid analysis. Furthermore, in several of the historical parchment samples in the present study, relatively high Hyp values are found in combination with low Pro. Therefore, studies of the relation between the Hyp and Pro content on the one hand, and the moisture content, hydrothermal and thermal behaviours on the other hand may be highly relevant in connection with damage assessment of historical parchments.

Additionally, the solid state ^{13}C NMR (60/71) ratio (i.e. (C2 of Pro+Hyp)/C4 of Hyp) can provide useful information when plotted against shrinkage temperature T_i (Fig. 18.9). The unaged NP7 has the highest T_i and (60/71) ratio, and in the historic samples there is a trend towards decreasing shrinkage temperature with decreasing (60/71) ratio. This means that the shrinkage temperature is falling in conjunction with a decrease in C2 of proline and hydroxyproline or an increase in C4 of hydroxyproline (or both) in the historic samples. The least changed samples with respect to NP7 are HP22 and HP37, and the most changed are HP36 and HP28, with the other samples located between those two extremes, except for HP16 and HP8 which appear more as outliers, having lower than expected shrinkage temperature values. The positions of the samples relative to NP7 are similar to those obtained from the principal component analysis (PCA) of the measured parameters in the solid state NMR spectra (Odlyha et al. 2002b), which indicated that the samples that had undergone most change were HP28, HP36, HP26 and HP18.

Sample HP22 can be further discussed. According to TEM observations the intensity of cross bands in this sample is reduced and there is evidence of gelatin. Sample HP22 (as well as HP31) provide a definitive fingerprint from the thermal scans by DMTA. Two transitions (peaks in tan δ) are observed at temperatures in the region of 70–90°C and 140–

Figure 18.9 NMR peak area ratio (60/71) against initial shrinkage temperature (T_i, DMTA).

150°C on second heating of the samples, i.e. after loss of physically adsorbed moisture. These transitions correspond to those observed in gelatin (Larsen 1994). Moreover it is reported that the relative intensities of the two peaks can further be influenced by the structure of the gelatin. If the gelatin is considered as a block of copolymer with sequences -(Gly-A-B)x-(Gly-Pro-Hyp)y, i.e. sequences of soft blocks (α-amino acids) and hard blocks (amino acids proline at every 3rd position), then a high proportion of soft blocks will result in a more dominant transition at lower temperatures and hard blocks will result in the transition at higher temperatures. From HPLC data both samples have a high amino acid content, i.e. higher proportions of proline and hydroxyproline amino acids than NP7 as shown in Table 18.6, and so both transitions in HP22 and HP31 are observed at higher temperatures.

Table 18.6 Proline and hydroxyproline values from HPLC data (Table 18.2).

Sample	Pro	Hyp
NP7	11.92	9.34
HP22	12.2	9.71
HP31	12.18	9.69

The amino acids must also therefore be incorporated in the structure to provide sequences of the type (Gly-Pro-Hyp). There must also be some degree of cross-linking in these samples particularly in HP31 since unlike HP18 and HP28 it does not solubilize on prolonged immersion in water.

The observation of transitions (peaks in tan δ) by DMTA indicates the presence of an amorphous phase in the polymeric structure of collagen. The intensity of the peaks and the temperatures at which they occur depend strongly on the type of bonding present in the materials. Where the forces involved in bonding (e.g. van der Waals, dipolar interactions, and hydrogen bonding) are strong then transitions will occur at higher temperatures since they rely on molecular motion. The nature of the transitions will also depend on, and be sensitive to, the presence of groups which hinder or restrict molecular motion. This explains why, for example, the presence of amino acid residues (these are bulky groups), cross-linking and crystallinity will restrict molecular motion. This will lower the intensity of the tan δ peaks and move them to higher temperature. Therefore DMTA provides markers for characterizing materials in terms of amorphous crystalline character and is sensitive to changes in the sequences of amino acid residues, particularly where size of the groups vary. Given the background work on gelatin it also provides a marker for identification of presence of gelatin in the parchment.

Figure 18.10 summarizes the information on the first measured tan δ peak (above 0°C) on second heating in the parchments after a first heating to 120°C. This means that the samples have now been brought to the same moisture content. The majority of the aged samples show their first transition at or just above room temperature. This corresponds to a presence of soft blocks, i.e. small amino acids which do not restrict the motion of the polypeptide chain. Its intensity varies in the samples and depends on cross-linking and sample crystallinity. The next group represents those samples where more of the gelatin hard blocks (Gly-Pro-Hyp) are present and dominate the sample response. The extreme case or outlier appears to be HP16 where additional crystallinity and cross-linking effects dominate.

On the basis of the above considerations, the following conclusions concerning parchments from DMTA thermal scans can be drawn. Samples HP18 and HP28, in addition to HP31 and HP22, show evidence of two gelatin tan δ peaks. In the case of HP18 and HP28 they are not as well defined. In TEM observations, HP22 has been reported to contain fibrils wrapped up in gelatin, and it is also present in samples HP18, HP28 and HP36. However, DMTA shows us that in this case the amino acid residue sequence has been altered and this is why only the dominant peak at lower temperatures is visible.

Thermogravimetric behaviour vs. $CaCO_3$ and sulphate content

The technique of DMTA then gives us a marker for identifying changes in amino acid residue sequences. Thermogravimetry gives us markers (thermal stability) for characterizing changes in chemical composition where bonding forces of the residual structure have changed, e.g. some bonds will be easier to break than others. In unaged samples, e.g. NP7 the molecular structure is intact and so thermal stability is high. As structure degrades, e.g. HP7 this

Figure 18.10 Tan δ of the first measured peak in samples (above 0°C) on second heating.

becomes less stable and this affects its value of thermal stability. Measured as the parameter (T_s) it is the lowest in the historic samples. It also has a low B/A value.

The thermal stability parameter (T_s), taken from thermal gravimetric analysis (TGA) measurements, has been plotted against the $CaCO_3$ content, as calculated in the TGA section (Fig. 18.11). For the historic parchments there appears to be an interesting correlation between $CaCO_3$ content and T_s. With increasing $CaCO_3$ content thermal stability, particularly for sample HP20, increases. This may explain why for some measurements HP20 behaves in a similar manner to NP7. It may explain also why HP36 has a higher than expected thermal stability. Samples HP7, HP31 and HP28 have low $CaCO_3$ content and low thermal stability. This may indicate that the liming process may assist, in the case of some historic parchments, in preserving their structure and improving their state of preservation. Although NP7 is shown on the graph our discussion focuses on the historic parchments only.

A plot of the T_s against increasing sulphate content (Fig. 18.12) has also been performed. This shows that sample HP7 clearly has both the lowest T_s (compared with NP7) and the highest sulphate content (lowest pH). Although there is no simple correlation, it appears in the case of some samples that with decreasing sulphate content (HP16, HP37 and HP8) there is an increase in T_s. This may indicate that samples like HP7 may have been exposed to SO_2 over the years and this accounts for its high sulphate and low pH. The very low B/A ratio originates from oxidative deterioration which most likely has taken place in a period of time before the pollution with SO_2.

B/A ratio vs. Fe content

The catalytic effect of, e.g. Cu and Fe ions on the oxidation of organic compounds is well known. Known also is the damaging effect of Cu and Fe containing inks and dyes on parchment. Trace amounts of these metals originating from the production of the parchment may influence the oxidation of the collagen and other organic substances in the material. Moreover, the metals may catalyze the oxidation of sulphur dioxide and nitrogen oxides in the parchment to accelerate the formation of destructive acids.

Cu and Fe determination was performed on eight of the HP samples (Table 18.5). Cu was only found in trace amounts in the samples HP7 and HP8, whereas Fe was found in somewhat higher amounts in all the eight samples. Apart from the B/A ratio, there is no clear or simple relation between the Fe content and hydrothermal, chemical or other data. With respect to the former, there seems to be a connection between decreasing B/A ratio (increasing oxidation of the collagen) and increasing Fe. As seen from Figure 18.13, the correlation appears to follow a power function, but the samples HP8 and HP26 are outliers. In particular, HP26 has shown to be an outlier in the correlation analysis of several of the other data set. Moreover, as indicated by the analyses of the B/A ratio versus T_s and T_i, both HP8 and HP26 belong to the group of samples deteriorated mainly by hydrolysis. By excluding these two samples, a very fine match to the smoothed power function line is obtained as shown in Figure 18.14.

Figure 18.11 % calcium carbonate concentration against thermal stability T_s (from TGA measurements).

Figure 18.12 Thermal stability (T_s) from TGA measurements against % sulphate content.

Figure 18.13 Plot of B/A ratio versus Fe content.

Chemical damage modelling by the prediction of T_s from chemical data

Previously it has been demonstrated that the hydrothermal stability, expressed by the shrinkage temperature of the vegetable-tanned leathers, can be predicted by means of multiple regression modelling (Larsen 1994, 1995b, 2000; Odlyha et al. 1999, 2000). The prediction was based on a few chemical characteristics of the leather and may be used

Figure 18.14 Plot of B/A ratio versus Fe content omitting the outliers HP8 and HP26.

in the study of the environmental impact and the breakdown patterns of vegetable-tanned leathers. It may also form the basis for improving the methods of artificial ageing. The method may also be used to analyse and predict the general state and type of damage of historical parchment.

Multiple regression analysis

The prediction of the T_s (T_{sPRE}) is performed as a common multiple regression based on the classical least-squares method (Wonnacott and Wonnacott 1990; Kirby 1993; Wilkinson 1990) using the general linear model:

$$Y = \beta_0 + \beta_1 X_1 + \beta_2 X_2 + \beta_3 X_3 + \ldots + e_1$$

where the observed Y is expressed as the expected value plus the random error e. The X_1, X_2, X_3, etc. are the independent variables or predictors. The calculated multiple correlation coefficient R measures how well the dependent variable is related to all regressors at once (R = 1.0000 by perfect correlation). R^2 gives the sum of squares that is explained by all the predictors (SS_{exp}) in proportion to the total sum of squares (SS_{tot}). Thus, $R^2 = SS_{exp}/SS_{tot}$ denotes the part of the variance of the dependent variable which can be explained by the regression equation. The goodness of the fit of the entire model (H_0: $\beta_1, \ldots, \beta_p = 0$) is tested by the analysis of variance expressed by the F-ratio which is the variance explained by the regression divided by the unexplained variance (to reject the null hypothesis, the probability p should be < 0.0500). The probability for the null hypothesis that the individual predictors do not influence the dependent variable (H_0: $\beta = 0$) is found on the basis of the t ratio = b_i/SE, where SE is the standard error of the coefficient b. The H_0 is rejected by a p (2tail) < 0.0500). The standardized coefficients are the partial, or more strictly semi-partial, correlations between each independent variable (predictor) and the residuals from the regression of T_s on all the other predictors. The standardized coefficients are used to compare the influence of each predictor (deterioration factor) on the prediction and are found by performing the regression calculation on the standardized variables = X-μ/SD, where X is the observed value, μ the mean of the variable values and SD the standard deviation on the mean.

Prediction model for historical leathers

The established regression model for the prediction of the T_s of deteriorated vegetable-tanned leather is:

$$T_{sPRE} = \beta_0 + \beta_1 X_1 + \beta_2 X_2 + \beta_3 X_3 + \beta_4 X_4 + \beta_5 X_1 X_2 X_3 X_4$$

where X_1 = the B/A value, X_2 = the % content of tannin monomers, X_3 = the % content of sulphate, $X_4 = [H^+] \times 10^4$ (Odlyha *et al.* 1999). The expression can be understood as a model of the expected event (the T_s of a piece of leather that has been exposed to decomposition directly or indirectly expressed by the factors X_1, X_2, X_3 and X_4). The interaction term reflects the chemical interactions between these decompositional factors.

Prediction model for historical parchments

On the basis of the sulphate content, pH, B/A ratio and the sum of Tyr and His, it is possible to obtain a significant prediction of the T_s (Table 18.7 and Fig. 18.15) of 11 of the 12 selected historic parchments with a measurable T_s. The prediction was based on the following equation:

$$\begin{aligned}T_{sPRE} = &-31.64 - 40.79 \text{B/A} + 65.94(\% \text{ Tyr} + \% \text{ His}) \\ &+ 108.92 \times \% \text{ sulphate} + 8.45 \times \text{pH} \\ &- 36.03 \text{B/A} \times (\% \text{ Tyr} + \% \text{ His}) \times \% \text{ sulphate} \times \text{pH}\end{aligned}$$

The correlation coefficient obtained is = 0.9536, the degree of explanation 90.93% and the goodness of the fit of the entire model is significant with a probability of 0.0122. The coefficient conditions are highly significant for (% Tyr+ % His) (0.0026) and sulphate (0.0067). Significant for pH (0.0104) and the interaction term (0.0150). The coefficient condition for the B/A ratio is very poor with a P(2 tail) = 0.5068. In this connection, as a reminder that even if a predictor is not significant at a 95% significance level, it is not the same as it does not have an actual influence on the ageing (in this case the T_s). The cause of the insignificance may be due to variations or errors in the data either from the measurements or due to material heterogeneity. This is a situation one very often has to face in observation studies in general, and specifically, in conservation studies with access (usually) to only a few small and heterogeneous samples. However, it may also reflect the presence of more subpopulations with different ageing patterns. This can only be clarified through further analysis and more data. Finally, the standardized coefficients of the predictors show that the order of influence of these on the observed T_s is % sulphate > (% Tyr + % His) > interaction > pH > B/A (Table 18.8). This indicates that the overall main cause for the decrease in hydrothermal stability is due to almost equal parts of hydrolysis and oxidation. The same analysis performed on the observed T_i results in weaker prediction with a correlation coefficient of 0.8119. Moreover, the coefficient condition is only significant for (% Tyr + % His).

Table 18.7 Shrinkage temperatures predicted from regression modelling.

	Prediction including HP8 and HP26			Prediction excluding HP8 and HP26		Prediction excluding HP8 and HP26 (reduced model)	
	$T_{S\,OBS}$	$T_{S\,PRE}$	ΔT_s	$T_{S\,PRE}$	ΔT_s	$T_{S\,PRE}$	ΔT_s
HP7	56.3	57.0	0.7	56.4	0.1	56.5	0.2
HP8	40.2	44.8	4.6	–	–	–	–
HP16	37.3	33.1	–3.2	37.2	–0.1	36.1	–1.2
HP18	40.9	38.4	–2.5	40.3	–0.6	40.1	–0.8
HP20	52.8	54.2	1.4	53.1	0.3	53.9	1.1
HP22	62.8	58.7	–4.1	63.4	0.8	62.8	0
HP26	41.3	46.1	4.8	–	–	–	–
HP28	33.8	35.7	1.9	35.3	1.5	36.3	2.5
HP31	53.4	51.4	–2	53.8	0.4	53.3	–0.1
HP37	64.2	65.9	1.7	64.8	0.6	65.1	0.9
HP38	56.1	52.6	–3.5	53.2	–2.9	53.5	–2.6

The regression analysis also shows that samples HP8 and HP26 are outliers. If these are omitted in the analysis, the prediction and the regression conditions are considerably improved (Fig. 18.14 and Table 18.7). The regression equation obtained was:

$$T_{S_{PRE}} = -95.26 + 66.28 B/A + 57.26(\% \,Tyr + \% \,His)$$
$$+ 116.57 \times \% \,\text{sulphate} + 8.86 \times pH$$
$$- 27.93 B/A \times (\% \,Tyr + \% \,His) \times \% \,\text{sulphate} \times pH$$

The correlation coefficient now becomes 0.9940, the degree of explanation 98.70% and the goodness of the fit of the entire model becomes strongly significant with a probability of 0.0050. The coefficient conditions are improved to 0.0022 for % sulphate (% Tyr + % His) (0.0024), pH (0.0029), interaction term (0.0106) and for B/A (0.2080). The order of influence from the predictors is changed for pH, which increases, and the interaction term, which decreases (Table 18.8). The changes in order and magnitude of the influence of the predictors indicates a larger influence from hydrolysis and less from oxidation and the interaction of the breakdown.

In order to improve the model conditions, the prediction was made on the basis of observations on the same 9 samples excluding the B/A ratio from the equation. When using the data from all 11 samples the correlation coefficient (0.9154) and the degree of explanation (0.8380) become weaker than in the full model equation. However, apart from the (% Tyr + % His) predictor the coefficient conditions improve. Excluding again HP8 and HP26 from the calculation gave rise to the following equation:

Table 18.8 Standardized coefficients obtained by the T_s modelling regression analysis.

Predictor	Prediction including HP8 and HP26	Prediction excluding HP8 and HP26	Prediction excluding HP8 and HP26 (reduced model)
B/A	–0.1548	0.2168	
(% Tyr + % His)	1.3193	1.1939	1.2801
% Sulphate	1.8170	1.9466	1.8293
pH	1.0434	1.1474	1.0784
Interaction term	–1.1263	–0.6586	–0.7063

Figure 18.15 Observed T_s versus predicted T_s.

$$T_{S_{PRE}} = -52.06 + 61.39(\% \,Tyr + \% \,His)$$
$$+ 109.55 \times \% \,\text{sulphate} + 8.11 \times pH$$
$$- 18.42 \times (\% \,Tyr + \% \,His) \times \% \,\text{sulphate} \times pH$$

In this case the correlation coefficient becomes highly significant (0.9912), and the degree of explanation significant with 98.26 % (Fig. 18.17). Moreover, the goodness of the fit of the entire model has improved to highly significant with a probability of 0.0009. This is reflected in the coefficient conditions which have all improved considerably: % sulphate (0.0004), (%Tyr + % His) (0.0004), pH (0.0008) and the interaction term (0.0041). As seen in Table 18.7, all predicted T_s values lie within or close to the accuracy of the measurement method (± 2.0°C). The order of influence from the predictors is % sulphate > (% Tyr + % His) > pH > interaction, still indicating equal parts of hydrolysis and oxidation. However, the difference in the influence on the model of the amino acids Tyr and His compared to the amino acids represented in the calculation of the B/A ratio (Arg, Asp, Glu, Hyl and Lys) is rather interesting. The latter may represent oxidative modifications of the side chains and cross-linking whereas the former may represent a higher degree of bond breakage and peptide chain cleavage, for example in the telopeptides (Larsen *et al.* 2002).

Figure 18.16 Observed T_s versus predicted T_s.

Figure 18.17 Observed T_s versus predicted T_s. The prediction is based on the reduced model excluding the B/A ratio from the equation.

PCA of thermomechanical, thermogravimetric and solid state NMR data

PCA using MINITAB (Version 10.2) has been performed on the data obtained from the various measured thermomechanical, thermogravimetric and NMR parameters in order to reduce dimensionality of the data to a more readily interpretable form. The parameters act as descriptors yielding a multi-dimensional space that reflects the perturbed profile of the historic parchments in relation to the unaged sample. By analysing all the data from the different measurements in one combined calculation, it was possible to get an overall picture of the degree of change between the modern and historic parchments.

The parameters used in the calculation were:

- Young's modulus
- Moisture content
- Thermal stability (T_S)
- $CaCO_3$ content
- Initial shrinkage temperature (DMTA creep)
- Shrinkage ratio R
- Percentage displacement change on immersion
- NMR ratio 60/71
- NMR ratio 43/71
- NMR ratio (174+171)/71
- NMR ratio 174/171

The result is shown in Figure 18.17. The modern parchment NP7 is in the top right-hand corner of the plot. Variation along both the first and second principal components has significance in this case, although PC1 is of more importance. It can be seen that samples HP36, HP28 and HP7 are the most separated from the unaged parchment NP7, indicating that the overall degree of change in these samples was the greatest. HP28 is the most separated along both PC1 and PC2. By comparison, HP20 and HP22 show the least difference, with HP20 in particular showing little change along the PC1 axis.

HP7 and HP22 are differentiated from NP7 only along the PC1 axis and not the PC2 axis, since they differ from NP7 in their thermal stability, for example, but in thermomechanical terms (e.g. shrinkage) they are all similar. HP36 differs in the opposite manner, since it has a similar thermal stability but different shrinkage to NP7. It is therefore placed in the opposite corner of the plot to HP7. HP28, which has a much lower shrinkage temperature and thermal stability than NP7, is therefore the most separated from it along both axes. The samples in the bottom left corner, such as HP28, HP18 and HP26 are also among the most gelatinized samples.

The main conclusion from the PCA analysis is that HP36 and HP7 samples differ from NP7 and from each other. This confirms earlier observations in this chapter concerning differences in degradation mechanisms occurring in the samples (e.g. hydrolysis and oxidation).

Macroscopic and microscopic properties vs. measurement data

Some correlation between physical properties at macroscopic and microscopic levels can be made which provide important information for users in practical conservation

Figure 18.18 Division of TGA curve between 200 and 600°C for principal component analysis.

and restoration. HP16, for example, is stiff and has high levels of crystallinity and cross-linking. The fibres can be divided into thinner ones and show discrete slow shrinkage activity. This may mean that sample wetting is made more difficult since it is cross-linked. Furthermore, there is a small amount of expansion (1.4%) on water immersion (DMTA creep test). The bundled-up nature of collagen units in TEM may be characteristic of cross-linking or crystallinity. In NP7, the fibres are intact but difficult to separate. The cross-linking is further indicated by the extreme low His and the low Tyr contents found by the amino acid analysis. Both these residues are known to be involved in cross-link formation by in vivo maturing of hide collagen.

The TEM analysis shows that HP31 has bundled-up collagen units but shows visible cross bands. The fibres are easy to separate and from the mechanical measurements they give the results for gelatin-like behaviour. Moreover, in gelatin terms they give a good mechanical signature (DMTA). It is an example of gelatin behaviour where there are more hard blocks. HP31 is a stiff sample which is resilient to deformation. It expands considerably on immersion in water (5% DMTA creep test) which shows that it is quite hydrophilic and it retains its shape after prolonged immersion in water.

Sample P22 behaves mechanically in a similar way to HP31. However, it expands more on immersion in water (10%), i.e. it is more hydrophilic than HP31. It is also more elastic and recovers better than HP31 on deformation. It has a high shrinkage temperature.

The very degraded sample HP36 is at the same time very brittle – probably the most brittle of all the samples – and breaks readily. This together with the very low B/A, Tyr and His values and relatively low Hyp and Pro, indicates that the oxidative reactions have produced some cross-linking of the collagen. This may lead to low flexibility of the fibres. Moreover, it has a small expansion (1%) on water immersion; some hydrophilic behaviour. Its tendency to break suggests that intermolecular forces of attraction are low and this can be seen in the dominant low temperature transition in DMTA. TEM appearance shows it is badly damaged and more collagen units are bundled up. Solid state NMR analysis (peak area 174/171 ratio) indicates a high degree of hydrolysis of the collagen in this sample.

Like HP36, HP7 has a very low B/A, low Tyr and His but also very low Hyp and Pro values. Moreover, it has the highest concentration of sulphate and the lowest pH value. These data reflect the presence of both acid hydrolysis and oxidation; this is supported by a relatively high (174/171) ratio. However, its hydrothermal stability (as measured by all three methods) is rather high. The TEM observation shows a high degree of fibrils transformed into gelatin and the microscopic observations that the sample is easily divided into layers. This indicates that to a great extent, the oxidative processes have produced cross-links in the inner fibrous collagen structure. This would explain the high hydrothermal stability of HP7.

HP18 is a thick sample and feels stiff like a piece of cardboard. It does not recover on bending, but has a tendency to break and it expands (1.8%) on water immersion. Sample HP28 is more flexible, i.e. it recovers better on deformation and is therefore more elastic than HP18 (it is also a thinner sample). On immersion in water it expands by 3.2%. HP18 has a very low Tyr value, but a relatively high B/A; the opposite is the case for HP28. However, both have low shrinkage ratios and similar mechanical behaviour to HP22 and HP31 with some variation in peak temperature and intensity. In both HP18 and HP28 cross bands are visible (TEM). However, unlike HP31 both completely dissolve on prolonged standing.

The observation of transitions (peaks in tan δ) by DMTA indicates the presence of an amorphous phase.

Conclusions

The general evolution of the deterioration of the parchment collagen from the fibrous into a gelatin-like state, as revealed in this study, is a conclusion of essential importance to practical conservation. This transformation process, as detected by the observation of the parchment fibres in water under the microscope or in TEM analysis, may in many cases lead to irreversible damage of historical parchment manuscripts and objects by humid treatment and storage. The pre-gelatin state of the parchment fibres is not detectable at the macroscopic level.

Although the hydrothermal stability (temperature of shrinkage activities) is an extremely valuable parameter in connection with damage assessment and conservation of parchment, it is important to notice that shrinkage temperature alone does not accurately reflect the state of the parchment. Also the amount of shrinkage (% displacement), the enthalpy value accompanying this change and other parameters such as the width of temperature range over which shrinkage occurs provide essential information on the state of the parchment. Thus, a broad temperature range of shrinkage and a low enthalpy value may indicate that a historical parchment with a high T_s does differ from unaged parchment.

A significant correlation between the T_s measured by thermomicroscopy and the T_i measured by DMTA indicates that both parameters represent the start of the main shrinkage interval. The outliers found by the regression analysis may represent deviations in the state of deterioration of the sub-samples. Deviations should therefore be expected in the other chemical and physical data of the same sub-samples. It is therefore suggested that the hydrothermal stability is used as an indicator for sub-sample deviations which can be taken into consideration in multiple data analysis.

The study of the relation between chemical deterioration and the hydrothermal stability concluded the plots of T_s against the B/A ratio (marker for oxidation of the collagen) calculated from the HPLC amino acid analysis data. This plot shows a grouping of the samples that may represent different ageing patterns. Thus, a low B/A in combination with a low T_s indicates a high degree of oxidative breakdown. On the other hand, samples with medium and high B/A in combination with a low hydrothermal stability should represent a deterioration mainly caused by hydrolysis.

The relation found between the B/A ratio and the Fe content of the historical samples indicates the catalytic effect of this metal on the oxidation of the collagen. Moreover, the two outliers in this analysis belonging to the group of samples mainly deteriorated by hydrolysis, as indicated by the B/A ratio versus T_s and T_i analyses, support the existence of sub-populations of samples with different breakdown patterns.

In general, the assumption that different mechanisms of degradation have occurred are supported by the trends found by plotting the solid state NMR ratio (174/171) against the B/A ratio. The peak at 171 ppm is the contribution from the carbon involved as the carbonyl of the peptide bond. The 174 ppm peak is the contribution from the carbon associated with free carboxylic acids. Increasing values represent an increase in contributions from the 174 ppm (increase in free carboxylic acids) and supports the idea that hydrolysis has occurred in the samples. This analysis also indicates that some samples with low T_s and B/A may also suffer from a high degree of hydrolysis. Plots of the ratio (174/171) against pH and sulphate content show similar trends. These indicate that there is a tendency towards lower pH and higher sulphate in the historic parchment samples.

An interesting correlation has been found by plotting the thermal stability parameter (T_s), taken from TGA measurement against the $CaCO_3$ content. This indicates that thermal stability increases with increasing $CaCO_3$ content. This may indicate that the liming process assists, in the case of some historic parchments, in preserving their structure and improving their state of preservation. A plot of the thermal stability (T_s) against sulphate content shows no simple correlation, but it appears that in the case of some samples the thermal stability decreases with increasing sulphate content.

Amino acid analysis of the historical parchments shows a decrease in Pro often followed by an increase in Hyp. These amino acids are considered to be essential for the physical structure as well as the chemical and hydrothermal stability of the collagen. Although no simple correlation between the content of the amino acids and the shrinkage temperature of the parchment can be found, the solid state ^{13}C NMR (60/71) ratio (i.e. (C2 of Pro+Hyp)/C4 of Hyp) can provide useful information when plotted against shrinkage temperature T_i. This shows a trend of decreasing shrinkage temperature with decreasing (60/71) ratio indicating that the shrinkage temperature is falling in conjunction with a decrease in C2 of proline and hydroxyproline or an increase in C4 of hydroxyproline (or both) in the historic samples.

The observation of transitions (peaks in tan δ) by DMTA indicates the presence of an amorphous phase in the polymeric structure of collagen. The intensity of the peaks and the temperatures at which they occur depend strongly on the type of bonding present in the materials and relates to Hyp and Pro containing segments in the collagen peptide chains. Two transitions (peaks in tan δ) are observed at temperatures in the region of 70–90°C and 140–150°C on second heating of the samples, i.e. after loss of physically adsorbed moisture. These transitions correspond to those previous observed in gelatin. Therefore DMTA provides markers for the identification of the presence of gelatin in the parchment and for characterizing materials in terms of their amorphous crystalline character. Moreover, it is sensitive to changes in the sequences of amino acid residues, particularly where size of the groups vary. For two of the historical samples, both transitions were detected. The HPLC data show that these two samples have a higher proportion of Hyp and Pro.

It has been shown that it is possible to obtain a significant prediction of the T_s on the basis of the sulphate content, pH, B/A ratio and the sum of the % mol Tyr and His by means of multiple regression modelling. The model indicates that the overall main cause of the decrease in hydrothermal stability is due to almost equal parts of hydrolysis and oxidation factors. The prediction made excluding the B/A ratio from the model is interesting and is significant, both with respect to the overall model conditions as well as for the individual coefficient conditions. Moreover, it indicates that the oxidation of the amino acids Tyr and His may lead to bond breakage and peptide chain cleavage for example in the telopeptides. This may influence significantly the decrease in hydrothermal stability compared to the amino acids represented by the B/A ratio, which may to a greater degree represent oxidative modifications of the side chains and cross-linking.

However, this should only be considered as indicative for an average breakdown pattern. The individual samples represent a variation in mechanisms and patterns of deterioration as indicated by the variations in their physical and chemical behaviour and characteristics. This is supported by the main conclusion of the PCA that confirms other observations concerning differences in degradation mechanisms occurring in the samples (e.g. hydrolysis and oxidation). Finally, an interesting feature in the regression analysis is the effect of the predictor represented by the sum of the amino acids His and Tyr on the model. Different from leather, these represent a specific marker for the deterioration of parchment, and may be involved in cross-linking reactions that may influence the hydrothermal stability and physical behaviour of the parchment.

Correlation between physical properties at macroscopic and microscopic levels can be made. Thus, the observed characteristics such as gelatinization and stiffness of fibres and samples can, in several cases, be explained by the specific features observed in the chemical and thermal data. In general, these observations provide important information to end users in connection with practical conservation, restoration and storage of parchment. These preliminary results call for a more intensive study and collection of data in order to provide a more solid basis for the applied assessment and conservation activities. Moreover, the deterioration interaction and synergistic effect of binding media, colour pigments, dyes and ink on the parchment and vice versa has not been included in these studies. However, some of the sampling techniques and microanalytical methods presented in this book provide very useful tools for obtaining additional information to give a more complete picture of the deterioration of parchment manuscripts.

Epilogue: The problem of model building and correlation analysis

Introduction

Parchment is a very complex material, its major component (~ 85%) being collagen (I) with various amounts of other components. The elemental building units of collagen (I) are 18 different amino acid residues. From these the two different α-chains may be constructed, and the combination of two α-chains and one α2-chain forms the collagen molecule. Molecules are assembled into (micro-) fibrils, which again are the building units of fibres, constituting most of the parchment. Ignoring the other compounds, we have four different levels at which the deterioration may be described. The different deterioration mechanisms may or may not be confined to a specific level, but it would be an over-simplification to assume that deterioration at a certain level does not affect the structure or stability at other levels. Furthermore, since deterioration is a process in time, any deterioration mechanism occurring at a certain level might influence the chances of occurrence of another mechanism. For example, hydrolysis of the peptide bonds in the α-chains may destabilize the fibril structure, which again may increase the chances for further hydrolysis. We may term these two effects space and time interaction, respectively.

Within the present project, several advanced techniques have been used to characterize the state of deterioration of parchment. Some of these techniques give information on very specific and different levels, and this may lead to difficulties in the interpretation of the experimental data. Questions such as 'how do oxidative changes of the amino acid composition influence the fibre structure of parchment?' are very difficult to answer, because the two levels are very distant, and because other deterioration mechanisms may be present. The following considerations are an attempt to develop a strategy to circumvent these problems, and to link the results to those obtained by conservators/restorers.

Conservators/restorers often describe a parchment object as being in a good or bad state, a judgement mostly based on visual assessment and/or mechanical testing, sometimes together with shrinkage temperature measurements. The following is a tentative list of properties for visual assessment:

1. Fibre structure (density of visible fibres)
2. Remains of hair follicles
3. Transparency
4. Thickness
5. Scratching properties (fibre separability)
 - dry state
 - wet state
6. Behaviour in water
7. Stiffness
8. Resilience
9. Toughness
10. Strength
11. Presence of calcite
12. Pigmentation
13. Shrinkage activity
14. Animal origin

How can the more advanced methods of analysis be of any help to conservators/restorers to obtain a better description of the state of deterioration, and thereby aid in the treatment decision-making process? Some experiments require expensive equipment while some require extensive knowledge within the field, and it is therefore highly improbable that these methods will be of general use.

The properties listed above are measured on several fibres (coarse-graining), and therefore they describe the macroscopic state of deterioration. Most of the more advanced techniques also give a macroscopic description. Currently, an experiment cannot be performed on, say, a single chain, a single molecule or a single fibril. The sample size comprises many units at each level, and we cannot assume that each unit is in the same state of deterioration.

Differential scanning calorimetry (DSC)

The effect of coarse-graining is illustrated by DSC measurements on a piece of deteriorated parchment (Fig. 18.19). The DSC curve shows the denaturation of parchment as a function of temperature; we may simply interpret the heat capacity (Cp) as some measure of the number of units that denature at a given temperature. It is seen that we have several, with respect to denaturation, very distant states of deterioration.

Level-specific experiments

In contrast to the visual assessment and mechanical testing methods, the advanced techniques may provide statistical information on the deterioration at a specific level. For example, amino acid analysis gives statistical information

Sample HP26
$\Delta H = 12.1$ J/g
$T_m = 50.0°C$
$T_{½} = 3.8°C$

Figure 18.19 DSC on HP26.

on the oxidative deterioration, but gives no information about the positions at which oxidation takes place or about the distribution of oxidation between molecules. Other experiments may give statistical information on other levels. For example, Raman spectroscopy provides information on the α-chains, especially the peptide bonds, and X-ray diffraction gives information on the fibril level. In general, correlation between results from different level-specific experiments will therefore only occur via space and/or time interaction. Taking coarse-graining into account, it is obvious that significant correlations between experimental results from different levels may only be obtained between samples in similar macroscopic states of deterioration. As a consequence of this, correlation analysis may possibly be used to classify parchment samples.

Model building

From a conservator's point of view, it is the macroscopic properties of parchment that are the most interesting. A model of the deterioration of parchment must therefore be a statistical model, a model that can mimic the deterioration, and from which a distribution of states of deterioration may be deduced from experimental data. Because of the complexity of the problem, it may seem impossible to develop such a model. There are, however, several complementary ways by which a model might be achieved:

- The sequences of the amino acid residues are known, and the helical and fibril structures of the intact collagen are known to a very detailed degree, and this information may be used to label every amino acid residue in accordance with its chemical and structural surroundings. Based on this, models may be proposed and subsequently tested by experiments.
- It may be possible to resolve the experimental data into different categories and try to interpret these in terms of deterioration. This approach has been partly successful in the interpretation of Raman spectra and of the amino acid distribution in leather.
- The results from DSC may be of great importance in model building. In some sense, the DSC curve, with respect to denaturation, gives the distribution of states. To fully exploit these data, it will be necessary to have a detailed understanding of the denaturation process.
- With a sufficiently large set of experimental data an artificial neural network might be of use for detecting subtle correlations between experimental data.
- A set of experiments on a piece of parchment gives a snapshot of the process of deterioration. If a set of these snapshots may be ordered, it provides us with a dynamic picture of the deterioration and the path by which the deterioration proceeds.

Strategy

The above considerations lead to the following strategy:

1. use the advanced techniques to develop a statistical model of deterioration,
2. elaborate on the visual assessment and mechanical testing methods,
3. develop standards for quantification of the results,
4. use as many different (advanced and simple) techniques as possible on each sample,
5. try to correlate these to the statistical model.

The correlation analyses must be performed on quantities that represent the macroscopic state of deterioration. The chances of a successful correlation between microscopic and macroscopic quantities (e.g. shrinkage temperature versus amino acid distribution) will be low, and the result will be of dubious value: the number of samples obeying the correlation will be small or the number of parameters needed to obtain significance will be large.

Future experiments

Much knowledge may be obtained from samples briefly exposed to controlled disturbance factors (e.g. pollution, light and heat), especially by performing level-specific experiments. This has been shown by Raman and electron paramagnetic resonance spectroscopy on SO_2 polluted samples. Immediate measurements may give a lead to the character of the space interaction, and monitoring the sample over time may provide information on the time interaction. Since the main purpose of these experiments is to obtain information on the distribution of states, we do not need to mimic the natural deterioration.

Conclusion

A successful outcome will very much depend on the amount of data available for model building and the subsequent correlation analysis. It is important that many different techniques – advanced as well as simple – are applied to a large number of samples in different states of deterioration. This will require an extensive cooperation between both conservators/restorers and scientists, and an efficient flow of data and software between the different research groups. One way of achieving this may be to establish a network of interested conservators/restorers and scientists and to build a central database containing all experimental data and software accessible to all members of the network. In general, information technology may be utilized as a very efficient tool of communication between network members.

References

Burjanadze, T. V. and E. L. Kisiriya (1982) 'Dependence of thermal stability on the number of hydrogen bonds in water-bridged collagen structure', *Biopolymers* 21, p. 1695.

Fraga, A. N. and R. J. J. Williams (1985) 'Thermal properties of gelatin films', *Polymer* 26, 1, pp. 113–18.

Juchauld, F. and C. Chahine (2002) 'Determination of the molecular weight distribution in parchment collagen by steric exclusion chromatography'. This volume, pp. 123–31.

Kirby, K. N. (1993) 'Multiple linear regression', in *Advanced Data Analysis with SYSTAT*, Multiscience Press, Inc. Van Nostrand Reinhold, New York, pp. 165–206.

Larsen, R. (1994) 'Summary, discussion and conclusion', in *STEP Leather Project, European Commission DG XII*, Research Report No. 1, The Royal Danish Academy of Fine Arts, School of Conservation, Copenhagen, p. 165.

Larsen, R. (1995a) 'Collagen – leather: structure and deterioration', in *Fundamental Aspects of the Deterioration of Vegetable Tanned Leathers*, PhD Thesis, The Royal Danish Academy of Fine Arts, School of Conservation, Denmark, ISBN 87 89730 20 8, p. 11.

Larsen, R. (1995b) 'The hydrothermal stability as a measure of the state of deterioration', in *Fundamental Aspects of the Deterioration of Vegetable Tanned Leathers*, PhD Thesis, The Royal Danish Academy of Fine Arts, School of Conservation, Copenhagen, p. 35.

Larsen, R. (2000) 'Experiments and observations in the study of environmental impact on historical vegetable tanned leathers', *Thermochimica Acta* June (special issue on Cultural Heritage and Environmental Implications) [in print].

Larsen, R., D. V. Poulsen, M. Vest and A. L. Jensen (2002a) 'Amino acid analysis of new and historical parchments'. This volume, pp. 93–9.

Larsen, R., D. V. Poulsen and M. Vest (2002b) 'The hydrothermal stability (shrinkage activity) of parchment measured by the micro hot table method (MHT)'. This volume, pp. 55–62.

Odlyha, M., N. Cohen, G. Foster and R. Campana (2002a) 'Characterization of historical and unaged parchments using thermomechanical and thermogravimetric techniques'. This volume, pp. 73–89.

Odlyha, M., N. Cohen, G. Foster, R. Campana and A. Aliev (2002b) '^{13}C and ^{15}N solid state nuclear magnetic resonance (NMR) spectroscopy of modern and historical parchments'. This volume, pp 101–8.

Odlyha, M., G. M. Foster, N. S. Cohen and R. Larsen (1999) 'Evaluation of leather samples by monitoring their drying profiles and changes in their moisture content', in *ICOM Committee for Conservation, 12th Triennial Meeting Preprints*, Lyon, p. 702.

Odlyha, M., G. M. Foster, N. S. Cohen and R. Larsen (2000) 'Characterisation of leather samples by non-invasive dielectric and thermomechanical techniques', *Journal of Thermal Analysis and Calorimetry* 59, p. 587.

Puchinger, L., D. Leichtfried and H. Stachelberger (2002) 'Evaluation of old parchment collagen with the help of transmission electron microscopy (TEM)'. This volume, pp. 9–12.

Ramachandran, G. N. and C. Ramakrishnan (1976) 'Molecular structure', in G. N. Ramachandran and A. H. Reddi (eds) *Biochemistry of Collagen*, Plenum Press, New York, pp. 45–84.

Richardin, P. and S. Copy (1994) 'GC/MS analysis of degradation products', in *STEP Leather Project, European Commission DG XII*, Research Report No.1, The Royal Danish Academy of Fine Arts, School of Conservation, Denmark, ISBN 87 89730 01 1, p. 75.

Wilkinson, L. (1990) in *SYSTAT: The System for Statistics*. SYSTAT, Inc., Evanston, IL, p. 146.

Wonnacott, T. H. and R. J. Wonnacott (1990) in *Introductory Statistics*, 5th edn, John Wiley & Sons, New York, pp. 369 and 496.